Wild Sound

Critical Conjunctures in

Music & Sound

Wild Sound

Maryanne Amacher and the Tenses of Audible Life

AMY CIMINI

OXFORD
UNIVERSITY PRESS

OXFORD
UNIVERSITY PRESS

Oxford University Press is a department of the University of Oxford. It furthers
the University's objective of excellence in research, scholarship, and education
by publishing worldwide. Oxford is a registered trade mark of Oxford University
Press in the UK and certain other countries.

Published in the United States of America by Oxford University Press
198 Madison Avenue, New York, NY 10016, United States of America.

Library of Congress Cataloging-in-Publication Data
Names: Cimini, Amy, author.
Title: Wild sound : Maryanne Amacher and the tenses of audible life /
Amy Cimini.
Description: New York : Oxford University Press, 2022. |
Series: Crit conjunctures music and sound series |
Includes bibliographical references and index.
Identifiers: LCCN 2020053806 (print) | LCCN 2020053807 (ebook) |
ISBN 9780190060893 (hardback) | ISBN 9780190060916 (epub)
Subjects: LCSH: Amacher, Maryanne—Criticism and interpretation. |
Electronic music—History and criticism. | Sound installations (Art)
Classification: LCC ML410.A4826 C56 2021 (print) | LCC ML410.A4826
(ebook) | DDC 786.7/092—dc23
LC record available at https://lccn.loc.gov/2020053806
LC ebook record available at https://lccn.loc.gov/2020053807

DOI: 10.1093/oso/9780190060893.001.0001

1 3 5 7 9 8 6 4 2

Printed by Integrated Books International, United States of America

AMS 75 PAYS Fund and the Claire and Barry Brook Fund of the American
Musicological Society, supported in part by the National Endowment for
the Humanities and the Andrew W. Mellon Foundation

CONTENTS

4. Eartones and Third Ears 169

5. Amacher's House for Strange Life 214

Afterword: Notes with Ears 278

FIGURES

TABLES

ACKNOWLEDGMENTS

In late May 2020, Bill Dietz, Kabir Carter, Keiko Prince, and I had reached the end of a long video chat. We had timed our conversation so that we could all watch dusk over the Boston Harbor from Prince's apartment window on our screens. She had told me to make sure that we spoke at "sunset time." Bill checked and, that day, sunset would happen at 8:32 p.m. EST. Thunderstorms were predicted. We had planned to meet in Boston to talk about her friendship with Amacher and about both artists' work, but pandemic conditions required another approach. As we conversed for about three hours, sunset time came and went. From her window, Prince pointed out the Harbor Islands to us, that she had studied, sketched and reimagined during her time at the Center for Advanced Visual Studies in the 1970s. It became darker and darker; we watched city light flicker across the inky blue harbor. As we eased into longer and longer reflective silences, Prince said quietly, "thank you, Maryanne."

She captured how Amacher had gathered us together in ways that I am still coming to understand and articulate. I remain incredulous about how this took shape, although I am not, myself, in a position to thank Amacher in the way that Prince did. As I will discuss in Chapter 1, I did not meet Amacher while she was alive and moved into ongoing research and social memory in 2012. Yet, this book is in many ways about how Amacher's work and musical thought entangled people together within provocative audiovisual, relational, and conceptual worlds; to me, Prince's words electrified these dynamics in her work. I have admired Prince's sharp observations and candor, since we met in early 2017. On that particular evening, she prompted me to reflect anew on how this project has given rise to creative collaborations, social connections, and friendships that I hadn't imagined were possible. Since 2017, it has been a privilege to be in the company of the Supreme Connections, a research group made up of Amacher's friends, collaborators, and former students who have begun to explore her working methods and archive in practice through public seminars and large-scale events. In Supreme Connections, I am grateful to have worked alongside Kabir Carter, Bill Dietz, Keiko Prince, Nora Schultz, Woody Sullender, Sergei Tcherepnin, and Stefan Tcherepnin. Thank you

for entertaining my queries and ideas in our working process. Dustin Hurt of Bowerbird, Lawrence Kumpf of Blank Forms, and Annette Wolfsberger of Sonic Acts supported large and complex projects that enabled Supreme Connections to experiment with ideas and methods on which, I think, we all continue to reflect and to grow. I am also grateful to many other people who engaged my questions at various research stage. For teaching me in many ways, I am grateful to Kathy Brew, Alvin Curran, Tom Erbe, Scott Fisher, Russell Greenberg, Earl Howard, Andrew Munsey, Keiko Prince, Micah Silver, William Siemering, Bonnie Spanier, Robert The, Peggy Weil, and Jan Williams.

Many people gave of their time to read and discuss drafts of this book at key moments. With intellectual intensity and good humor, Anthony Burr, Michael Gallope, Sarah Hankins, Roshanak Kheshti, Clara Latham, and Julie Beth Napolin gave generous feedback that held the book accountable to ideas and contexts that I could not have seen on my own. These conversations bolstered my courage to make big changes, where the text needed it most. Two reviewers provided comprehensive and challenging feedback that pushed me toward conceptual and expressive clarity in a way that I had not experienced before. I learned so much from the depth and seriousness of their engagement, which has impacted not just this project, but how I now read, teach, and engage with others' work. Josh Rutner provided high-quality editorial services on a fast-moving timeline. Any errors or excesses are, of course, my own.

This book also built on articles that I have published over the last four years. These include "Telematic Tape: Notes on Maryanne Amacher's City Links," "In Your Head: Notes on Maryanne Amacher's *Intelligent Life*," and "Music Theory, Feminism and the Body: Mediation's Plural Work." Editorial support from brilliant colleagues focused my interest in experimentation, in these writings, and challenged me to bring ideas into uncompromised and clear expression. Andrea Bohlman, Georgina Born, Emily Dolan, and Peter McMurray gave richly of their intellectual energy as these articles came together and helped me engage Amacher's work through new eyes and ears.

I am grateful for the training that I received by graduate professors and mentors, including Michael Beckerman, Suzanne Cusick, Martin Daughtry, Don Garrett, Ana Maria Ochoa, and André Lepecki. I have tried to emulate in my own mentorship the trust and unwavering support that Jairo Moreno gave so generously as my graduate advisor. For courage at various stages in this writing, I recalled the fearlessness with which he taught us to craft questions and share ideas. I am also grateful for the work that visionary series editors Jairo Moreno and Gavin Steingo have done to support this manuscript and for the sharp editorial guidance of Suzanne Ryan, at Oxford University Press, through review and revisions, and for Norman Hirschy's support and diligence during the final stages of preparing the manuscript.

So many communities of musicians and artists have challenged me to work toward nuanced, transforming understandings of the roles that music making

can play in musicological research. Such conversations have nourished this project more than perhaps friends and collaborators know and have pushed me to hold my work accountable to music and art practices near and far to those that appear in this book. This includes new and longstanding collaborators Monica Camacho, Henna Chou, Erica Dicker, Seth Garrison, Haydée Jimenez, Sam Kulik, Nick Lesley, Sam Lopez, Emily Manzo, John Melillo, Francisco Morales, Scott Nielsen, Jessica Pavone, Stephanie Richards, Wilfrido Terrazas, Armando de la Torre, Itza Vilaboy, and Katherine Young. Dancer and choreographer Justin Morrison enriched my understanding of the choreographic language in *Torse* and, as we were just getting to know one another, visual artists Alexis Negron and Melissa Walter helped me hear *Adjacencies* in new ways that transformed how I later studied and interpreted the piece.

I have also been grateful to present talks and seminars that enabled me to grow and nuance this research between 2013 and 2021. Audiences at the University of Pittsburgh, University of Pennsylvania, Wesleyan University, UC Santa Barbara, UC Irvine, UC Berkeley, Northwestern University, University of Chicago, University of Minnesota, New York University, Cornell University, UT Austin, the Society for American Music, American Musicological Society, American Comparative Literature Association, International Society for Minimalism, New Media Art and Sound Summit, and Festival de Música Nueva de Ensenada have offered intense engagement that have given me pause at every turn. Thank you to everyone who organized these talks, listened, asked a question, or pulled me aside to discuss things further. Such candor and generosity sustain the social fabrics that make this work worth doing, in the first place.

UC San Diego has been an exciting context within which to carry out this research. A UCSD Faculty Career Development Grant supported course releases during which I completed a first draft manuscript in Winter and Spring 2017. The Institute of Arts and Humanities Manuscript Workshop Program supported substantive feedback and review prior to submission. I am grateful to Luis Alvarez and the IAH staff for facilitating the program and was very privileged to receive feedback from Brigid Cohen through the workshop. Colleagues in the UCSD Music Department have been wonderfully supportive and I am grateful to department chairs, mentors, and area chairs David Borgo, Anthony Davis, Nancy Guy, Lei Liang, and Rand Steiger for helping me balance work, life, and writing at crucial stages. Between 2016 and 2019, vice chair Anthony Burr guided me through two academic review periods and, in that capacity, wrote about what was then work-in-progress in supportive, sharp, and thoughtful terms that helped me see the project from new and unexpected perspectives. When I started at UCSD in Fall 2013, this project was still in its early stages and it has been a sounding board throughout my teaching and advising during the last eight years. I am grateful to have dialogued with my wonderful current and former graduate students Lydia Brindamour, Teresa Díaz de Cossio, Juliana Gaona Villamizar, Keir GoGwilt, Judith Hamann, Yvette Jackson, Sadie Hochman, Rebecca Lloyd-Jones,

Michelle McKenzie, Caroline Miller, Celeste Oram, Juan David Rubio Restrepo, Kevin Schwenkler, Alexandria Smith, Peter Sloan, and Suzanne Thorpe. Madison Greenstone provided brilliant research assistance in Summer 2019.

At the time of this book's publication, the Maryanne Amacher Archive has been transferred to the New York Public Library, through the stewardship of Maryanne Amacher Foundation and Blank Forms, under artistic director Lawrence Kumpf. Prior to this, a herculean digitization effort, in 2015, moved the archive's paper contents onto a dedicated hard drive that remains in composer and theorist Bill Dietz's possession. Starting in Fall 2016, Dietz and I began to present seminars and listening sessions on Amacher's life, work, and musical thought in a wide range of contexts. This facilitated points of public and semi-public access to the archive and a slow turn toward public memory, which swept me toward new sources in specific, partial ways. With Dietz's 2012 *Supreme Connections Reader* as a kind of model, we assembled five new anthologies that introduced specific works series, themes, and periodizations in Amacher's work through writing, project notes, photographic documentation, and letters drawn from the archive. Our programs typically took place over two days. The first day offered a three-hour seminar discussion; the second, we devoted to listening session focused on recorded documents. We have had the pleasure to present seminars with Blank Forms, Space Time, Sonic Acts, écal, Darmstadt, Cologne College of the Arts, the Serralves Museum and CUNY Art Science Connect. Some of these discussions resonate, in shorter form, in the volume of Amacher's *Selected Writings and Interviews*, which I co-edited with Dietz and was published by Blank Forms Editions in Winter 2020. Alongside traditional, solitary practices of study, my relationship to the archive has, with Dietz, been from the outset, dialogical, semi-public, and experimental. The feeling was at first one of sitting side-by-side with a finding aid that was being improvised in conversation and in real time. Informing these improvisations were hopes and fears about what initiating the archive as a project of semi-public interpretation could be. Static and sparkle stuck to sources that we discussed in a matter of days or (sometimes) hours before presenting them to audiences. Something of the vitality and opacity of the archive came through these experiments and continues to reverberate across *Wild Sound*. Working with Dietz has been an experience of ever deepening admiration and trust. With Bill, I have learned how intellectual work can become bound up with friendship and care that overflows its boundaries. His thinking with and through Amacher inspires and challenges me, and I am so grateful that our work brought such a brilliant thinker and friend in my life.

Much of this book was written while sitting next to friends in cafés and backyards. As many of those friends were also writing their own dissertations, articles or first books, together we dreamt up what our projects could even be, in the first place; what compromises could not be made, what risks we would commit to taking. It often felt like we were at the limit all the time. Friends helped navigate the

scarier moments when I was not sure I could write at all, especially amid personal losses in the summers of 2015 and 2016. Their care quieted the anxious pressure toward ceaseless productivity and imagined how to proceed otherwise. I am grateful to Saiba Varma and Lilly Irani for fortitude and good humor during those most exhilarating and difficult moments, and to Clinton Tolley, Erin Rose Glass, and Sarah Hankins, for their kindness, and insight, throughout. Clara Latham, Adele Mitchell, and Aksel Latham-Mitchell lovingly welcomed me into their home as their "writer in residence," and I am grateful for how lovingly they enfolded me into their family during Fall 2015 and after. Countless friendships and intellectual exchanges have also buoyed this work, over many years. For this, I am grateful to Andrea Bohlman, Andrew Burgard, Emily Capper, Delia Casadei, Rachel Corkle, Ryan Dohoney, Glenda Goodman, Lorena Gómez-Mostajo, Sumanth Gopinath, Ted Gordon, Roger Mathew Grant, Aftab Jassal, Jenny Olivia Johnson, Brian Kane, Roshanak Kheshti, Matthew Leslie-Santana, Andrea Moore, David Novak, Kerry O'Brien, Ben Piekut, Jenny Rubottom, Jessica Schwartz, Daniel Villegas Vélez, Naomi Waltham-Smith, Holly Watkins, and Emily Wilbourne. The Music and Philosophy Study Group crew, Michael Gallope, Brian Kane, Stephen Decatur Smith, Tamara Levitz, Seth Brodsky, and Holly Watkins, have been a committed, nourishing intellectual community for almost a decade. Dustine Belle Cimini Jassal Varma provided welcome editorial provocations throughout and Puppy Daisy Flor Chewy Cimini Irani de la Torre reminded me daily that one simply cannot sit in front of the computer forever. As I worked through difficult revisions during the pandemic lockdown and social uprisings in Spring and Summer of 2020, Armando de la Torre created a kind and convivial environment that made it possible to persevere, a reminder that the arts of care and perspective-taking are etched into this book's every page. A work of feminist musicology well knows that such work is not only supportive but constitutive, in creative projects of all kinds. May we all do this work for each other.

To my family and late father David Cimini, I owe the quiet determination that moved this project at every turn. I wish I could hand a copy to him. My mother, Audrey Cimini, and sister, Megan Cimini, extended great patience and kindness, especially when I was often unable to talk about the book's progress amid crucial intervals in the review and revision process. Sometimes not talking about the book was what made it possible to continue working on it, in the first place. I definitely understand the irony and am grateful for your love and patience through those opaque moments. Now we can talk about it all the time.

"I Want to Make a Music..."

Introduction

While preparing a class at Mills College in the early 1990s, Maryanne Amacher paused to write—or at least to imagine writing—a little something about her own music. Heavy black Sharpie announces a "big quote" from Donna Haraway's "Situated Knowledges: The Science Question in Feminism and the Privilege of Partial Perspective" as it appeared in Haraway's 1991 *Simians, Cyborgs and Women.*[1] In pencil, Amacher copied out the middle of Haraway's long paragraph and added emphatic underlining that does not appear in the original text—in particular, the phrases "in our bodies" and "name where we are" are made to stand out. Then, with a stunning change of voice—and a shift to red pen, as shown in Fig. 1.1—Haraway's text becomes "my [Amacher's] text," which is now to begin not with "I want a feminist writing" but rather "I want to make a music."[2]

It is difficult to know exactly how Amacher's reworking might have gone. In five pages of notes that cover the complete book, she reproduced many comparably long extracts as well as shorter, more fleeting annotations. Nothing like this

[1] Donna Jeanne Haraway, "Situated Knowledges: The Science Question in Feminism and the Privilege of Partial Perspective," in *Simians, Cyborgs and Women: The Reinvention of Nature* (London: Free Association, 1991), 183–202.

[2] Maryanne Amacher, "Haraway Transcriptions," undated note. Amacher was appointed the first Rosekrans Artist-in-Residence at Mills College in 1993 and, during the fellowship, taught courses, gave public lectures, and presented a commissioned telematic project titled *The Reference Room: A Psybertonal Topology* that April. In it, she connected two telelinks from the Port of Oakland to the Bender Room at Mills College and mixed the incoming feed with pre-recorded sounds amid visual sets. Amacher had presented work at Mills prior to her 1993 appointment and was well known in the Bay Area, especially after her 1985 *Sound House* staged at Capp Street Project with the support of Kathy Brew and Ann Hatch, as discussed later in the chapter as well as in Chapter 5. In a 1981 project titled *No More Miles (City-Links #19)*, Amacher transmitted a live feed from her Pearl Street Studio in lower Manhattan to the Mills College Auditorium, where it was mixed with live and recorded music prepared by Amacher, Tim Lippard, and students. For more on Amacher's work in the Bay Area, please see Brian Reinbolt, "The 18th Annual Electronic Music Plus Festival," *Computer Music Journal* 15, no. 4 (Winter 1991): 89–94. Reinbolt discusses Amacher's *2021 The Life People* (excerpts), an installation of sound and visual sets at the Pro Arts Gallery in Oakland in April 1991.

Wild Sound. Amy Cimini, Oxford University Press. © Oxford University Press 2022.
DOI: 10.1093/oso/9780190060893.003.0001

Figure 1.1 Amacher's handwritten notes on Donna Haraway's 1988 essay "Situated Knowledges: The Science Question in Feminism and the Privilege of Partial Perspective." Courtesy of the Maryanne Amacher Foundation.

"big quote" appears in her published writing. And nowhere else in her notes on the book did Amacher begin to rewrite or revise what she read. Notes, after all, are tenuous; they are not quite something, but neither are they nothing.

Nonetheless, Amacher's declaration remains quite stunning. The hypothetical ventriloquy of "I want to make a music" moves across vast spaces of meaning, practice, and value to make first-generation feminist science studies speak through theorizations of listening, music, and sound. These pages remind us that, throughout the 1970s and 1980s, Amacher's work coincided with a burgeoning cultural study of science committed to producing concepts of objectivity that could center the perspective of marginalized, oppressed, or disenfranchised people in the production of scientific knowledge.[3] Such work can take root, Haraway's

[3] In her notes on Haraway's book, Amacher highlighted foundational literature in this critical project. She makes note of Ruth Hubbard's *Genes and Gender* and *Women Look at Biology Looking at Women: A Collection of Feminist Critique* and well as Nancy Hartsock's concept of "abstract masculinity" as articulated in her 1983 *Money Sex and Power: Toward a Feminist Historical Materialism* (New York & Boston: Northeastern University Press, 1983). Other signal texts not mentioned in Amacher's notes would be, for example, Sandra Harding, "Rethinking Standpoint Epistemology: What is Strong Objectivity?" in *Feminist Epistemologies*, ed. Linda Alcoff and Elizabeth Potter (London: Routledge, 1993), 49–82; Nancy Hartsock, "The Feminist Standpoint: Developing the Ground for a Specifically

passage insists, in arrangements of the sensorium. How one sees, writes about see-ing, or deploys a metaphorics of vision catches the sensorium already implicated in logics of capital accumulation; such writing takes a position on that implica-tion, whether explicitly or not. But where Haraway speaks of a "feminist writing," Amacher speaks only of "a music" with no adjective and no other qualifier. What is this music that Amacher declared that she wanted to make? What is the feminism that such a music seems to erase or absorb? By the time she had written this note, three decades' worth of work suggested many answers, which, for Amacher, could register in notated compositions, conceptual text pieces, telematic transmission work, large-scale audiovisual and architectural projects, unrealized proposals, and voluminous theoretical writings. Her emphasis on "learning in our body" and naming "where we are and are not" suggests, in these projects, a guiding thread through nascent theories of musical embodiment in which a politics of life, sound, and audibility enmeshes with distributions of power, agency, and security in the late-twentieth-century United States.

Who was Maryanne Amacher? This book must make many kinds of introduc-tions. Some might remember her standing over her custom mixer, swathed in long blond locks, as in Fig. 1.2, in command of a thunderous stereo mix coursing through the walls and floors of venues in the United States, Europe, and Japan during the 1980s and 1990s. With a tape collection comprising material dating back to the mid-1960s, she assembled hours-long sets for rock clubs and episodic or evening-length dramas for galleries and museums, offering dynamic live mixes that seemed to move listeners through built space, so attentive were they to a nascent drama in sound's architectural staging.[4] Many people carry her stories; her students enact her meticulous listening; her performances resonate through listeners' ears, brains and bodies, years and even decades after the fact. An intro-duction to Amacher—let alone a book that places her at its center—could begin with many such remembrances.

The stories this book tells come by way of hundreds of documents that date mostly from before the turn of the millennium. These documents establish *Wild Sound*'s roughly chronological focus between the mid-1960s and the mid-1980s. This timeframe meets Amacher amid dense, rapidly changing intervals of artistic production. It moves across the multi-part series *City-Links*, *Music for Sound-Joined Rooms*, and *Mini Sound Series* to find sonic material and conceptual strategies shared between seemingly distinct projects. It also encompasses the early elec-troacoustic work *Adjacencies*, the mid-1970s research program *Additional Tones*,

Feminist Historical Materialism," in *Feminism and Methodology: Social Science Issues*, ed. Sandra Harding (Bloomington: Indiana University Press, 1987), 157–80; Patricia Hill Collins, *Black Feminist Thought* (Boston, MA: Unwin Hyman, 1990); Chela Sandoval, "New Sciences: Cyborg Feminism and the Methodologies of the Oppressed," in *Cybersexualities: A Reader in Feminist Theory, Cyborgs and Cyberspace*, ed. Jenny Wolmark (Edinburgh: Edinburgh University Press, 1999), 247–63.

[4] See Micah Silver, "Remembrance," http://www.arts-electric.org/stories/091028_Amacher.html, accessed July 17, 2015.

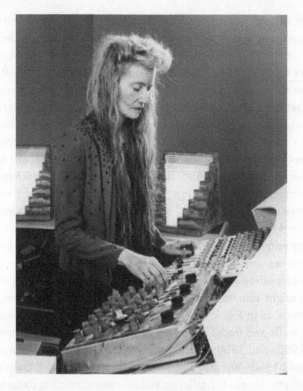

Figure 1.2 Photo of Amacher prior to the opening of her *Sound House: A Six-Part Mini-Sound Series* at Capp Street Project, San Francisco, CA; November 16–December 21, 1985. Courtesy of the Maryanne Amacher Foundation.

and the unrealized media opera *Intelligent Life*. One gets the sense that some projects don't so much end as re-establish their conditions of audibility in new, often unexpected registers of analysis. Amacher's correspondence and informal notes to others suggest that she could be dreamy, sardonic, and also profoundly generous. She pursued new knowledges with fierce autodidactic enthusiasm. Especially intrigued by science fiction, microbiology, biochemistry, telecommunications and virtual reality, she was a meticulous explainer of her ambitions, plans, and goals, but did not suffer skeptics gladly. She navigated social, institutional, and professional hierarchies with a razor-sharp precision; sometimes, her insights became a source of joy or desire, and at others, of anger, anxiety, and desperation. Her loyalty and commitment to friends, collaborators, and some teachers takes one's breath away. A younger contemporary of Lejaren Hiller, Karlheinz Stockhausen, John Cage, and Merce Cunningham, Amacher extrapolated deep insights about their work in her own original audiovisual contexts and mediatic configurations.[5]

[5] Amacher met Cage in the late 1960s and the pair remained friends and collaborators for the rest of Cage's life. As is well known, Cage engaged Amacher to create tape reel recording for *Lecture on the*

Reviews during her 1960s Fellowship with the University of Buffalo's Creative Associates weave comments about her young age, flaxen hair and charm into otherwise frank reportage on her confident handling of musical materials and complex, multi-day intermedial projects, as evidenced in Fig. 1.3.

Her uncompromising autodidactic sensibility comes through four composition notebooks titled *Inharmonic*, *Space*, *Timbre*, and *Additional Tones*, that she drafted or revised between 1966 and 1987. Her dealings with unfamiliar knowledges were patient and systematic. Drawn to the epistemic edges of seemingly qualified knowledge, she rarely proceeded without testing so-called expert claims against her own listening or her personal terminology for sound's embodied complexity and phenomenal impacts. Well aware at an early stage that bids for aesthetic legitimacy would have to engage the modernist figure of "composer-theorist," Amacher cultivated a writerly voice that established epistemic authority as much through critical and technical exposition as the idiosyncratic poetics of awe, exhilaration, and frustration with which she narrated her research processes.

The chronology established by these documents also overlaps key episodes in the governance of life that cut across industrial telecommunications, urban transformation, and emerging biotechnologies in the late-twentieth-century United States. Many concepts of life swirl and eddy among the sounds and sources that resound in this book. This technoscientific quagmire teems with discursive, material, and technological gestures that suggest that sound might be made to seem as though it were, itself, alive. One way to engage Amacher's life, work, and musical thought is to move along the grain of this changing, layered fascination with life. This includes the life of the human body (and of the ear, especially) as well as the life of cities, animals, microbes, and other hypothetical forms. But this does not yield simple celebrations of vitality. Across Amacher's work, life arrives already alienated, managed, mediated by technology, and attenuated across the sociocultural field. Life is not simply othered by concepts of form and structure: in

Weather (1975) and later asked her to make an audio work to be performed along with his ten-hour text composition *Empty Words*, which she entitled *Close-Up* (1979). For Cage's reflections on working with Amacher on *Lecture*, please see Richard Kostelanetz, *Conversing with Cage* (New York: Routledge, 2003), 87. "I knew that her work was very beautiful," he told Kostelanetz in 1979. In this book, I will engage Amacher's correspondence with Cage throughout the 1970s. Their exchanges provide insight into Amacher's work-in-progress as well her candid theorizations about a number of unrealized projects. In these letters, we will also witness Amacher's deep concern for Cage's work and reception. Indeed, in a 1984 proposal to the NEA to fund a multi-tape VHS version of *Empty Words/Close Up*, Amacher included a dedicated note, to this end: "Although we have many published scores and writings by John Cage, there exists no recording of interdisciplinary works created by him! [. . .] This is a very sad fact, considering that it is now 1984! [With this project] we now have the opportunity to EXPERIENCE THIS MAN'S ART—other than a shallow knowledge of his fame, which is how he is mostly known." (Maryanne Amacher, *Empty Words/Close-Up*, Proposal to the NEA, John Cage Collection at Northwestern University). *Wild Sound* prioritizes the ways in which Amacher extrapolated Cage's ideas in her own work, with less focus on the realized projects *Lecture* and *Empty Words/ Close Up*.

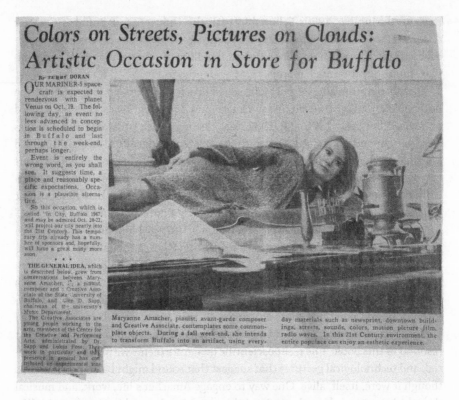

Colors on Streets, Pictures on Clouds: Artistic Occasion in Store for Buffalo

By TERRY DORAN

OUR MARINER-5 spacecraft is expected to rendezvous with planet Venus on Oct. 19. The following day, an event no less advanced in conception is scheduled to begin in Buffalo and last through the week-end, perhaps longer.

Event is entirely the wrong word, as you shall see. It suggests time, a place and reasonably specific expectations. Occasion is a plausible alternative.

So this occasion, which is called "In City, Buffalo 1967," and may be admired Oct. 20-22, will project our city nearly into the 21st Century. This temporary trip already has a number of sponsors and, hopefully, will have a great many more soon.

 * * *

THE GENERAL IDEA, which is described below, grew from conversations between Maryanne Amacher, 27, a pianist, composer and Creative Associate at the State University of Buffalo, and Allen D. Sapp, chairman of the university's Music Department.

The Creative Associates are young people working in the arts, members of the Center for the Creative and Performing Arts administrated by Dr. Sapp and Lukas Foss. Their work in particular and their presence in general has contributed an experimental tone to much of the area's cul-

Maryanne Amacher, pianist, avant-garde composer and Creative Associate, contemplates some commonplace objects. During a fall week-end, she intends to transform Buffalo into an artifact, using everyday materials such as newsprint, downtown buildings, streets, sounds, colors, motion picture film, radio waves. In this 21st Century environment, the entire populace can enjoy an esthetic experience.

Figure 1.3 Preview article for Amacher's *In City, Buffalo, 1967*, a weekend-long festival of participatory and multi-media events that took place in October 1967. Courtesy of the Maryanne Amacher Foundation.

Amacher's work, it is implicated in different registers of political, social, cultural, economic, and technological analysis. This is *Wild Sound*'s feminist gambit.

To ask after a politics of life is already to ask after many things, and where to begin looking and listening is anything but self-evident. While Amacher's work undoubtedly evokes complex visceral impacts, that intensity also delivers concentrations of imaginative excess. Amacher's particular ways of putting things together—ways, one might say, of simply being a composer—call for theorizations of sound that move in many directions: as fictive and partly-unreal; as an organization that both divides and connects social forms; as a variably stable discursive achievement; as a heat-seeking index for new arenas and technologies of vitality—and, thus, as a mediation for many kinds of material effects. Routing sound across this conceptual terrain and toward constitutive frameworks for life raises many questions: What might such frameworks sound like? How are their conditions of audibility established and sustained? What does listening under such conditions bring together or hold apart?

In *Wild Sound*, these difficult questions emerge through grounded inquiry into what it means to put things together in the way that Amacher seems to have done. Thus, "Amacher" garners a few different inflections as this text unfolds. First, as Amacher, the composer, artist, performer, and improviser who stood at the mixing desk, described sounds and concepts, crafted instructions, and otherwise assembled things in patterned, dynamic, and idiosyncratic ways. Second, as 'Amacher,' the composer, artist, performer, and improviser whose particular way of putting things together conjured far-flung social and institutional locations of a transforming technoscience in which she was only sometimes indirectly involved (if she was involved at all). And third, as "Amacher," an approach to those combinations as diagnostic of modern formations of power staked on precisely crafted ways of listening whose embodiments confronted constitutive frameworks in surprising, often ironic ways. Within this intra-layered approach to "Amacher," themes of listening, materiality, body, and life cohere *Wild Sound* as a whole and bring together an essayistic, often conjectural treatment that locates all three inflections as an ongoing project of social memory.

Consider a talk from 2005, shortly after Amacher was awarded the prestigious Golden Nica in Digital Musics.[6] "I just like learning more," she said in response to a question that is not included in the edited video, "because I don't understand this."[7] Amacher stands close to a gaggle of young artists who are seated in a brightly lit room and caught on camera in alternately thoughtful and bemused postures, as shown in Fig. 1.4. She gestures openly with her right hand and leans slightly toward the group, keeping her shoulders low and square. The person holding the microphone nods and smiles, upper body pitched forward to meet Amacher's response.

Amacher's narration is warm and shaded with self-deprecatory humor. "And so if I can associate my stupid sound work," she continues, "[with] learning something new about the reality of the world . . . of my existence . . . ," and then trails off again. Apart from accounting for the "this" that she reported to not understand, one might wonder what it could have meant to her to "understand" (or not) in the first place. Amacher's remarks make clear that she counted her sound work as one among interlocking knowledge projects that, together, sustained precise conditions for their own ongoingness and open-endedness. There's something

[6] The award recognized Amacher's work *TEO! A Sonic Sculpture*, conceived as a sound installation for the Esplanade des Palacio de Bellas Artes in Mexico City. Though the complete work remains unrealized, Amacher's research on the project entailed recording and processing sound samples emitted by sub-atomic particles called muons beneath the Pyramid of the Sun at Teotihuacán. For academic and journalistic coverage of Amacher's honor, please see the following: Joyce Shintani, "Review: Ars Electronica 2005: Festival for Art, Technology and Society, Linz, Austria, 1–6 September 2005," *Computer Music Journal* 30, no. 2 (Summer 2006): 84–87. See also Paul O'Brien, "Ars electronica," *Circa*, no. 114 (December 2005): 83–85 and "News," *Computer Music Journal* 29, no. 4 (Winter 2005): 7–10.

[7] Video edited by Bill Dietz, Courtesy of the Maryanne Amacher Foundation.

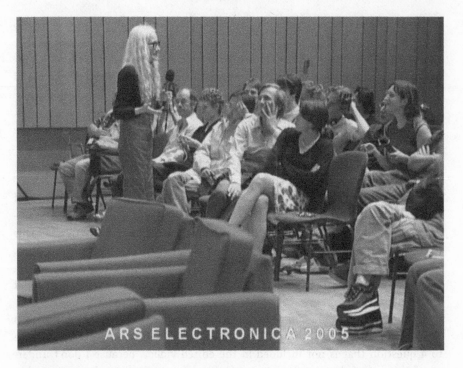

Figure 1.4 Maryanne Amacher speaking at Ars Electronica in 2005. Video still edited by Bill Dietz.

profoundly provisional about all of this: if sound carried Amacher toward what she didn't understand, she also perhaps staked something of her very existence on where it might end up and what it might become. *Wild Sound* takes an ethical chance on this protracted state of "not understanding." This does not necessarily mean highlighting mistakes, miscalculations, or misrememberings—although such quasi-events will often feature throughout the text. Taking this fragment from 2005 seriously means imagining that "not understanding" could also be a kind of strategy for life, a way of organizing one's life and work around personalized temporal coordinates that insist relentlessly on remaining unfinished and ongoing. For *Wild Sound*, this will mean bringing attention to how Amacher conjugated sounds, materials, knowledges, and rhetorical tools in social time in order to create a partly-fictive milieu where they could register and persist—although perhaps not be fully guaranteed. *Wild Sound* follows her self-exposition by alloying speculative intensity with this sense of programmatic unfinishedness. If "not understanding" becomes the book's very grounding, it does not do so as a problem to be solved, but as a sensibility to be explored and narrated. And it is here that this book's concern with tense begins to make itself felt.

Tenses and Moods of the Audible

Wild Sound comes at once too early and too late. I did not meet Amacher during her lifetime, and her papers, though meticulously catalogued, have not been publicly accessible since I began research in 2012. To the living artist's presence and pressure, *Wild Sound* arrives belatedly, but to the possibility of a comprehensive engagement with the Amacher Archive, it arrives too early;[8] this book's ethics of narration respond to not one but two kinds of bad timing. The stories that follow find Amacher archived in many genres of expression and modes of address. Following Ann Laura Stoler, I use "archive" as (at least) part-metaphor.[9] "With a capital 'A,'" the "Archive" leads us toward Amacher's papers, but also into a latticework of remembering, forgetting, and attachment through which we can follow Amacher moving into discourse where she is poised to become many things.[10] Many public and semi-public reflections come through an efflorescence of elegiac writing published across various sources shortly after Amacher's death in 2009. Elegiac writing channels personal and often private remembrances into public genres like the eulogy.[11] The eulogy's apostrophic conventions invite the speaker to turn aside, as though addressing the lost one directly by moving from third-person to second-person modes of address. During such asides, the work of mourning takes shape. Someone says what they always wanted to and, for a moment, couples the fact of telling the truth with a rhetorical gesture that brings the addressee to the cusp of presence.[12] Such moments are often cited over and over again, in part because they arrive already vested with moral authority and

[8] To this end, I appreciate Michael C. Heller's candid reflections on the incomplete nature of his own "point of entry" to the loft era and the Juma Sultan Archive as chronicled in *Loft Jazz: Improvising New York in the 1970s* (Oakland: University of California Press, 2013), especially in Chapters 1 and 7. Heller deals with the incomplete catalogue and transfer of tapes in the Sultan Archive; indeed, at the time of this writing, this is also true of the Amacher Archive. Heller specifically notes the familiar trope of the "lost tape," common among "producers of historical reissues." Amacher's own complex relationship to recording formats notwithstanding, *Wild Sound* strenuously opposes an approach to the archive that would search out "lost" material for commercial release in favor of research and presentation methods that emphasized multi-valent and open-ended dynamics that animated Amacher's practice.

[9] Ann Laura Stoler, "Colonial Archives and the Arts of Governance: On the Content in the Form," in *Refiguring the Archive*, ed. Carolyn Hamilton, Verne Harris, Jane Taylor, Michele Pickover, Graeme Reid, and Raiza Saleh (Dordrecht: Kulwer Academic Publishers, 2002), 87.

[10] Ibid.

[11] This is especially the case with the two remembrances that appeared in the *New York Times*:Allan Kozinn, "Maryanne Amacher, 71, Visceral Composer, Dies," *New York Times*, October 28, 2009and Alvin Curran, "The Score: In Memory of Maryanne Amacher," *New York Times*, December 27, 2009.

[12] For example, see Barbara Johnson, "Apostrophe, Animation, and Abortion," *Diacritics* 16, no. 1 (Spring 1986): 28–47.

because they preserve intimate, first-person experiences that other genres may not welcome.[13]

Apart from the materials from Amacher's own typewriter and pen, no text has influenced this book more than an untitled 2009 essay written by composer and theorist Bill Dietz.[14] Dietz met Amacher in Europe in the early 2000s and, during a decade-long friendship, the two worked together on her electroacoustic *GLIA* (2006) with chamber ensemble, and many other projects.[15] Yet, his text does not exactly detail that work. It begins with an imagined scene in Kingston, New York, and closes with recollections from their first meeting in Berlin, which touch on garlic pasta, an early morning lightning storm, and a taxi ride to the airport. In his text, Dietz channels Amacher's musical thought through demands that amplify its more radical speculations: "Let us replicate atmospheres of our neighboring planets here on Earth, play our sounds within these, and observe the results!"; "Let . . .us conduct Wagner in zero gravity!"; Let us put pearls in our ears and marvel at the color of the book's interface!" Dietz dares the reader to responds that this is all impossible. Or to rationalize limitations that may have hindered Amacher's work—too utopian, too difficult, too little institutional support, too many technologies that did not yet exist. Even if true, these diagnostic guesses would miss the point. "Amacher," Dietz writes, "is a composer in the subjunctive."[16] This phrase is beguiling if opaque. The subjunctive points less to precise distinctions in time (like tense) than to the moods and manners in which nouns

[13] For a reflection on the politics of mourning as a way to sustain life and, especially, the sonorous presence of loss, see the Editor's "Introduction: To Reckon with the Dead: Jacques Derrida's Politics of Mourning," in *The Work of Mourning*, ed. Jacques Derrida, trans. Brault and Nass, 1–30 (Chicago: University of Chicago Press, 2001) and David L. Eng and David Kazanjian, "Introduction: Mourning Remains," in *Loss: The Politics of Mourning*, ed. David L. Eng and David Kazanjian, 1–28 (Berkeley: University of California Press, 2003).

[14] The essay has been published as "Bill Dietz on Maryanne Amacher," at https://www.kamm erklang.co.uk/events/maryanne-amacher-interview/ and in German as "Keine Töne ohne Ohren!" in *MusikTexte*, no. 123, Cologne (December 2009): 21–22, accessed June 8, 2020.

[15] Dietz was directly involved in a number of projects and worked closely with Amacher on installation and preparation. In May 2009, while artistic director of Ensemble Zwischentöne, Dietz began work with Amacher on a commission that went unrealized after she died. Other projects included an untitled performance on the main stage of the Berlin Volksbühne am Rosa-Luxemburg-Platz on May 21, 2005, as a part of ErsatzStadt: Stadt und Theater; a panel discussion and accompanying untitled performance on December 11, 2005 for "KUNST UND DIE POLITIK DES KLANGS," which featured Maryanne Amacher, Arnold Dreyblatt, and Björn Gottstein, hosted by Texte zur Kunst upon the release of their December 2005 "Sounds" issue in the Roten Salon of the Volksbühne am Rosa-Luxemburg-Platz, Berlin; GLIA, her composition for two flutes, two accordions, violin, viola, cello, and live electronics, first presented by Ensemble Zwischentöne at TESLA IM PODEWILS'SCHEN PALAIS in Berlin on June 28, 2006, as a part of Peter Ablinger's "HÖRSTURZ" series; *Gravity—Music for Sound Joined-Rooms Series*, a "sound screening" presented in the Berlin Parochialkirche by singuhr-hoergalerie from September 21 to October 29; and Brückenfindings, her final completed work, inside the hollow chamber of the Deutzerbrücke in Cologne, presented by Brückenmusik from June 21 to June 28, 2009. Many thanks to Dietz for his guidance in compiling this list.

[16] Dietz, "Untitled."

or verbs are expressed.[17] The subjunctive includes wishes, desires, doubts, and hopes, relevant especially to ongoing actions that, because ongoing, must remain to some degree open-ended—even partly unreal. Relative to the generic context of elegiac narration, Dietz's subjunctive seemed to suggest that Amacher had already structured her work around precise ways of persisting in existence. The subjunctive refuses to couple "Amacher" with "composer" in order to bid for inclusion in an already-existing category. Rather, the subjunctive refers this coupling to the actions of sound and listening in the world, to actions that may not have happened *yet* or may not happen *at all*. In the subjunctive, one cannot know for sure. By starting with the tentative gestures of Amacher's note-taking and not, say, the more solid ground of performances, recordings, public talks, or published writings, *Wild Sound* plunges headlong into this hypothetical mode but insists, too, that such an effort must be genealogically and aesthetically elaborated.

Wild Sound suggests that Amacher is also a composer *of* the subjunctive. The protraction of sound in a state of only part-reality could be central to Amacher's working methods and terminologies of study.[18] This practice makes itself felt, in *Wild Sound*, through attention to the non-events of sounds that were hoped-for

[17] As a mood that expresses wishes, doubts, and possibilities, the subjunctive can conjoin narrative and poetic practices with critical, political, and historiographic challenges. In her "Venus in Two Acts," Saidiya Hartman develops a signal formulation of the subjunctive "to tell an impossible story and to amplify the impossibility of its telling" in order to critically assess how the discipline of history intersects with that of the Atlantic slave trade. While *Wild Sound* works with contexts quite different from Hartman's monumental formulation, it elaborates the subjunctive as an approach to conceptualizing life as at once ongoing and foreclosed in ways that have relevance for analytics of race and gender. Saidiya Hartman. "Venus in Two Acts," *Small Axe* 12, no. 2 (2008): 1–14.

[18] Much writing on Amacher's work, especially after 1980, celebrates the seemingly immediate experience of sonic materiality that many listeners undoubtedly cherished in her architectural stagings. Peter Watrous writes about a "sense of physical danger" in "Music Review: Maryanne Amacher," *New York Times*, February 28, 1988;Nicholas Collins invoked "the blissed-out Maryanne Amacher fan, raptly wrapped around her subwoofer for 2 hours" in "Introduction: Thoughtful Pleasures," *Leonardo Music Journal* 12 (2002): 1–2. Florian Hecker writes, "As Henri Bergson observed, what comes to consciousness is a drastically reduced and schematized portion of that which is immediately given to the senses. This is how one might understand the work of the late Maryanne Amacher, whose unique compositions of sound in space, though minimal in form, are sources of intense sensation." "Best of 2010," *Artforum* (December 2010). Consider alsoKyle Gann, "Shaking the Kitchen," *Village Voice*, March 22, 1988, p. 96. While I have elsewhere read Amacher's eartone music through a Spinozistic lens that yielded an account of matter's expressivity, *Wild Sound* moves in a different direction that is perhaps more consistent with a sound art criticism that explores sound's "discursivity" as a messy and figurative project with complex material effects. In this sense, *Wild Sound* will attempt to uncover some conditions under which Amacher's work seems to be put into discourse in specific material terms across the projects that span the mid-1960s through the late 1980s and insists that sound is materialized as intense in precise ways within biopolitical coordinates that can be historically elaborated. For relevant debates across sound art criticism, see Brian Kane, *Sound Unseen: Acousmatic Sound in Theory and Practice* (Oxford: Oxford University Press, 2014); Seth Kim-Cohen, *In the Blink of an Ear: Towards a Non-Cochlear Sound Art* (London: Bloomsbury, 2013); Christoph Cox, "Beyond Representation and Signification: Toward a Sonic Materialism," *Journal of Visual Culture* 10, no. 2 (2011): 145–61.

or imagined and a sense of musical storytelling that takes up sound's conditional temporalities as a primary dramaturgical strategy. The visceral impacts of *Music for Sound-Joined Rooms* and *Mini Sound Series*, for example, can arrive already tied to a sound elsewhere, which remains unheard but nonetheless ongoing. This suggests permeability and part-unreality as ontologies for sounding and listening, and it meets the composer of the subjunctive amid acoustical encounters that entangle questions of social time, tense, and mood.

Adapted from Elizabeth Povinelli, this book elaborates tense and mood as analytics of difference and power.[19] A subjunctive for which sounds are variably "here-ish or there-ish, now-ish and then-ish" approaches audibility as a question of how social forms can be connected or divided through the conjugation of social time.[20] Audibility is always already many things: a collection of institutions, normative structures, practices, and ideologies backed by laws, markets, and power. Tense drags biopolitics along inside it to the extent that it throws into relief the consubstantiality of one body's thriving with another's expenditure—a crucial question for feminist theorists grappling with economies of affective and biological labor and parahuman life.[21] Such occlusions occur, for example, when bodily expenditure is relegated to the past perfect or when attention to present suffering is downplayed in favor of hypothetical attenuation in an uncertain future. With an emphasis on social processes that are open-ended and ongoing, the subjunctive follows how sound qua "vital energy" moves between social locations of expenditure to locations of thriving and dramatizes how these transits become naturalized as constitutive elements of social reality.[22] I borrow the term "vital energy" from feminist science studies scholar Kalindi Vora, for whom it encompasses "a substance of activity that produces life" in not only biological or biotechnological contexts but also between social conjuncture, affective exchange, and fictive speculation that can be gathered up in figurations of artistic activity.[23] Subjunctive phrasings entangle questions of audibility with a politics of life as grounded in specifics of time and place. This analytic of tense is not so much a summary of any one of Amacher's self-statements but rather a kind of nascent outcome of how her sonic concerns encounter, carve, assemble, and oppose other promissory figurations that structure Cold War technoscience in the 1970s and 1980s United

[19] Elizabeth A. Povinelli, *Economies of Abandonment: Social Belonging and Endurance in Late Capitalism* (Durham, NC: Duke University Press, 2011), 4–5; see also Amy Cimini and Jairo Moreno, "Inexhaustible Sound and Fiduciary Aurality," *Boundary 2: An International Journal of Literature and Culture* 43, no. 1 (February 2016): 5–42.

[20] Elizabeth Povinelli, *Geontologies: A Requiem for Late Liberalism* (Durham, NC: Duke University Press, 2016), 13.

[21] Povinelli, *Economies*; Anna Tsing, *The Mushroom at the End of the World: On the Possibility of Life in Capitalist Ruins* (Princeton: Princeton University Press, 2015).

[22] Kalindi Vora, *Life Support: Biocapital and the New History of Outsourced Labor* (Minneapolis: Minnesota University Press, 2015), 3–4.

[23] Ibid., 3.

States.[24] Unlike a technophilic US experimentalism eager to "discover" the sounds of living bodies and submit their raw material to composers for aesthetic refinement and technological elaboration, Amacher's subjunctive underscores how these audibilities come already compacted by technology, capital, and politics and carved by matrices of desire and attachment to competing formations of the vital and the human.

Book Overview and Selected Works

How to imagine the complete text that could have followed the note that Amacher partly began with "I want to make a music . . ."? Instead of a politics of citation that confirms vertical lines of descent or influence, Amacher embraced a paracitational politics of ventriloquy, which suggests ongoing contestations across different social and institutional locations. Through Haraway, Amacher speaks through a signal text in feminist science studies as, also, a theorist of sound. But more than substitution or palimpsestic overlay, this ventriloquy suggests coalitional possibilities as much as common processes or even unbridgeable social distanciation. Though stakes are high for the poetic guesswork it would take to fill out Amacher's note, this section introduces the projects that will be discussed throughout *Wild Sound* by (partly) taking this chance.

Replacing visual figures with auditory ones seems obvious enough. Leading with "I want to make a music" suggests moves from the register of the visible into the audible: vision becomes hearing, visualizing becomes listening, audibilizing, or some such cognate. But these isomorphisms would misrepresent Amacher's formation amid visual and gallery art exhibition practices, active knowledge of stereoscopic imaging, and long-term exploration of sound's materialization amid changing audiovisual logics. They would also miss emphatic details about Amacher's comprehensive engagement with Haraway's book in her complete reading notes. She hand-copied keywords and bombastic sentence openers in which Haraway conjoins bodies, vision, and writing: from "Situated Knowledges," "a view from a body" and "vision technologies"; from "In the Beginning was the Word," "the god trick," and "we should demythologize masculinist science . . ."; and from "The Cyborg Manifesto," "cyborg writing is about the power to survive."[25] These notes shorthand the work that Haraway applied to vision in order to make it serve critical feminist science projects. Before writing what becomes Amacher's "big quote," Haraway works up an ironic deference to maligned visual systems in

[24] See also Kaushik Sunder Rajan, "Introduction: The Capitalization of Life and the Liveliness of Capital," in *Lively Capital: Biotechnologies, Ethics and Governance in Global Market* (Durham, NC: Duke University Press, 2012), 1–44. This is also, of course, tied into a general disciplinary shift in the history of science that sought to pay much closer attention to the messy contingencies of scientific practices and to understand the social construction of knowledge.

[25] All essays appear in *Cyborgs, Simians and Women*, see 71–80; 149–82; 183–202.

two long paragraphs that she acidly calls "a tribute." Before declaring "I want a feminist writing," she blazes through a list whose pointed details and emphatic length caricature technologies that conjure what she calls a "dream of infinite vision," making their utility to colonial, capitalist, and militarist domination impossible to miss. From magnetic resonance imaging to endoscopic pictures of a marine worm's gut, tomography scanners, and electron microscopes, this flashy list reveals a superadditive fantasy poised to collapse under its own weight.[26] With this collapse, Haraway shows that a feminist writing can give rise to a vision that grasps how unbearable its infinite dreams have always been. When vision implodes, in other words, its fragments reveal the limits and distances that distinguish one partial view from another.[27] A feminist writing that places a metaphorical emphasis on vision electrifies these partialities and asks how they can become the basis of "a new physiology," as anthropologist Joseph Dumit puts it.[28] Taken together, the experience that Haraway calls "being in our bodies" and the writerly work that she calls "nam[ing] where we are and where we are not" center epistemic responsibility and coalitional possibility in any calibration that would determine the relevance of perception, embodiment and the senses to one another. Naming where we are uncovers mediations and metaphors that are already beyond our control. Under what conditions does a body take one perspective on itself more easily than another? How do those perspectives regularize the movement of vital energy so that some configurations of bodily matter come to seem more or less active or alive? How might such configurations exceed their sites to reproduce elsewhere and interact with other constitutive frameworks for life?

As Amacher's reference text, Haraway's essay "Situated Knowledges" pulls "I want to make a music" in many directions. It orients an introduction to her working and research methods toward embodied threshold experiences in which transforming materializations of sound and the aural move life across distinct arrangements of tense and mood. Lists of such couplings are scattered across Amacher's writings from the mid-1960s onward and they are quite unlike the ironic enumerative performance to which Haraway applied her feminist writing. Amid a post-Cagean continuum within which "all sounds" promised inexhaustible plenitude, Amacher prioritized questions like "Where does sound come from?" and "How can worlds of sound be joined?" that centered how sound could be perceived. For her, this was a locus of ferocious conceptual invention that intersected imagination, change, and the unknown with concepts of life, body, and alterity and the institutional and technical arrangements that support them. To describe such intersections, Amacher developed original and multivalent theoretical terms, like "negative notation," "long distance music," "perceptual geography," "the listener's

[26] Haraway, "Situated Knowledges," 189.

[27] Joseph Dumit, "Writing the Implosion: Teaching the World One Thing at a Time," *Cultural Anthropology* 29, no. 2 (2014): n.p.

[28] Ibid.

music," and "structure borne-sound." Through detailed work with these construc-
tions, *Wild Sound* considers how constitutive frameworks for life inhabit the
complex meeting places between, for example, acoustical spectra; environmental
sound, remote transmission via telelink, broadcast, and other media; the skin,
outer ear, inner ear, and auditory cortex; sounds in the distant past and future or
sound as experienced by other life forms. To catch such conjunctures in action,
the chronological selections that follow introduce nodes in Amacher's work and
practice that orient *Wild Sound* and sketch the capacious, rigorous methods with
which she analyzed conditions that structured the meeting places sound and lis-
tening could or could not become.

Consider her 1966 description of a speculative broadcast format titled "Red
Seasons of You." In "Red Seasons," Amacher imagined a mediatic environment
in which she could make her early tape pieces available to listeners for home use
via subscription service and, at times, transmit music directly from her studio to
their homes. Listeners could use "Red Seasons" to program selections and to make
score-like instructions to share with other subscribers who could then follow each
other's programming instructions on their own. These could circulate between
friends, like letters or mail art. Here, Amacher speculates:

> A tape collection making available 11 hours of music for home or public
> use. In idea, modeled on future subscriber oriented storage-retrieval
> possibilities—direct transmission of music from the maker's studio,
> museum via remote circuitry.
>
> The collection is composed to be played in full as a single composi-
> tion, "Red Seasons of You," and to serve as an available source for a num-
> ber of different pieces, when only segments of it are selected and played.
> Music lasting only eight minutes may be selected and played as an indi-
> vidual piece, depending on the user's need and interests at the time. (He
> might want to give the music he has found to a friend for examples (like
> a postcard) and especially name what he has selected with, e.g., "Sun,"
> "Snow," "Fire," "Moon," etc. with other additional greeting.
>
> A time / material score accompanies the collection indicating pos-
> sible selective and combining possibilities for isolating individual
> pieces. The collection gives the user the opportunity to make a number
> of individual selections, and later, after some time to return to the full
> collection, for others as his needs (home, friends, concert hall, theater
> broadcast, etc.) and interest changes.[29]

[29] Maryanne Amacher, "Undated Works List (1965–early 1970s)," in *Supreme Connections Reader*,
ed. Bill Dietz (unpublished, 2012). *The Supreme Connections Reader* was assembled by Bill Dietz while
compiling the preliminary inventory of the unprocessed Maryanne Amacher Archive for internal use
in the planning and execution of the 2012 Berlin exhibition *Maryanne Amacher: Intelligent Life* at the
daadgalerie.

"Red Seasons" wove enchanted sonorous threads into architectures of domestic intimacy but also framed the home as a node in a large broadcast network that could include live concert events, theaters, and neighborhood connections with shared a bank of musical selections that could be circulated in a decentralized manner. "[Returning] to the full collection," as Amacher suggests, would not index its integrity so much as ready its recombinable materials for further experiments across friendship and social location. Though this prescient service was never realized, Amacher utilized tapes from "Red Seasons" in live performances during the 1960s and early 1970s, and, in the dedicated long distance transmission projects she realized in *City-Links* (1967–1988), later renamed the collection *Life Time and Its Music* and continued to employ its tapes in live settings.[30]

In the mid-1960s Amacher also articulated questions about location and jointure in her concert music, although she programmatically stepped away from traditional concert formats shortly thereafter. While there exist only fragmented documents of a large choral work *Arcade* (1966) and two tape pieces *Autonomy I & II* (1967) have not yet been located in the archive, a complete score and over sixty pages of working notes provide a rich picture of her electroacoustic work *Adjacencies* for two percussionists and quadraphonic diffusion. Though *Adjacencies* cites a Euro-American avant-garde in thrall with percussive noise within a charged semiotics of mastery and provocation, it addressed the deep interiors of complex spectra with an open-ended approach to listening and actively eschewed playing instructions as such.[31] Her explanatory notes were effusive: "FOLLOW THEM [complex spectra] as far as you can," she writes in a performance note, "in IMAGINING, listening and playing."[32] The score consisted in what Amacher called "negative notation," which Amacher understood not as "graphic" per se, but instead as a temporary heuristic for imagining and conjoining spectral nuances that could also reproduce elsewhere, in excess of the concert setting. Alongside the voluminous technical writings that accompany it, as we shall see in Chapter 2, *Adjacencies* captures Amacher's approaches to spatialization and spectral dimensionality at an early stage, while two 1966 performances—one at the Albright-Knox Gallery in Buffalo and other at Carnegie Recital Hall—generated a

[30] Between 1966 and 1972, the projects that involved "Red Seasons" include work with the PULSA group and the Yale School of Art and Architecture as well as a 1970 tour of Midwest universities with Musica Elettronica Viva in which Amacher joined Anthony Braxton, Serge Tcherepnin, Alvin Curran, and Frederic Rzewski, which was cut short by the Kent State shootings. In a Fall 2013 conversation with the author, Braxton underscored his understanding of Amacher as an especially skilled improvisor.

[31] She also described concrete examples of open-ended acoustical scenarios that the players might encounter while performing the piece. "Timbre is indicated rather than customary hit instructions. Structure is variable: the material is composed to allow change in its formal function through time alteration, e.g. an area sounding in 53" may function differently in another e.g. only 11". A short drum figure on one occasion 7" might circulate the room or another for 5 minutes." Maryanne Amacher, *Adjacencies*, performance notes, in *Supreme Connections Reader*, ed. Dietz, 43.

[32] Ibid.

suggestive flurry of critical commentary that dramatized its challenging and even inscrutable relationship to modernist percussion repertoires.

While *Adjacencies* formalized spectral elisions and jointures in its musical language, the series *City-Links* (1967–1988) asked "how worlds of sound can be joined" through a particular site of inquiry—a city—which renders the political, economic, and social actuality of the question more vivid. In the spring of 1967, Amacher produced the first of what would become, by 1988, a twenty-one-part series, when she helmed the mixing board at public radio station WBFO in Buffalo, New York, and mixed eight live feeds incoming via FM-quality leased lines from various locations in the city during a twenty-eight-hour-long broadcast. Shortly thereafter, Amacher formulated this general description:

> CITY-LINKS is a piece in which sounding resources of two or more remote locations (cities or locations) are fed back to each other to allow for interaction between men and sound at distant locations.[33]

This capacious framework gave rise to conceptual, formal, and technical variations that took shape across fifteen new installments in museums and galleries in the Northeast and Midwest throughout the 1970s, with signal projects at the Walker Art Center, the Museum of Contemporary Art in Chicago, and the Hayden Gallery in Cambridge, where *Hearing the Space 'Live,' Day by Day* appeared in the group show *Interventions in Landscape*.[34] In some cases, Amacher exhibited remote transmissions with visual set pieces that dramatized distanciated listening, as in *Hearing the Space* (1973) and *No More Miles—An Acoustic Twin* (1974), while in others, she employed the same transmissions in concert-like events, in which she mixed incoming sound with her *Life Time* tapes, as shown in Fig. 1.5, or with a live performance transmission from remote sites.

In an eponymous manifesto, Amacher provided *City-Links* with a conceptual grounding in what she called "long distance music" that encompassed telelinks and broadcast technology as well as a listening in situ that extended *Adjacencies* modes of spectral attention to environmental sound and a linkless listening that covered extreme distances germane to an earlier, twentieth-century wireless

[33] Maryanne Amacher, *Hearing the Space, Day by Day, 'Live'*, November 7, 1973–June 7, 1974 (press release).

[34] While Amacher used serial numeration to organize *City-Links* (i.e., *City-Links #1, City-Links #4, City-Links #5*, and so on) by at least the mid-1970s, she also provided each installment with an evocative title and often reused these titles for multiple projects that took place in different cities. This does not indicate shared sonic material per se but instead suggests conceptual subgroupings within the work series. In 1974, for example, Amacher used the title *Everything-in-Air* for concert-like performances in which she mixed live feeds with the *Life Time* tapes to prioritize boundary play at thresholds of audibility. In contrast, she used the title *Hearing the Space, Day by Day 'Live'* for longer-term installations in which incoming feeds were largely left unattended.

Figure 1.5 Maryanne Amacher preparing to perform *Everything-in-Air* at the Museum of Contemporary Art in Chicago, May 1974. She used six tracks of recorded sound from her LIFE TIME AND ITS MUSIC collection to create a sounding environment in the interior space of the Museum of Contemporary Art galleries. As she wrote, "the composition explores familiar acknowledgements of boundary and illusion: auditory dimension and perspective existing between selected sounding material and the physical possibilities within and outside the immediate structure of the performing space." Courtesy of the Maryanne Amacher Foundation.

imagination.[35] But long distance music was no speedy modernist collapse. Instead, it coordinates patient conjugations in the subjunctive and queries social distanciation as a horizon of compositional possibility that, as Chapter 3 details, attaches complex histories to what I will call a "long distance sensorium," an attempt to summarize liminalities in bodily matter through which, according to a Amacher, a long distance music could travel. Amacher deepened this work while a Fellow at MIT's Center for Advanced Visual Studies ("CAVS") between 1972 and 1976.[36] By 1971, its founder, former New Bauhaus faculty György Kepes, had positioned the Center at the nexus of civic and artistic imperatives to address material changes in the city (and the waterfront specifically) amid a protracted period of

[35] Douglas Kahn and Gregory Whitehead, eds., *The Wireless Imagination: Sound, Radio and the Avant-Garde* (Boston: MIT Press, 1992).

[36] Although Amacher provided these dates for the Fellowship on her *vita*, her work at the Center began on an ad hoc basis in 1972 with the traveling group exhibition *Multiple Interaction Team*. She officially became a Fellow in 1973.

state and federal disputes about ecological remediation. Fellows proposed public infrastructures that centered environmental remediation as a locus of civic coherence staked on low-tech public media interactives that wove environmental data streams into everyday life. These efforts took shape in the Boston Harbor Project (1968), Charles River Project (1971–1973), and Boston Harbor Islands Project (1975–1976) as well as the group shows *Weather* (1973), *Interventions in Landscape* (1974), and *You Are Here: Boston Celebrations I & II* (1976), in which Amacher exhibited *City-Links* projects. Among Fellows working in architecture, sculpture, and virtual environment design, Amacher deepened research on spatial perception in environmental sound transmission and auditory processing. From 1973 to 1976, an open and dedicated line transmitted a live feed to her Cambridge studio from the Boston Harbor. As a research program she often called *Tone and Place (Work 1)*, this transmission afforded her deep experiential knowledge of sonic shapes, patterns, and cyclicities that came to inform both her Boston-centered proposals for CAVS and arrangements of long distance music in *City-Links* elsewhere. This concern for both environmental sound and remote transmission brings sectoral changes in industrial telecommunications to bear on the issues of environmental abandonment, structural inequality, and post-industrial public infrastructures that were central to CAVS approaches to material change.[37] Long distance music's rhetorical kinship with long-distance dialing highlights changing labor markets, technological arrangements, and working conditions for telephone operators, a workforce that has historically been gendered and racialized along power-differentiated lines of reproductive work.

Amid this formative interval in *City-Links*, Amacher also explored auditory processes in a meticulous and autodidactic research program focused on sounds that originate within a listener's aural anatomy. Here, she put questions about location and jointure to the ear itself. In a ninety-seven-page compiled manuscript that she called the *Additional Tones Workbook* (1976, rev. 1987), she paired careful source study across otology and so-called psychoacoustics literature with experiments that tested her new knowledge against tone combinations she constructed using the Triadex Muse Sequencer. As she worked slowly through tone combinations, Amacher tracked how they evoked response tones across the skin, outer ear, inner ear, and brain and developed an idiosyncratic poetics that captured the patterns, tendencies, and thresholds that made up their interplay. These studies attuned her compositional protocols to how incident energy moved and transformed across the auditory pathway and to the thresholds levels that delimited

[37] For a robust and recent account of Kepes's technocratic approaches at CAVS, please see John R. Blakinger, *György Kepes: Undreaming the Bauhaus* (Cambridge, MA: The MIT Press, 2019). Across multiple installments, *City-Links* brought together environmental sound streams in the Northeast and Midwest that collide with sectoral dislocations driven by telecommunications and the relocation of production and labor from the Rust Belt to the so-called Sun Belt in the US South and West. Michael Omi and Howard Winant, *Racial Formation in the United States from the 1960s to the 1990s* (New York: Routledge, 1994).

response tones in different auricular structures. By enhancing or attenuating threshold levels, Amacher could create an interaural counterpoint that emerged from distinct locations along the auditory pathway and streamed between built space and the inner body. Amacher gave this music many names: an eardance, an eartone music, a third ear music, a perceptual geography. She described:

> The response tones we create as a result of the acoustic space we are in matter to me as a composer. Tones in the room affect our mind and our body. The after response by creating new tones. What I am calling perpetual geography is the interplay and meeting of these tones, our processing of the given. I distinguish where the tones originate in the room, in the ear, in the brain in order to examine this map and amplify it musically. I want to listen more carefully to what are innate, perhaps distinctly human capabilities. This involves developing a music which more clearly lets us hear some of the responses, lets us "know" that given acoustic intervals are indeed affecting responses in our ears and brain. It is a music which emphatically brings attention to what is "happening" to us.[38]

Amacher's research showed that ears could take partial perspectives on their own morphology. As another way that worlds of sound could be joined, Amacher attached exuberant affects to how auditory processing entered into novel relations with itself. Compositional questions about eartones and other auricular responses opened onto liminal perspectives on the life of a listening body that could become a kind of meeting place for other things and interests. Amacher balanced eartones at the intersection of genealogical and fictive elaborations within which their intermediary perspectives admitted a drama all their own.[39] The work of composing for eartones could convoke commercial and mediatic environments, extraterrestrial embodiments, cellular structures, enchanted domestic architectures, and alternative music historiographies, as Amacher's 1980s work series elaborated.

Begun in 1980 and 1985, respectively, *Music for Sound-Joined Rooms* (*MSJR*) and *Mini Sound Series* (*MSS*) involved listeners in story-like scenes led by three-dimensional sonic shapes that located listeners ambiguously inside and outside of hypothetical worlds conjured by thunderous sonic intensity. While Amacher had coupled visual and sculptural provocations with long-distance listening in *City-Links*, in *MSJR* and *MSS* she proposed new presentational formats that reworked audiovisual logics to create fictive, episodic music dramas on a massive scale. As she wrote, in a project description:

[38] Maryanne Amacher, "As Told To and Edited by Simone Forti," in *Supreme Connections Reader*, 177.

[39] Volker Straebel, "The Day the Music Died: From Work to Practice," July 28, 2012. *Maryanne Amacher: Concert and Presentation*, "*Supreme Connections Laboratory*," Berlin.

In MUSIC FOR SOUND JOINED ROOMS (1980–) the architecture of a building—an entire house, or rooms, walls and other features—is used to create the sound structures, and to evolve stories with scenes and episodes, which are dramatized by the music and sets (including photography, graphic, video and projected images, lighting, furniture, sculpture and texts). The idea is to create an atmosphere that gives the drama of walking into a cinematic close up and being part of the scene, surrounded by its sounds and images. *The audience walks into the world of the story—enters the sets.* I use the architectural features of a building to create intensely dramatic sound experience which cannot be created any other way: a form of sound art that uses the architecture of rooms, specifically TO MAGNIFY THE EXPRESSIVE DIMENSIONS OF THE MUSIC. With the dramatic concepts of these works, I wish to achieve a new genre for experiencing sound, distinct from minimalist and more passive installation forms, as developed in the 1970s and 1980s.[40]

Expressly avoiding the term "installation," Amacher turned to what she called "structure-borne sound" to establish a "new genre" in which an audience's movement through built space would become inextricable from a narrative's unfolding.[41] Structure-borne sound employed idiosyncratic speaker placements, which sent playback first through the solid medium of the built space and only secondarily through the air. Its spectral features emerged from solid-to-air transduction as acoustical shapes with distinct three-dimensional profiles and movements: structure-borne sounds might slither at ankle level, curl around an elbow, or hulk in a corner.[42] Amacher composed with these shapes as though they

[40] Maryanne Amacher, "Project Notes: Music for Sound Joined Rooms" (undated), in *Supreme Connections Reader*, ed. Bill Dietz (unpublished, 2012), 76–78. Italics are mine but all-caps emphases are Amacher's.

[41] Brandon LaBelle analyzes modes of embodiment that can come about when auditory experience informs architectural understanding, with Amacher as a key exemplar. He describes her work as located "against architecture rather than within it," which I take to mean that *MSJR* and *MSS* subject built space to material interventions whose resultant auditory experiences called its infrastructural determinations into question. But even more than what LaBelle calls an "instrumental body," structure-borne sound gives rise to a kind of virtual transport—indeed, this a central conceit in *MSJR* and *MSS*—that emphasis on architectural staging tends to downplay. When describing Amacher's late music thought and practice, Keiko Prince explains, "at this point, I don't think she needed to talk to the world of architecture anymore. I think she wanted to go somewhere in your head." Brandon LaBelle, *Background Noise: Perspectives on Sound Art* (New York: Continuum, 2006), 170–74.

[42] Amacher's writing on the *Mini Sound Series*, specifically, helps to illustrate how "sound characters" were to be developed across the Series' multiple episodes. In a particularly vivid case, she supplied proper names for the sounds whose interactions created long-range formal coherence between episodes that took place over as long as four or six weeks. "The LEAD CHARACTERS are five or more major sound shapes, staged architecturally and interacting dramatically with each other—the STARS of the Mini Sound Series. Their interactions are [. . .] developed in the storyline. (What happens to 'WAVE #4' when it's set up to meet 'THE FRIGHT.' 'DEEP AND DEEPEST TONE' disappears. Was it

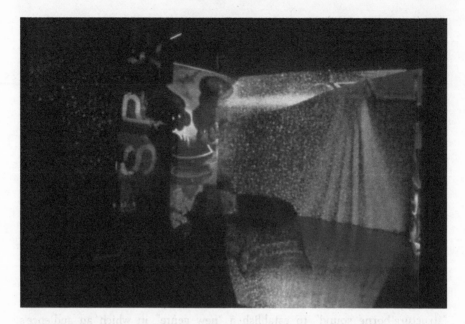

Figure 1.6 Video projection and set pieces for Amacher's *Sound House*. Video was crafted by virtual reality researcher Scott Fisher and, in the background, a prop which replicated Freud's couch can be seen in the shadows. Courtesy of the Maryanne Amacher Foundation.

were actors or characters. But most importantly, they guided listeners as they "walked into the world of the story" and "entered the sets." Sound characters enacted elaborate dramas of dimensional and spectral layering that also built on audiences' familiarity with conventions of serialized narrative. Project director Kathy Brew recalled how, in Amacher's *Sound House* (1985), her first *Mini Sound Series* at Capp Street Project in San Francisco, such characters led visitors to points of special focus, like the projections or props shown in Fig. 1.6 that offered "clues" to the episode's unfolding.[43] "It was a scene," she recalled. On six consecutive Saturday nights in fall 1985, she described visitors lined up around the corner in advance of each episode.[44]

In *MSJR* and *MSS*, Amacher avoided the diffuse and seemingly endless sound installation, while simultaneously eschewing the bounds of the evening-length concert (with its disciplined focus toward the proscenium). For formal models, Amacher looked to the episodic structures of pop cultural forms like the Hollywood musical, mid-century science education films, news articles, and the

really shot down by 'THE HARDBEAT FORCE'? Will it reappear? When it does, two weeks later, it's supporting 'THE COAST' who we know has fallen in love with 'GOD'S BIG NOISE')."

[43] Kathy Brew in conversation with the author, October 11, 2016.
[44] Ibid.

TV miniseries, while, at times, making allusions to grand opera that highlight its long history of intermedial play. "I wanted the kind of engaging format television has developed—with all the 'readymade mind stuff' a mini-series form implies— an evolving sound work 'to be continued' [. . .] As a form, the mini-series is powerful and challenging, yet up to now, only television develops it."[45] Her vast popular reference points offered built-in generic logics for narrative continuation and diegetic models that employed stretches of heightened musicality to reveal new social arrangements and technical knowledges coming into being.[46] *MSJR* began in earnest with *Living Sound (Patent Pending)* (1980), staged in an empty brick house on a St. Paul hilltop during the New Music America festival. Structure-borne sound coursed through the house and pooled around visual and textual clues lit with modest stage spotlights. Petri dishes, newspaper clippings, music stands, DNA photostats, and excerpts from Olaf Stapledon's 1930 novel *Last and First Men* offered clues to a story that conjoined eartones and microorganisms in a fictive ad hoc laboratory setting and bore a title that referenced the pending US Supreme Court decision *Diamond v. Chakrabarty*, which determined that laboratory-created life forms would be available for patent. Subsequent structure-borne projects—like *Sound House* (1985), *The Music Rooms* (1987), *Stolen Souls* (1988), *A Step Into IT* (1992), *2021: The Life People* (1989), *The Biaurals* (1992), and *Intelligent Life* (unrealized treatment, 1980)—differently located eartones and other intermediary perceptions as a way to enter fictive worlds in which they were also protagonists. With themes and topics ripped from the headlines or adapted from literature, science fiction and other music practices, *MSJR* and *MSS* insert the eartone into dramas of intimacy, labor, gendered expertise, and high-tech capital needs that involve a listener's bodily self-awareness in the transforming technoscience and politics of life of the United States in the 1980s.

This survey underlines *Wild Sound*'s chronological focus and introduces projects and contexts that animate the chapters that follow. Between these series, *Wild Sound* will weave dozens of writings, proposals, notes, and unrealized projects that catch their working methods complexly entangled. But this effort is not comprehensive; in the subjunctive, it cannot be. To this end, one could return to the unwritten text that Amacher had begun with "I want a music . . ." to register how auditory thresholds reconfigure through these projects and to synthesize how intra-layered embodiments protract both realized and unrealized projects in the subjunctive. However, this demand also collides with complex histories that shaped where and how such a music could (or could not) register, in the first place. Haraway suggests that one way to access such histories is to "learn in our bodies to attach the objective to our theoretical and political scanners in order to name

[45] Maryanne Amacher, "ABOUT 'The Mini Sound Series,'" in *Supreme Connections Reader*, 90–95.

[46] Indeed, in a 1989 lecture at Ars Electronica, Amacher emphasized how popular serialized narrative provided crucial formal templates that enabled her to move her 1970s research on perceptual dimension in environmental and interaural sound into larger musical structures.

where we are and where we are not, in dimensions of physical space that we barely know how to name."[47] Across the areas in which Amacher worked—and those that would claim her as an exemplar or subject of study (this book included), how-ever—this "body" could mean many things.

Amacher among the Musicologies and Other Studies

I learned of Amacher's music in a circuitous way. In spring 2004, I performed an electroacoustic piece composed by one of her students, composer and improviser Woody Sullender, with a small ad hoc chamber ensemble in Chicago.[48] Sullender would soon return to Bard College to complete the MFA in Sound, where he studied with Amacher and, later, contribute banjo recordings to her 2008 album *Teo!: Sound Characters 2 (making sonic spaces)*.[49] An open instrumentation like Terry Riley's *In C*, Sullender had, that night, convened a vocalist, cellist, bassoon-ist, and violist (myself), and we were to play through repeated notated modules, fade while fixed-media electronic music carried a long middle section, and then rejoin with new notated material. Curious, but also tired and distracted, I recall how the rehearsal's minor affects washed over me while Sullender troubleshot at the mixer. When ready, he told us what to expect: sound will come out of your ears—try turning your heads side to side, "as though shaking 'no,'" he suggested, to explore the auditory dimensions we would soon experience. Bright, sustained sinusoidal tones ignited the air. My ears responded with buzzes and hums. When I moved my head, as recommended, the sounds inside my ear seemed to carve shapes and fissures into the room-bound playback that incited them. Sullender explained that this was his attempt to compose music for eartone responses—something he had learned from Amacher. On the viola, I bowed through a few notated cells, curious to play amid this glittery interaural interplay. I found that I couldn't hear myself playing while also hearing my ears responding.

I offer this scene in the spirit of first-person narration that ballasted late twentieth-century musicology's commitment to the epistemic standpoints of per-formers. Though some have noted that much in this disciplinary moment seems unfinished, *Wild Sound* asks after the constitutive frameworks that sustained its commitments and placed certain concepts of body and not others at its center

[47] Haraway, "Situated Knowledges," 189.

[48] This 2004 concert was presented with curatorial platform "Elastic Arts" that, between 2002 and 2006, programmed concerts, festivals, and film screening at the Humboldt Park venue "3030." Since relocating to Chicago's Logan Square neighborhood, their dedicated space has been renamed "Elastic." Past and present programming can be found here: https://elasticarts.org/programs/.

[49] Amacher was a dedicated teacher and mentor to younger artists through her teaching work at the Bard College MFA program between 2004 and 2009 and in other contexts. I have been grateful to engage her former students, friends, and collaborators in various capacities during my research process.

in the first place.[50] This rehearsal scene pointed in at least two directions: first, toward an instrument-playing body in whose disciplines and pleasures a new, critical, or cultural musicology found evidence for a constitutive instability of musical meaning; second, toward features and figures of listening that did not register in the disciplinary divergences that leveraged their political will along these lines.[51] *Wild Sound* treats this double formation as an impetus to retrieve the historicity of "the body" that cohered meanings and values within an embodied musicology and music theory. Yet, one would be forgiven for thinking that this musicological lineage moves a bit far afield of Amacher. Indeed, *Wild Sound* will, at points, address music and sound studies through critical lenses that Amacher assembled in her work and practice. Such moments draw out part-speculative conjunctures between notions of "body" that inform this lineage and those of "body" and even "life" that I will discern in hers. This section, for example, will build out one such a conjunction with a shared interlocutor in Haraway. At the same time, *Wild Sound* crosses this disciplinary inheritance with the experimental, technological, and audiovisual traditions with which Amacher worked in concert and in conflict—those that drag different powers, figurations, and constitutive frameworks for life along with them.[52] Let's trace some crucial entanglements.

[50] Holly Watkins and Melina Esse have recently argued that despite demanding "more sustained inquiry into musical embodiment in all of its forms as well as novel research methodologies grounded in the principle of body-mind integration, efforts to appraise the embodied and affective dimensions of musical experience still do not enjoy prominence in the discipline at large." Even the *Boston Globe* buttressed a short feature on the analysis of Aretha Franklin's vocal practice with the caveat that until recently "musical analysis had been [. . .] largely limited to notated elements of pitch and rhythm, sidestepping the expressivity encoded in the physicality of performance," retrenching this limitation as "one of musicology's more troubling gaps." The *Globe* article also cites Cusick's 1994 essay. Matthew Guerreri, "When We Listen to Aretha Franklin, Why Do Words Fail?" *The Boston Globe*, September 8, 2016, https://www.bostonglobe.com/arts/music/2016/04/08/when-listen-aretha-franklin-why-words-fail/F5SHfuTgyUxp3bg6sSUUaI/story.html, accessed November 10, 2016. Holly Watkins and Melina Esse, "Down with Disembodiment; or Musicology and the Material Turn," *Women and Music: A Journal of Gender and Culture* 19 (2015): 160–68; for a complementary account, see Elisabeth Le Guin, *Boccherini's Body: An Essay in Carnal Musicology* (Berkeley: University of California Press, 2006).

[51] Robyn Wiegman calls this process "field formation," which "requires a reproductive apparatus that can generate and sustain the critical rationalities, objects of study, and modes of inquiry that enable a field to both claim and perpetuate its identity as a self-legitimating academic authority." More than content or method, she understands such formations as also a sense of belonging rooted in shared political demands and a consensus about on whose behalf those demands should work. Robyn Wiegman, *Object Lessons* (Durham, NC: Duke University Press, 2012), 69–81.

[52] Although I will not go so far as to propose a new disciplinary conjuncture in this book, I would highlight how Martha Mockus's navigation through a 1980s feminist musicology bridges 1960s experimentalist cultures and highlights a "heightened, sensual and cognitive attention" as shared processes in operation across these critical formations. While I will approach these intensities differently in Amacher's work, I hold open the possibility that extensions of 1980s and 1990s feminist musicology can be elaborated in sound art criticism. Martha Mockus, *Sounding Out: Pauline Oliveros and Lesbian Musicality* (New York: Routledge, 2008), 8–9. For critical engagement with this turn across the music fields, see Amy Cimini, "Baruch Spinoza and the Matter of Music: Toward a New Practice of Theorizing Musical Bodies" (Ph.D. diss., New York University, 2011).

Suzanne Cusick's formative 1994 essay, "Feminist Theory/Music Theory and the Mind-Body Problem," strikes a detailed contract with the reader using terms that come directly from Haraway. To be part of what Cusick calls a "useful" study, the reader should prepare to be addressed as a "situated knower," for whom questions of embodiment will become central throughout the essay. Here, she extends the invitation,

> feminist epistemology assumes that all knowledge claims begin life as partial knowledge, determined by the situation of the knower; and that they develop into more generally useful knowledge claims as the result of "conversation" among situated knowers. It is from this idea—that useful knowledge emerges from conversation among situated knowers—that I want to situate my self in relationship with you, with music, and with feminism by revealing the original impetus for this paper.[53]

Cusick's essay systematically explores a performer's epistemic standpoint and models a no-nonsense commitment to the complex task of making music with voices and instruments. This epistemic authority becomes potentially vast in scope, encompassing both musical meaning in general and critical insights about gender in particular. But by toggling back and forth between the standpoints of performer and musicologist, Cusick adds layers of irony. Whatever one knows would not meet the other's standards for value or evidence. This comparison demonstrates how standpoints farthest from a dominant practice become best positioned to give accounts of its biases.[54] Cusick models how to articulate the access, aspect, and scope of a partly hypothetical performer's knowledge and shows how marginality and objectivity share an internal relation that, in turn, can articulate the limits and biases of musicological projects. Such standpoints are not given, they are made by reworking "negative social constraint" into "positive insight" in the dialectic.[55] Neither innocent nor celebratory, this epistemic work is ever partial and remains implicated in processes that it also cannot control.

Cusick's ironic doublings establish two things: first, knowledge projects of theorists, composers, and musicologists are revealed to have always also been embodied or partial despite their disciplinary appearance to the contrary. In fact, the contract with which Cusick opened her essay had already moved her reader in no small degree toward this position. But second, a more complete critical picture of dominant disciplinary bulwarks could not rest on just one (performer-musicologist's) knowledge project. This would require epistemic articulations from a far

[53] Suzanne Cusick, "Feminist Theory, Music Theory and the Mind/Body Problem," *Perspectives of New Music* 32, no. 1 (Winter 1994): 8–27.

[54] Sandra Harding, "Rethinking Standpoint Epistemology: 'What is Strong Objectivity?'," in *Feminist Epistemologies*, ed. Linda Alcoff and Elizabeth Potter (New York: Routledge, 1993), 52.

[55] Fredric Jameson, "*History and Class Consciousness* as an 'Unfinished Project'," *Rethinking MARXISM* 1, no. 1 (Spring 1988): 68.

wider range of differently situated standpoints.[56] Shared conversations in episte-
mology should give rise to webs of connection that would, in the realm of politics,
be called solidarity and coalition. What Cusick calls a "feminist music theory" belies
a broader imperative to reground music studies on an alternate epistemic terrain
built in coalition with heterogeneous marginal knowledge. Instead of co-com-
posing minds, "knowledge oriented to shared authority"; instead of score-bound
analysis, a "plurality of powers and laws"; instead of departmental and institu-
tional hierarchies that would subordinate performance instruction to scholarly
research, "new institutional comportments" and "new forms of sociability based
on weak hierarchies."[57] This reconfiguration would cut across traditional distinc-
tions between creative labor and reproductive work, and, with a broad enough
approach to music's social, material, and discursive distribution, might gather
up knowledge projects rooted across wide-ranging performance practices, medi-
atic circumstances, technical supports, and labor markets. While a sound studies
that took shape amid a mid-2000s materialist turn that, according to Roshanak
Kheshti, risked "organizing and hierarchically ordering the sonic world much like
the material world had been," Cusick's part-speculative coalition suggests a more
tenuous negotiation between epistemic standpoints within which "sound" may
not have emerged as a privileged and progressive interdisciplinary referent.[58] If
parting ways with music to establish, in sound, a more inclusive research object
was among sound studies founding political attachments, this coalitional aspi-
ration in feminist music theory seemed poised to part with music on different
terms: as a determinedly epistemological project that could intervene on distinc-
tions between creative work and reproductive labor that stabilized music's disci-
plinarity in the first place.[59] In *Wild Sound*, we will see and hear Amacher intervene
on such distinctions again and again.

Because a stringent and anti-Cartesian approach to the mind-body relation was
a key epistemic ingredient in such a project, "the body" could serve as its disciplin-
ary referent in multiple registers of analysis. As Rosi Braidotti notes, "body" and
"mind" are powerful heuristics that have "historically functioned as shortcut[s]

[56] See STAR FEM CO*LAB. *The Science We Are For: A Feminist Pocket Guide*. Manuscript in Progress,
2021, 111. As the authors explain, "To gain what Sandra Harding calls 'strong objectivity' and what
Haraway suggests is 'feminist objectivity,' we put together as many of these partial perspectives as
possible. Recognizing objectivity as situated knowledge makes feminist collaboration essential to
improve the accuracy of scientific results."

[57] George Yúdice, *The Expediency of Culture: Uses of Culture in the Global Era* (Durham, NC: Duke
University Press, 2004), 31.

[58] Roshanak Kheshti, "Towards a Rupture in the Sensus Communis: On Sound Studies and the
Politics of Knowledge Production," *Current Musicology* 99 (2007): 7–20, 13.

[59] See Sandra Harding, "Rethinking Standpoint Epistemology: 'What is Strong Objectivity?'," in
Feminist Epistemologies, ed. Linda Alcoff and Elizabeth Potter (New York: Routledge, 1993), 52. The
"radically different experience of the body" proffered by marginal knowledge projects would have
required even the most dominant-seeming standpoints—those of music theorists, composers, and
some musicologists—to be rethought as themselves ineluctably both embodied and partial.

through the complexities of in-between contested zones" and "political arenas,"
which can include departments and disciplines upheld by institutions, capital,
and histories of exclusion.[60] I have long been interested in how specific concepts
of "the body" materialize within these heuristic functions. Robyn Wiegman notes
that, amid an explosion of studies in academic publishing during the 1990s,
"the body" was complexly employed to connect "institutionalized domains of
study" with the social movements or groups on whose behalf those domains also
sought to work.[61] Working primarily within a social constructionist framework,
she explains, "the body" could be expanded and resignified around "constraints
of social formation," "to figure subversion, disidentification, dissidence," and "to
denote [. . .] emergent identities central to the practices and politics of social
movements."[62] Such resignifications could sustain the coalitional shimmers built
into the figuration "embodied music theory" and at the same time attenuate its
distance from other modes of disciplinary knowledge production. In other words,
as subject and object of study, "the body" could galvanize knowledge, interpreta-
tion, and empirical evidence in academic music studies and, at the same time,
provide a disciplinary referent that worked in tandem with or even on behalf of
whatever projects "performers" or "performer-scholars" would undertake from
more marginal standpoints. With composer-theorist and performer-musicologist
as baseline figurations poised for reworking, a wide range of interventions fol-
lowed: renewed interest in renaissance and early modern repertoires; hermeneutic
frameworks that established pleasure, desire, discipline, and alterity as interpre-
tive priorities; theoretical and post-epistemological touchstones that prioritized
subject-formation; historiographies of performance; analytics of vibration, inter-
corporeality, and carnality. To be clear, my point here is not to pull the rug out
from under "the body" but instead to reflect on how, as a "collectivizing sign" in
music and sound studies, it convenes disciplinary and political hope that bridges
some material configurations and lives (but perhaps not others).[63] While, with a
shared reference point in Haraway's "Situated Knowledges," I have highlighted
a speculative edge in the formulation of an "embodied music theory," I also ask
how its figurations worked otherwise across the institutional and technoscientific
circumstances through which Amacher might have threaded that same reference.

Other histories are also relevant here. Such work took place following a reac-
tionary historical moment in which a conservative backlash during the 1970s
re-energized classical liberal discourse around the individual to undermine group-
based directives of the New Left, post-countercultural movements and post–Civil

[60] Rosi Braidotti, "The Politics of 'Life Itself' and New Ways of Dying," in *New Materialisms: Ontology, Agency and Politics*, ed. Diana Coole and Samantha Frost (Durham: Duke University Press, 2010), 201–20, 207.

[61] Wiegman, *Object Lessons*, 39.

[62] Ibid., 39.

[63] Ibid., 41.

Rights projects of the previous decade.[64] The so-called New Right, as Michael Omi and Howard Winant explain, anathematized group rights as anti-democratic and retrenched individual interests as the measure of social and political life.[65] Indeed, Chapters 2, 3, and 5 will encounter concrete instances in this history amid the complex contexts in which Amacher carried out *City-Links* and other environmental projects. As Jairo Moreno and I have chronicled, US cultural policy moved concurrently toward crisis management based not on political economic demands but on narrowed definitions of cultural expression that managed material resources and disciplined civic value at the level of both groups and individuals.[66] Aligning epistemic authority with embodied knowledge established an alternative terrain upon which groups and coalitions could assemble and demand recognition. Claims that "bodies embody knowledge" meant that "different bodies would . . . liberate subordinate knowledges, defetishize scientific expertise and restore to the province of history and culture various groups denied entry to official narration."[67] However, this imperative remained haunted by precisely the liberal and self-possessed individualism that it sought to overcome. Not only must a body be there to create knowledge, in the first place, its unity or integrity must be legible within constitutive frameworks for knowledge and life. As Hortense Spillers has shown and as Frank B. Wilderson III, Alexander Weheliye, and others have discussed in her wake, this integral and intelligible unit has been historically barred along racialized lines.[68] Taking "the body" as the minimal unit of constancy, Wilderson explains, conceals the presumption of a "capacity for spatiality and temporality possessed universally by all." He continues, "each disparate entity in any drama of value must possess not only the spatiality but the power to labor on space, the cartographic capacity to make place—if only at the scale of the body. Each disparate entity in any drama of value has to possess not only the temporality but the power to labor over time: the historiographic capacity to narrate events."[69] A disciplinary turn toward embodied knowledge also entails constitutive exclusions in which narrative and capacity register as "possessions" across spatiotemporal coordinates that anchor a hierarchical politics of life.

[64] Martha Minow, *All the Difference: Inclusion, Exclusion, and American Law* (Ithaca: Cornell University Press, 1991), 3, cited in Ruth Solie, "Introduction: On 'Difference'" in *Musicology and Difference: Gender and Sexuality in Music Scholarship*, ed. Ruth Solie (Berkeley: University of California Press, 1995), 1–28, 2.

[65] Omi and Winant, *Racial Formation*, 192–94.

[66] Amy Cimini and Jairo Moreno, "On Diversity," *Gamut: Online Journal of the Music Theory Society of the Mid-Atlantic* 2, no. 1 (July 2009): 1–86.

[67] Wiegman, *Object Lessons*, 118.

[68] See, for example, Hortense J. Spillers's signal formulations about racialization and flesh in "Mama's Baby, Papa's Maybe: An American Grammar Book," *Diacritics* 17, no. 2 (Summer 1987): 64–81 and elaborations in Alexander G. Weheliye, *Habeus Viscus: Racializing Assemblages, Biopolitics and Black Feminist Theories of the Human* (Durham, NC: Duke University Press, 2014).

[69] Frank B. Wilderson III, *Red, White & Black: Cinema and the Structure of U.S. Antagonisms* (Durham, NC: Duke University Press, 2010), 315.

Complex histories emerge when following the work of a single individual—Amacher—across social and institutional contexts that sustained intellectual genealogies for "the body" that both supported and attenuated life, not least her own. *Wild Sound* extends critical genealogies of the body that have oriented music studies, but complicates them with refocused attention on constitutive frameworks for life. This clarifies how the body belies a series of terms held in play by an array of governing structures—life, nature, matter, vitality, viscerality—whose innervation in sound differently arrange vitality at its most vital, life at its liveliest, body at its most bodily, and so on. This body was not othered or feminized by form and structure, in the manner of many 1980s and 1990s musicological interventions; rather it was made to live in and through the governing protocols that it was also called upon to guarantee. Pulling this critical thread across knowledge projects that, like Amacher's, begin from the standpoint of embodied listeners can challenge how different couplings of sound with "body" are materialized and implicated in technical, social, political, and aesthetic processes or registers of analysis. Parting ways, in other words, with certain heuristic functions can also turn toward the consequences of how bodies are differently materialized and made to live within unevenly distributed matrices of thriving, attenuation, extension, and abandonment.

Life in a Sound and Its Figurations

Consider some social discourses on life that, in Amacher's 1970s and 1980s historical moment,[70] cohered amid the commercialization in the United States of basic biomedical research problems and changing intellectual property regimes that facilitated the transfer of science and technology from universities to the market.[71] Within a US economy reorganized along financial and neoliberal lines with the "commercialization of all kinds of biological products," "bits of vitality"—plasmids, genes, and other proteins—came to represent life at its liveliest for a number of reasons.[72] Amacher named her first *MSJR* project, *Living Sound (Patent Pending)*, in reference to the intellectual property case *Diamond v. Chakrabarty* (1980) involving a laboratory-created bacterium. The lateral transfer of genes

[70] As W. J. T. Mitchell observed, "there is a new kind of vitalism and animism in the air," noting how philosophies of life proliferated in response to biogenetic capitalism, which, for Stefan Helmreich, indicates not only a "social dissensus around [life's] meaning" but also a "fascination with extremes and limits." Cited in Stefan Helmreich, "What Was Life? Answers from Three Limit Biologies," *Critical Inquiry* 37, no. 4 (Summer 2011): 693.

[71] See Kaushik Sunder Rajan, *Biocapital: The Constitution of Postgenomic Life* (Durham, NC: Duke University Press, 2006), 6; Susan Wright, "Recombinant DNA Technology and Its Social Transformation, 1972–1982," *Osiris* 2 (1986): 303–60.

[72] Helmreich, "What Was Life?," 673. See also Melinda Cooper, *Life as Surplus: Biotechnology & Capitalism in the Neoliberal Era* (Seattle: University of Washington Press, 2008), 34–40.

and plasmids between microbes seemed to evidence an exceptional vitality that flouted restraints that held other organisms together. This suggested an abridged connection that commingled biotechnological applications with organic extensions of natural activities,[73] even as their organismal parts were directed—supervivified, one might say—toward the market as commercial value.[74]

There are, in other words, many places to look to discern the life with which Amacher's sounds might collide, ranging across heterogeneous spaces of biopolitics in the 1980s and engaged in "struggles with and against Cold War technoscience and its imperial consequences," as McKenzie Wark puts it.[75] Critical media operations in sound can be understood in relation to spaces of biopolitics in which bodies are innervated as more or less lively in relation to emerging capitalist modes of extraction. For Tara Rodgers, for example, this coupling calls into question a longer history of sound synthesis and its relation to modern mechanisms of biopolitics taking shape in eighteenth- and nineteenth-century Europe.[76] In nineteenth-century sound synthesis, sounds could be newly broken down into constitutive sinusoidal tones, which could then be manipulated as isolable lively individuals and also measured, grouped, reordered, and managed in larger, aleatory units. This inaugurated a genealogy that, for Rodgers, tracks alongside the technologies of knowledge by which, also during the nineteenth century, "basic biological features of the human became objects of a general strategy of power."[77]

[73] Cooper, *Surplus*, 34. See also Lynn Margulis and Dorion Sagan, *What Is Life?* (Berkeley: University of California Press, 1995) and Stefan Helmreich, "Trees and Seas of Information: Alien Kinship and the Biopolitics of Gene Transfer in Marine Biology and Biotechnology," *American Ethnologist* 30 no. 3 (August 2003): 345, 346, and 348.

[74] Sheila Jasanoff, "Taking Life: Private Rights in Public Nature," in *Lively Capital: Biotechnologies, Ethics and Governance in Global Markets*, ed. Kaushik Sunder Rajan (Durham, NC: Duke University Press, 2012), 179.

[75] McKenzie Wark, "Blog-Post for Cyborgs," Public Seminar, September 2015. https://publicseminar.org/2015/09/blog-post-for-cyborgs/, accessed October 4, 2015.

[76] Some music scholars have taken up acoustical arrangements in ways that foreground emphatically biopolitical questions. Robin James explores how auditory culture delivers a qualitative experience of the normative statistical continuities that comprise biopolitical management with an emphasis on ratio and proportion as common processes in operation. Like Rodgers, Brian Kane addresses contexts that involved sonic quanta in changing dramas of value, focused not on feminist analysis but on the stochastic methods of Iannis Xenakis. Kane finds that Xenakis's insistence on Epicurean models from nature conceals the historical and biopolitical genealogies that locate probabilistic analysis in relation to governance and control. Both Kane and James find a one-step rhetorical connection between data and sonic quanta such that, by explaining one in terms of the other, tools of statistical management become not only sensible and expressive but naturalized in auditory culture. Naomi Waltham-Smith emphasizes an intellectual genealogy that comes through Jacques Derrida, Giorgio Agamben, and Hélène Cixous by working through auditory and acoustical figures. See Robin James, *The Sonic Episteme: Acoustic Resonance, Neoliberalism and Biopolitics* (Durham, NC: Duke University Press, 2019) and Naomi Waltham-Smith, *Shattering Biopolitics: Militant Listening and the Sound of Life* (New York: Fordham University Press, 2021).

[77] Michel Foucault, *Security, Territory, Population: Lectures at the Collège de France, 1977–1978*, trans. Graham Burchell, ed. Michel Senellart (New York: Picador, 2007), 2. In addition to the key texts from

Disciplinary enclosures individuated bodies and architectural management secured their hierarchical arrangement while biological potentials were statistically aggregated (at the level of the population) and measured against acceptable norms and limits in biopolitical governance. But lived processes were not just measured; those measurements were merged with gendered and racialized types such that power seemed to produce bodies, material, and life with "attributes that seemed to emerge as natural and in critical ways, consubstantial with them."[78] When we hear life in a sound, Rodgers argues, we might actually be hearing—or perhaps reproducing—analogies between the critical media operations of nineteenth-century sound synthesis and the materialization of bodies at the intersection of disciplinary incitement and biopolitical management.[79]

Rodgers summons these genealogies for feminist analysis in an essay that follows composer Annea Lockwood's reflections on the question "what, for me, constitutes life in a sound?" into technological and historical registers of analysis. Some of this may perhaps be no surprise. Many artists invoke newly enlivened notions of sound to dramatize changes, for example, across institutional affiliation, media environments, exhibition practices, or collaborative and participatory methods. However, the meeting places that these tropes hold together also drag complex histories along with them; some unexpected figurations will emerge in Chapter 2. Lockwood's conversation with Rodgers make for a vivid case in point. She leads with a summary of early musical formations that began with composition studies at the Royal Conservatory of Music in 1961 and included the Darmstädter Ferienkurse in 1962 and 1963, followed by two years of electronic music study with Gottfried Michael Koenig in Cologne. She explained:

> Part of it was because I was studying electronic music with Koenig in the early '60s, the process was very much like those early Stockhausen pieces—*Studie I*, *Studie II*—assembling blocks of sound from multiple oscillators and filters and ring modulators. And the sounds which were

Foucault's genealogical middle period that explicate disciplinary enclosure (*Discipline and Punish*) and locate sex at the center of nineteenth-century European biopolitics (*History of Sexuality, Vol. I*), see also Foucault's complete 1970s lectures at the Collége de France, which, in addition to *Security*, includes *Society Must be Defended: Lectures at the Collége de France, 1975–1976*, trans. David Macey (New York: Picador, 2007) and *The Birth of Biopolitics: Lectures at the Collége de France, 1978–1979*, trans. Graham Burchell (New York: Picador, 2008).

[78] Povinelli, *Economies*, 106. To be gendered and racialized can mean, in part, to be atomized into divisions or data points and reassembled as animate or productive on observational scales, to which individuals can be denied epistemic access.

[79] Tara Rodgers, "'What for Me Constitutes Life in a Sound?': Electronic Sounds as Lively and Differentiated Individuals," *American Quarterly* 63, no. 3 (2011): 513. Lockwood's query responds to work with synthesized sound in Cologne's 1960s electronic music studios, but Rodgers also identifies this commitment to "lively" sound in a range of women electronic music practitioners linked to analog electronics and circuit design. See also Tara Rodgers, "Introduction," in *Pink Noises: Women on Electronic Music and Sound* (Durham, NC: Duke University Press, 2010).

assembled with all of that care, all of that mathematical interrelation-ship—you know, struck me as not really being alive. I just didn't much like them. [But] I loved the idea of being able to make sound from scratch, right?[80]

Lockwood describes values germane to an electronic music that crafted composi-tions using elementary signals, such as sine waves, impulses, and filtered noise. Koenig likened the short clicks created by analog impulse generators to little, individualized packets of energy, like single "leaping sparks," and imagined ultra-precise operations that would enable composers to cut, filter, or splice individual impulses lasting a mere 1/440th of a second. Koenig conjures a kind of sound that becomes at once livelier and more like raw material the further it is broken down into smaller units. However appealing she may have found this hands-on work, Lockwood distinguishes it sharply from how she wished to experience life in a sound. Ambivalence flickers between Lockwood's story and Rodgers's analysis. To return to life in a sound, Lockwood breaks with the critical media operations that underpin Rodger's analysis of life in a sound qua biopolitical management. My point here is not to overcomplicate the story or to make it into an aporetic puzzle. Instead, I want to highlight this slippage in order to pose a companionate question to the one that Rodgers and Lockwood discuss, that is: what is listening for life in a sound when that listening is also informed by a refusal of biopolitics?

Rodgers's approach to critical media operations follows Haraway's recommen-dation to study technoscientific "things" as "figurations" that condense practices, meanings, and contestations on historically specific terrain.[81] Consider, for exam-ple, Rachel Grossman's provocation that "there is no place for women in the inte-grated circuit."[82] This declaration hits iconic nodes; the integrated circuit numbers among technoscientific icons like the genome, the plasmid, the clinic, or the labo-ratory.[83] Each compacts vast fields of power-differentiated labor organized by a complex semiotics of gender, race, and nation that can also reveal shared processes that may remain invisible to other registers of analysis or to "Western dichoto-mies."[84] Figurations show how things get gathered up by technoscience and how frameworks for belonging become vested in shared—if unlikely—meanings. As

[80] Rodgers, *Pink Noises*, 117.

[81] Cited in Rodgers, "What for Me," 513. Donna Haraway, "The Biopolitics of Postmodern Bodies," in *Simians, Cyborgs and Women* (London: Free Association Books, 1991), 203–30and Donna Haraway, *Modest_Witness@Second_Millennium.Femaleman_Meets_Oncomouse: Feminism and Technoscience* (New York: Routledge, 1997), 11.

[82] Cited in Haraway, "Manifesto," 165. See Rachel Grossman "Women's Place in the Integrated Circuit," *Radical America* 14, no. 1 (1980): 29–50.

[83] Haraway, *Modest_Witness*, 204.

[84] Michelle Bastian "Haraway's Lost Cyborg and the Possibilities of Transversalism," *Signs* 31, no. 4 (Summer 2006): 1027–49.

Michelle Bastian explains, figurations ask how their component hierarchies might not exactly be stopped, but may perhaps instead be "made to work differently."[85]

Though women remain excluded from many kinds of high-tech work, this is not Grossman's main point.[86] Classical technoscience has long relied on tradition-ally feminine strengths—detail orientation combined with care-based service work—resulting, as Venus Green has shown, in de facto job segregation along gendered and racialized lines.[87] Amid encroaching automation, this has often meant working under threat of imminent technological obsolescence.[88] The cat-egory "women" cannot register the dynamics of power-differentiation that hold together high-tech industries and their commercial products. It also cannot rep-resent how bodies are materialized, stabilized, and mined for value across the locations and processes involved in the so-called integrated circuit. Naming these logics of exclusion requires new terms, groupings, and metaphors. Such a lexicon would have to describe a politics that could convene power-differentiated subjects without claiming to speak for "all women" or "all workers." Haraway applied the term "cyborg" to the partial knowledges that might cut through technoscientific figurations in ironic, coalitional terms.

Figurations can address the body within an analytics of life that presumes neither capacity and integrity from the outset. Theorizations of the body that begin with specific parts can inter-implicate figural, organic, symbolic, and socially situated questions at once, as both an analytic resource and speculative engagement. Ann Pollock's "heart feminism" or Elizabeth Wilson's "gut feminism" offer examples. Both articulate the body through nonreproductive parts whose functions and scales arrange material configurations across social worlds.[89] For Pollock, theorizing the biological body through the heart gathers up objects, like heart cells, hearts, and circulatory systems, whose "scalar disparities" can regis-ter how women are interpellated into heart health, and highlight, for example, cardiovascular stresses of racism as well as public debates about personhood.[90] Wilson also takes a similarly distributed and scalar approach in order to articulate figurations of the autonomic nervous system in contemporary biomedicine, early twentieth-century psychoanalysis, and contemporary narrative and memoir.[91] By approaching the body as at once biological and constructed, Wilson establishes the gut as an organ of the mind and explores depression and aggression as politi-cal assets for feminist theory. I find these ironic figurations particularly sugges-tive for historical experimental music practices in which biological potentials and elemental materials have long stabilized aesthetic protocols and guaranteed their

[85] Bastian, "Haraway's Lost Cyborg," 1031.

[86] Haraway, "Manifesto."

[87] Green, *Race on the Line*, 218–26.

[88] Ibid.

[89] Elizabeth Wilson, *Gut Feminism* (Durham, NC: Duke University Press, 2015), 21–45.

[90] Ann Pollock, "Heart Feminism," *Catalyst: Feminism, Theory, Technoscience* 1, no. 1 (2015): 1–30.

[91] Wilson, *Gut Feminism*, 1–17.

apparent inexhaustibility.[92] That the post-Cagean continuum has staked so much on evidencing the presence of life opens questions about how one understands life to move or attenuate between energetic configurations of bodies and environments.[93] While *Wild Sound* stops short of formulating something like "cochlear feminism" (paralleling Wilson and Pollock's interventions), the book will excavate how historically situated engagements with cochlear function link up with constitutive frameworks in research environments as well as Amacher's compositional and fictive elaborations. Ironic figurations take unlikely jointures and political metaphors as a kind of consolation prize in what Roshanak Kheshti calls "an era where matter, politics and ideas are mutually contaminating."[94]

As Amacher made her way through *Simians, Cyborgs and Women*, she would have encountered, in myriad forms, the caveat that Kheshti summarizes. And if she read all the way to the end—as her notes suggest she did— she may have also encountered the hybrid term "biopolitics" in the title of the book's final essay, "The Biopolitics of Postmodern Bodies." In a long and sardonic footnote in that essay, Haraway seizes on the hideous poetics of what she calls multinational corporate "technobabble." She heaps scorn on stupid compound proper nouns like Genentech, Hybritech, Repligen—all names for biotech firms that rode juridical, political, and economic accelerants throughout the 1970s and early 1980s.[95] Haraway demands a counter-poetics: when "no noun is left whole," a "feminist

[92] Consider the assured Cage who, after the adventure in the anechoic chamber, underscores that "as long as a I live, there will always be sound." The qualifier "as long as" temporalizes both claims: it will be true *"as long as* humans are conceptualized as living things," *"as long as* this or that individual human continues to exist," and *"as long as* humans continue to exist," more generally. Sound cannot be merely heard, it must also be guaranteed; here, that guarantee comes through a normative trajectory of human life. As Elizabeth Povinelli shows, such emplotments are upheld by biopolitical regulation that track birth, followed by growth and reproduction and then by illness and death. See Richard Kostelanetz, *Conversing with Cage* (Routledge: New York, 2003), and Povinelli, *Geontologies*, 7.

[93] This arc, in *Wild Sound*, picks up on research that has centered biological potentials in US experimental practices. For example, Branden Joseph address "bio-potentials" (in relation to Tony Conrad's 1966 *The Flicker*) as a "part of a socioeconomic transformation in which human mental and physiological faculties were being rendered into data and input into similar circuits of automation and feedback, operating in networks that stretch beyond the limitations of disciplinary institution and sovereign forms [. . .] *The Flicker* acted as both a harbinger and disruptor of this new 'infrastructure' of control." Joseph reveals how biopolitical frameworks register in technologically and aesthetically specific ways. To this, *Wild Sound* adds attention to how biological potentials garner meaning and value in relation to other "substances of activity that produce life" like labor, reproduction, built environments, and figurations of transport that move affects and energies between bodies and between areas of depletion to those of thriving. Branden Joseph, *Beyond the Dream Syndicate: Tony Conrad and the Arts after Cage* (New York: Zone, 2011), 351. See also Alan Licht, *Sound Art: Beyond Music, Beyond Categories* (New York: Rizzoli, 2007), 269.

[94] Roshanak Kheshti, "Wendy Carlos's Switched-On Bach" (unpublished manuscript draft), September 2018.

[95] Donna Haraway, "The Biopolitics of Postmodern Bodies," in *Simians, Cyborgs and Women* (London: Free Association Books, 1991), 203–30, 245 and Donna J. Haraway, *Modest_Witness@Second_Millennium.FemaleMan_Meets_OncoMouse: Feminism and Technoscience* (New York: Routledge, 1997).

writing"—and a music?—must generate expressive figures all its own.[96] To be clear, Amacher used neither the term "figuration" nor the term "biopolitics" to describe any aspect of her work or working methods. Yet the dramas *MSJR* and *MSS*, for example, teem with audiovisual and conceptual logics that again and again carry the biotechnological into the sonorous and the tele-technological into the auditory. Consider, too, the buzzy eartones that throughout this study will appear as microbes, violins, dances, pop songs, and even in romantic love relationships. To engage these seemingly unlikely conjunctions, *Wild Sound* embraces what Kalindi Vora has called a "juxtapositional reading practice" for its commitment to discerning common processes across "[mismatched] sites of interest, genres of documentation and other modes of archiving."[97] This approach encourages detailed excavation of Amacher's wilder combinations, even those that perhaps hang on slender hooks. It also suggests that introducing new juxtapositions can be a productive way to emphasize or comment on a specific project's figural terrain. *Wild Sound* does both. Amacher's approach to sound takes on powerful formations of the material world—as a locus of imaginative excess, as a formation of tense that can divide as much as connect social forms, as a discursive achievement or failure, as a figure for new arenas and technologies of vivification, and, thus, as a mediation for many kinds of material effects including visceral bodily impacts. Continuing, with Amacher, to question "how worlds of sound can be joined" might also begin to ask, in Vora's words, how, in mapping of new arenas of life and matter, we can conceptualize sounds, lives, subjects, and matter "besides and despite their utility to capital accumulation even when it is through the lens of capitalism that we can see these arenas in the first place?"[98]

Life in an Eartone and Its Figurations

Shortly after experiencing Woody Sullender's eartone music in 2004, I sought out Amacher's 1999 album *Sound Character (making the third ear)*, which has introduced many new listeners to her work and musical thought. It is difficult to read about Amacher's work without encountering a description of the two-part cut "Head Rhythm 1" and "Plaything 2," which opens the album with a blaze of eartone music. On the album, Amacher explains, listeners can experience dual-channel remasters that she had composed for structure-borne diffusion in multiple channels and, to this end, included three excerpts from earlier *MSJR* projects. Floor plans for both the Tokushima 21st Century Cultural Information Center, where

[96] Haraway, "Biopolitics," 245.

[97] Vora, *Life Support*, 18. Working between fictive and ethnographic sources enables Vora to draw out what she calls "virtual and often imagined" aspects of social relations to analyze how imagined relations produce material effects within and across global divisions of labor.

[98] Vora, *Life Support*, 21.

she staged *Synaptic Island* (1992), and the Kunsthalle Krems Minoritenkirche, where she staged *A Step Into It: Imagining 1001 Years* (1995), are printed in the album booklet alongside three short program essays titled "Sound Characters For Large Spaces, Architecturally Stages," "Music for Sound-Joined Rooms," and "Sound Characters for a Third Ear Music." While she states that listeners will not experience the intended spatial and architectural impact in a casual stereo listening environment, the album is also less a collection of integral "pieces" or even "tracks" than an anti-comprehensive introduction to sound characters and how Amacher composed with them. Listeners meet individual characters in the tracks "Head Rhythm 1," "Plaything 2," "Tower," "Dense Boogie 1," and "Chorale 1," which Amacher distinguishes according to their perceptual address—some cite their architectural staging, others animate the eartone intensities that she called, in this context, "third ear music."[99] She provides the eartone-centric characters "Head Rhythm 1," "Dense Boogie 1," and "Chorale 1" with special instructions. "Not to be experienced with headphones," she explains, the music should be played at a high level; if not, it will "lose energy and take on an innocent 'ice cream man' character not intended in this recording."[100] Stratified over a four-octave span, "Head Rhythm 1's" starry tone bursts cycle through quartal patterns with microtonal variations and leave space in the texture for buzzes and hums, which soon emerge from a listener's inner ear. As these little shocks resolve into rhythmic patterns and melodic contours, one experiences an event in the auditory pathway that, as Amacher often puts it, usually just "goes on without you." But this ear does not just respond: it sings, it dances.

And, so, what is this third ear? Amacher describes a third ear music in the essay that accompanies this album, but the phrase does not appear in her eartone research nor in other texts that elaborated her findings. Nonetheless, the concept has followed her work into discourse more readily than most of her other formulations.[101] This undoubtedly reflects how few of her writings have been publicly accessible since *Sound Character*'s release in 1999. A third ear is at once real and unreal. In her 1972 study of metaphorical style in the middle-period works of Friedrich Nietzsche, philosopher Sarah Kofman theorizes metaphor as an action that can create more-or-less regularized perspectives on a body and the

[99] Three tracks excerpted from *MSJR* projects in dual-channel mixdowns feature multiple characters whose order and sequence Amacher also lists in the CD booklet.

[100] Maryanne Amacher, "Sound Characters for 'Third Ear Music'," *Sound Characters: Making The Third Ear* (Tzadik 1999).

[101] Across both criticism and scholarship, one will find Amacher's work referred to as a "third ear music," although the term does not appear in the 1970s research notes or other writings. For examples, please see Sarah Cramer, "Tang Museum: Who Said Elevators Couldn't Be Fun"; Meara O'Reilly, "Resonance Games," SFMOMA; Jaime Fennely, "Mind Over Mirrors," *Impose Magazine*; Tara Rodgers, "Approaching Sound," in *The Oxford Handbook of Digital Music Studies*; "Blue" Gene Tyranny, "Out to the Stars: Spatial Movement in Recent and Earlier Music," *New Music Box*.

constitutive frameworks within which its sensations and processes are made to live.[102] A third ear signals a liminality in bodily matter between the apparent constancy of the body qua its auricular structures and the regularization of those structures qua habits and iterations in the aural.[103] Like Haraway's emphasis on metaphor, a third ear demands new and partial perspectives on this coupling. Kofman reveals that metaphors can unsettle "logics of creation and rationality" that attach functions and attributes to a material substrate qua essence.[104] As a result, Kofman finds metaphors to be especially invaluable to genealogical work that breaks up regularized perspectives that can be taken on a body or sensorium. A metaphor can be an analytic of power, Kofman suggests. That is, a third ear suggests a notion of body that is neither fully reducible to its biopolitical materialization nor so "plastic" as to seem never to materialize or stabilize at all, to paraphrase Elizabeth Povinelli. While, in "Head Rhythm 1," a third ear certainly highlights cochlear biomechanics, the figure also invokes genealogies across body and life in the interaural compositions that also animate *Wild Sound*.

Figurations that begin in the inner ear carry tremendous force across Amacher's corpus. Because eartone frequencies can be precisely calculated, they court analytic and compositional strategies that employ traditional aspects of pitch, duration, rhythm, and timbre—as Amacher's mid-1970s workbook amply demonstrates. Her research inherits interdisciplinary contexts in which work on interaural sound long persisted as an insufficiently elaborated object of knowledge, as we shall see and hear in Chapter 4. In response to gendered skepticism aimed at her commitment to first-person research methods, Amacher highlights constitutive instability of otological knowledge in her writings and music dramas. But in *MSJR* and *MSS*, for example, these research processes are blown up to create fictive worlds that present research in awesome color as a dramatic genre all its own, not least in the unrealized media opera *Intelligent Life*, as Chapter 5 will explore. To this end, a third ear captures how pleasure, life, and epistemic legitimation work in concert and conflict across the vast contexts in which Amacher employs her eartone music. Its auditory thresholds emerge through a tangled plexus of factual and fictive connections across transforming spaces of biopolitics,

[102] Sarah Kofman, *Nietzsche and Metaphor*, trans. Duncan Large (Stanford, CA: Stanford University Press, 1994).

[103] In this sense, the third ear can also be employed as a metaphor for genealogy as Foucault understood it; in *The Ear of the Other*, Derrida also invokes this meaning. In some of the Nietzschean formulations, the third ear is described as "small and sharp," an impetus to break apart hierarchies of body in order to uncover the notions of life that they naturalize and made to appear continuous. In its capacity to unsettle continuity, the third ear also captures something of Foucault's genealogical slogan: "knowledge is not made for understanding, it is made for cutting." Michel Foucault, "Nietzsche, Genealogy, History," in *The Foucault Reader*, ed. Paul Rabinow (New York: Pantheon, 1984), 88.

[104] Judith Butler, *Bodies That Matter*, excerpted in *Beyond the Body Proper: Reading the Anthropology of Material Life*, ed. Margaret Lock and Judith Farquhar (Durham, NC: Duke University Press, 2007), 172.

experiments in mediatic distribution, and queries about matter, creativity, and sociability.

Musicologist Volker Straebel took an uncompromising position in a 2012 talk on Amacher, with the striking title: "The Day the Music Died: From Work to Practice."[105] The essay militates against restaging Amacher's work and instead grounds whatever "Amacher studies" may yet come in her "practice," or working methods. The structure-borne sound-projection pieces simply "cannot be moved," he states. This assessment dogged Amacher's reception during her lifetime in complex ways. Tropes of gendered meanness—"difficult" or "crazy," accompanied by a poorly disguised eye roll or toss of the head—often accompanied accounts of how she refused nightly booking protocols and instead spent days in a space to create spatial and spectral dramas that staged "where sound comes from" and "how [its] worlds can be joined" anew.[106] As Micah Silver explains, "she would spend hours listening to a seemingly unchanging tone or making minute adjustments to loudspeaker placement."[107] These details "were the very heart of her work— equivalent to the painstaking working out of themes or harmonic progressions in traditional music."[108] Readers can expect to find detailed work, in the pages that follow, on Amacher's methods across structure-borne sound and diegetic involvement (Chapter 5); interaural dimension in composition and research (Chapter 4); long-distance transmission and environmental sound (Chapter 3); spectral exploration and multi-sited listening (Chapter 2). But because a focus on method can also shade toward work-like dogma, such a study must delimit its scope with care. While I agree that the sound projection pieces "cannot be moved," it is also true

[105] Straebel, "From Work to Practice."

[106] Pamela Z makes the provocative argument that gendered reception might have oriented Amacher's commitment to electronic media. She writes, "Women are expected to excel in using the voice and do get recognition for it. Cathy Berberian, Diamanda Galás, Joan LaBarbara, and Meredith Monk are well known for their work with this technically complex instrument. They are much more celebrated than are any of the men who use extended voice as a main component in their work. But Pauline Oliveros, Laetitia Sonami, Annea Lockwood, Laurie Spiegel, Maryanne Amacher, and the many other women who have done great work in designing and using systems for electronic music are much less likely to be mentioned than their male counterparts. The message seems to be, 'If you want recognition for what you do, you need to stick with the tools you are expected to use.'" Pamela Z., "A Tool Is a Tool," in *Women, Art and Technology*, ed. Judith Malloy (Cambridge: MIT Press, 2003), 348–61. On the contrary, Lindsey Eckenroth suggests that electronic media has enabled "women composers to work outside the autonomous streams of serialism and minimalism." While readers will likely find evidence for both claims in *Wild Sound*, the book will also consider how Amacher actively resisted the legibility of her own work within these coordinates. Lindsey Eckenroth, *Women and Music: A Journal of Gender and Culture* 17 (2013): 92–101 (Review). For a complementary account see "Composers Speaking for Themselves: An Electronic Music Panel," *The Musical Woman: An International Perspective, Volume II, 1984–1985*, ed. Judith Lang Zaimont and Catherine Overhauser (Westport, CT: Greenwood Press, 1984).

[107] See Micah Silver, "Remembrance," http://www.arts-electric.org/stories/091028_Amacher.html, accessed July 17, 2015.

[108] Ibid.

that much moves between them (as well as *City-Links*, *Adjacencies*, and their companionate materials); this included writings, texts, citations, terminologies, titles, images, props, sound characters, tapes and ways of listening—in myriad combinations.[109] Embedded in practice and method, in other works, are also fragile conditions under which Amacher's projects would persist in the subjunctive. Attention to relays, reuses, and recontextualizations that sustain this persistence rewards a language of critical interpretation that Michael Gallope describes as "attention to small details of form and part-whole relations, moments of irony and paradox" as well as events of intertextual play.[110] Insofar as Amacher works within these coordinates to ascribe meaning and value to sound's visceral impacts, this interpretive practice enables *Wild Sound* to navigate a nascent sound art criticism that continues to grapple with what Brian Kane has called "musicophobia" in search of descriptive practices that can attend to both sound's discursive pressure and its material allure.[111] This book's ethics of description builds on Amacher's studies, heuristics, and conceptual gestures in order to trace how she put sounds together

[109] *Wild Sound* is, in many ways, constructed around many such cases. For example, Amacher employs recordings from the 1960s in *City-Links* into the 1970s and *MSJR* into the 2010s, alongside sound characters like Wave 4 and God's Big Noise that recur within and between series. The title *Intelligent Life* appears in a 1980s treatment, a 1979 event at The Kitchen, and a 1980 proposal to De Appel in Amsterdam, each with distinct mediatic forms and narrative goals. At this time of writing, archival tapes have been digitized by Robert The and Bob Bielecki with the financial and technical support of the New York City–based curatorial platform Blank Forms.

[110] Michael Gallope, "On Close Reading and Sound Recording," in *Humanities Futures* (John Hope Franklin Humanities Institute at Duke University, 2017), https://humanitiesfutures.org/papers/close-reading-sound-recording/, accessed September 5, 2018.

[111] Brian Kane, "Musicophobia: Sound Art and the Demands of Art Theory," http://nonsite.org/article/musicophobia-or-sound-art-and-the-demands-of-art-theory, accessed July 17, 2016. Though Amacher appears in many sound art lineages, key distinctions should be emphasized. Dietz and Axel J. Wieder have both differently argued that the consolidation of the institutional and conceptual category "sound art" foreclosed interdisciplinary channels across which Amacher worked in the 1970s and 1980s, crosscutting the visual arts, contemporary music, popular forms, and research. See Amy Cimini and Bill Dietz, "Introduction: 'Premature Attempts to Think about Ways of Indicating [. . .] Range of (B) with Given A Intervals. Part of the 'Understanding Ritual,' Before Finding Approach," in *Maryanne Amacher: Selected Writings*, ed. Amy Cimini and Bill Dietz (New York: Blank Forms, 2020), 11. Relatedly, *MSS and MSJR* suggest that, *pace* Joanna Demers, that a sound art that would claim Amacher in its lineage would not be able to accept a definition staked on "nonnarrative sound." Joanna Demers, *Listening through the Noise: The Aesthetics of Experimental Electronic Music* (Oxford: Oxford University Press, 2010), 6. An interpretive method based on the ironic analysis of figurations can register concerns for "sound's inherent discursivity" alongside an analysis of its materiality and materialization. Seth Kim-Cohen, *In the Blink of an Ear* (London: Bloomsbury, 2009), 119. While Kim-Cohen calls for critical engagement with sound's conceptual underpinnings, historiographic or interpretive methods that would move this critique through art historical inquiry and into other registers of analysis are also needed. To the end, I take seriously the thesis that guides the editors of *Experimentalisms in Practice*. "We follow Brigid Cohen in not hearing experimental music simply as a private place for expression or as a retreat from worldly concerns, but instead as a medium of bonding within the avant-garde communities" as well as a "localized intervention that reflects upon the practical particular experiences of geographic, cultural and discursive marginalization of musicians and audiences

as much as how she imagined them or referred their continuation to distant, fictive, or as-yet-incomplete circumstances. *Wild Sound* will narrate sounds that are hypothetical (Chapter 2; in *Adjacencies* and related projects); inaudible (Chapter 5; in the auditory systems of microbial life); studied and documented across complex embodied and epistemic terrain (Chapter 4; in the *Additional Tones* research program); and captured on tape or transmitted via telelink (Chapter 3; in long distance listening and *City-Links*). By addressing the reader as a listener in the subjunctive, the chapters weave together a field guide for imagining sounds in ways that Amacher seems to have done.

The Archive and the Title

In 2012, when I started the research that would become this book, Amacher's papers were packed in over 100 cardboard boxes, stored—as they had been since Amacher's death in 2009—in a rented unit in Kingston, New York. Items had been boxed together because they were found together inside Amacher's house on Marius Street during the summer of 2009. Silver and Dietz often used the term "topographical" to describe this deliberate project, while what kind of knowledge this arrangement might come to support remained an open question.[112] Visitors were asked to write their name and the date of their visit on the boxes they opened—as much an ad hoc kind of bookkeeping as a way to mark that a question had been posed amid what was, at the time, a very new and fragile arrangement. If these names might someday be useful to someone, it is in the context of an archive initially assembled under the presumption that anything in the house could be taken up as evidence. The boxes suggest double—even triple—epistemic overlays. Written names register the archive as a site of observation and extraction, but the signature made the signer accountable to Amacher's home insofar as it seemed to have been paused in medias res, with everyday details of life and work still in place. In this pause, the subjunctive makes itself felt. The boxes seem to wait to be sent back to the house and embody less a will to remember than a will that Amacher would continue to work and live amid their contents. They are at once forms of lived, everyday documentation (such as the personal diary or community museum) even as they also suggest officializing and monumental narratives familiar to many signal texts of the archival turn in the humanities and social sciences. The latter tends toward an older, humanist vision of the archive, which Arjun Appadurai attaches to the "sacralization of the trace":

beyond mainstream metropoles." Alejandro Madrid, Eduardo Herrera, Ana Alonso Minutti, "An Introduction," 3.

[112] An early version of the catalogue from 2012 contains 1,690 individual entries and lists as the contents of one box as "a bag of rice and three black glasses" and another as "bags of moldy bills."

The central property of the archive in this humanist vision is to be found in the ideology of the "trace." This property is the product of contingency, indeed of accident, and not of any sort of design. The archive is fundamentally built on the accidents that produce traces. All design, all agency and all intentionalities come from the uses we make of the archive, not from the archive itself. The very preciousness of the archive, indeed its moral authority, stems from the purity of the accidents that produced its traces.[113]

The intentional design that informed the boxes' assembly cleaved as closely as possible to the accidents that created them in order to assure that their moral authority remained visible and tangible. Somewhere between archive and temporary storage solution, any single box suggests a wish to become a locus of collective memory and at the same time materializes a reticence to do so.[114]

My two trips to Kingston also involved visits to Amacher's gravesite and her house on Marius Street. The drive ascended a steep grade toward a hilltop where the road ends at the cemetery. Etched into the flat headstone are bamboo stalks and leaves that frame the text "*She was a jolly good fellow.*" As the tweaked quotation's familiar tune and celebratory allusions rudely commandeered my mind's ear, I wondered about the gendered entanglements that held "she," "fellow," and "Maryanne Amacher" together on the shiny marble stone. I had driven to the cemetery with Amacher's close friend and, before I decided what question to ask, he explained the sentence to me. While many experimenters of her generation found their way to university appointments, Amacher moved from fellowship to fellowship, each a few years in length. The phrase dramatized the gap; the "fellow" never became the "professor." It cracks, in other words, a complicated inside joke about creativity, aspiration, and expenditure within a US experimental music whose marquee figures benefitted in uneven ways from its institutionalization during the 1960s and after. But the compound adjective "jolly good" matters, too. It suggests an ease and effortlessness that Tiziana Terranova associates with unalienated labor and seemingly free qualities in creative work that capitalism "does not so much appropriate as sustain, nourish, and also exhaust."[115] To ask, "Who was Maryanne Amacher?" means also querying how Amacher navigated these straits and what it means to have done what she did as this "jolly good fellow."

[113] Arjun Appadurai, et al., *Archive Public: Performing Archives in Public Art* (Athens: Cube Art Editions, 2012).

[114] At the time of this book's publication, the archive has been transferred to the New York Public Library under the stewardship of the Maryanne Amacher Foundation and New York City–based curatorial platform Blank Forms. It has not yet been processed.

[115] See Tiziana Terranova, *Network Culture: Politics for the Information Age* (London: Pluto Books, 2004), 94. Cited in Neda Atanasoski and Kalindi Vora, "Surrogate Humanity: Posthuman Networks and the (Racialized) Obsolescence of Labor," *Catalyst: Feminism, Theory, Technoscience* 1, no. 1 (2016): 25.

"Dear Parents": Desires and Plans

In a mid-1960s letter, Maryanne Amacher tells her parents that she will become a composer. What she calls in its second line "only a note" spans three single-spaced typewritten pages with handwritten corrections and revisions in the margins alongside long paragraphs peppered with emphatic underlining throughout. The letter ends abruptly when Amacher hits the far-right margin in mid-sentence at the bottom of the third page. The sudden truncation of a draft that simmers with anger and hurt befits the events of interruption and curtailment that Amacher narrates in vivid detail, throughout. The first paragraph indicates that her parents had recently sent her a bit of money. After a quick thank you, Amacher turns to the circumstances that led to this need and explains that she had been without bus fare to visit the Creative Associates at the State University of New York at Buffalo, where she would begin a fellowship in 1966. Amacher narrates the untaken trip as an affront—a threat, even—to what she had achieved in the previous five years. To this end, she describes early projects and works in progress with meticulous detail and exhorts her parents to understand the institutional contexts and financial circumstances that might foster or foreclose them to different degrees. Amacher organizes this entreaty around two narrative trajectories that alternate throughout the letter. Chronological episodes in her musical formation detail successes in Philadelphia, Urbana, and (hopefully) Buffalo and demonstrate for her parents what it was like to have been heard as a composer by her teachers and new colleagues—if not by them. Between and sometimes within these episodes, fiery irruptions reveal how dueling formations of sex, gender, and class structure their clashes about "how [she is] making out" and inform how Amacher evidences her plans, in the letter.

She leads with an angry non-apology: "I'm very sorry that you completely misunderstood what I was trying to do with my life this year." She explains that she had spent part of the summer steeling herself against dissuasion. "I did not come home," she admits, "because I was not as strong as I am now." From 1964 to 1966, she undertook acoustical studies with Lejaren Hiller at the University of Illinois at Urbana while also engaging in independent research at the Studio for Experimental Music and working as a research assistant in the School of Electrical Engineering. Her forceful account suggests an unremunerated and relatively informal arrangement. "I had to decide this year not to commit to <u>any</u> steady [paid] work, live on almost no money so that I would be completely free to carry out my work. I have <u>never done</u> this," she explains. She sets this decision against two sharply contrasting contexts. The first, a swipe at two female cousins who "[make] a salary" but spend lavishly on domestic and hetero-reproductive class aspirations. The cousins are made to epitomize daffy feminine consumers eager to accumulate clothes, cars, hi-fi systems, and other things that arrange bodies according to gender type in the sociohistorical space of the home. Amacher aligns domestic accumulation

with feminized media work in order to refuse both, over the course of the letter. Amacher worked at a typist, the letter reveals, a labor market that idealized single, straight, native-born women who were eager to recontextualize care and detail-oriented work in mediatic environments as an extension of domestic duties and hetero-reproductive coupling that would, ultimately, subsume them.

Amacher entered the University of Pennsylvania in the fall of 1955 and graduated with a Bachelor of Fine Arts in Music in the spring of 1960. She was supported by a Senatorial Scholarship for four years, with an additional loan in her third year and two institutional prizes in her fourth—both of which she included in her vita through the mid-1970s.[116] From 1962 to 1964 she worked as a research assistant at the Moore School of Electrical Engineering and took additional courses at the Philadelphia Conservatory of Music. "Always, in Philadelphia," she explained, "I worked full time, paid my University loans, lived in apartments—the apartment in terms of city living was not extravagant. The city is too cold and barren to live in rooms that are mostly dirty, etc." "Dead tired" after doing this "stupid" work, she could not work on music "as I might have."

To reach her parents, this letter would have traveled to north central Pennsylvania. Amacher's college transcript lists Kane, Pennsylvania, as her birthplace and her home address at 233 7th Street in Renovo, Pennsylvania.[117] Nestled on the eastern border of the Allegheny National Forest, Kane had been a popular resort destination and logging center since the mid-1920s, while Renovo was developed by the Pennsylvania Railroad to house workers at the rail line's midpoint—as a kind of reserve labor force that could be sent to work on other parts of the line at any time. The small town was developed in an industrial-style grid more common in early twentieth-century manufacturing centers. An only child, Amacher attended St. Joseph's High School in Renovo, graduating in 1955. Her father, Leon A. Amacher, worked as a freight conductor for the railroad between 1916 and 1958 and her mother, Melba Tingely had grown up in Kane, where the couple lived after marrying in November 1918.[118] A skilled woodworker and steward for the Brotherhood of Railmen,[119] her father retired after suffering a heart attack in the late summer of 1957, and his health weighed heavily on Maryanne, especially during a series of hospitalizations during the 1960s prior to his death in 1968.[120] "When Daddy was in the hospital," she wrote in the letter, for a moment

[116] This statewide grant program was coordinated by the State Senate of Pennsylvania and provided each nominee with $300 to be applied to tuition at a private or public university. Amacher's transcript indicates that she took a leave of absence in the 1957–1958 academic year, during which, as an Institute for International Education Fellow, she continued music study in Salzburg and Dartington.

[117] Courtesy of University of Pennsylvania, Institutional Records.

[118] The couple were married in Kane, Pennsylvania, where Amacher was born. "Marriage Announcement," *The Kane Republican*, December 12, 1918.

[119] Obituary, *The Express* (Lockhaven, PA), November 16, 1968.

[120] An article in *The Wellsboro Gazette* dated August 29, 1957, that covered an "Amacher Reunion" reports that Leon had suffered a heart attack shortly before the reunion and was unable to attend for

addressing only her mother, "and I knew you were alone and frightened. I had to telephone you to reassure you that you were not alone, that I was here. [. . .] [A]t that time I had money and thought nothing about [. . .] checking about doctors and with doctors." Anger and hurt belie deep worry in Amacher's charged missive.

However, praise animates the musical episodes that Amacher presents to her parents in the letter's first page. She begins with the recent past: "I have never fully dedicated myself to what I must do as I have in the past months." A detailed recollection follows:

> In Philadelphia, I composed on the spot in 10 minutes music which George Rochberg, the composer at Penn, discussed for 2 hours in a class as having the unfettered freedom and genius of Beethoven. Yet, I could not begin to write in paper any of this music; it was only here in Illinois that I discovered intellectually what I was doing. Stockhausen, the German composer likewise, told me to work very hard, how much I was needed etc. . . . I was always dead tired from doing stupid O'Connor's work, to work as I might. Hiller told people here of my "genius."[121]

Though the masculinist category "genius" is clearly designed to impress, Amacher also pits this compliment against how much she had left unfinished, even unstarted. This scene argues for a kind of temporal repair that would enable Amacher to align her nascent approaches to sound and music with a time of sustained study—and evidences others' high opinion of what the outcome would be. In a 1985 interview, Amacher explains that she started composing small pieces shortly after beginning to play piano, at age eight. "I was fascinated with the pedal," she told Golden, "and so the first ones used a lot of holding tones in it."[122] After learning canonic eighteenth- and nineteenth-century repertoires on the instrument, she explained, "I began to compose more when I was in college, and I stopped playing piano as I had before, at that time." During the 1950s and 1960s, the stated intention of the University of Pennsylvania music department's curriculum was to serve the "training of professional musicians."[123] After becoming chair in 1960, George Rochberg resisted adding the PhD in music composition to undergraduate and terminal master's programs in order to retain a commitment to professional training, which he believed would "open contact with the world in which one

that reason. The Lockhaven Express also reported that Leon had been hospitalized in August 1964, in early August 1965, and again in early September 1965.

[121] Amy Lynn Wlodarski, *George Rochberg, American Composer: Personal Trauma and Artistic Creativity* (Rochester: University of Rochester Press, 2019), 128. Rochberg was ambivalent about his teaching career at the University of Pennsylvania, where he earned a terminal master's degree in composition while also teaching at the Curtis Institute during the 1950s. In 1960, he accepted a full-time position as chair of the music department at the University of Pennsylvania. He resigned in 1968.

[122] Maryanne Amacher to Barbara Golden on KPFA 91.4 FM, December 1985.

[123] "Music," in 1954 University of Pennsylvania Course Catalogue, 40–45.

must function"—a view that sharply contrasted with programs like Princeton or Columbia.[124] Undergraduate majors chose concentrations in theory, composition, orchestration, or music history and literature in a curriculum structured around three main "pillars," a 1959 catalogue reads: "courses in theory, music history and literature, aesthetics and composition;" "applied music;" and "a substantial background in liberal arts subjects."[125] Although applied music was not taught within the University, the department recommended Philadelphia-based private teachers and monitored students' progress in regular exams. Amacher seems to have followed a typical coursework trajectory, which included up to four music courses per semester as well as up to three in the liberal arts, one ensemble, one unit of applied music, and physical education. Amacher fulfilled the liberal arts formation with courses in philosophy, English literature, French language, and journalism.[126] Her journalism courses reflect that the department had recently begun to train students in criticism across a wide range of media like theater, film, and television and to prepare short programs for radio.[127] Training in composition was not nearly so hands-on and rarely involved working closely with instrumentalists or toward a first rehearsal or performance. A works lists that begins in 1960 reveals that instrumental and electroacoustic works created in 1961 and 1962 (while Amacher was still in Philadelphia) were not performed until 1965 and 1966 after her arrival in Urbana—an extremely generative period, the continuance of which seems to hang in balance at the time she wrote this letter.

When Amacher discussed Urbana, in the letter, she emphasized a very different set of social and institutional circumstances. This series of episodes intersects garden variety conservatory sexism and interpersonal rivalries germane to the university setting, which Amacher approaches with an idiosyncratic analysis, emphasizing gender, sex, and class formations. Advice from masculinist gatekeepers in bad faith reappear throughout:

[124] See Wlodarski, *George Rochberg*, 128. As department chair from 1960 to 1968, Rochberg eschewed technological and technocratic pedagogy, embracing instead a classical liberal arts curriculum that rooted intellectual training and emotional sensibilities in Western traditions, even amid curricular debates of the 1960s (to which Amacher seems also to have been rather insulated). As student James Primosch recalled, Rochberg taught a path through musical modernism that vaunted Ives and Mahler over the inheritance of Webern and Varèse.

[125] "Music," in 1954 University of Pennsylvania Course Catalogue, 40–45.

[126] Maryanne Amacher, "Undergraduate Transcript," University of Pennsylvania School of Fine Arts, 1955–1960.

[127] Amacher enrolled in journalism courses that addressed a variety of media. The course catalogue entry for "Reviewing and Criticism," which Amacher took in 1957 listed among its topics: "evaluation of books and of stage, screen, and television plays. The criticism of art and music. The book publishing business. The preparation and delivery of radio scripts dealing with the criticism of plays, motion pictures and books." Notably, the course also trained students in "the preparation of reviews and criticism for newspapers, magazines, television and radio," which would have introduced Amacher to audiovisual production and design at an early stage.

Now this is what is a tremendous responsibility for my future. I am told
it's difficult to get music performed; last spring I spoke to the conductor
here who had never done any new music—none of his faculty's music
(the older composers)—I was told not to go near him—but by accident,
I talked to him about my music—10 minutes later her was singing to
me. And 3 weeks later we rehearsed with his chorus of 60 people. (Last
week he did perform an older composer's music here for the first time.)
The other composer, besides Hiller (who has had one small piece of
his done here by musicians who play new music anyway) told me that
he asked the man who runs the harp department to lecture about the
harp—the same composer is the favored one around here—he teaches
and has made his money through grants, such as the one I was recom-
mended for and the harp man refused. I went to him last week with
an outrageous request which was granted in five minutes. I told him
that I had recently written a piece using harps; he immediately asked if
I need harpists. I told him no—the piece was written not for harpists
and I told him but for percussionists (commonly <u>Drummers</u>). He prob-
ably knows who I am as most people do; but at the time I could have
walked in from Mars. Anyway, he gave me the keys to the room with the
2 harps and I spent the weekend, having also gotten a tape recorder and
microphone from the recording men, doing very strange things.

Without naming names, Amacher conjures a homosocial department pocked
with power struggles between individual composers and, more generally, between
composers and performers. Hiller appears as an ally whose successes she is
eager to measure alongside her own. Neither a student, colleague, employee, nor
someone official in between, Amacher would not have been easily locatable in
extant departmental structures—a liminality perhaps further enhanced by her
insistence on "no paid work." She seems as thrilled to have maneuvered around
the instructor as she does with her experiments with playing and recording the
instruments. Of having slipped between these institutional divisions, she tells
her parents, "these things are not done every day."

These episodes also find Amacher in the middle of working on both *Adjacencies*
and *Arcade*, the choral project whose reading she perhaps describes at the begin-
ning of the preceding excerpt. An early works list describes *Arcade* "for chorus and
/or orchestra" and includes it with *Adjacencies* in a suite titled *Audjoins* designed
for multi-sited presentation across what she calls "stage" and "room areas" with
additional players and electroacoustic components. Although it remains unclear
whether or not *Audjoins Suite* was intended to include additional components
perhaps yet-to-be composed, the project seems to coordinate spatial and spec-
tral interaction between instrumental, vocal, and electronic sound masses in a
large room or between adjacent spaces that, as we shall see, will become a capa-
cious context for subjunctive listening. She offers the parenthetical "(commonly

<u>Drummers</u>)" to explain to her parents that, in *Adjacencies*, she is composing for percussionists who will also be required to play harps in addition to drums, mallet instruments, an array of cymbals, small metal instruments, and industrial materials. Her weekend spent "doing very strange things" in the harp studio proved crucial to the technical, conceptual, and acoustical coordinates within which *Adjacencies* developed and those that Amacher later reworked throughout the later series *City-Links*, *Music for Sound-Joined Rooms*, and *Mini Sound Series*. Versions of the material that she recorded that weekend recur at various points in all three series and take on a conceptual plasticity that spans the late 1960s through the turn of the millennium. The tape's source material is far from obvious: thick, quivering sound masses seem to spiral alternately through bright and shadowed spectral regions while short, micro-melodies ricochet toward audibility before disappearing into the seething texture.

This follows a furious direct address in which Amacher excoriates her parents for being concerned that her appearance negatively impacts "how she is making out," as she puts it in vague but sarcastic paraphrase. An icy exhortation follows: "I can't stress it enough, that your insults in fact do not credit you with the upbringing that leads people to listen to me." Again, Amacher wants her parents to hear themselves in how others have also heard her, throughout the ventriloquisms that intensify the letter, and not least in how she broaches power-differentiated situations at the intersections of gender, sex, and personal style: "The hair helps," she leads curtly. Not in "knots," but in a "long braid," whose easy femininity she juxtaposes with "tattered" shoes, continuing that "I wear masculine suits for convenience and thus desire to keep my hair feminine." She details the gendered costume dramas into which her studied looks cast masculinist interlocutors. "I am these men's grandmother, their mother, etc.," she explains, but "I am not their cold blooded (perhaps) short haired wife." While it is not hard to miss the searing disdain for marital coupling and domestic accumulation, she invokes vertical lines of descent that articulate familial (but not professional) obligations of a different sort. Amacher plies generational displacements that exploit the heteroreproductive family to play up a sense of trust and care that tends to attach to maternal bodies, which have long been overdetermined as desexualized, selfless, and plenitudinous. But her looks also cite the gendered heuristics that organized knowledge production in conservatory contexts—as Cusick noted decades later—to "performers" or "composers." She is not a harpist, but she nonetheless needed to handle the instruments; she is not a "favored" composer, but she is a composer nonetheless. Her personal style cited institutional and familial conjunctions so that she could appear "as though [she] walked in from Mars," as she summarized for her parents, in this letter.

"I must be solid," Amacher stated flatly, "and not be mistaken for a wild woman." She informs her parents that she will soon be seeking patrons. "<u>This is a great responsibility</u>, I realized this last summer. That before I could go asking these businessmen etc to support my music I had better sit down and establish myself

properly." "My written word and theories were there and solid," she declares, well aware that legitimacy will come—at least in part—through the re-emerging figure of the composer-theorist characteristic of a post-war Euro-American modernism.[128] "Some idiot composers can't write about their ideas," she charges, "I can and have." Her detailed performance notes in *Adjacencies* and a concurrent notebook of writings and diagrams titled *Space* amply evidence this claim, as Chapter 2 will explore. But halfway through the dense penultimate paragraph in the letter, Amacher returns to its inciting frustration: "However, what were these three weeks—here I could go to Buffalo if I had bus fare and instead I have had to type lousy forms in some stupid office." The irony stings. Instead of making the visit, Amacher returns to precisely the work that she had sworn in the first place not to do in Urbana. In a letter that has staked so much on a booming, post-Kennedy-era foundation culture, the support for which Amacher had been preparing herself slips out of reach—if only for a stretch of weeks.[129] The "only place" to do this, Amacher insists throughout, "is Buffalo." However strenuously she defended her decision to forego paid work, this letter evidences that Amacher was ready—even anxious—to leave that interval behind, once she would soon establish herself in Buffalo. This letter seems also to declare "I want to make a music . . ." but to do so with familial love, institutional strategy, and compositional understanding as early anchors under which the ground was very much shifting. After she joined the Creative Associates, *Adjacencies* would be that music as Amacher became, for the first time, a jolly good fellow.

[128] She also tells her parents that people sometimes even think she's "European." Indeed, the family's French-Belgian surname is not easily locatable. Though Amacher does not elaborate, the reference does touch on institutional connections between Urbana and idealized continental centers of post-war modernism like IRCAM, Köln, or Darmstadt. Joseph Auner, *Music of the Twentieth Century* (Cambridge: Cambridge University Press, 2011), 78. Consider also Amy Beal's argument that "manifestations of experimentalism on both sides of the Atlantic are marked by constant exchange, influence and interactions in a complex network of factors that have less to do with perceived musical style and more to do with a system of European patronage that made possible a flourishing of a US experimental tradition." Cited in Eduardo Herrera, Alejandro Madrid, and Ana Alonso Minutti, "The Practices of Experimentalism in Latin@ and Latin American Music: An Introduction," in *Experimentalisms in Practice: Music Perspectives from Latin America*, ed. Eduardo Herrera, Alejandro Madrid, and Ana Alonso Minutti (Oxford: Oxford University Press, 2018), 1–18, 4.

[129] Amy C. Beal, "'Music is a Universal Right': Musica Elettronica Viva," in *Sound Commitments: Avant-Garde Music and the Sixties*, ed. Robert Adlington (Oxford: Oxford University Press, 2009), 99–120.

Adjacencies and Its Negations

> When I started to do my first real music, I always wanted to be
> able to realize many things that I would imagine and find ways to
> discover them. They weren't really . . . they didn't . . . these sounds
> and these combinations that I imagined were really not in other
> people's scores and so I had to learn how and what they were in the
> world, they were more or less inside my head . . . or somewhere.
> I had to find a way to manifest them . . .
> —Maryanne Amacher to Barbara Golden on KPFA 91.4 FM,
> December 1985

Introduction

On November 8, 1966, Amacher's *Adjacencies* roved through Carnegie Recital
Hall for about fourteen minutes immediately after intermission.[1] Now a Creative
Associate (CA) at the Center for Creative and Performing Arts at SUNY Buffalo,
Amacher had rehearsed the duo with percussionists and fellow CAs Ed Burnham
and Jan Williams. Co-director Lukas Foss had programmed it on the Evenings for
New Music series presented in Buffalo at the Albright-Knox Gallery and at Carnegie
Recital Hall, a collaboration facilitated by Julius Bloom as a New York City–based
partner since the CAs' inception in 1964.[2] *Adjacencies* stood way out that night,
according to Williams.[3] The concert's first half reprised portions of Foss' program-
ming for the Third International Webern Festival which had taken place in Buffalo
just over a week earlier, from October 28–30.[4] After Henri Pousseur's *Quintet in
Memory of Webern* (1955), the chronological program offered three unpublished

[1] I am grateful for Levine-Packer's clarification about the piece's duration during the 1966
preparations.

[2] John Bewley, "The Center of the Creative and Performing Arts: Commemorating the Fiftieth
Anniversary of Its Founding." University at Buffalo Music Library Exhibit, January–May 2015, https://
library.buffalo.edu/exhibitions/pdf/ubmu_pdf_center2015.pdf, 29, accessed February 10, 2019.

[3] Interview with the author, August 17, 2017.

[4] Bruce Carr, "Report From Buffalo: The Third International Webern Festival," *Current Musicology*,
no. 5 (January 1, 1967): 117–19. Carr chronicled Amacher's contribution to a panel discussion dur-
ing a symposium titled "Webern's Legacy" and notes that both she and Cornelius Cardew seemed to

Wild Sound. Amy Cimini, Oxford University Press. © Oxford University Press 2022.
DOI: 10.1093/oso/9780190060893.003.0002

single-movements—the expressionistic String Quartet (1905), starry String Trio (1925), and *Kinderstück* (1924) performed by Cornelius Cardew.[5] *Adjacencies* then brought to the stage harps, orchestral percussion, industrial metals, and household junk in pairs, apportioned between the two percussionists. Outfitted with directional microphones, Amacher diffused diaphanous scrims and clangorous shapes across a quadraphonic array while acoustic sound surged from the stage. She crafted the piece so that its duration could be adjusted to the space where it would be played with exceptional latitude. Imagine not only this fourteen-minute-long performance but also one an hour or two in length, which would never happen during Amacher's lifetime.

Amacher did not mention *Adjacencies* by name to Golden. By 1985, she had long parted ways with concert music and, with it, the works she had presented in that format during the mid-1960s. Yet when she recalls her early music, she describes the piece uncannily well. For a moment, she perseverates, as though re-experiencing this nascent uncertainty: "these sounds, they weren't really, they . . . they didn't . . . " she begins to tell Golden. "I imagined them," she explains, "they were more or less in my head . . . or somewhere." More than how they actually sounded, Amacher lingered on where such sounds could be and how they could be experienced, in the first place. In *Adjacencies*, Amacher honed these early questions by organizing the duo around how its players imagined sounds as much as how they would generate them. Fragments from the archive illuminate how at this early stage Amacher materialized spectral listening as a supercharged locus for sound's unruly subjunctivity. This chapter tracks her theorizations across score pages, working notes, sketches, tapes, and technical descriptions in a twenty-eight-page-long notebook she titled *Space* (1966). Spectral listening, Amacher suggests, was also especially well suited to the work of joining and connecting what she called "worlds of sound." In a published program note to *Adjacencies*, she described such processes:

have refused its premise entirely. Amacher, he wrote, "pointed out that composers were now more interested in great masses of sonority than in Webern's pointilism and that, anyway, it was more important to get out and create music than to spend time discussing influences." Though she did not mention *Adjacencies* in her remarks, the November concert program on which it appeared seemed poised to test her claim about spectral masses. Cardew seems to have been more curt. Carr wrote that he "stated flatly that he felt Weben had not influenced him." Other participants in the panel were Henri Pousseau, Allen Sapp, Niccolo Castiglioni, and Lukas Foss. Overall, Carr was not enthusiastic about the Festival's focus on unpublished works. He described Cardew's performance of *Kinderstück* as "perfunctory" and seconded critic Jeremy Nobles's assertion that the pieces that also appeared on the Carnegie Hall concert were "mature in style but too fragmentary to stand satisfactorily by themselves." See also Concert Program, "Evenings For New Music," Tuesday, November 8, 1966. Courtesy of the Maryanne Amacher Archive. *Adjacencies* was followed by Charles Wuorinen's *Chamber Concerto for Cello and Ten Players*.

[5] Cardew was a Creative Associate during the 1966–1967 academic year and arrived in Buffalo just prior to the Webern Festival. See Levine-Packer, 53–59.

I made Audjoins [the suite from which "Adjacencies" comes] so that
worlds of sound could be joined. They receive each other, interrupt,
interact and bring the unexpected to each other. What previously could
not have happened simultaneously in the same place, either because of
distance, as in the case of countries, or within one composition because
of sound levels in one room, is now possible through electronic means.[6]

Even as audiences experienced *Adjacencies* in performance, Amacher invited them
to imagine the piece sounding elsewhere and otherwise.[7] How? Questions implicit
in her phrase "how worlds of sound could be joined" open many possibilities. In
what follows, a detailed analysis that weaves *Adjacencies* together with the *Space
Notebook*'s technical and theoretical accounts will animate Amacher's early con-
ceptualizations of spectral shapes, movements, and exchanges, to this end. More
than hypothetical alternative durations, *Adjacencies* established approaches to
spatial jointure and spectral attention whose sensitivity to the subjunctive could
also connect a wide range of social and technical arrangements. Less than one
year after Buffalo and New York performances of *Adjacencies*, Amacher created
the twenty-eight-hour radio broadcast *City-Links, WBFO, Buffalo* and the festival-
like multi-day program *In City, Buffalo, 1967*. Both developed conceptual and
mediatic approaches to audible entanglements and durational overlap among
iconic, though contested, city sites. While her break with the concert piece was
decisive, material traces and common processes link *Adjacencies* to Amacher's
1967 projects, recapitulating its fascination with jointure and connection amid
institutional and infrastructural contestations that shaped the social landscape
in Buffalo within which *City-Links* and *In City* were formed. Complex histories
emerge when one asks "how worlds of sound could be joined" amid these arrange-
ments. And when bits of *Adjacencies* show up in unusual ways in *City-Links, Music
for Sound-Joined Rooms*, and other proposals, strategies of reuse, re-grouping, and
intertextual play commence a partly fictive genealogical drama all their own.

In *Adjacencies*, singing metals and spectral bands conjured a Euro-American
modernism, which had long staked an overdetermined insurrectionary charge on

[6] Maryanne Amacher, "Adjacencies from Audjoins Suite," program note, 1966, courtesy of the
Maryanne Amacher Foundation. For additional engagement with this note, see Amy Cimini, "Some
Sound and Shapes: Maryanne Amacher's *Adjacencies*," in *Blank Forms Journal, Vol. 2: Music From the
World Tomorrow* (New York: Blank Forms, 2017): 246–69.

[7] For a suggestive but fragmentary rehearsal outline and score page for the the the choral work,
Arcade, that may have been part of *Audjoins*, please see Amy Cimini and Bill Dietz, eds., *Maryanne
Amacher: Selected Writings and Interviews* (New York: Blank Forms Editions, 2020), 28–35. The archive
contains fragments from a complete score, though no document of a public performance has been
discovered among her papers. Amacher seems to have continued to compose choral music while at
Buffalo and her works list includes a piece titled *January Poem* for chorus and pre-recorded tapes. *The
Buffalo Spectrum* reported in spring 1967 that the UB Choral Ensembles was to perform a "new piece
for taped sounds and chorus" composed by Amacher as representatives of the United States at Expo
'67 in the World Festival of Amateur Performing Groups.

inharmonic complexity and spectral plenitude, especially when correlated with percussion instruments. These assemblages suggest a vibrancy that disturbs concepts of subject and object and can provide alibis for exchanges of conceptual intensities around emergent concepts not only of sound, body, and life but also alterity, abandonment, and biopolitics. Tara Rodgers sees one such exchange at work in gendered and racialized figurations that cohered in the waveform as early twentieth-century acoustical science's privileged object of aesthetic and empirical knowledge.[8] Brian Kane discerns related exchanges in his essay "Xenakis: The First Composer of Biopolitics?"[9] Kane emphasizes that, despite Xenakis's appeals to Epicurean naturalism, his commitment to statistical principles shares crucial intellectual genealogies with nineteenth-century approaches to biopolitical management.[10] In the rips and pocks that accrete in orchestral works like *Metastasis* and *Pithoprakhta*, Kane hears confusion between the natural and the normal, which ushers life into sound and conjoins that life with biopolitical materialization. And so one might again ask: what does it mean to listen for life in a sound when that listening is also informed by a refusal of biopolitics?

Claims to see, hear, and compose life in a sound connect vast cultural circuits of production, technology, and capital. Regularized in auditory culture, those circuits can attach life in sound to different bodies to diverging degrees and ends.[11] A Euro-American avant-garde, for example, often renews its disruptive force by claiming to restore life to sound. Because such claims tend to attend decisive breaks with institutions, materials, interlocutors, presentational strategies, or conceptual orientations, their resultant figurations suggest provocative ways to examine how constitutive frameworks for life reproduce in perhaps unlikely ways.[12] As Jacques

[8] Tara Rodgers, "'What for Me Constitutes Life in a Sound?': Electronic Sounds as Lively and Differentiated Individuals," *American Quarterly* 63, no. 3 (2011): 509–30.

[9] Brian Kane, "Xenakis: The First Composer of Biopolitics?," in *Exploring Xenakis*, ed. Sharon Kanach (Hillsdale, NY: Pendragon Press, 2012): 91–100.

[10] For example, as Tiziana Terranova explains, "In the first lectures of the 1977–8 course, Foucault defined the mechanisms of security as essentially techniques of optimization that addressed themselves to a life understood as an aleatory and indefinite seriality, a process of circulation characterized by the reversibility of effects and causes." Tiziana Terranova, "Another Life: The Nature of Political Economy in Foucault's Genealogy of Biopolitics," *Theory, Culture and Society* 26, no. 6 (2009): 239.

[11] I borrow this caveat from Brian Kane, "Sound Studies without Auditory Culture: A Critique of the Ontological Turn," *Sound Studies* 1, no. 1 (2015): 2–21. For another critical essay about how punctual microsonic events are used as metaphors for data that naturalize frameworks for life, body, and materiality, see also Mitchell Whitelaw, "Sound Particles and Microsonic Materialism," *Contemporary Music Review* 22, no. 4 (2003): 93–101.

[12] A case in point would be Lockwood's reflections on FM synthesis, discussed in Chapter 1. Yet, such figurations are vast. Some assume, to quote Stefan Helmreich and Sofia Roosth, a "limitless plenitude for living things that underwrites wild speculation about the processes that generated biological forms and their transmutations." While this plenitude can be marshalled through intervention and extraction, it can also refuse containment to various ends. Consider, for example, figurations of virality and animality that orient Douglas Kahn's chapter on William Burroughs and Antonin Artaud in *Noise, Water, Meat: A History of Sound in the Arts* (Cambridge, MA: The MIT Press, 2001): 290–321. This can also include Henry Cowell's pathophilic meditations on bacterial cultures in "The Joys of Noise."

Rancière puts it, "the avant garde aestheticizes life and then institutionalizes that aestheticization."[13] Situated material interventions and sound worlds coordinate such exchanges and, while spectral listening coordinates jointure and separation in *Adjacencies*, it can also function as a meeting place where relationships between sound and life are barred, enforced or routed elsewhere. Putting into play what I called, in Chapter 1, a "juxtapositional reading practice," this chapter takes up Karlheinz Stockhausen's *Mikrophonie I* (1964) and Anthony Braxton's *Composition No. 9 for Amplified Shoveller Quartet* (1969) to extend similarities in construction with *Adjacencies* but also as a provocation to take seriously how distinct modes of spectral attention can mediate notions of alterity and articulate diverging concepts of life and body. While Kane and Rodgers work between critical media operations and Foucauldian analytics of power, this chapter follows transpositions across life in a sound that surface in dramaturgy and tense to entangle embodied action and auditory thresholds. In other words, it explores dreams and expectations that weave, into spectral materialization, logics of connection and separation that can be subjected to variations across larger social, historical, or aesthetic terrains.[14] Staying close to *Adjacencies*' construction catches its play of structured imagining turned toward connections that *City-Links* and *In City* establish across auditory thresholds in quite different material and historical interventions. The material traces of *Adjacencies* will lead this story, for they come with all sorts of partly fictive wagers.

A Tape and Untaken Pictures: Learning *Adjacencies*

During rehearsals in advance of *Adjacencies*' 1966 performances, Creative Associates admistrator and later codirector Reneé Levine-Packer did not take photographs. She advised me not to make the same mistake when, in 2017, the piece was reconstructed in performance with percussionists Russell Greenberg and Ian Antonio and engineers Daniel Neumann and Woody Sullender. "Imagine

Henry Cowell, "The Joys of Noise," in *Audio Culture: Readings in Modern Music*, ed. Christoph Cox and Daniel Warner (New York: Continuum, 2006): 22–25. *Wild Sound* approaches distinctions between the avant-garde and the experimental through the constitutive frameworks for life by which individual practitioners sought to distinguish their own interventions. Stefan Helmreich and Sofia Roosth, "Life Forms: A Keyword Entry," *Representations* 112 (Fall 2010): 27–53.

[13] Jacques Rancière, *The Politics of Aesthetics* (New York: Continuum-Bloomsbury, 2004), 29.

[14] See Elizabeth Povinelli, *Geontologies: A Requiem to Late Liberalism* (Durham, NC: Duke University Press, 2016), 6. In another departure from classical Foucauldian analytics, Ana Maria Ochoa, for example, has shown how the conjunctions between orality and aurality have historically arranged the human and non-human on a continuum within which a politics of life that can be traced in and through mutual constitution of nature and culture in nineteenth-century Colombia. See Ana Maria Ochoa, *Aurality: Listening and Knowledge in Nineteenth Century Colombia* (Durham, NC: Duke University Press, 2013).

it," she enjoined me, recalling how the instruments looked together on stage.[15] She conjured orchestral harps and placed Amacher, Edward Burnham, and Jan Williams among their ornamented crowns, golden columns, and curved shoulders. I sensed the visual drama she wished to evoke. Alongside the harps, industrial gas tanks towered amid orchestral percussion that included cymbals, steel drums, tam tams, cup gongs, toms, and marimbas as well as smaller metal junk like hoops, door springs, refrigerator shelves, and brake drums. Levine-Packer's untaken photographs would have captured the sculptural and dramaturgical environment in which players and listeners interacted with a spectral abundance that also shimmered in the subjunctive. This unphotographed scene courts many Orphic dreams—whatever clangorous masses, spectral embodiments, and spatial transformations converged in *Adjacencies* would also be coaxed to sing.

Such dreams would begin with the graphical strategies that Amacher used to represent listening. One strategy cut across metal instruments, shown in Fig. 2.1; a second organized the harps' pitch-focused events, narrow tremolandi, and diaphanous, Debussyan complexes, discussed shortly in relation to Fig. 2.2. Both balanced analytic uniformity with spectral heterogeneity and spontaneous generative procedures. Shaded rectangles apportion each metal instrument's frequency spectrum into five equal-sized spectral bands. Amacher catalogues their characteristics: "as metallic and rich in high frequencies as possible," "rich high frequency content mixed with 'some' metallic less rich than above," "ordinary high or high frequency content tending to be less rich [. . .]," "ordinary low or low frequency content not as rich as below mixed with a lower metallic timbre," "as rich as possible in the lowest frequency characteristic of the instrument."[16] Yet, Amacher gave no instruction as to how to produce the sounds. She accepted whatever techniques would dramatize a spectral region and encouraged whatever adjustments would enable a player to explore its ambitus more deeply. Draw out idiosyncratic "rhythms and singing" or "beating," she writes. Each outline is a heuristic for a listening that moves ceaselessly into the deep interior of a single spectral complex. A uniform application of these five apportionments guarantees wild outcomes. Imagine a spectral carpentry that combines the tam tam's "lowest characteristic" with that same band expressed on a cymbal. An on-the-spot analysis of complex timbres generates composite characters with new spectral depths all their own. Amacher calls these combinations "frequency structures." Unified listening protocols maximize a timbral heterogeneity whose five-part disarticulations enabled Amacher to compose with frequency bands themselves. As something like singing emerges from these combinations, the voice seems to haunts their terminologies of spectral attention not as a particular kind of sound, but as an "ideology of what sound should be." This, Delia Casadei summarizes, prescribes that sound be "present, intelligible, yet detachable from language enough to exist as an excess both

[15] Conversation with the author, January 18, 2018.
[16] Maryanne Amacher, *Adjacencies*, front matter.

GENERAL NOTATION: 4 TYPES (I - IV):

Classed According to Degree of Function in
Indicating Timbre.

(I) Timbre specifications given <u>directly</u> for
(a). metal instruments:
(b). frame of harp
(c). ∿, Ⅰ

by the indications described in 1.a, 1.b, and 1.c.

(1.a) METAL INSTRUMENTS: the following score indications
are to be read as follows.

GET OUT OF THE INSTRUMENT A TIMBRE, (AND CONTINUE TO PLAY, i.e
EXPLORE MORE SPECIFICALLY THE COLLECTION OF FREQUENCY CHARACTERISTICS
WITHIN THIS TIMBRE)

+H: AS METALLIC & RICH IN HIGH
FREQ. CONTENT AS POSSIBLE:

H: RICH HIGH FREQ. CONTENT MIXED WITH
"SOME" METALLIC LESS RICH THAN ABOVE. Stress <u>High</u>
Freqs.
-H: ORD. HIGH OR HIGH FREQ. CONTENT above
TENDING TO BE LESS RICH THAN THE
2 ABOVE:

L: ORD. LOW OR LOW FREQ. CONTENT NOT
AS RICH AS BELOW, MIXED WITH A
LOWER METALLIC TIMBRE. Stress <u>Low</u>
Freqs.
+L: AS RICH AS POSSIBLE IN THE LOWEST below
FREQ. CHARACTERISTICS OF THE
INSTRUMENT.

+H:
+L: etc. are to be read as part of the verbal timbre descriptions;
they designate a more specific aspect, namely <u>INCREASING</u>
and <u>DECREASING</u>. (+ or -), whenever possible the <u>AUDIBILITY</u>
of possible self-organizing characteristics you might
hear within the <u>HIGHEST and LOWEST FREQ. COLLECTIONS</u> of a
timbre generally rich in High or Low Freq. Content.

EXAMPLE: ⬖⬗⬖ (-H: ord. High) is rich in high freq.
content, but possible interacting characteristics of the
<u>highest</u> frequencies are not to be as audible as in H.

Later in these notes I use +H, H, -H, etc. simply as
abbreviations when referring to the score indications,
▬, ⬚⬚⬚, ⬚⬚⬚ etc..

Figure 2.1 Graphic performance instructions for metal instruments in *Adjacencies*
show how Amacher notated timbres for metal instruments, which included pairs of
suspended cymbals, cup gongs, tam tams, heavy metal hoops, steel drums, brake
drums, metal tanks, and "cymbals [placed] freely [to] vibrate on timpani." Courtesy of
the Maryanne Amacher Foundation.

carnal and metaphysical, something that, if necessary, might even be traced back to the flesh of a single unrepeatable human body."[17] Following Casadei, however, one might also ask: What is the historical place of instances in which form and structure do not get out of the way? What happens when such phenomena take place in the subjunctive? How might we address the possibility that these arrangements insert everyday vitalisms into the vibrancy of their assemblages that at the same time function as alibis for other constitutive framework for life?

In a performance note revised multiple times, among her extensive writing about *Adjacencies*, Amacher explains why she tasked percussionists with this real-time spectral work. Hands and bodies entwine amid the piece's commitment to jointures between worlds of sound:

> The fact that a percussionist can not only produce more than one timbre simultaneously on many of his instruments, but significantly control these timbres even when several, of different tendencies, are produced simultaneously on the same instrument became important to me. The possibilities, here, as well as being uniquely approachable in the composing of "percussion" music are more intimately related to my concern in exploring aspects of timbre organization. And there I consider primary aspects of the percussionists' working experience [. . .] to be at this point more fundamental for the explanation of possibilities of this area [. . .]
>
> 2 facts of extreme importance in the basic planning of this score concerns the percussionist's (i.e., those who play "do you hear!," rather than simply "isn't it fun to be a musician") practical and <u>individual</u> (i.e. other musicians might have this experience in group playing of such music as Stockhausen's "Carré" and Penderecki's "Flourescences") EVERYDA[Y] experience, far exceeding that of most composers and other musicians, in areas of sound organization, seldom audible to others, i.e. those thresholds, unless you are [very] close to the vibrating source.[18]

It is no surprise that she calls upon modernist exemplars that required orchestral string players to adopt percussive extended techniques. In *Flourescences*, this meant humming, striking the fingerboard with an open palm, and scraping a metal file across open strings. The piquant "do you hear!" suggests a comprehensive fascination with these composite actions and their resultant sound worlds: how the strings respond to the palm's soft skin, how the instrument wobbles against the shoulder and jaw upon impact, the subtle click when the hand leaves the fingerboard in preparation to tap it again. "Do you hear!" connects gestural procedures

[17] Delia Casadei, "I fatti di Milano, 1969: Recording a Milanese Riot," paper present at the American Musicological Society National Meeting, Louisville, KY, 2015.

[18] Maryanne Amacher, *Adjacencies*, undated working notes.

with what Amacher called "exploring aspects of timbre" and foregrounds touch and proximity as their central technical mediations. In comparison, a composer's conventional instructions convey very little, she suggests. "It is the percussionist who takes these indications," Amacher explains, "and goes to the instruments to find what possibilities he can reveal in the time given him on the score [. . .] He finds, chooses, sorts, selects what he is going to reveal and correlates his physical gestures accordingly."[19] To say that *Adjacencies* leaves quite a lot up to the performers does not quite capture Amacher's interest in their epistemic situation. Implicit in it, she finds idiosyncratic and embodied knowledges through which complex spectra can become, as she puts it, "approachable."[20] In this note, Amacher uses scare quotes to characterize *Adjacencies* as less a work of "percussion music" than an underdetermined but auspicious intersection between percussionistic knowledges and her burgeoning interest in complex spectra. "This simple fact is extraordinary to me," Amacher concludes, "I shall never be able to take it for granted."[21]

A single rehearsal recording exists in the archive.[22] Jan Williams described their rehearsals as a process of "trying things," and it is not hard to imagine Amacher's "simple [but extraordinary] fact" documented on the rehearsal tape.[23] Amacher, Burnham, and Williams experimented with techniques to produce sounds that she imagined. They placed cymbals on a timpano drumhead, struck industrial gas tanks against one another and applied implements to different areas on the metal cylinders. Williams found that a small electronics component called a heat sink evoked high spectral regions on metal instruments especially well. The device channels heat from mechanical processes onto thin aluminum fins where it diffuses across their surfaces areas, arranged compactly in parallel. Williams used the fins to bow metal instruments, and, in the rehearsal recording's opening seconds, one hears the bright streaks of metallic tone that it could draw from the steel drum. The sound has a hard edge and a sinuous spectral profile that would not be easily confused with the lower frequencies characteristic of a horsehair bow on metal. In the recording's opening minute, harp tremolandi fill pauses between the sink's breath-length gestures and singable, falling contours.

Though the tape cannot chronicle the piece's spatial adventures, it does reveal how trills and tremolandi provided textural coherence and spectral consistency amid unstable metallic combinations. Amacher provided lavish detail on how the percussionists should handle the harp strings and, thus, inserted a retrospective record of her formative hands-on experiments in Urbana's harp studio into the piece's spectral world. Running fingertips and fingernails lengthwise along the

[19] Ibid.

[20] Ibid.

[21] Ibid.

[22] However, Amacher later wrote that there existed no "suitable" recording of *Adjacencies* that she felt could be shared with future performers as a model or reference. I do not present this rehearsal recording as exemplary or authoritative in any way.

[23] Interview with the author, August 17, 2017.

string would produce swells rich with high frequencies; palms, bows, and felt erasers could activate larger or smaller frequency regions that paralleled the metal instruments' five-part divisions. Amacher's attention to bowing technique even comes close to serialization. To a single frequency region, she applies four possible techniques: bowing irregularly and slowly with points of stress; bowing quickly with continuous stress; sawing, which isolates two or three different tones; or beating, which isolates two or three different tones. Applied to two regions, these techniques yield forty-eight possible sound behaviors that could then be combined to create innumerable "frequency structures."[24]

Consider a long stretch that begins around the rehearsal recording's midpoint. Continuous harp tremolandi across approximately one octave whip up overtone clouds that the percussionists ornament with plucked tones and short melodies on the harps and mallet instruments. These sound worlds bring to mind works of La Monte Young or Julius Eastman, in which figuration interacts with massified partials. Ornaments can carve negative space into a larger spectral mass and retrospectively reveal their subjunctive inherence in it. Such impacts suggest hidden processes and partly unreal sonic relationships that can be inhabited with powerful interpretive gestures.[25]

Williams laughed when he reminded me that *Adjacencies* required the two percussionists to find specific strings on the harp. Additional graphical shorthand parsed the instruments' six-and-a-half octave range with the five-line staff as a reference, evidenced in Fig. 2.2. Amacher apportioned the harps and marimbas at the octave and subdivided single-octave units again at the fourth, fifth, or tritone. On the rehearsal recording, the pair take this guide literally. Especially prevalent is the second-highest division's symmetrical B–F–B subdivision: in warm plucked tones, it becomes the basis for a recurring gesture that leaps up or down by tritone and then moves stepwise in the opposite direction. The duo also employs Bs and Fs in that same range on the marimba amid transforming metallic complexes. These melodies matter not because they establish centricity but because they host questions about how a spectral complex can be inhabited, in the first place. They

[24] Maryanne Amacher, *Adjacencies*, front matter.

[25] These moments emphasize an undecidability underpinning how spectral complexes are held together, which can give rise to many critical interventions interpretations. Consider, for example, how Jeremy Grimshaw describes the use of near-neighbors in *The Well Tuned-Piano* to "nuance different repetitions of a repeated gesture" that "do not sound like separate tonal entities but rather as one note undergoing an ethereal shift in pitch." *Draw a Straight Line and Follow It* (Oxford: Oxford University Press, 2011), 163. In a reading focused on triplet figures figuration in Julius Eastman's large ensemble musics as a trickster figure at once "everywhere, part of the piece and at times merely a garnish," Isaac Alexandre Jean-François gives a rich account of "fascinating patches of over- and undertones;" "each note in this section generates two conclusions," Jean-François writes. "[. . .] one note echoes into a close that is never quite closed in earnest." In this, one hears a "trick" that induces audiences to believe that concert music is apolitical while at the same time experiencing what he calls disavowed "black sonic movement." Isaac Alexandre Jean-François, "Julius Eastman: The Sonority of Blackness Otherwise," *Current Musicology* 106 (Spring 2020): 9–35.

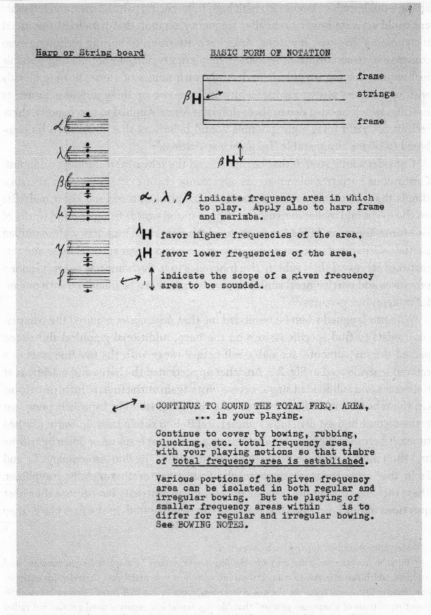

Figure 2.2 Graphic performance instructions for harps in *Adjacencies* delimit techniques and frequency ranges. Note that Amacher includes notations for the harp frame, treating it as a percussive component with sympathetic resonant strings. Courtesy of the Maryanne Amacher Foundation.

guide listeners into frequency structures where Amacher's early questions about "how worlds of sound could be joined" will meet new material, social, and dramaturgical arrangements. If they seem to sing, it is a singing that remains, partly, in the subjunctive.

Negative Notation: How to Wish for Sound

Amacher described her approach to notation as "intuitive." Across five pages, frequency bands are stacked and ordered, mimetic zigzags express how to bow the harps and arrows delimit their ranges. She made things up as she went along and hoped that someone else might later standardize her ad hoc efforts.[26] Her description, however, suggests that the graphical traces of *Adjacencies* are provisional in other important ways, as well:

> [T]his notation was the most efficient set of signs I could devise for direct concentration to the complex listening requirement of the work. Once familiar with the signs, they are easily recognized at a glance, there should be little need to "read" in the score during preparation and performance of the music—attention can be entirely free for hearing.
>
> The score sets up possibilities for finding. Explore and reveal as much as you can the "contouring" you will hear WITHIN the interacting energy of the material. . . . Before deciding attacks, listen for interacting possibilities within the total frequency structure—the two or three frequency structures sounding together. Forget source timbre and explore.[27]

Amacher also referred to her pages as "negative notation." As players' spectral acumen grows, the score's graphical constraints are remade, in the dialectic, as spectral insight. The score is not to be memorized; it should instead be set aside once it has obviated this heuristic function. Though their visual impacts are complex, each graphical component functions as a minimal notational unit for keeping players engaged with "exploring" spectral energy *"as much as you can."*[28] Each page is to dissolve into its own graphical detail, revealing that *Adjacencies* had simply always been its players modes of spectral attention. Yet, as Amacher's notes suggest, they will still never not be at the limit. The limit of what? Negative notation reasons from the subjunctive. That is, its graphical detail materializes a superadditive mass of spectral detail that is presumed to exist, regardless of whether or not it actually reaches audibility. Negative notation conjures ways of

[26] Maryanne Amacher, *Adjacencies*, front matter.

[27] Maryanne Amacher, *Adjacencies*, front matter

[28] Ibid., italics added.

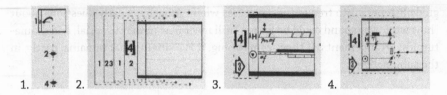

Figure 2.3 Four spatial strategies, as presented in score of *Adjacencies*. Courtesy of the Maryanne Amacher Foundation.

wishing for sound, or wishing in sound about some further nuance or combination that remains inaudible but ongoing elsewhere. Whatever choices the players of *Adjacencies* make, their listening stitches together the material and the fictive in a drama of spectral detail at once partly real and partly imagined.[29] And so, any analysis of Amacher's instructions must also enclose the notation's negative slide toward what else could be happening in its sounding present as much as an unheard subjunctive. A description is also, in other words, a guess at where the threshold between the audible and hypothetical might fall at any moment. Both catch the imaginative work to which negative notation gives rise in medias res.

Amacher introduces spatialization strategies in the score's front matter using notated examples. And although she treats spatial and spectral strategies separately in the score, the *Space Notebook* illustrates how thoroughly she conceptualized their interdependence. With prose and diagrams, the notebook reveals the shapes, curtains, and scrims that frequency structures would send streaming across her square quadraphonic array. Let's begin, in Fig. 2.3, with a synoptic look at four spatial approaches.[30]

After an instrument is struck, Amacher's first strategy directs the sound's decay to additional speaker locations. In this example, a strike on the cup gong sounds at speaker 1, and its bright decay is moved to speaker 2 and then to speaker 4. This strategy becomes the basis for what Amacher calls "melody," which in *Adjacencies* means "sounds [that] meet without attack in a new location."[31] As resonant decays move from speaker to speaker, they obscure subsequent attacks that introduce new timbres. This creates a continuous thread of sound, the timbre of which changes as a condition of its movement around the quadraphonic square. Strategies three and four further entangle location and subjunctivity by doubling or tripling ongoing sonic events. Strategy three intensifies continuity

[29] While each chapter in *Wild Sound* embraces a different approach to the sonorous nuances of Amacher's work, this one will pay perhaps a surprising amount of attention to the score—an approach typically associated with a disembodied music-theoretical positivism that would vaunt the score's authority over the aural cultures in which it functions and intervenes. In this case, however, close attention to the score is a way to illustrate the negativity that also destabilizes it.

[30] Maryanne Amacher, *Adjacencies*, front matter.

[31] Ibid.

and strategy four, contrast. Amacher introduces strategy three with a complex example that combines the bowed harp's upper-middle register with an upper-middle and ordinary low frequency structure in the cymbal-timpano pair. This composite sound begins in speaker 3 and, when doubled in speaker 4, surges from an additional and adjacent location to reinforce ongoing frequencies. In *Kontakte*, Karlheinz Stockhausen refers to this quadraphonic strategy as *Flutklang*—"flood sound"—a gentle and evocative metaphor for monophonic intensification, distinct from the spatialized attacks of integral serialism's so-called point music.[32] In strategy four, timbre, attack, and dynamics change markedly when one or more new speakers joins an extant arrangement. Her example places discrete harp events in speaker 4; after a single *mf* strike of the cup gong, adds speaker 3 and at the same time introduces new material on refrigerator shelves. Only strategy two rotates sound around the speaker array, with a continuous event, in this case, sounding in speaker 4.

The re-orderable pages of *Adjacencies* establish proportional relationships between stretches of music devoted to each spatial strategy; Fig. 2.4 presents four pages together and labels the spatial procedures that appear on each one in order to introduce Amacher's spatial and durational schemes in tandem.[33] Pages A and B each address a single spatial paradigm (melody and *Flutklang*, respectively, both marked *p* and *pp*) and should share identical durations, that is, a one-to-one proportion relative to the space of the page.

Melody commands one third of Page C, in high dynamic contrast (*ff* to *pp*), with the remaining two-thirds dedicated to *Flutklang* and, on a seemingly climactic Page D, five *ff* harp events—two diagonal projections, two rotations, and one *Flutklang* event—are packed into the center, braced by blank space on both sides. However the pages would be ordered, this proportional structure would organize durational relationships: Pages A and B establish equal parts melody and *Flutklang* while Page C supplies stretches of melody and *Flutklang* one-and-two-thirds their length and Page D, an intense, composite spatial structure proportionally framed by silence. In *Adjacencies*, spectral attention, frequency structures, and quadraphonic spatial strategy generate an architectural drama that takes place within a listener's embodied circumstances of encounter. Turning to Amacher's *Space Notebook* draws three-dimensional shapes and layers from this conjectural description. This is a drama of rooms, walls, curtains, and scrims that open, close,

[32] See Stockhausen's front matter for *Kontakte*. Karlheinz Stockhausen, *Kontakte: elektronische Musik, Nr. 12* (London: Universal Edition, 1976). In her writing on *Adjacencies*, Amacher unambiguously highlighted "melody" as her own, original spatial and spectral innovation. Although she did not use the term *Flutklang* in her writing, I use it in order to dramatize *Adjacencies*' heterogeneous spatial dynamics and to highlight how her applications differed from *Kontakte*'s, especially with respect to listening and gesture in live performance.

[33] Among the material traces of *Adjacencies* are doubled sets of pages. For each page printed in black ink on white paper, a corresponding page presents the same material in negative space against a dark background.

a. Strategy 1 (melody) b. Strategies 3 & 4 (flutklang)

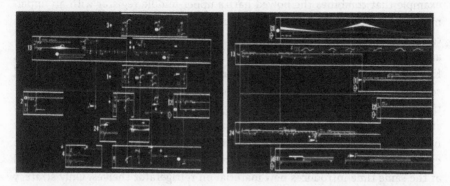

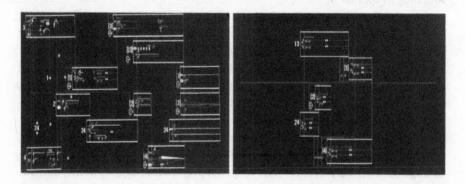

c. Strategies 1 & 4 d. Strategies 2, 3 & 4

Figure 2.4 Four pages from *Adjacencies* presented side-by-side. Because there are
often more events in vertical alignment than can be executed by two performers, the
player could move between or recombine material with the proportioned time frame.
Courtesy of the Maryanne Amacher Foundation.

and change shape and size around an audience that is moved "inside" and "out-
side" so often that it becomes, perhaps, hard to tell which is which.

The *Space Notebook*: An Analysis in
the Subjunctive

Densely packed into twenty-eight pages, the *Space Notebook* explicates how spec-
tral shapes arise between four speaker points and interact within and beyond
the quadraphonic array. Amacher organizes the study around two processes that

interlock in systematic ways: one correlates timbral features with quadraphonic shapes and another tracks their spatial overlap and temporal succession in a progressive scheme that builds up what Amacher calls "forms," "characters," and "appearances."

She accompanies her prose with sketches that illustrate how sounds densify the air between speakers. And so, the notebook teems with squares. Some have thick sides, some thin; some lose two sides and become triangles; lines are dotted, shaded, filled-in, or inlaid with additional shapes. These sketches connect the quadraphonic square with lines composed of a more or less ordinary series of points. When, at each vertex, the directionality of one line differs from another, Amacher seizes upon the transition to anatomize a multiplicity of exchanges.[34] In her sketches, in other words, whatever happens at a vertex intensifies the constitutive points that make up an intervening line, both in relation to themselves and to one another. According to the notebook, those points can stream in one direction or another; cluster in thickly or loosely configured patterns; expand, contract, or even disappear into thin air. Invested with intensity, the quadraphonic array becomes a kind of event that seems to lack self-evident parameters. As shown in Fig. 2.5, Amacher uses the shorthand "Σ" to represent these intensifications in general terms.

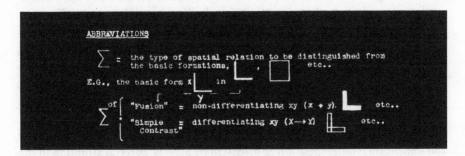

Figure 2.5 Basic spatial notation in the *Space Notebook*. Using this square as a kind of shorthand, Amacher assesses dimensional transformation between speakers. Courtesy of the Maryanne Amacher Foundation.

[34] This description draws from Povinelli's reflections on Gilles Deleuze's idea of assemblage and event. Povinelli is especially interested in how this approach to expressivity and event comes through geological, ecological, and geometrical arrangements of existence, in both Deleuze's work as well as the co-authored work with Guatarri. For example, in *The Logic of Sense*, Deleuze explains the event as a geometrical concept that "demands that we cease opposing the singular to the universal and start understanding that the opposite of the singular is the ordinary." The singular opposes the ordinary, for example, each time a line changes direction. This jointure is an event in and through which each line's constitutive points become differently intense in relation to one another. Amacher's notes suggest tests and configurations for these events. Elizabeth Povinelli, *Geontologies: A Requiem to Late Liberalism* (Durham, NC: Duke University Press, 2016), 30–54.

Within this framework, Amacher makes two distinctions that become foundational to how transitions and successions will work. "Local" events emphasize vertices while "dimensional" events intervene on the square's sides and diagonals.[35] Amacher explicates these intensifications in timbral terms and addresses their interrelation in an increasingly complex account of what she calls "locality-and-dimensional-differentiation." This lays the groundwork for reading and hearing the notebook's geometric sketches as interruptions, connections, and importantly, as characters.

Returning to *Adjacencies*'s instructions proves illustrative. To produce a local event, Amacher recommends discrete attacks with timbres that do not tend to blend or fuse. This she calls "simple contrast." Consider the detached harp handfuls and single cup gong stroke that she uses to illustrate spatialization strategy four, as we have already seen in Fig. 2.3.[36] These events nestle into speaker four until similarly discrete thuds introduce refrigerator shelves in speaker three. In her notebook, Amacher names such local transitions "moving" or "block-switching" to convey their unambiguous emphasis on one vertex after another. "Local" emphasis also underlies the decay-based events that Amacher calls "melody." Simple contrast glues attacks to a single speaker so that traveling decays can mask them unambiguously without added emphasis on sides or diagonals. In contrast, "dimensional" events involve sustained and fused frequency structures like the mids and high-mids in the harp and cymbal-timpano couplet that appeared in spatialization strategy three, as Fig. 2.3 again illustrates. "Dimensional" events downplays speaker points and instead expand, contract, or densify diagonals and perimeters to variable degrees. Locality and dimension shorthand less opposing strategies than singular configurations of the (hypothetical) line that connects one vertex to another. The prefix "ad-," after all, suggests not fixed points, but directional tendencies of movement. To be "adjacent" can mean to meet, to touch, to add, to precede or follow, to relate strongly but not identically. In the notebook, space is simply the "multiplicity of exchanges" that arise between local and dimensional differentiation as mediated by players' spectral attention in the subjunctive.[37]

Let's look closely at the eight melody events that appear on Page A in order to consider how "local" events interact, throughout. In Fig. 2.6, these melodies are numbered 1–8. A first melody marked *p–pp* moves the tam tam's mid-range frequency band and a low register harp swell from speakers 1 and 3 to speaker 4 where it meets *p* shapes on the door springs and cup gong. Melodies build in intensity and crest at *ff*, just past the middle of the page. A second melody begins

[35] In the *Space Notebook*, Amacher experiments with a few names for these oppositions, as though experimenting to find the right terminology; for example, she sometimes refers to "local differentiation" to describe the meeting of contrastive material at one or more vertex and "high spatial differentiation" to describe its dimensional ramifications in quadraphonic space.

[36] Amacher, *Space*, 2.

[37] Ibid, 3; Povinelli, *Geontologies*, 56.

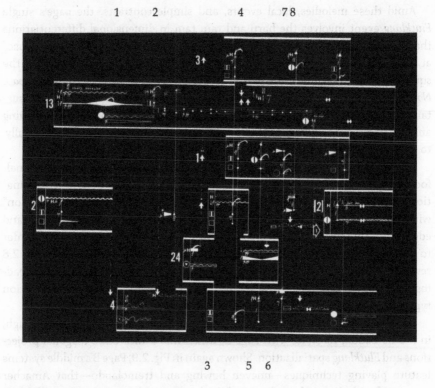

Figure 2.6 Devoted almost exclusively to "melody," this page of *Adjacencies* reveals how Amacher combined decays and static local events. Courtesy of the Maryanne Amacher Foundation.

again in speakers 1 and 3 and combines the harp's low range with a brake drum strike that travels to meet an undulating harp event in speaker 4, while the toms provide local contrast with light pocks fixed in speakers 1 and 3. Amacher structures subsequent melodies similarly, that is, the harp or cup gong decay is spatialized while the toms generate local events in the speaker location where that decay originated, in melodies 3–5. When, in melody 6, Amacher introduces the steel drum decay—which Williams had produced with the heat sink—the harp changes roles and, with the marimba, places local events in both the decay's original and new locations, in melodies 6–8. Throughout, three sustained frequency structures establish a consistent, *p* or *pp* low register and non-metallic spectral wash, through which these melodies move and thread. This includes tremolandi in the harp's lowest register, the steel drum and tam tam's lower frequency blocks, and vibrating door springs that, "played with pipe cleaners, produce no metallic but low voice like sounds," Amacher explains. On this page, spatial strategies become, themselves, an impetus for macro-spectral groupings and distinctions.

Amid these melodies, local events, and simple contrasts, the page's single *Flutklang* event involves the harp and tam tam in dimensional differentiations that activate the square's invisible perimeter. When frequency structures "fuse" at one or more of the square's vertices, their dimensional impacts emphasize the square's sides or diagonals to differing degrees. On the dense page from the *Space Notebook* that appears in Fig. 2.7, Amacher sketches how isolated attacks, sustained tones, and long decays will yield "side orientation," while uneven bowing and tremolo make the diagonal "more noticeable."[38] The latter applies, especially, to the piece's nearly omnipresent harps.

With these protocols in place, Amacher further categorized side- and diagonal-focused presences by type so that she could schematize transitions and combinations. Using traditional terms for texture, she associates "homophonic fusion" with thick, wall-like densities and "polyphonic contrast" with thinner scrims and edges. Into this two-part division, Amacher inserts further distinctions in order to capture tensions and tendencies within individual configurations. As Fig. 2.8 reveals, she applied a four-part rubric to these tendencies and delimited "spreading," "focusing," "stabilizing," and "moving" as general "transition-orientation types" that could be used to sequence and overlap spatial constructions.

The technical approaches to dimensional events that Amacher worked through, in the notebook, resonate with Page B, which was dedicated to diagonal projections and *Flutklang* spatialization. Shown again in Fig. 2.9, Page B's middle systems feature playing techniques—uneven bowing and tremolando—that Amacher associated with diagonal emphasis, while the top and bottom systems offer sustained frequency structures that generate "side orientation." The dynamic range is weighted toward piano and pianissimo, suggesting not raucous masses, but soft curtains that expand or evanesce. In two far-left systems, bowing on the harps in speakers 1 and 3 and speakers 2 and 4 suggest an X-shape, formed by dynamically distinct, uneven sawing that crisscrosses the audience. Sustained frequency structures carved from the tam tam and cymbal-tympano pair, in two *Flutklang* blocks, complete the square with side-orientation. Harp and marimba tremolandi, on the right-hand third of the page, introduce *Fluklang* events that concentrate diagonal emphasis between speakers 1 and 3.

This page suggests six discrete configurations; no fewer than two overlap at a given time, while four commingle for about one-third of its duration, and five for a shorter interval. Though the *Space Notebook* meditates on tendencies in block-like units, an attempt to hear a hypothetical *Adjacencies* must also imagine palimpsestic layers that move quadraphonic architecture across horizontal logics in real time.[39] In addition to four "transition- oriented tendencies," Amacher generated descriptive "characters" and "intensity adjustments," shown in Fig. 2.10, to detail the dimensions and shapes that can emerge when two or more

[38] Amacher, *Space*, 2.
[39] Ibid., 8.

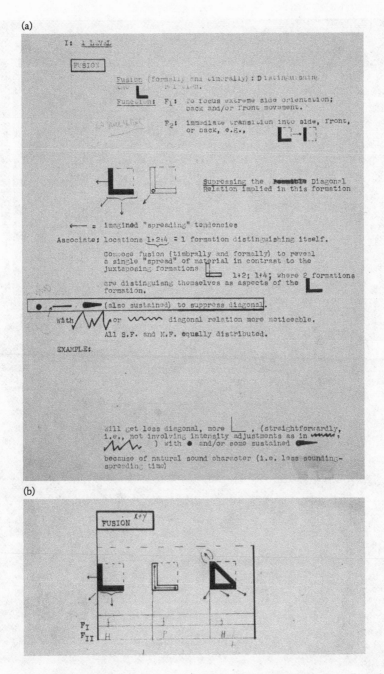

Figure 2.7 Quadraphonic spatial types in the *Space Notebook*. (a) This page describes playing techniques and sounds that enhance or suppress diagonal spatial relations. (b) This drawing represents Amacher's approach to spatial dimension through timbre and texture. With filled-in rectangles and directional arrows, these sketches suggest conditions under which the square would expand or contract. Courtesy of the Maryanne Amacher Foundation.

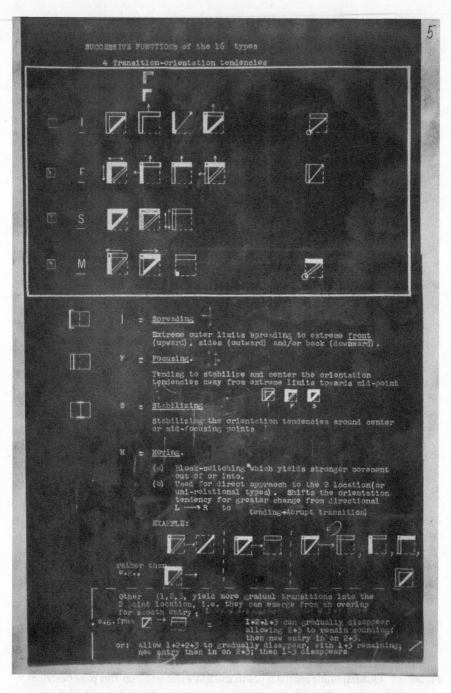

Figure 2.8 Amacher categorized stability and movement as transitional spatial tendencies. To her four basic categories—"spreading," "focusing," "stabilizing," "moving"—this sketch adds significant nuance. Courtesy of the Maryanne Amacher Foundation.

Figure 2.9 This page of *Adjacencies* exemplifies the *Space Notebook*'s approach to side-focused and diagonal spatial relationships in practice. Courtesy of the Maryanne Amacher Foundation.

configurations meet on the quadraphonic grid. Like the spectral listening that underpins them, these shapes evidence multi-dimensional depth and rich internal detail.

Amacher's fascination with percussionistic knowledges haunts the *Space Notebook*, although she does not once mention a specific sound source, throughout. Before a second performance of *Adjacencies* in September 2017, percussionist Russell Greenberg remarked that no repertoire from that period took its players' aural experience and bodily awareness so thoroughly into account.[40] But when negative notation casts a player's listening into the subjunctive, it also dares the project to turn into something else. This constitutive instability can be marked in various ways, and Keiko Prince—Amacher's close friend and colleague at the Center for Advanced Visual Studies—tailored her suggestions

[40] Greenberg had in mind the percussion and prepared piano music of Cage as well as Stockhausen's *Zyklus* (1959). Conversation with the author, September 18, 2017. See also Blank Forms RADIO #21 "Maryanne Amacher's Adjacencies" with Cimini, Greenberg, and Blank Forms founder and artistic director Lawrence Kumpf in conversation. https://soundcloud.com/blankforms/maryanne-amach ers-adjacencies.

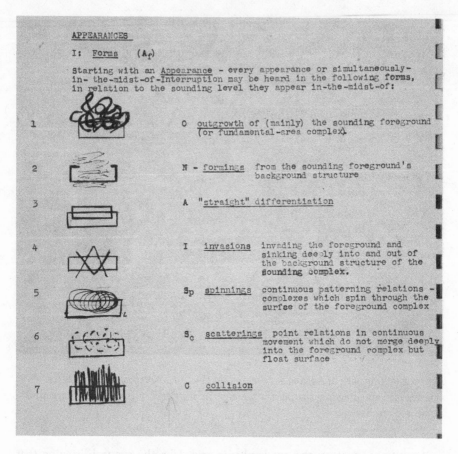

Figure 2.10 These sketches, in the *Space Notebook*, describe distinct sonic shapes that would emerge during transitions, interruptions, and layers between discrete and square-based spatial procedures. Courtesy of the Maryanne Amacher Foundation.

to the September 2017 performances, specifically.[41] Performances should be subtitled with their date, she asserted. Not just *Adjacencies*, but that night, "*Adjacencies: September 18, 2017*"; the night before, "*Adjacencies: September 17, 2017*"; months later, "*Adjacencies: January 18, 2018*"; and so on.[42] By rooting spectral insights in time and place, Prince created an ethical shorthand that caught the notation's negativity in process. When *Adjacencies* plunges head-long into spectral detail, it must also leave behind something that persists as a

[41] Conversation with the author, September 18, 2017.

[42] At the time of this writing, none of these events have been publicly named according to Prince's recommendation. This conversation is also discussed in Cimini, "Some Sounds and Shapes: Maryanne Amacher's *Adjacencies*."

condition of possibility for its further iteration.[43] By dating this errant remainder, Prince distances it from the performances that Amacher oversaw in 1966 and, at the same time, indexes their ongoing protraction in the subjunctive. Though Amacher also distanced herself from the piece, its spectral conjectures persist across social locations, material forms, genealogies of body, and analytics of power in subsequent works. Prince's titles suggest that *Adjacencies* is a way to couple spectral insight with social life along these lines. Her recommendations sweep fragments of the archive toward questions about what, in some other historical moment, the negative gambit of *Adjacencies* might become.

Life in a Frequency Spectrum and Its Figurations

"One of his first questions was to me: 'Do you want the tones to shimmer inside?' "[44] Fifty years afterward, Amacher recalled how Stockhausen had first invited her to approach acoustic material as a lustrous sort of depth. Amacher narrated this apprenticeship as a decisive break with her formation in music as a liberal art and illustrated the stakes as, also, experiencing life in a sound.[45]

> My conventional/traditional/academic background in music provided no approach to understanding or investigating what mattered most to me about the physical nature of sound, our responses to it perceptually, and the creation of the sonic worlds I imagined!

> Imagine what it was to encounter Stockhausen's supreme energy, to *discover*, to explore entirely new ways of presenting music, to delve into the interacting energy of the spectrum itself, and *listen into the inner life of sounds themselves*! And perhaps even more important his incisive attention to the experiential, to observing sensorial features, how we respond to the acoustic information. One of his first questions was to me: "Do you want the tones to shimmer inside?"[46]

[43] Adapted from Amy Cimini and Jairo Moreno, "Inexhaustible Sound and Fiduciary Aurality," in *Boundary 2: An International Journal of Literature and Culture* 43, no. 1 (February 2016): 5–42. See also Elizabeth A. Povinelli, *Economies of Abandonment: Social Belonging and Endurance in Late Capitalism* (Durham, NC: Duke University Press, 2011).

[44] Maryanne Amacher, "Thinking of Karlheinz Stockhausen," (2007) in *Supreme Connections Reader*, ed. Bill Dietz (2012), 218–223, 221.

[45] As Penn music alumnus Andrew Rudin recalled, Penn had no "department of instrumental study [so] most of the compositions [he] produced were of a speculative nature." Personal website, http://www.composerrudin.com/bio.php, accessed September 9, 2019. This would also have been the case for Amacher's early composition study.

[46] Maryanne Amacher, "Thinking of Karlheinz Stockhausen," (2007) in *Supreme Connections Reader*, ed. Bill Dietz (2012), 218–223, 221 [second italics added].

To this question, Amacher answered "yes" many times over. A sound's inner life, in other words, involves both its frequency structures as well as the acoustical wishes and desires they can protract in the subjunctive. *Adjacencies* spatial drama materializes at this threshold. Players' listening moves inside shimmering frequency structures; those structures move into the subjunctive where they shimmer with as-yet-inaudible nuances; a partly unreal spectral drama of dimensions and melodies moves through a listener so that it becomes hard to tell what is inside, outside, or both at once. Rather than restore life to a sound, this drama locates it elsewhere in a shimmer that couples imagination with emergent entanglements between listening, bodies and spaces in the alterity of the acoustic.

In November 1966, reviewers invoked patrilineal reference points that contextualized *Adjacencies* amid twentieth-century modernist precedents with notable ambivalence.[47] Longtime *Village Voice* classical music critic Leighton Kerner delivered an appreciative review that nonetheless described *Adjacencies* as though it simply had been Edgard Varèse's *Ionisation*. Drawing on the language of speed, planes, and angles that characterizes Varèse's writings on sound masses, Kerner described "great tensions built up from accumulations, contrasts" as well as "timbres and sophisticatedly complex rhythms [with] natural instrumental sound [...]" at the center of a mechanical sound spectrum."[48] This canonic touchstone lent credence to Kerner's emphasis on unbroken bombast and articulated rhythms but misleadingly attached, to *Adjacencies*, the dry sonorities and controlled resonances of *Ionisation*'s instrumental subgroups, leaving aside Amacher's meticulous attention to protracted decay and resonance qua "melody."[49] While Kerner tucked the piece under Varèse's long shadow, *Buffalo Evening News* music critic John Dwyer cast *Adjacencies* as a friendly, feminized outlier. Dwyer used his platform at the *Evening News* to build public support for the Creative Associates in 1963 and covered their work comprehensively thereafter.[50] He wrote in a colloquial tone that

[47] Interview with Frank Oteri, "Extremities: Maryanne Amacher," *New Music Box*, May 1, 2004, https://nmbx.newmusicusa.org/extremities-maryanne-amacher-in-conversation-with-frank-j-oteri/, accessed September 7, 2019.

[48] Leighton Kerner, "Contemporary Series," *Village Voice*, November 17, 1966. Included in Amacher's 1970s CV as submitted with press materials to the MCA Chicago in advance of *City-Links, Chicago 1974* and *Everything-in-Air*, two installation-performances that were part of the *City-Links* series in May 1974.

[49] Steven Schick, *The Percussionist's Art: Same Bed, Different Dreams* (Rochester, NY: University of Rochester Press, 2006), 37–52.

[50] For an example, please see John Dwyer, "Nation Comes to Know Buffalo as a City of Musical Foment," *Buffalo Evening News*, January 26, 1966. "There will be young professional musicians—performers, scholars, educators and composers. They will design and present concerts, hold forums and panels on new trends, seek to bring the community at large into the music picture and special cultural 'cadres' or lecture/performance terms, for visits to area school," he wrote. "The development has national significance and it is most heartening to The University and to the Buffalo Philharmonic that a deciding factor in awarding this rich grant for Buffalo was the growing artistic climate of Western New York."

acknowledged potential skepticism but encouraged readers to embrace the CAs as dynamic hometown fixtures nonetheless. Under the title "Far Out Crowd Is Back In, With (Yes) Lovely Effect," his remarks on *Adjacencies* were no exception.[51] He narrated an in-progress rehearsal whose mise-en-scène prepared readers for the clangorous sound worlds that dominated Kerner's account: heavy metal gas tanks are dragged on stage while tam tams and harps stand at the ready.[52] But his description delivers something quite different. It emphasized delicate dynamics shadings, "fine structurations of frequency" and counted "subtle hammering" and "felicitous bowing" among the low-impact techniques that made *Adjacencies* so welcoming—even solicitous. As much enchanted by the piece as by Amacher herself, Dwyer concludes with an unambiguously gendered summary: "It was rather sweet," he wrote, "that's right, rather sweet."[53] Complex or felicitous, tense or tepid, these reviews would have *Adjacencies* either prop up an earlier Euro-American modernism, or become its gendered variant.[54]

But there are also other versions. A sound that "shimmers inside" asks anew about how spectral complexes become meeting places for figurations of life in a sound, not least those that propped up the insurrectionary percussive charge that Kerner invoked in his *Adjacencies* review. Percussion ensembles, in particular, court elemental figurations that cast spectral attention as an atavistic return to raw material like minerals (cymbals, bells, tam tam), plants (marimba, woodblocks), animals (drums).[55] At the same time, this attention also encloses ambiguities that merge historical and cultural organologies with nascent vitalisms in unnerving ways.[56] Reckoning these interrelations through aural and affective experience, in

[51] John Dwyer, "Far-out Crowd Is Back In, With (Yes) Lovely Effect," *Buffalo Evening News*, November 7, 1966. Williams described CA's audiences as young and adventurous and stated with certainty that *Adjacencies* would have appealed to them. Interview with the author, August 17, 2017.

[52] For an engaging account of the administrative drama involved in gathering instruments and materials for *Adjacencies*, see Renée Levine Packer, *This Life in Sounds: Evenings for New Music in Buffalo* (Berkeley: University of California Press, 2010), 64.

[53] Dwyer, "Far-out Crowd."

[54] For her part, Amacher spoke admiringly of Varèse (see Oteri 2004) though she also did not mention *Adjacencies*, the *Space Notebook* or compare her work to his by name.

[55] One might also recall the bells and tongs through which, for the late Jean-Phillipe Rameau, the *corps sonore* spoke through human voices, musical instruments, animal sounds, and inanimate objects alike. See Jairo Moreno, *Musical Representation, Subjects and Objects in the Construction of Musical Thought in Zarlino, Descarts, Rameau and Weber* (Bloomington: Indiana University Press, 2004). See also Daniel Chua, *Absolute Music and the Construction of Meaning* (Cambridge: Cambridge University Press, 1999), 98–104 and Thomas Christensen, *Rameau and Musical Thought in the Enlightenment* (Cambridge: Cambridge University Press, 1993).

[56] See Schick's observations on rhythmic language as well as bongo and bass drum idioms in *Ionisation* in *Different Dreams*, 41, also 6–9. In *The Rite of Spring*, for example, an alternative technique on the tam tam provides shrieks and screams during "The Glorification of the Chosen One," which requires scraping metal implements in a circle along the instrument's inside lip. Siglind Bruhn, *Messaien's Explorations of Love and Death: Musico-Poetic Signification in the "Tristan Trilogy" and Three Related Song Cycles* (Hillsdale, NY: Pendragon, 2008), 232. John Tresch and Emily I. Dolan, "Toward

other words, also collides with "division[s] of materiality organized and practiced as a biopolitical tools of governance," as Katherine Yusoff suggests.[57] How might spectral figurations retrench or contest these divisions? This question asks after what sort of things a musical repertoire materializes as more or less hospitable to speculation about life in a sound. These attenuations, Elizabeth Povinelli explains, transpose biological concepts like metabolism, exhaustion, birth, growth, reproduction, and death into "ontological concepts such as the event."[58] Although "biology and ontology do not operate in the same discursive field," she clarifies, an ontology or a materialism that remains "dominated by Life and the desires of Life"[59] reinforces "meeting place[s] where each can exchange conceptual intensities, thrills, wonders, anxieties, perhaps terrors, of the other of Life."[60] This meeting place she calls "The Carbon Imaginary" in order to capture how its exchanges regularize human, ecological, and geological relationships and to point up how a classical Foucauldian biopolitics cannot reckon Nonlife as its historical or analytic threshold.[61] Put a little differently, questions about life in a sound ask, critically, how connective logics and transits articulate "where life was, is not now, but could be if knowledge, techniques, and resources were properly managed."[62] Music can be one such meeting place where sounds can seem to gain or lose a kind of life in ways that become sensible and dramatic in relation to constitutive frameworks. These determinants, Povinelli calls "governing ghosts." Freighted with mediations between sound and life in these late 1960s instances, spectral complexity is perhaps one such apparition. After Povinelli, one might ask: what exists between life in a sound and its otherwise?

To Dwyer and Kerner's references, this section adds two 1960s comparisons that dramatize spectrality and subjunctivity in *Adjacencies*: Karlheinz Stockhausen's *Mikrophonie I* (1964) and Anthony Braxton's *Composition No. 9 for Amplified Shoveller Quartet* (1969). The three works share many features: graphic notational strategies, open-ended construction, and spontaneous approaches to real-time listening, amplified metals, and theatrical dramaturgy. According to Robin Maconie, *Mikrophonie I* took up challenges that had plagued Stockhausen in

a New Organology: Instruments of Music and Science," *Osiris* 28, no. 1, Music, Sound, and the Laboratory from 1750–1980 (January 2013): 278–98.

[57] Katherine Yusoff, *A Billion Black Anthropocenes or None* (Minneapolis: University of Minnesota Press, 2016), 5. There, she explains how divisions between the human and the inhuman work through geological knowledge and resource extraction that render notions of nonbeing through an "indifferent register of matter" that double reference points for racialization.

[58] Povinelli, *Geontologies*, 17.

[59] Ibid., 17.

[60] Ibid., 17.

[61] Ibid, 16; see 14–15 for Povinelli's discussion of Life and Nonlife in Foucauldian context.

[62] Ibid, 16.

Kontakte (1958–1960).[63] How to integrate fixed electronic media into a total serial discourse? Because the tape did not share pre-compositional procedures with the piano and percussion music, their relation lacked an integral basis and because magnetic tape foreclosed real-time manipulation, the two parts brooked little gestural or expressive interaction. *Kontakte* could combine its components but could not embed them into a unified serial discourse.[64] Maconie cast this impasse in sweeping terms: "the absence of a coherent relationship between the parts and whole of serial music remained a challenge to be solved on its own terms."[65]

A solution would have to achieve "significant communication in real time" and become both "theoretically integrated in form [and] aurally integrated in sound." In *Mikrophonie I*, this entailed two material interventions.[66] Stockhausen traded time-consuming work with cut-and-paste tape construction that yielded little more than "static and dead sounds"[67] for hands-on engagement with complex timbres whose drama emerged from how the players manipulated the microphone and tam tam.[68] Cast in moment form, the score consists of thirty-three oversized graphical pages and a connective scheme, labeled with evocative gerunds like "keening," "trumpeting," "grating," and "scraping" that applied a pre-given classificatory scheme to the tam tam's complex spectra.[69] Positioned on both sides of the hammered bronze instrument, one player on each team touches the tam tam with implements while the second follows their movements with a directional microphone and a third operates filters at the mixing desk. Gestural interplay produces amplified shrieks with thin implements and low blooms with soft ones as well as electronic thwacks and squeals when the microphone is jerkily moved in relation to the other player's contact point. Maconie characterized the electroacoustic result as a "totally organized structure" rooted in the "coherent spectral image" of the tam tam itself.[70] Because each event "subtract[ed] individual sounds from precisely the same spectrum," expressive manipulation at last married integral construction and open-ended gesture, Maconie effused. [71] With the

[63] While a mid-1960s Stockhausen eschewed collage-like instrumentation associated with Cage and Varèse, Amacher created a harp-centric spectral milieu in which to explore her own superadditive approach. A complementary analysis could also begin with this negotiation.

[64] Karlheinz Stockhausen, *Stockhausen on Music: Lectures and Interviews*, ed. Robin Maconie (New York: M. Boyars, 1989).

[65] Robin Maconie, "Stockhausen's *Mikrophonie I*: Perception in Action," *Perspectives of New Music* 10, no. 2 (Spring–Summer 1972): 92–101, 97.

[66] Ibid., 101.

[67] Ibid., 100. Maconie's scare quotes recognize that the "dead sound" is, in fact, a figure for a number of sonic and technical features, but at the same time puts life, death, and non-life in sound into underdetermined relation.

[68] Robin Maconie, "Revisiting 'Mikrophonie I,'" *The Musical Times* 152, no. 1914 (Spring 2011): 95–102.

[69] Karlheinz Stockhausen, "Mikrophonie I (1965), für Tamtam, 2 Mikrophone, 2 Filter und Regler," in *Texte zur Musik* (Cologne: Verlag M. DuMont Schauberg: 1971), 3:57–65.

[70] Maconie, "Revisiting," 101.

[71] Ibid., 98 and 100.

tam tam as its raw material, *Mikrophonie I* returned the synthesis of complex tim-
bres to the body, and the body returned complex timbre to integral communica-
tion. Or did it?

An uneasy dramaturgy holds these arrangements together in a twenty-seven-
minute-long performance film from 1966, directed by Sylvain Dhomme and
introduced by Stockhausen. Cinematographer Robert Juilliard creates a visual
style that privileges what Maconie calls the tam tam's "spectral image" but also
grapples with material interventions that do not resolve into abstraction quite
so easily. Typically suspended at the back of the orchestra, the giant disc suggests
exoticist spectacles. Like a rising or setting sun, it courts an epochal gaze that
seems already to have possessed a vast, distant horizon. Exoticist orchestration
has long used its slow-developing wash and long, booming decay to accompany a
superhuman victor's confrontation with gendered and racialized others in a drama
that often ends in death. While Stockhausen did not distance the piece from these
significations, the film also tends not to present the instrument from this van-
tage. Instead, when the stage set is framed in a straightforwardly proscenium-
facing shot, the tam tam is presented from the side and flanked by four players.
The medium shot shown in Fig. 2.11 recurs like a visual refrain throughout the
film, along with a medium high-angle shot that gazes down upon the symmetri-
cal scene from a god-like perspective. Suspended in the center of the frame, the
instrument redoubles the invisible seam along which the on-screen image would
be reflected or folded over onto itself.

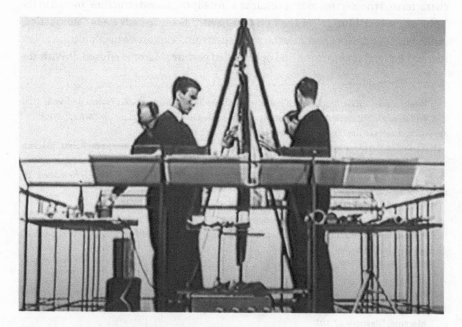

Figure 2.11 Still from *Mikrophonie I* performance film.

The film presents shots in alternating pairs that route the viewer's gaze into and sometimes through the instrument in varied, often jarring ways. In its opening four minutes, the film cuts six times between players' positions on opposite sides of the instrument, a shot-reverse-shot style that typically connects sight-lines between characters that face one another, in the diegesis. This visualizing trick suggests that players actually see each other through the undeniably opaque instrument whose "spectral image" guarantees expressive and formal coherence in their performance. After this pair of medium close-ups, Dhomme introduces Fig. 2.11's proscenium-like medium shot and throughout the film, pairs it with shots that face one side of the tam tam so that the dark bronze disc fills the frame and gives viewers a close look at the moving microphone and implements. In Fig. 2.11, high contrast between the identically dark clad players and the lucent background heightens the visual juxtaposition of the instrument's opaque surface area to its thin edge. Against bright white negative space, the shots that emphasize the tam tam's edge attenuate its stolidity, again suggesting that the metal instrument becomes transparent, to the players on both its sides. While the film undoubtedly celebrates the real-time exploration that Stockhausen and Maconie both valued, in order to do so, it creates audiovisual logics in which the instrument appears intractable in its presence, but also thinned and attenuated by the performance itself. This ambivalent dramaturgy performs the instrument's dissolution into its own spectral image and confronts the underlying conceit that the piece comes not from the instrument, but from the spectrum, as such, in precisely the terms that Maconie had set forth.[72]

To further entrench this gambit, Maconie and Stockhausen appeal to tympanic technologies like the eardrum, stethoscope, and the corrugated aluminum strip inside a ribbon microphone that involve the tam tam in additional figurations.[73] Maconie is especially taken with the microphone analogy and assembles a didactic reading that treats the tam tam as a massive metonym for its own amplification. Stockhausen adds a second tympanic figuration that returns to the performance film's audiovisual play with thinness and attenuation. "I used some of the implements at hand as the mood took me at the time," he writes, "and probed the surface of the tam tam with the microphone as a doctor probes a body with the stethoscope."[74] This post hoc account models the stethoscope's spatial interventions on a body and aligns his composition with "investigative techniques and conceptual tools of rationality" that Jonathan Sterne attributes to its ascendance in late nineteenth-century medical culture.[75] The stethoscope mediates

[72] Ibid.

[73] Ibid., 101.

[74] Ibid.

[75] Jonathan Sterne, *The Audible Past: Cultural Origins of Sound Reproduction* (Durham, NC: Duke University Press, 2003), 128.

between the ear and inner body and establishes a surface upon which they meet in the aural. "Coupling internal causes and external effects on the body's surface remakes it as a different kind of space"—a flat and thin plane upon which clinical knowledge can be made to seem self-evident.[76] Bringing a body's interior mass "into the concrete space of perception"[77] also subtracts out its dimensions, densities, and depths.[78] In addition to acting upon a so-called body, Stockhausen's analogy performs precisely the unmitigated access to spectral depth upon which the piece's claim to communicative coherence also rests. Amid these spatial transformations in medical culture, Michel Foucault summarizes, "the ideal configuration of the disease becomes a concrete, free form, totalized at last in a motionless, simultaneous picture, lacking both density and secrecy, where recognition opens of itself onto the order of essences."[79] These remarks prove apt for *Mikrophonie I*'s "spectral image." Consider how the film maximizes the tam tam's intractable material (and indexical relation to difference) while, at the same time, applying cinematographic techniques that attenuate, even dissolve it. It is not only the case that in order to establish spectral coherence, the tam tam must also be tolerated as a necessary disturbance. Rather, its sound must also itself be made totalized, concrete, and fully accessible without remainder. No ongoing subjunctive, this is spectral listening "in the order of essences."

Against this backdrop, I highlight, in Anthony Braxton's *Composition No. 9*, two related and entwined critical questions: One: how do avant-garde figurations of life in a sound also delimit the social and material arrangements that can host them?; and two: what auditory thresholds do those limitations establish or enforce? Braxton's instructions outline an audiovisual scenario that resonates with *Mikrophonie I*'s theatrical presentation on film. An eleven-page-long graphic score tells four performers how to lift and drop pieces of coal from piles placed on the performance area with shovels outfitted with contact microphones to amplify their metal blades. If possible, Braxton notes, the audience should see the coal delivered and, after the performance, driven away. The scene should be well lit and the performers were to dress in identical work clothes, like the coveralls and hats sketched in his *Composition Notes, Volume A*. Within this theatrical set, Braxton instructs performers in how they should manipulate the coal and shovels, specifying how much coal should spill over its side, how deeply into the pile to dig, how to let coal fall to the ground, and so on.[80]

[76] Michel Foucault, *The Birth of the Clinic: An Archaeology of Medical Perception*, trans. A. M. Sheridan Smith (New York: Random House, 1994), xiii. Clinical knowledge does not just localize internal causes; it also brings those causes into alignment with their external effects.

[77] Ibid., 9.

[78] Ibid.

[79] Ibid.

[80] I grateful to Katherine Young for bringing this piece to my attention around 2006, when she was studying with Anthony Braxton at Wesleyan University. Unpublished performance notes. See also Anthony Braxton, *Composition Notes, Vol. A* (Lebanon, NH: Frog Peak Music, 2009).

The circle size tells how deep to shovel (how much to take in) notation inside the circle tell what method of manipulation is required to get particular kind of sound (i.e.—like pouring the coal, or shaking). The actually shoveling time for each event is determined by the performer. Once set, it remains constant throughout the sections (each section can be adjusted according to the speed and strength of the players).

Instructions continue, enumerating actions, such as:

pour out coal; put back coal; spray coal; shovel out coal; toss out coal; don't come out with coal (just bring shovel in hand for sound and slide out as quietly as possible); double bars between circles mean sliding shovel over coal (the wider the circle the louder the sound).

at the end of the piece, the performers are free to improvise in any area as long as it is discussed beforehand and worked out.

a concrete or steel plate will be needed for the performers to scrape their shovel on.[81]

There's something sardonic and even perverse about an avant-garde scene that centers as its acoustic material a resource that had demarcated social abandonment, environmental devastation, and brutal labor conditions throughout the twentieth century.[82] But as a paradigmatic exemplar in what Povinelli calls The Carbon Imaginary, *No. 9* seems also already in on the joke: such stagings—like *Mikrophonie I*'s—are already biopolitical articulations about where life can and cannot be, given how "knowledge, techniques and resources" are managed within constitutive frameworks. Staging the delivery of the coal invokes vast circulation networks that move fuel between social spaces of exhaustion and thriving.[83] The uniformed players are not *Mikrophonie I*'s decorous, white professionals in pursuit of spectral knowledge but instead suggest a fuzzier individuation often associated with repetitive work and a surplus labor force. However, *No. 9*'s material arrangements do critically redouble Maconie's integral standards; their coherent spectral image materializes not in suspended metal, but in piles on the floor, from which audible events are "subtracted out" by the shovelful and remain, nonetheless, "theoretically integrated in form [and] aurally integrated in sound." However, Braxton dares this integrity to be dismissed on spurious grounds. "What about the integral form of *these* sounds?," the intervention seems to ask. While this

[81] Ibid.

[82] Yusoff, *A Billion Black Anthropocenes or None*, 5.

[83] For a detailed account of sectoral displacements and the coal industry in the mid-century United States and the Midwest in particular, see Gregory S. Wilson, "Deindustrialization, Poverty and Federal Area Redevelopment in the United States, 1945–1965," in *Beyond the Ruins: The Meanings of Deindustrialization*, ed. Jefferson Cowie and Joseph Heathcott (Ithaca, NY: Cornell University, 2003).

hypothetical query performs *No. 9*'s racialized distance from classical centers of electronic music research and avant-garde experimentation, it also counters *Mikrophonie I*'s figurations move for move: instead of hammered metal, unresonant rocks; instead of a white room, a stylized delivery that disrespects the proscenium; instead of evanescing flatness, an implacable floor-centric dramaturgy; instead of scalable and motionless totalities, proliferating sounds that can be tracked in lumps and piles; instead of clinical enclosures, figurations of extraction and circulation.[84] Braxton stages a claim on spectral integrity that refuses to break with a material heterogeneity that arrays across a field of meanings and values. *No. 9* also demonstrates what researchers like Tara Rodgers and Brian Kane argued much later: claims to life in a sound materialize in historical spaces of biopolitics that regulate how vitality can move between bodies and materials. Through this, *Adjacencies* charts a difficult path. Its subjunctivity marks an alterity in the acoustic that *Mikrophonie I* stringently barred but that *No. 9* tested using materials that cited exclusionary logics in spectral exploration as such. By 1969, Amacher had already begun to move subjunctivity as a kind of life in a sound into other conceptual, social, and technical meeting spaces.

Here (—ish): Another Tape and *City-Links, WBFO Buffalo, 1967*

The harps that had hosted the spectral heterogeneity of *Adjacencies* proved central to what else the piece might become relative to the sonic terrains of sociality that could shimmer in its negative notation post hoc. On two handwritten pages nestled among typed-out drafts of performance instructions, Amacher reflected on a small audience's responses to a tape piece she had made in Urbana. Her frustration is evident. "I may do some hasty things," her note to herself begins, "[to] the tape I played in Smith Hall in the spring."[85]

> There were around 15 people there, all musicians and composers concerned with the making of polite silences. I did not announce what this tape was a part of or where it occurred in the piece.
>
> After a time of many changes, you are here where you have never been before, voices change, singing as if time were endless, a very simple figure, strong verticality . . . on instruments—percussion—etc.
>
> This is the universe to me and a first attempt after two years of searching, of celebrating it. And to reveal it to those who do not hear beyond their neighbor's musicianship.

[84] The fact that *No. 9* has not been programmed once by this time of writing performs the continued relevance of its questions.

[85] Maryanne Amacher, undated working notes, Courtesy of the Maryanne Amacher Foundation. "In the Spring" likely refers to the spring of 1966.

[Handwritten in the margin:] I also hold them responsible for the situation of our not getting anywhere. To reveal only one of the elements or about the element of what it was a part they would never imagine. They have never even dreamed that far even to the point of choosing an element. Why should I bother to tell them that it was an element.[86]

Amacher revealed to the audience that what she played was part of something larger, but seems to have said little more. Seemingly unnerved by its fragmentary status, listeners fixated on structure and coherence. Without an account of whatever logics governed its hypothetical part-to-whole construction, the tape's sound world became inscrutable, even irrelevant. It seemed as though listeners did not even experience it. To that end, Amacher's middle paragraph stands out. In the margin, she gives this section an emphatic blue bracket, suggesting that it could be excerpted or elaborated in another bit of writing. Her change in tone is hard to miss: in a performative second-person mode of address, Amacher describes what the tape's sound world *should* have made happen. "You" should be moved so deeply into your implicit situation, as a listener, that something of that situation begins to break apart. Becoming fascinated with "time of many changes," also refers a listener elsewhere—all at once, "you are here where you never have been." "This," Amacher adds, "is the universe to me."[87]

Amacher's tape piece was called *Here*. It was an outcome of the weekend she had coyly related to her parents, in the hard-to-access harp studio with a tape machine. With layers of mono sources, extreme manipulation of tape speed infused quaking spectral masses with rich, stereophonic effects. Frequency structures surge from tremolandi and glissandi that traverse the harp's entire register. The effect is a more-or-less evenly paced ovaloid rotation through alternately brighter and more covered spectral regions. The "very simple figure" that Amacher described in her post-concert reflection is a resonant falling fifth that recurs throughout. Repeated at the octave with a balanced short-long, short-long pulsation, this singable gesture slingshots across the tape's viscous texture. While traditional structures of anticipation tag along with this intervallic reference, it also offers a stable, open frame that many spectral micro-melodies begin to occupy. What "hasty" things she imagined doing with this tape, it remains, for now, hard to know.

Though *Here* did not replicate *Adjacencies*' blocky frequency structures, Amacher called upon it to support the piece's pedagogy of spectral attention in other ways. In a typewritten note affixed to the 1976 tape case that appears in Fig. 2.12, she frames the tape in heuristic terms with no reference to its earlier, more freestanding or work-like title. In lieu of a "suitable recording" of *Adjacencies* in its entirety, Amacher presents *Here* as its model, for future performers. "In both compositions," she wrote, "the music demonstrated the kind of melodic

[86] Ibid.
[87] Ibid.

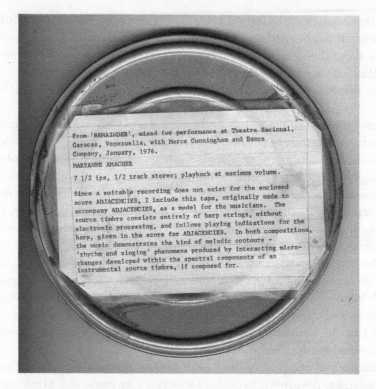

From 'REMAINDER', mixed for performance at Theatre Nacional, Caracas, Venezuelia, with Merce Cunningham and Dance Company, January, 1976.

MARYANNE AMACHER

7 1/2 ips, 1/2 track stereo; playback at maximum volume.

Since a suitable recording does not exist for the enclosed score ADJACENCIES, I include this tape, originally made to accompany ADJACENCIES, as a model for the musicians. The source timbre consists entirely of harp strings, without electronic processing, and follows playing indications for the harp, given in the score for ADJACENCIES. In both compositions, the music demonstrates the kind of melodic contours - 'rhythm and singing' phenomena produced by interacting micro-changes developed within the spectral components of an instrumental source timbre, if composed for.

Figure 2.12 Typewritten tape canister label that explains how and why performers should use the tape as a "model" for playing and listening, in *Adjacencies*. (Label also lists Amacher's *Remainder*, discussed in Chapter 5.) Courtesy of the Maryanne Amacher Foundation.

contours—'rhythm and singing' phenomena—produced by interacting micro-changes developed within the spectral components of an instrumental source timbre, if composed for."

The tape demonstrates what it would be like to listen into a spectral band's deep interior to experience where and how it could "shimmer." A spectrogram shows, for example, how frequency ranges cohere and disperse, creating precisely the "micro-changes" for which Amacher hoped her players would listen.

Perhaps more striking are working notes that conjoin *Here*'s nascent transports with *Adjacencies* subjunctivity and the *Space Notebook*'s technical details. Two draft paragraphs appear on a single page and build on an identical topic sentence to explore how these three projects could, together, move "worlds of sound" across distance in unexpected ways.

The spatial (multi-dimensional) sound basis for making *Audjoins* is given technically in the Space Notebook. It is a way of receiving and creating change. Paralleling the mind in such moments. It is wind and warmth of summer appearing in the middle of winter. Still appearing in the midst of Joy. Australian music brightening the energy of our awareness.

The spatial (multi-dimensional) sound basis for making *Audjoins* is given technically in the Space and Timbre Notebooks and is available for any musicmaking. The works I include are simply a model for this kind of change between different worlds of sound I have made. Ideally it would happen with the music of other men and women.[88]

Recall the techniques that Amacher employed to create shape and room-like transformations in the *Space Notebook*. As exchanges between "locality-and-dimensional-differentiation" multiply across the quadraphonic square, its vertex-based geometry begins to host worlds of sounds, places, affects, and seasonal shadings that stream in from vast distances. Now theorizing *Adjacencies* and its companionate notebook as such, Amacher reveals that their spatial instructions always already enclosed a broader concern with social distanciations across which other musics could be moved toward or away from one another, as had Amacher's own. More here-ish and there-ish than either "here" or "there," *Here* suggested new channels through which other worlds of sound could commingle.

At 8 p.m. on Friday, May 26, 1967, Amacher commenced *City-Links, WBFO Buffalo* on 88.7 FM, WBFO Buffalo Public Radio. For the next twenty-eight hours, she mixed eight live feeds from remote locations in the city and wove into the mix pre-recorded sounds from her tape collection *Life Time and Its Music*, with *Here* prominent among them. In the May 1967 WBFO program booklet, Amacher characterized the broadcast as one instance in a burgeoning—and potentially quite expansive—working method rooted in city environments. "CITY-LINKS broadcast version appears as a part of the composer's 'In City No. 1,'" she explained "a scheme proposed in terms of collaborative composition for relating a network of events celebrating the resources of the city." These titles warrant some untangling. At this early point, the "scheme" she called "In City, No. 1" included both the long-form broadcast *City-Links, WBFO, Buffalo* and the festival-like *In City, Buffalo, 1967* that Amacher coordinated between October 20 and 22, across print media, TV, and radio as well as photography and sculpture exhibitions, storefront installations, cloud projections, group painting, and other participatory activities. Though she used numbers and subtitles to distinguish subsequent *City-Links* installments in the mid-1970s, this early description suggests a nascent *In City* series that would group transmission works together with civic events whose connective logics cohered in situ. While Amacher referred to the broadcast variably as "City-Links WBFO Buffalo," "City-Links," and "City-Links No. 1" in the late 1960s, I will henceforth use *City-Links WBFO* to emphasizes its 1967 context and sometimes simply *City-Links*, in this chapter, to mark its singularity, at the time. Complex histories emerge when the spatial and subjunctive transports

[88] Maryanne Amacher, *Adjacencies*, undated working notes.

that characterize *Here*, *Adjacencies*, and the *Space Notebook* move into "the FLOW of experience in the living environment" as Amacher later described these 1967 projects.[89]

Quite a lot went on in Buffalo, during the weekend that Amacher broadcast *City-Links WBFO*. "This is the week-end during which the city and University celebrate commencement and the inauguration of President Meyerson," the program booklet explained. Urban planner and former dean at UC Berkeley Martin Meyerson had begun his tenure as SUNY Buffalo president in fall 1966 during fraught stages in plans for campus expansion that intersected with long-standing disputes about ideologies of redevelopment in downtown Buffalo. Amacher's remote feeds conjoined sites poised, at the time, for contestation, which included Bethlehem Steel, Pillsbury Flour Machines, Hengerer's Department Store, the Greater Buffalo International Airport, the Niagara Mohawk Power Plant, Main Street, and areas around the Erie Canal. However, the WBFO program booklet did not list these, leaving it to listeners to follow the broadcast through the city for themselves.[90] In one sense, a listening that moved through Buffalo's urban core, its suburban developments, and industrial concentrations in spring 1967 would catch market capitalism, infrastructural change, and social abandonment in overlapped dislocations and stages. In another sense, that listening would also access the sites through a mediatic event—Amacher's mix—that performed their interrelated implications on emphatically spectral terms that, like *Adjacencies*, attached complex affects to their subjunctivity. The point, in other words, was not so much that the feeds converged at the station but that Amacher's broadcast would return, to the city, a version of itself in a detailed, dynamic mix.

To this end, Amacher cast the city in an anticipatory posture: "I hear the city waiting," she mused in a detailed note in the WBFO program guide. Subjunctivity again innervates sonic terrain: waiting for what? " . . . to be celebrated in the joy of its resources," Amacher continued, "it [the city] waits to be acknowledged." Like the "shimmer" inside *Adjacencies* spectral bands, this joy moves deeply into whatever material, social, and technical mediations might carry the strange time of waiting toward audibility.

> This month WBFO combines two resources of everyday availability, the city and radio, to create a resource of joy . . . The always available tuning-in-whenever-you-want character of broadcasting appears in this scheme as a link-circle surrounding the many discrete, interruptible events within the city. Who can interrupt broadcasting—a

[89] Maryanne Amacher, "In City, Buffalo 1967," in *Supreme Connections Reader*, 52.

[90] However, local press did report on the microphone locations. In his review "27 Hours of Sounds—A Unique Experience" in the *Buffalo Courier Express*, J. Don Schlaerth quoted Amacher stating that "It's very beautiful to hear the changing patterns of the sound world. There's a complexity outside your imagination."

non-discrete, continuous presence in the city—there like the weather—
whether we open or shut our windows, look or do not look, it is there
[. . .] yielding its own special kind of listening, in the process of inter-
acting, of evolving a course, the tuning in constantly [. . .] Tuning in
to WBFO is like tuning in to the weather, seeing what it is doing now—
seeing slight and bigger changes as forming its course.[91]

What Amacher called a "link-circle" catches two processes at work. The broad-
cast demonstrates that its sites are always already also one another's auditory
contexts. Rather than characterize these contextual entanglements as inaudible
under most circumstances, Amacher instead imagined that they await each other
and commingle in the subjunctive. But more than affective embellishment, this
joy was, in very practical ways, *City-Links WBFO*'s organizational principle, which
she called "evolving a course." Hearing any single site in *City-Links* means also
having heard it opened to another and moved between the hypothetical subjunc-
tive and the audible present. While the joy she references does not belong to a
specific outcome per se, it overflows to suggest an auditory, social, and ethical
relation to how the city could be imagined to wait for itself.[92] This double stress
on waiting narrates the city in a tricky sort of social time that emphasizes both
the subjunctive and a progressive past tense in which something could be left
incomplete or undone.

May 1967 had marked the endpoint of debates that freighted downtown loca-
tions with contradictory meanings and implicated the university in fraught dis-
courses on infrastructural change. Top-down expansionist imperatives had been
at work in the state university system since 1960, after Buffalo's steel and manu-
facturing industries, like many wartime producers, began a steady decline in the
1950s. Founded in 1865 as a small private school, the University at Buffalo was
converted into a public university and designated by Governor Nelson Rockefeller
in 1961 as one of the expanded state system's "graduate centers," vaunted in boost-
erish terms as "the Berkeley of the East" for its massive English and Philosophy
Departments.[93] In 1963, the Governor called upon the New York State Office of
Planning Coordination to research locations to build a second, larger campus that
would be designed in his favored master-builder model.[94] The report evaluated
a site at Buffalo's downtown waterfront against a larger tract in the northwest

[91] Maryanne Amacher, untitled program essay published in the May 1967 WBFO Program Guide.

[92] This description builds on Jean-Luc Nancy's theorization. See Jean-Luc Nancy, *The Inoperative Community*, trans. Peter Connor, Lisa Garbus, Michael Holland, and Simona Sawhney (Minneapolis: University of Minnesota Press, 1991), 78.

[93] Carol Kino, "Renaissance in an Industrial Shadow," *New York Times*, May 2, 2012, http://www.nyti mes.com/2012/05/06/arts/design/buffalo-avant-garde-art-scene-revisited-at-albright-knox.html, accessed December 23, 2017. See also Mark Goldman, *City on the Edge: Buffalo New York, 1900–Present* (New York: Prometheus Books, 2007), 232.

[94] Godman, *City*, 228.

suburb of Amherst.[95] Although the trustees voted unanimously in favor of the Amherst site in 1964, activists excoriated the insular move, which would accelerate infrastructural abandonment and immure the well-resourced public university in a remote suburb inaccessible by public transportation. As historian Mark Goldman chronicles, amid an "atmosphere of dissent," agitation for the downtown campus between 1964 and 1967 was spearheaded by the Committee for an Urban Campus (CURB), a coalition of Black political and social organizations as well as a virtually all downtown businesses chaired by African American architect and urban planner Robert Traynham Coles.[96] After graduate study with Charles Abrams at MIT, Coles returned to Buffalo in 1961 and rebuked massive in-progress demolition projects, executed with alacrity under the auspices of architect Milton Milstein and modeled after Pittsburgh's Allegheny Conference for Community Development, which privileged commuters and accelerated suburbanization by hollowing out an otherwise walkable urban core, especially for east and southwest neighborhoods and the Ellicott District, whose Black residents had been especially impacted by 1960s demolition projects.[97] In his Master's thesis, Coles anticipated that private involvement in housing development, in the Ellicott District, would increase density, while, at the same time, making changes to the downtown street grid that would attenuate mobility and access.[98] "The system of radial streets converging upon the central business district has also been detrimental to this area" he wrote, "[and] these broad, heavily traveled arteries have sliced the community into a number of unrelated and unsafe sections."[99] The thesis assembled an alternative plan, balancing high-rise housing with street-level land use that prioritized park space, recreation, and community facilities.[100] Although, by 1967, Bethlehem Steel remained the region's largest employer, a federal case against the Lackawanna Plant exposed long-standing patterns of racial discrimination; the case found that Bethlehem Steel and the United Autoworkers marginalized African American workers to undesirable jobs, especially amid peak periods of migration during the 1910s and, later, during wartime production.[101]

[95] Ibid., 242.

[96] Ibid., 240.

[97] Ibid., 190. Established in 1943, the Allegheny Conference drove postwar development in Pittsburgh and initiated massive infrastructural change during the early 1960s, which included arterial highways that crosscut the city and downtown riverfront as well as office tower construction and a massive amphitheater arena that razed that Lower Hill District and separated the once-walkable Upper Hill District from the city's downtown core.

[98] Robert Traynham Coles, "Community Facilities in a Redevelopment Area: A Study and Proposal for the Ellicott District in Buffalo New York" (MA thesis, Massachusetts Institute of Technology, 1955), 30–32.

[99] Ibid., 38.

[100] Ibid., 38.

[101] Neil Kraus, *Race, Neighborhoods, and Community Power: Buffalo Politics, 1934–1997* (Albany: SUNY University Press, 2000), 39–41. For a trenchant account of post-war urban development that nurtured new consumption patterns—organized by mortgages in tandem with consumer and college

New construction on the airport-bound Kensington Expressway sliced through the neighborhood and further entrenched segregation on the city's east and south sides. "Why not give Lafayette Square back to the pedestrians?" Coles wrote in a 1963 critique of proposals to replace the Square's layout with a rectangular grid that obstructed pedestrian access in favor of a so-called modern approach to traffic circulation downtown.[102]

"What is being done in the city is the building of empty monuments," Coles stated in remarks at the conference "Designs on Waterfront" organized by seven New York universities with an entire panel devoted to Buffalo waterfront development, in November 1966.[103] In 1960, the Manufacturers and Traders Trust Company purchased an entire block on the east side of Main Street to build the new M&T Building, a twenty-one story office tower designed by Minoru Yamasaki and overseen by local architects Duane Lyman and Associates.[104] Three more banking institutions followed suit, constructing what Goldman describes as a "large rectangular superblock" with retail locations, new offices, an enclosed park, and underground parking. These modernist slabs were the "empty monuments" against which Coles posed the downtown campus as a bulwark. It would be a social antidote and alternative vision for the city's urban core that kept social educational goals within reach of walkable neighborhoods on the east and southwest sides. "The university is tied to the city," Coles explained, "and an urban university can raise the level of living in the city as never before."[105] When Meyerson's appointment was announced in spring 1966 "the tilt toward a waterfront university appeared to be gaining support," Goldman writes and "everyone assumed that the city planner and former dean of the College of Environmental Design at UC Berkeley would support the waterfront campus."[106] However, a subsequent study found that faculty, staff, and alumni overwhelmingly supported a move to Amherst that dovetailed with white post-war suburbanization more generally.[107] As Coles witheringly summarized, "the study seems to be based on narrow educational goals rather than broad social educational goals which take into account the urban crisis that we are facing today."[108] *City-Links WBFO* and *In City* wove

debt—and accelerated suburbanization as an alternative to redistribution, see Neil Smith, *The New Urban Frontier: Gentrification and the Revanchist City* (New York: Routledge, 1996), 92–118.

[102] Cited in Goldman, *Edge*, 189.

[103] Quoted in "'Designs on the Waterfront' is Subject of Conference," November 15, 1966. Universities involved in this event included Cornell, Radcliffe, Bryn Mawr, Barnard, Vassar, Smith, Mt. Holyoke and Wellesley. Coles spoke alongside Erie County Planning Commissioner Ralph M. Barned and Buffalo Redevelopment Director Richard S. Danforth. Only Coles addressed the importance of the university in waterfront development.

[104] Diana Dillaway, *Power Failure: Politics, Patronage and the Economic Future of Buffalo, New York* (New York: Prometheus Books, 2006), 54–55.

[105] Coles, quoted in "Designs."

[106] Goldman, *Edge*, 241.

[107] Ibid.

[108] Coles, quoted in "Designs."

together many of the sites that commanded Coles critical attention and broadcast their soundworlds amid a celebration shaped, that year, by these debates.

WBFO station manager William H. Siemering recalled that Amacher approached him with plans for *City-Links* fully formed and explained that her proposal coincided with a transitional period at the station.[109] WBFO broadcast from downtown Main Street and Siemering had conceptualized his work at the station in relation to its locale, at an early stage. Before Siemering's arrival in 1962, WBFO's programming changed on a semesterly basis depending on the schedules of a small group of interested students. He was hired for a student services position whose scope could include work with the student radio station for an interested candidate with broadcast experience. With a Master's degree in Social Work and experience with media production during his military service, Siemering fit this bill.[110] To get a sense of how WBFO might be reshaped along these lines, Siemering wandered the nearby neighborhood known as the "Fruit Belt" and asked neighbors and passersby what kind of broadcasts they wanted to hear.[111] By 1967, Siemering had established weekly programs, including "Nation within a Nation," focused on Iroquois oral histories, "Talking Painting," which "enabled listeners to 'see' a canvas" as described over the air by an invited artist, and interview-based programs broadcast from a storefront studio helmed by Black residents of the city's east side and from the Main street location. One week after Amacher's twenty-eight-hour broadcast, Siemering had already begun work on a report about the project and wrote to John Cage, enclosing the program book and an original text, to request his comments on its significance. Cage and Amacher had already met in Urbana and, to him, Siemering described *City-Links* as a model for future projects in public radio. "[I]n hopes that other educational radio stations will be inspired to try similar experimental broadcasts, it would be most helpful for this report and other evaluations of the project to have comments from a noted composer such as yourself."[112] Siemering succeeded; later in 1967, he nominated *City-Links* for the Institute for Education by Radio and Television's Ohio State Award in experimental programming, and the station received the award.[113] Although the honor was publicized in both national and regional print sources, Siemering stated that WBFO received practically no responses from listeners after the broadcast aired.[114] This was not unusual, he explained. At the time, WBFO's

[109] Interview with the author, August 22, 2019.

[110] Interview with the author, August 22, 2019.

[111] Interview with the author, August 22, 2019.

[112] Siemering to Cage, May 31, 1967.

[113] Charles Zeldner, "WBFO Receives National Award," *The Spectrum*, February 16, 1968.

[114] Amid cresting student rebellions, in the spring of 1970, the station's profile changed quickly. From February 1970 and after the Kent State shootings through spring recess, WBFO covered a general strike and long-term police occupation in the student union. Coverage took place close-up and "sometimes confrontations broke right below WBFO studios and they were reported as they happened." As one student recalled, "After the Kent State killings, thousands marched down Main Street, protesting the Cambodian invasion. High school students joined in. Buffalo police fired tear gas.

listenership was still quite small and the station received little feedback, making it difficult for Siemering to track reception to the new programs he had established in the previous five years.[115] Announcements about the Ohio State award centered WBFO as much as it did Amacher and located the project in discourse on university and public-school run radio stations (as represented by National Association of Education Broadcasters of which Siemering was a member) and less so in relation to experimental music composition or the sonic arts.[116]

Amacher did not consult Siemering about her choice of sites and told him little about how she came up with the project. He recalled her as serious, forthright, and consumed by ideas—"as though her life was her music," he said.[117] He had never imagined someone using a radio station in this way, but understood immediately that *City-Links* had to be live. During its twenty-eight-hour duration, he awoke in the middle of the night to listen, checking on the sounds of the city. "You might even know the place," he continued, recalling the bells that signaled the changeover of workers' shifts at General Mills and the campus tower chimes, specifically. "Listeners will have a sense of participation," he wrote to Cage, "as they can hear the airplanes taking off [in the broadcast] and moment later hear that same plane over their homes."[118] Tuning in on a car radio, home stereo, or commercial public address systems would feed Amacher's mix back into the city's sound world, where it could be hypothetically transmitted back to WBFO via one

Rocks were hurled through bank windows." WBFO wove together about 140 hours of coverage, which documented "complex, fluid situations" and "conflicting eyewitness reports" as well as institutional responses, like Faculty Senate meetings with live radio commentary. Jack Allen, "University, Radio Station Beacon of Light Amid Strife," *Beacon Courier Express*, April 19, 1970.

[115] Interview with the author, August 22, 2019. When Siemering moved from Buffalo to Philadelphia to join co-founders of National Public Radio, his 1970 mission statement emphasized contemporary artistic work in radio, praising "new artistic usages" and "composition and performances of new work for the medium." William H. Siemering, "National Public Radio Purposes," personal copy shared with the author. Once in Philadelphia, Siemering continued to program participatory and loop-like radio work. This included, for example, an on-air movement class narrated by Mumia Abu-Jamal in which listeners could stretch, pose, and dance in response to broadcast prompts as well as weekly shows in which composers created music in response to images printed in the program books, to which artists responded with additional pictures (and so on). For a complementary account of how Siemering brought work in Buffalo to bear on NPR programming, please see Louise Elizabeth Chernosky, "Voices of New Music on National Public Radio: *Radio Net, RadioVisions* and *Maritime Rites*" (PhD diss., Columbia University, 2012), 26–31.

[116] The award provided a platform for reportage on WBFO's new programming, in general, which yielded a portrait of the station, but less so of Amacher. Indeed, in a 1980 works summary, Amacher underscores that "prize was awarded to the Buffalo FM station WBFO" and not to her, specifically. While Max Neuhaus's *Public Supply* is written about as a "subversion" of the radio format because its continuity could be interrupted by the telephone call, Amacher's WBFO broadcast celebrated radio as continuous and "uninterruptable," often referring to the broadcast as shared "weather" or likening it to "the air we breathe," as she had done in the WBFO booklet.

[117] Interview with the author, August 22, 2019.

[118] Siemering, untitled report, sent to John Cage, May 31, 1967.

or more remote links. Listeners could hear the city "as it slept, as it woke up, as it worked and then slept again."[119] Amacher emphasized broadcast's "non-discreet character and continuous character" and argued that it need not be a "programmable item" or "reporting agent of this city" but should instead be considered, in her words, "an event of the city."[120]

More than a guide or a detached commentary, WBFO's program booklet partook of the project's conceptual terrain, as captured in Fig. 2.13. A series of photographs by university graphic designer Donald Watkins provided visual supports for the broadcast's focus on interaction, subjunctivity, and "evolving a course." From relatable angles, his photographs captured moving scenes that nest obscured components within multiple frames. Consider the photograph on the program booklet's cover. In motion, a bus window both frames and occludes a vertical marquee. Only parts of an adjoining building and the letters "B-U-F-F . . ." make it into this frame-within-a frame; the city appears by name, but only in a fragment. While the large window guides the eye toward the marquee, a smaller, inset rectangular side-view mirror also turns it in the opposite direction, away from the attached building. The image's nested frames work at cross purposes to overlap and embed fractured images in motion. What Amacher called the broadcast's "link-circle" would provide a kind of mediatic weave that brought these fragments together in the subjunctive.

The final thirty minutes of Amacher's broadcast begin with *Here*'s ovaloid shadings.[121] *Here* established a kind of spectral channel through which parallel sound worlds could meet one another and, to this end, Amacher's mix was detailed and dynamic. A jagged fade introduces light chirrs that contrast *Here*'s voracious spectral coverage. Cyclical metallic clunks join low-mid machinic hums; crashes punctuate both, low in the mix. The airport delivers stark crescendi that surge—for dramatic moments—from chunky mids that otherwise masked them. Every minute or two, Amacher returns to the airport feed to add another such event. About fifteen minutes before the broadcast's conclusion, Amacher turns to downtown feeds from Main Street and Hengerer's department store, introducing sirens, car horns, and human voices and another bit of recorded material from the *Life Time* tapes. This addition offers a lumbering, staccato pulsation that skips up and down

[119] Interview with the author, August 22, 2019.

[120] Maryanne Amacher, untitled program essay published in the May 1967 WBFO Program Guide.

[121] John Dwyer, "Gifted Far-Outers Offer Space Tunes, Forceful Duo," *Buffalo Evening News*, December 14, 1967. In this review, Dwyer discusses an evening concert in Baird Hall that featured David Rosenboom's tape-piece "Brandy of the Damned" and a duo-piano work by Victor Grauer, who also created *In City*'s lakeside participatory radio event. Dwyer calls Amacher a "beautiful enchantress" and recalls her work on *In City* as an "epic occasion." Interestingly, this review suggests that Amacher programmed an edit from *City-Links, WBFO* as a self-standing thirty-minute tape piece that combined recordings from the live feeds with pre-recorded sounds. Dwyer wrote, "The excerpt involved a sustained, wide-spaced pedal tone, you might call it, with far too painful a buildup at the amplifier console, but some stretches of hypnotic, delicate variants and the associative nostalgia of the campus tower chimes, striking a long-gone hour."

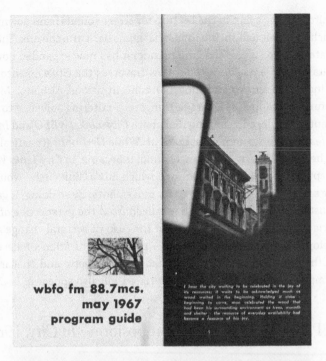

wbfo fm 88.7mcs.
may 1967
program guide

I hear the city waiting to be celebrated in the joy of its resources; it waits to be acknowledged much as wood waited in the beginning. Holding it close beginning to carve, man celebrated the wood that had been his surrounding environment as trees, warmth and shelter - the resource of everyday availability had become a resource of his joy.

Figure 2.13 (a) Cover and (b) inner pages from WBFO program booklet, May 1967. Courtesy of the Maryanne Amacher Foundation.

a minor third, leaving space in the texture for street sounds from downtown sites, while Amacher occasionally bring industrial hums back into the mix. This new connective material also signals that the broadcast has now expanded how it will be "forming its course"—its "link-circle" now traverses the city's downtown core as well as its industrial centers and suburban concentrations. Although Milstein had unsuccessfully attempted to leverage Hengerer's faltering solvency to build support for another enclosed shopping mall, both *City-Links, WBFO* and *In City*, later that year, featured this commercial holdout. While *Here* bore acoustical hallmarks that Amacher associated with life in a sound, it became, in *City-Links WBFO*, precisely the spectral meeting place through which mix's "link-circle" would connect and, at the same time call attention to its movements. By so doing, it gathered up iconic industrial sites that, although idealized from the perspective of high-tech capital societies[122] also poised the city on the cusp of sectoral change and revanchist development amid the university's pending abdication of its downtown core.[123] Both the sites that Coles defended, like Lafayette and Niagara Squares, and the "empty monuments" that he excoriated will also appear in *In City*.

"A Page from a Musical Composition": *In City, 1967*

When readers opened the *Buffalo Evening News* on October 20, 1967, a page from the score of *Adjacencies* would have greeted them above the fold in the arts section, as the complete page in Fig. 2.14 shows. Beneath it was an article announcing *In City, Buffalo 1967* a weekend-long program of concerts, projections, collaborative performances, and sound environments that would take place throughout downtown. By simply seeing *Adjacencies* in the paper, Amacher explained, audiences would actually already be participating in the weekend's coordinated, overlapping experiences—whether reading at home, at the newsstand, or anywhere else.

> When the first edition of the *Buffalo Evening News* appears on the newsstands, readers will discover an art product on one of the inside pages, something they can use as a program but also hang on their walls as a piece of art. As you see, we want to utilize all the media that we can.[124]

This souvenir offered *In City*'s participants what the players of *Adjacencies* had to discover it could become: a heuristic for listening. One might imagine this printed page as a mysterious invitation to weave that exceptional listening into everyday

[122] See Haraway, "Cyborg Manifesto," in *Cyborgs, Simians and Women*, 170.

[123] See Smith, *Frontier*, 51–74.

[124] Terry Doran, "A Psychedelic Week-end of Color, Sound To Turn on Buffalonians to Their 'In City,'" *Buffalo Evening News*, October 20, 1967.

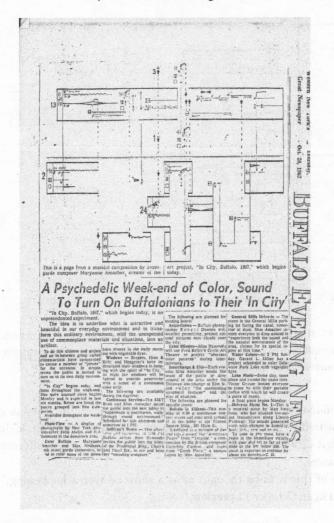

Figure 2.14 Page from *Buffalo Evening News*, October 20, 1967, featuring a "melody"-focused page of *Adjacencies* in draft. Courtesy of the Maryanne Amacher Foundation.

life, especially if later displayed on one's wall, as Amacher suggested. In a separate diagram that did not appear in local press, Amacher used five notational symbols from *Adjacencies* to sketch a schedule for *In City* that emphasized temporal overlap and durational flow. This schedule, shown in Fig. 2.15, eschewed clock time and instead embraced charmingly fuzzy diurnal markers: "once beginning, available for most of the weekend"; "available during afternoon hours"; "available during evening hours"; "made available by communication resources"; and "available for a short time only." This smattering of durational units, Amacher explained, would enable participants to imagine that *In City* occurred as much as in one place as

Figure 2.15 Undated diagram featuring *In City* events. Note that this schedule states that *In City* will take place October 20–24. Local press instead gives the dates October 20–22. Courtesy of the Maryanne Amacher Foundation.

in a continuous circulation that she called "Life Time."[125] The schedule chronicles ongoing activities that would course through the city as a "link-circle" in situ, not unlike what *City-Links WBFO* had done months earlier under different mediatic circumstances.

"None of this is to be thought of as a show or even a happening," Amacher explained in an October 11 preview,

> The idea is not to go someplace at a fixed time to hear or see something. We want to transform the environment people live in into art.[126]

As with *City-Links*, Amacher imagined that people would simply check in with *In City* as they went about their days and evenings.

> For example, early Friday when people are going into the city to work, the gray streets will have been transformed with color, perhaps vegetable dye from the city spray trucks. At the same time, as you are driving, special music becomes available over one of the local stations, thus

[125] Amacher, "In City, Buffalo 1967," in *Supreme Connections Reader*, 52.
[126] Amacher quoted in "Far Out In City, *Buffalo Evening News*, October 18, 1967.

mixing the everyday radio sounds with life around you. Certain uses of broadcasting can be regarded as a lyrical link with the environment.[127]

Amacher approached locations with a soft focus that downplayed punctual events and destinations in favor of non-discrete itineraries. "The public is invited," Amacher writes, "to attend and come especially to this area of the city, e.g. Niagara Lafayette Square, the center city, General Mills, The Ellicott Square Building." Simply come to an area, the diagram suggests.[128]

Or stay home. In the unpublished diagram's upper left corner next to the arrow that denoted *Adjacencies*' *Flutklang* events, the parenthetical "(newsprint 1967)" refers to the half-page reprint that sent the piece's notational plentitude home with *Evening News* readers on October 20. It enumerated at least four additional domestic media insertions that involved TV, radio, and recorded sound. (WBFO covered the weekend with five remote feeds, but it remains unclear whether the TV events occurred.) *Adjacencies* provided these in-home experiences with an evocative audiovisual reference point that wove them into *In City*'s subjunctivity and connective logics. By so doing, this negative notation generated another meeting place for what Amacher had called "worlds of sound," one year prior.

After *City-Links*, according to the *Buffalo Evening News*, Amacher had gotten ahold of the article "2066 and All That," written by Allon Schoener, then-assistant director at the Jewish Museum in Manhattan, and published in the May/April 1966 issue of *Art in America* dedicated to the question "what will artists be doing in fifty or a hundred years?"[129] "The article seemed nearly perfect to her," the *Evening News* reported. In it, Schoener extolled the computer as a creative medium and speculated about a network aesthetics in which "existing systems of electronic communication—telephone, telegraph, radio and television—are unified as an information-utility, all of this computerized information will be available to anyone located anywhere who has access to this information-utility

[127] Ibid. This preview titles the early morning street painting "Color Buffalo" and explains that Amacher and Max Neuhaus planned to paint the streets themselves.

[128] Although perhaps not all events in this graphical diagram took place, note "General Mills Drive-In," a sunset event in which visitors came to watch the sunset over the City Ship Canal accompanied by church bell music. As journalist Lee Coppola described after the fact, "Saturday at dusk, with an estimated 40 persons present, Miss Amacher used the rushing air from parking lot ventilations ducts to create a musical composition at General Mills." Amacher also used five microphones to create another radio broadcast, which is listed on the diagram as also *City-Links*, but does not appear in her subsequent works lists or among later, serialized *City-Links* installments. While Max Neuhaus' *Drive-In Music* remains among *In City*'s better known components, it bears underscoring that the program featured at least one additional vehicle-bound or "drive in"-related event. Local press explained how to interact with Neuhaus's installation. See Terry Doran, "The Avant-Garde Sound: Music to Turn Buffalo On" and "Widely Known Solo Percussionist Composed 'Drive-in Music No. 1' for New Art Project," *Buffalo Evening News*, October 19, 1967.

[129] Quoted in CCA Libraries, "Fifty Years Ago, Fifty Year Forward," https://libraries.cca.edu/news/fifty-years-ago-fifty-years-forward/, accessed August 30, 2020.

system."[130] While Amacher did employ broadcast media in *In City*, the project also approached the built environment as a network all its own, as evidenced in the diagram's attention to the "integrated" components and materials that make up each event; i.e. "COLOR BUFFALO: streets: integrated: *windows, sky, lake, houses*" or "WINDOWS: department stores: integrated: *streets, sky*." Amacher also summarized further,

> There are a number of other pieces being worked on. They will be integrated into the whole network. Briefly, some of them are a sound world in a downtown building, painting a park lake with vegetable coloring, a light show using specific architectural shapes.[131]

For Schoener, such integrated environments could give rise to the utopian figure "citizen-artist," and this hybrid term appears frequently in local press coverage throughout the weekend. "Everyone will contribute to what we now call art and the designation 'artist' will disappear; a new kind of citizen-artist will evolve," the *Evening News* quoted Schoener, "The world," he wrote, "will become a gigantic canvas created by millions of citizen-artists."[132]

In City attempted both interventions. When visitors arrived at Delaware Lake Park on Sunday afternoon, the printed schedule would have primed them to see Gerald L. Miller—educator, playwright, and theater director—paint the lake with vegetable dye. This audience had also been invited to bring portable radios, in order to participate in a collective performance based on changing frequencies and volumes led by UB graduate student Victor Grauer. Instead, visitors were handed cans of spray paint and created collaborative diaphanous paintings on 50' x 20' sheets of translucent plastic, which one reviewer called "rainbows of color."[133] Amacher seems to have appreciated the unscheduled painting party as a "highlight" among Saturday's many events. Yards of plastic bubble wrap were unrolled nearby and visitors created snaps and pops by stomping on the two-foot-wide strips, overwhelming Grauer's radiophonic efforts. On Saturday evening, *In City*'s participating artists sprinkled gold and silver glitter onto the sidewalks between Kleinhans Music Hall and the Circle Art Theater, where sculptor and early EAT contributor Amy Hamouda projected abstract color patterns during intermission. (She also exhibited a work titled *Sounding Sculpture* in the Prudential Building.) The weekend's most concert-like event, which took place in Ellicott Center, was framed as an "empha[sis] on the fine architectural qualities of some of the city's buildings." Another bemused review from John Dwyer

[130] Ibid.

[131] Maryanne Amacher, quoted in "Far Out In City," *Buffalo Evening News*, October 18, 1967.

[132] Amacher quoted in "Far Out In City, *Buffalo Evening News*, October 18, 1967.

[133] Lee Coppola, "250 Delaware Park Audience Improvises with 104 Spray Cans," *Buffalo Evening News*, October 21, 1967.

highlighted this point: "Mostly young visitors to Buffalo [Amacher and the CAs] had discovered this grand, ancient downtown lobby which most Buffalonians take for granted or ignore, and this concert was a tribute to its arts and architecture."[134] The evening involved a display of colored lights and patterned film slides while Jan Williams, Edward Burnham, David Rosenboom, Lynn Newton, Thomas McFaul, and Richard Stanley performed the "American Pages" from recent CA Cornelius Cardew's *Treatise* in the center-lobby while Amacher mixed a tape piece titled "Earth Music" as an interlude.

In City also lavished attention on the sky. Dramatic mediations between atmosphere and infrastructure were to evoke situated intensifications of "the flow we are in everyday." As Amacher put it,

> When darkness begins, the sky begins. The continuous filmstrip in the
> downtown store windows emerges clearly. If there are clouds in the sky,
> we want to project movies and slides onto them. We might even be able
> to create the effect of images of the city in the clouds.[135]

Three downtown department stores—including Hengerer's, which had been a part of *City-Links* earlier that year—redecorated their storefront displays with coordinated colors, lighting, and tableaux vivant. These block-length displays evoked filmstrips. With each window as a kind of frame, passersby could animate the images as they walked, ran, or drove past the store at various speeds. Nighttime cloud projections integrated the sky, windows, and streets. Although Lockport photographer Robert Dawson was slated to project movies and slides into a cloudy sky on Saturday evening, the clear night required a change of plans and Dawson instead projected color and light slides from the roof of the Prudential Building onto the core of Main Place on Saturday and Sunday evenings. Each instance integrated light, color, atmosphere, and cloud play to make create an expressive "link-circle" that conjoined the sky around Main Place, the sky at General Mills, the sky above Hengerer's, and so on.

Like *City-Links WBFO, In City* indeed moved ambivalently through infrastructural change in the city.[136] Though Amacher was billed as its "creator," the *Buffalo Evening News* lists a supporting committee made up of one city councilman at large, three attorneys associated with M&T Bank and Main Place, as well as architect Peter Castle from Duane Lyman and Associates, who would later move

134 John Dwyer, "'In City' Concert Honors Grand Old Architecture," *Buffalo Evening News*, October 21, 1967. See also Terry Doran, "Avant Garde Music is Part of Week-end Art Experiment," *Buffalo Evening News*, October 20, 1967.

135 Maryanne Amacher, quoted in "Far Out In City," *Buffalo Evening News*, October 18, 1967.

136 Additional coverage cast *In City* in emphatically futuristic terms as a "21st Century" experience. Playing up the Mariner-5 spacecraft's rendezvous with the planet Venus on October 19—one day before *In City* began—journalist Terry Doran writes, "So this occasion which is called 'In City, Buffalo 1967,' and may be admired Oct. 20–22, will project our city nearly into the 21st century."

neoclassical fragments from downtown Buffalo to the Amherst site in a 1975 public artwork. Coverage states that Castle, Schapiro, and Miller contributed ideas to the project, although only Miller appears by name in the *Evening News'* October 20 schedule, beneath the *Adjacencies* page.[137] There, Amacher indeed described the project in the first person plural. "We want to create an environment which will produce a total coordinated experience. The three days' experience will model what could become a part of the daily flow of everyday life."[138] Amacher narrates *In City* in the subjunctive. This weekend, she suggests, is a model of something that could, yet, take place. In poetic reflections penned in the early 1970s under the title "In City, Buffalo 1967" with the added subtitle "The Wind in the Garden," Amacher reprises *In City* with a soft focus, lingering on elements that the unpublished diagram lists together as, "integrated." "He sees the lake," one sentence simply reads; "We PLAY them as INSTRUMENTS. Radio, TV, newspapers, department store windows, city streets," lists another.[139] However, in this retrospective write-up, Amacher distanced the project from concrete policy debates or initiatives. "No reform. No purpose," Amacher stated in the middle of a short paragraph— a refusal that also registers the contested and instrumentalized contexts within and against which *In City* took shape.

Conclusion: *Adjacencies* and the Phone Block

Though she broke with concert music after *Adjacencies'* 1966 performances, Amacher did not relinquish the graphical impacts that moved its listening into the subjunctive. One could still wish for sound, after all. Amacher displayed score pages alongside at least two *City-Links* pieces during the 1970s, and included the score with numerous CVs, applications, and press packets—sometimes with little or no explanation. Amacher started receiving sound from Pier 6 at the Boston Harbor in her studio at 40 Massachusetts Avenue on November 7, 1973. Between April 10 and May 11 the following year, Amacher installed a second link that connected her studio-bound line to the Hayden Gallery at MIT to create *Hearing the Space, Day by Day 'Live'*, her contribution to the group show *Interventions in Landscape*, co-curated by Visual Arts Department Chair Wayne Anderson, who taught a seminar by the same name between 1968 and 1977. "At my studio," Amacher explained, "I will be listening and observing patterns occurring in the Pier environment and going about daily activities in the room. I will occasionally

[137] Narratives that emphasize Amacher's so-called charm recur in *City-Links* and *In City* coverage. Consider how another local press account narrates the project's genesis. "The idea for the unprecedented project here is Maryanne Amacher. She also is a composer of the so-called new music and she has charmed the city, prestigious public and private institutions and numerous citizens, artists and a new citizen artists into taking part." Terry Doran, "Widely Known Solo Percussionist Composed 'Drive-in Music No. 1' for New Art Project," *Buffalo Evening News*, October 19, 1967.

[138] Maryanne Amacher, quoted in "Far Out In City," *Buffalo Evening News*, October 18, 1967.

[139] Amacher, "In City, Buffalo 1967."

Figure 2.16 Amacher's *Hearing the Space, Day by Day 'Live'* in the exhibition *Interventions in Landscape* at MIT's Hayden Gallery. From left to right: receiving phone block; equalization charts on which Amacher could log the feed's sound quality and diagonal-focused and melody-focused pages of *Adjacencies*, with added photographs from the Boston Harbor. Courtesy of the Maryanne Amacher Foundation.

be relating what is sounding at the Pier to other patterns of frequency from previously recorded or altered environments, transmitting this in 'live' mix to the Gallery, as well as interrupting the sounding space of the pier with other environmental spaces."[140] At this early stage in the telelink-based series that would occupy Amacher throughout the 1970s, she first referred to *Hearing* as a "version" of *City-Links, Buffalo, 1967* (now renamed without "WBFO" in its subtitle).

Amacher embraced an expository exhibition practice in *Hearing*, as Fig. 2.16 reveals. Phone blocks were attached to the wall; next to them a page-long equalization worksheet and to their right, two large pages from *Adjacencies*. One page was devoted entirely to melody and the other to harp-centric diagonals (in Fig. 2.4, these are Pages B and A). To each, Amacher affixed two photographs from the remote Boston Harbor site: one in negative space on the page, another over spatialization instructions. Five text-filled pages explained that the transmission

[140] Maryanne Amacher, *Hearing the Space, Day by Day, 'Live,'* November 7, 1973—June 7, 1974 (press release).

connected the Pier to her studio and both to the Gallery. In a single sentence fragment, Amacher identified the pages as "first notations of sound for audjoined rooms," repurposing both *Adjacencies* and the earlier, unrealized *Audjoined Suite* to describe remote connections between the Gallery, her studio, and the Harbor as though that had been their purpose, in the first place.

Hearing did connect three rooms: the vacant office at the Pier, Amacher's studio, and the small Gallery. The public-facing texts that she wrote about *Hearing* invited visitors to root the Harbor feed in its architectural circumstances: "a microphone has been installed on the sill of an open window in a completely vacant room at the New England Fish Exchange. The microphone is placed on the Northeast window facing the ocean. It receives sound from the Southeast window, as well." If the *Space Notebook* functioned like a field guide for both constructing and experiencing *Adjacencies'* transforming walls and scrims, *Hearing* arranges those "rooms" across material and social distances with *Adjacencies* as their conceptual and audiovisual jointure. Now radically distanced from its earlier thrall with percussionistic listening, *Adjacencies* provides conceptual support for palimpsested and distant sonic presences. *Hearing*'s close-cropped images aligned with land-art exhibition practices, which relied on models, miniatures, and two-dimensional documentation to capture larger works that embraced random and seemingly natural activities like scattering, piling, and breaking elemental materials. Her photos, too, conjured melancholic sensibilities that encouraged artists to see, in contemporary industrial ruins, one-step connections to distant places or times that could usher an open-ended physical presence into the gallery. In 1995, Lucy Lippard assessed this enterprise as "not entirely successful" in its attempt to return sculpture to "the ground level—to the floor, or the earth—rejecting the pedestal and felling the traditionally anthropomorphic stance of heroic vertical sculpture by identifying with roads and journeys."[141] Perhaps more effectively, Anthony Braxton's *Composition No. 9* had already utilized similar materials and performatives—its amplified coal would do nothing but fall to the ground—to expose enduring logics of exclusion that took root in conceptualizations of acoustic spectra and through avant-garde valuations of life in a sound. Displayed alongside the work of land-art geology buffs like Robert Smithson, Amacher's audiovisual couplet reprises the central question of *Adjacencies*—how sounds receive each other—across a vast weave of social locations and haunted by a semiotics of creative, civic, institutional, and technical work that shaped the 1967 projects in Buffalo. While it is true that the *City-Links* projects do "relocate live sound from one location to another," as Brandon LaBelle puts it, Amacher's exhibition strategy highlights the material and imaginative supports that underpinned those transports and emphasized overlapping figurations of long-distance connection, in any single project.[142] By

[141] Lucy Lippard, *Overlay: Contemporary Art and the Art of Prehistory* (New York: New Press, 1995), 30.

[142] LaBelle, *Background Noise*, 170. Alan Licht suggests connections with earthworks and land artists, with Les Levine's adage "environmental art can have no beginnings or endings" as a capacious

displaying phone block hardware, for example, Amacher created an experience held together, in part, by low-tech, minimal-maintenance, and amateur-friendly lines with obvious market applications. It should not be lost on us that Amacher cast *Adjacencies* in the plural and that its paradigms of spectral attention would arch toward new social locations, material forms, genealogies of body, and analytics of power in *City-Links*.

summary. While Amacher was undoubtedly fascinated by protracted temporalities and multi-sited connections, her work and musical thought also queries what material interventions and embodied expenditures would be necessary to create and sustain such connections. The many "elemental" components that appear in Amacher figurations of environmental connection prove strikingly fragile and contingent. Alan Licht, *Sound Art: Beyond Music, Between Categories* (New York: Rizzoli, 2007), 124.

Scenes from a Long Distance Music, 1970–1976

Introduction

Very quietly, the transmission streamed across the open line. "In the best moments," Amacher told WFMT manager Norman Pelligrini in 1974, "you do not hear the presence of the loudspeakers." In the photo shown in Fig. 3.1, Amacher sits at her desk, beneath the phone blocks and speakers affixed to the wall that delivered the transmission to her Cambridge studio. "At threshold levels," as she put it, one could almost trace patterns or contours in air while listening to the live feed. "It's almost as though you had such a thing—which of course we don't, that I know of at this moment—as, like, a sound hologram."[1] Because the feed transmitted in mono with no spatial cues, it enabled Amacher to study nuances in frequency and amplitude as three-dimensional sonic shapes, moving and transforming in space.[2] Uninterested in waterfront "sound effects" per se, Amacher studied their appearance and disappearance as a dimensional drama that took place both at distance and proximity in environmental sound and the remote feed, at once.[3] Her studio floor was painted a dark blue, over which those shapes could hover or commingle, as though on an azure stage.[4] During the 1970s, Amacher referred to

[1] Amacher gave this interview with program director Norman Pelligrini on Chicago's Fine Art Radio Station, WFMT 98.7 FM, on May 7, 1974, before presenting *Everything-in-Air* and *City-Links: Chicago 1974, Hearing the Synchronicity* at the Museum of Contemporary Art Chicago (MCA). For local press related to Amacher's projects at the MCA, please see "A Sound Ambience from Inner Space" (*Chicago Tribune*, May 10, 1974; Section 2–3 Weekend, Thomas Willis); "Maryanne Amacher and the Music Around Us" (*Chicago Guide*, May 1974); "Maryanne Makes Music from Sounds of Chicago" (*Chicago Today*, May 10, 1974, Karen Monsen); and "Electronic Portrait of Our City" (*Chicago Style*, May 1974).

[2] See Micah Silver, "Remembrance," http://www.arts-electric.org/stories/091028_Amacher.html, accessed July 17, 2015.

[3] Maryanne Amacher. "Lecture" at Ars Electronica, 1989. https://vimeo.com/30955464, accessed June 18, 2019. Ten minutes before an approaching plane or vessel would become audible in the remote feed, Amacher could detect changes in the air's ambient frequency and in the density and tone of avian activity.

[4] Keiko Prince in conversation with the author, April 13, 2019.

Wild Sound. Amy Cimini, Oxford University Press. © Oxford University Press 2022.
DOI: 10.1093/oso/9780190060893.003.0003

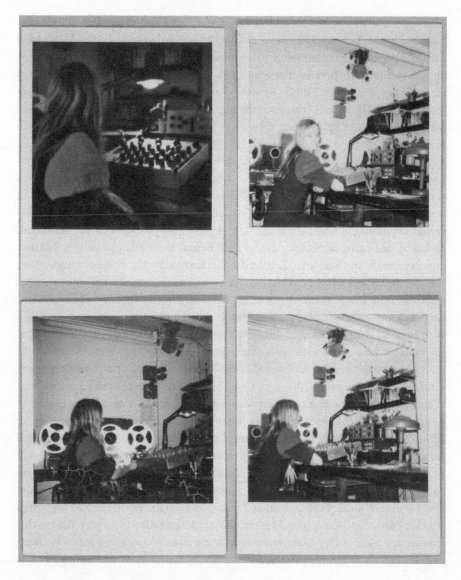

Figure 3.1 Maryanne Amacher in her CAVS studio with phone blocks. Courtesy of the Maryanne Amacher Foundation.

this long-term telelink transmission as an "installation-study" and titled it *Tone and Place (Work One)*. Imagining that the blue floor doubled the feed's watery origin point dramatizes the distance that the transmission had traveled to give rise to this near-holographic play, in her studio.

This chapter spans 1970 through 1976 and gathers together five *City-Links* projects that Amacher created during that interval: this includes *Tone and Place (Work One)* (Boston, 1973–1976); *City-Links, Chicago 1974* and *Everything-in-Air*

(Chicago, 1974); *No More Miles–An Acoustic Twin* (Minneapolis, 1974); and *Incoming Night* (Boston, 1975) as well as an unrealized proposal titled "Anywhere City" and tape works composed with recordings from the Harbor feed that do not appear in the retrospective numeration that Amacher applied to the *City-Links* series in the late 1980s.[5] While Amacher imagined the *City-Links, WBFO, Buffalo* broadcast as a "link-circle" threaded through the city, she embraced varied presentational formats in subsequent *City-Links* projects. Evening-length events with remote performers, unattended feeds in gallery spaces with audiovisual supports, tapes, and live electronics performances, for example, each materialized listening as a kind of distanciated life within whose subjunctivity Amacher could also compose. Put a little differently, *City-Links* approached distance as a horizon of compositional strategy that could be experienced as something that both holds things together and keeps them apart, and combined poetic, textual, conceptual, technical, mediatic, architectural, and audiovisual materials to mediate distance and proximity. In their introduction to the anthology *The Wireless Imagination*, Douglas Kahn and Gregory Whitehead caution a sound art practice and criticism cresting in the 1990s against forgetting precedents from a speedy early twentieth-century Euro-American modernism in which vital and necrotic tropes commingle with colonial claims on terra nullius.[6] In contrast, *City-Links* does not court a spatial collapse associated with instantaneous transmission but instead introduces distinct constructions of distance that could be configured and sensed in determinate, if complex ways. Although *City-Links* is made up of serial installments, the methods and materials that underpin it also suggest a composite tele-technological system that entangles telephony, telelinks, telepathy, and television to activate an alternativity in the sensorium that attunes to historical and political constructions of social distanciation. "Industrialization and its concomitant technologies," Roshanak Kheshti writes, "working in lockstep with perceptual and sensory differentiation, isolated imaginary processes to particular organs."[7] Amacher knew well that music both upheld and relied on such distributions and suggested that long distance listening could set critical reconfigurations into play. And so this chapter approaches *City-Links* as, in part, a speculative communications network that transports environmental sound across liminal ways of listening and casts

[5] Throughout the chapter, I will use Amacher's original titles for *City-Links* projects but will give their serial numeration in the notes and explicate instances in which the subtitles are reused. I hope that this will illuminate how Amacher built subgroupings into this corpus and support further research on individual installments. Readers familiar with the exhibition catalogue from the 2010 exhibition *Maryanne Amacher: City-Links* at Ludlow 38, New York (October 20–November 28, 2010), curated by Tobi Maier, Micah Silver, Robert The, and Axel Wieder will likely recognize the numerations and poetic subtitles.

[6] Douglas Kahn and Gregory Whitehead, eds., "Introduction," in *The Wireless Imagination: Sound Radio and the Avant Garde* (Cambridge, MA: MIT Press, 1992), 20–21.

[7] Roshanak Kheshti, *Modernity's Ear: Listening to Race and Gender in World Music* (New York: NYU Press, 2015), 57.

listeners as, themselves, constitutive nodes in long distance music's transmission. What emerges is a rich sense of the long-distance sensorium that did not so much mitigate the "too-closeness of the world" as explore how social distanciations were constructed in listening and ask how both could work otherwise.[8]

City-Links also gathers up figurations and processes that have historically had significance for feminist histories of music and sound, like communications labor and environmental interventions. Taking long distance music's insistence on ongoing time seriously opens up a narrative strategy that can prioritize divergent but synchronous projects and seek, in them, what Anna Tsing calls "patterns of unintentional coordination."[9] To this end, this chapter embraces an episodic and experimental form that extrapolates *City-Links* secondary and tertiary figurations. With no progressive narrative, that is, it moves in loops and layers in order to dramatize how distinct temporalities and tenses in *City-Links* also captured cycles of obsolescence and change across remote circuitry and long-distance imaginaries as well as the city environments in which they took shape. For example, central to how *City-Links*' main technical supports were marketed and partly obsolesced by the mid-1980s were digital technologies, in US telephony, that moved operators into new labor markets and regimes of service work; the commercial product "long-distance *dialing*" entailed a biopolitical regularization of the sensorium that, as we shall see, "long distance *music*" entangles and contests. This suggests feminist histories of communications labor that anthologize many formations of listening, understood as the conjunction of ears, mouths, and sounds that drag conflicting frameworks for life inside their various couplings. Complex histories emerge between these long-distance constructions and the material histories that shaped *City-Links* remote sites, especially the Pier 6 telelink. In the 1971 Charles River Project, György Kepes and the Center for Advanced Visual Studies combined remediation projects with large-scale infrastructural interventions that prioritized perceptual access to complex environments. Project proposals reveal how Fellows designed perceptual surprises and interactive loops within which people were to experience the degraded waterfront environments as a meaningful intensification of embodiment and connection. Although these were not telematic projects, they sought historical constructions of alternativity in the sensorium that transported "vital energy" into city environments that could become legible as civic value.[10] In one sense, this chapter will register how

[8] Kahn and Whitehead, *The Wireless Imagination*, 21.

[9] Anna Tsing, *The Mushroom at the End of the World: The Possibility of Life in Capitalist Ruins* (Princeton, NJ: Princeton University Press, 2015), 23.

[10] As Keiko Prince explained, Amacher visited the Center in 1972 to interview with Kepes to work as an organizer for the group exhibition *Multiple Interaction Team*, which opened at the Museum of Science and Industry in Chicago in 1972 and traveled to various venues through 1973. She officially started the CAVS Fellowship in 1973, and her name appears in Charles River Project meetings notes in January and February of that year. As part of the project, she wrote prose descriptions for two waterfront and / or island interventions titled "Garden of Energy" and "Garden of Stillness," respectively. For

these perceptual projects can be read as symptomatic and diagnostic of modern formations of power that, as Jasbir Puar puts it, arrange discipline ("exclusion and inclusion") and control ("modulation and tweaking") across bodies and materials.[11] But, in another sense, recordings, documents, photographs, and sketches suggest that long-distance interventions, in *City-Links*, emphasize how desires for a concurrent listener in the social time of the present also involves a subjective experience of social distanciation that unsettles the sensorium and asks after alternative ways that sound can register.

How to Glow in the Dark: 1970s Textual Experiments

Five short texts from the early 1970s connect a suggestive chronology. Between *City-Links, Buffalo, 1967* and *Tone and Place (Work One)* in 1973, Amacher penned a two-and-a-half-page-long manifesto titled LONG DISTANCE MUSIC, theorizing a music that took place across multi-sited situations in synchronic time. Seven companionate text pieces provide instructions and an interconnected poetics that put this manifesto into practice. Turning distance into intimacy electrifies time, space, and body with desires for transmutation. LONG DISTANCE MUSIC stokes this desire and invites readers to question how social connection can be experienced when listening interacts with tense and mood. These intersections again ask after "how worlds of sounds could be joined" and insist that many answers commingle in a single material instance. These writings figure listening across distance as light, heat, or color as much as sound that registers in the ear or other areas on the body. Many long distance musics, we shall see, can coexist at once.

Titles and components remain slippery throughout these writings. I will use Amacher's emphatic all-caps when discussing LONG DISTANCE MUSIC as a generic or heuristic invocation of heightened experience, and lower-case when examining the material or discursive details that make up the specific approaches that she describes. Consider how she organized these projects in an early-1970s dossier: prior to 1973, Amacher used the heading *Life Time and its Music* to group *City Links, WBFO, Buffalo*, and *In City, 1967* together with the essay LONG DISTANCE MUSIC and numerous text pieces dated between 1968 and 1971— for example, SWEET SALT (1968), TIME AND THE WIND PLACES (1969), IT SHOULD BE BOUGHT, for M. Duchamp and J. Cage (1969), GREEN WEATHER

the latter, she reported experimenting with selective filters and tape speed to study frequency characteristics in environmental sound. "Stillness" instructs that "6 trees are chosen. 6 more are planted. Sitting under a tree a place is made." She continues to explain that "only sound which is distilled - in melt or balance with surroundings is brought in the environment." Amacher, "Garden of Energy and Garden of Stillness for the Charles River, Cambridge, Massachusetts," undated description, Center for Advanced Visual Studies Special Collection, MIT Program in Art, Culture, and Technology.

[11] Jasbir Puar, "I Would Rather be a Cyborg than a Goddess: Becoming-Intersectional in Assemblage Theory," *philoSOPHIA* 2, no. 1 (2012): 62.

(1970), BECOMING HARMONICS (1970), EYE SLEEP, EAR BREATHE (1971), TO GLOW IN THE DARK (1971), and SUMMERLAND (1971). In a 1973 works summary written after starting at CAVS, Amacher described the text works as an effort to "extend" *City-Links, WBFO, Buffalo* across vast distances to further develop the "idea of performances taking place between cities," which Amacher realized with telelink connections in 1976 and again in 1981.[12] In the meantime, titles again reshuffled. After 1973, Amacher began to refer to *City-Links, WBFO, Buffalo* as *City-Links No. 1* and, as the work series grew, repurposed the title *Life Time and its Music* for the tape collection that she mixed with remote feeds in some *City-Links* events.[13] Together, the texts, telelinks, and tapes assemble complex conduits that transmit and accumulate ongoing life.

Amacher makes these conduits sensible in the essay LONG DISTANCE MUSIC, shown in its entirety in Fig. 3.2. Sentence fragments that begin with gerunds make it hard to tell who is acting and whether or not the reader might already be doing what the text describes. On the first page, Amacher makes sure that adjectives associated with single units are thrown into relief. With each successive ONLY or ONE, another social location pierces the text to stand alone—isolated like the ONE PLACE situations that LONG DISTANCE MUSIC will attenuate. As points aggregate, so would more and more ongoing sounds.

When Amacher notes that this is happening ALL THE TIME, the subjunctive makes itself felt. Point-like ONEs can now slide between verb tenses. No longer sounding in different places, these sounds can be reconjugated to share the same durative present. ALL THE TIME now also becomes THE SAME INSTANT OF TIME. This temporal pronouncement leaps off the page, now readied to connect with another unheard sound elsewhere. Amacher's all-caps effusions demonstrate what their accompanying pieces will explain: more than a modernist fantasy of being in more than one place at once, LONG DISTANCE MUSIC treats auditory thresholds as a matter of social time. The text threads those thresholds into ongoing actions with a gentle address that delivers instructions without invoking the reader in the second person.

Amacher concludes this performative stretch in the text by announcing that "WE ALL BEGIN TO HEAR EACH OTHER MUCH BETTER IN THE PLACE WE

[12] These pieces include *No More Miles (City-Links #19)* at Mills College and, in 1976, *City-Links #18*, a telelink "installation performance" from the Boston and New York habors transmitted to Radio France Musique in Paris on the occasion of the US bicentennial in 1976. Prior to starting at CAVS, however, Amacher framed her early 1970s text pieces as long distance musics that did not require broadcast technology, to which she might not have ready access between her fellowships at Buffalo and CAVS.

[13] In press releases for *Hearing the Space, Day by Day 'Live' in Interventions in Landscape* (November 7, 1973, to June 7, 1974), Amacher refers to her installation as "a version of *City-Links*" and also states that it "is included with other Long Distance Music in a collection where sounding resources of the city are fed back to each other." Although she did not use the term "Long Distance Music" as frequently—or with the theoretical intensity—as I do in this chapter, I highlight her early usage as an umbrella term for *City-Links*, its subgroups, and other projects like *Tone and Place (Work 1)* and *Tone and Place (Work 2)*.

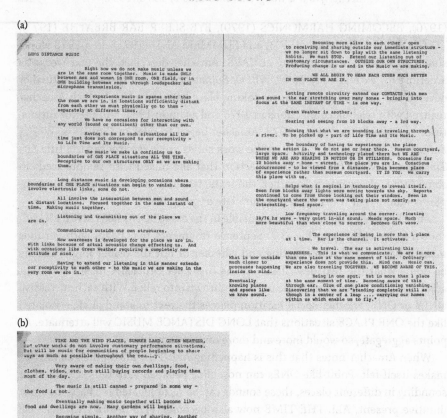

Figure 3.2 Complete text of Amacher's "LONG DISTANCE MUSIC." Courtesy of the Maryanne Amacher Foundation.

ARE IN" and lists three ways to do so, without rhetorical preparation. Amacher makes it easy to miss that the reader has arrived at a systematic list with textualized numbers that appear at each fragment's end:

> Letting remote circuitry extend our CONTACTS with men and sound—
> the ear stretching out over many zones—bringing them into the SAME
> INSTANT OF TIME—is one way.
>
> Green Weather is another.
>
> Hearing and seeing from 10 blocks away—a 3rd way.

GREEN WEATHER

> There are no electronic links. We make a special occasion to listen for each other, even though we are at distant points in the world. Playing music in our own places, New York, Los Angeles, Rome, Tokoyo.
>
> The score is based on exchange of energy using sun and moon as guides. Orienting to distant sun and moon, sending and receiving. Playing in early morning (East Coast) we are receiving full sun of Rome. Our music will reflect this. Sending to Rome the stillness of early morning. We stop at 8:30 while West Coast gives the grace (before sunrise energy) in their music making to Europe now in mid day. Europe stops in mid energy and in the next cycle would receive a night to re-absorb.
>
> We set ~~aside~~ *ASIDE* a period of 8 days to perform Green Weather in the beginning.

Figure 3.3 Amacher's text piece "Green Weather." Courtesy of the Maryanne Amacher Foundation.

Each long distance music suggests contexts all its own. "Remote circuitry" plunges into a vast cyborg apparatus of transmission technology (which could include domestic or public radio, television, and telephony) as well as their industrial infrastructures, entangled histories, and claims on a US entertainment market. "Green Weather" is a paragraph-long text piece, which Amacher neither includes nor excerpts in LONG DISTANCE MUSIC. Her third way eschews remote links and embraces precise distances that can be seen and heard unaided when listening in situ. But you need not rush to where the action is, this last instruction suggests. Listen to where you are and where you are not, Amacher's hypothetical rewriting of Haraway might have put it.[14]

A closer look intertwines the instructions that appear in LONG DISTANCE MUSIC with the accompanying text pieces. The unprepared and unelaborated appearance of "Green Weather" in LONG DISTANCE MUSIC beckons the other text pieces into its performative attenuation of ONE PLACE situations. "Green Weather" coordinates musicians over the course of eight days but does not require sound as a mediating step, as the complete text featured in Fig. 3.3 explains. Using clock time instead of remote circuitry, "Green Weather" synchronizes diurnal patterns and aligns three intervals of heightened auditory experience within a day-long energetic cycle. Participants "listen for each other," even though there will be nothing to hear. In Rome and New York, afternoon and early morning energies coincide. At 5:30 a.m. Pacific Standard Time, Los Angeles–based participants add the dark hours before dawn to this sunlit transatlantic pair. With coordinations

14 Haraway, "Situated Knowledges," 189.

that couple light with dark, midday with midnight, dawn with dusk, Amacher employs paired opposites as poetic proxies for linkless listening, often without also addressing distance in any straightforward way. This holds in abeyance the spatial collapse often associated with what Kahn and Whitehead call "an ideal of instantaneous transmission."[15] Intralayered coordinations that combine moonlight, sunlight, dawn, and dusk creates a quotidian composite that Amacher calls "green" to index an experience of heightened musicality that does not appeal directly to the ear.[16]

Why green? In 2001, Amacher outlined a research program titled "Rare and Unusual Atmospheres" that proposed virtual auditory environments with an illustrated book as its interface, deriving colors, images, and shapes from what she called the "perceptual foundation" of Goethe's *Farbenlehre*, or Theory of Colors.[17] Although she did not explicitly reference this early text in the proposal, it provides suggestive ground upon which to extrapolate:

> Ways of hearing—how we locate, sense and feel sonic events—as the specific factors which characterize experience in immersive sonic environments to construct distinct transformative experiences. What perceptual modes they will trigger for the listener—where and how they will exist for the listener.[18]

In the *Farbenlehre*, Amacher sought "striking examples of perception in operation" and Goethe associates green with spatio-temporal dynamics that align suggestively with long distance listening.[19] When green is mixed in "perfect equality," Goethe states, it becomes a "single color," as stolid as the primaries that comprise it.[20] Unlike most composite colors, green instills a quietude and stillness that invites the "eye and mind to repose" and roots the beholder gently in place.[21] Because a well-mixed green leaves the beholder with "neither the wish nor the power to imagine a state beyond it,"[22] Goethe suggests that it is an ideal hue for "rooms to live in constantly."[23] Like this green, LONG DISTANCE MUSIC also moves into an implicit situation that one could "live in constantly."

[15] Douglas Kahn and Gregory Whitehead, eds., *The Wireless Imagination: Sound, Radio and the Avant Garde* (Boston: MIT Press, 1992).

[16] Her 1970s collection includes another note titled PREPARATIONS FOR MAKING GREEN MUSIC, which gives instructions to put on "The Green Coat and the Yellow Cap."

[17] Amacher, "Creating 'Perceptual Geographies' for Emerging Media: Multimodal Sensory Worlds," 1, concept summary. In conversation very early in my research process, Robert The emphasized Amacher's interest in Goethe's color theory.

[18] Ibid., 7.

[19] Ibid., 7.

[20] Goethe, *Theory of Colors*, trans. Charles Locke Eastlake, 316.

[21] Ibid., 321.

[22] Ibid., 321.

[23] Ibid., 321.

```
TO GLOW IN THE DARK, 1971

             Singing energy comes from a fire burning bright.
Flame speakers augmented by wood fire.  A bonfire, or a ring of
fire, beneath a mountain, on a lake, in a dessert, in a city
center, Washington Square.

        The music may be live musicians transmitted through
the fire.  Or it may continue electronically.  Others may send
music to the fire.  One orchestra within a city might be transmitted
out of the hall where it is playing to the fire for others not in
the hall to hear.  To gather around the fire as they are passing
through the streets.

        Several orchestras, e.g., Boston, New York, transmitted
from their halls and mixed on the spot through electronic means.

        Global Melts to occur whenever possible!

        One good alchemist to keep the fire going!
```

Figure 3.4 Amacher's text piece "To Glow in the Dark." Courtesy of the Maryanne Amacher Foundation.

Additional text pieces call upon elemental images to express connective dispositions that involve fire, air, and water. "To Glow in the Dark," shown in Fig. 3.4, sketches a fantastical fireside scene in which remote circuitry coexists with linkless listening. Radiophonic flames suggest a composite transmission medium forged in pure energy. They also drag transmission into a much broader "thinking of substance in its propagation, its generation," as phenomenologist Gaston Bachelard puts it. Fire is not a body, but it can act as a vitalizing force that innervates other substances as what Bachelard calls a "formal principle," or as a supplemental excess that troubles proper relations between agency and passivity.[24] At once brilliant and monotonous, fire can confound boundaries and opposites—life or death, warmth or pain, desire or purification, community or authority—and give rise to reverie and fantasy.[25] In "Glow," visitors "send music to the fire" to keep both the fire and the transmission alive, like a strange, hybrid creature that must be fed.[26] Seeking out "one good alchemist," as Amacher put it, nudges the task of tending the fire toward questions about gender type that index feminized domestic knowledge as much as a masculinist head of household or other liminal figures. "Glow's" convivial scene involves gatherers in a dreamy play of opposites but does not explicitly count distance and proximity among them.

While "Green Weather" and "To Glow in the Dark" dream up elemental mediations, the aphoristic "Vistor Series" addresses long distance music's coupling with

[24] Gaston Bachelard, *The Psychoanalysis of Fire*, trans. Alan C. Ross (Boston: Beacon Press, 1964).
[25] Ibid., 89.
[26] Ibid., 13–15.

THE VISITOR SERIES:

Wind in the Garden Wakes the Visitor.

The Visitor Remains in the Garden for a Thousand and
 One Nights.

He Dances in Sunlight and Gardens in Moonlight.

He Learns to Sleep in the Garden.

The Visitor Hears the Sun. He Has New Eyes.

He Sees the wind. He has New Ears.

The Visitor Travels.

The Crow Swims, the Salmon Flys.

He is Breathing Sound

He is Glowing in the Dark

Figure 3.5 Amacher's text piece "The Visitor Series." Courtesy of the Maryanne Amacher Foundation.

the sensorium more directly. Amacher anthropomorphizes this coupling (as a "he") and lists sensations, sense modalities, activities, and diurnal cycles in counterintuitive pairs to describe "his" actions and habits: "He Dances in Sunlight and Gardens in Moonlight," "The Visitor Hears the Sun. He has new eyes," "He Sees the wind. He has New Ears," "He is Breathing Sound," "He is Glowing in the Dark." The complete text is shown in Fig. 3.5. Although she elsewhere leans on traditional Western frameworks to describe The Visitor as a discrete unit in sensorium—"just like [the] eye and ear"—Amacher creates language for the existence and practice of long-distance sensitivities by coupling synesthetic intensifications with actions that nourish and sustain life (e.g., waking, sleeping, breathing, and so on).[27] Amid these oppositions, The Visitor makes himself felt. Slotting his activities (dancing, gardening) into incongruous diurnal intervals (sunlight, moonlight) suggests that unusual re-emplotments in the time of life can also be a way to unsettle ONE PLACE SITUATIONS. Deliberate mismatches call attention to the durative present tense and highlight both banal and strange affinities without an explicit framing in geography, distance, or transmission.

Finally, let's turn to what Amacher calls "a 3rd way" to experience long distance music. Also a linkless listening, "hearing and seeing from 10 blocks away" evokes city blocks with clear landmarks and sightlines. She continues,

[27] Maryanne Amacher, "In City, Buffalo 1967," in *Supreme Connections Reader*, 52.

The boundary of having to experience in the place where the action is. We do not see or hear there. Museum courtyard, large space. Activity and technology placed there but WE ARE WHERE WE ARE AND HEARING IN MOTION OR IN STILLNESS. Occasions for 10 blocks away—home—street. The place you are in. Conscious occurrences—to be viewed from a distance. This becomes place of experience rather than museum courtyard. IT IS YOU. We carry this place with us.

[. . .] Seen from blocks away, lights were moving towards the sky. Reports continue to come from those looking out their windows. Seen in the courtyard where the event was taking place not nearly as interesting. Need space.[28]

Do not rush to where the action is. From the home or from the street, this linkless listening in situ moves with you as you move—like an undulating seam or lace that connects but does not collapse distance into proximity. Amacher revels in sounds that reach listeners at a distance and imagines composing long-distance audiovisual diffusions that can make this experience explicit. When Liz Phillips described the sound environment beneath and around the loft that she and Earl Howard shared with Amacher and Luis Frangella in the late 1970s, she sketched a suggestive backdrop for this mode of long distance listening.[29] Sounds that originated at street level, many floors down, sounded as detailed in the loft (and on the roof) as they did on the street, she explained. Visual attention to the vertical plane dramatized a listening that confounded what was sounding "here" and "there." When the nighttime sex-work hub became, on some occasions, an early morning meeting point for parade bands, Phillips characterized its acoustical cycles as, "you know, like [Charles] Ives."[30] Listening in the loft coupled counterintuitive auditory dimensions with diurnal patterns. Consider another vivid vertical example from Amacher's preparatory research for *City Links, Chicago, 1974*:

My own vivid experience of this occurred on the roof of the Sears Tower in Chicago (while researching remote microphone locations for an installation of "City Links" at the Museum of Contemporary Art). Hearing the traffic sounds below me was a complete surprise. The familiar sounds of traffic were no longer recognizable from this elevation. The sounds were musical, a choral ambience, more like a diffuse cloud of floating aural shapes moving in many different patterns, all at once at a great distance.[31]

[28] Amacher, *Long Distance Music*. Note that definite articles are also missing in the original.
[29] Conversation with the author, December 3, 2016.
[30] Ibid.
[31] Amacher, "Creating 'Perceptual Geographies' for Emerging Media: Multimodal Sensory Worlds," 4.

Long-distance listening refuses a clasping kind of touch that would turn distance into proximity and make, of sounding environments, yet another spate of ONE PLACE SITUATIONS.

Music has been made in ONE PLACE SITUATIONS for so long, Amacher suggests, that the ONE PLACE SITUATION has become inextricable from music's very constitution. What kind of music is a long distance music in the first place? Amacher's elemental poetics do not so much answer this question as provide contexts and heuristics for finding answers for oneself. These texts dance a playful but precise choreography that brings together listeners' knowledge of light, darkness, warmth, heat, color, and atmosphere. ONE PLACE SITUATIONS turn green; strangers and passersby dream beside a radiophonic fire; listening glows in the dark; mismatched senses and sensations welcome a Visitor whose inaudible sound worlds never quite disappear. Far from some kind of torpid, encircling immersion, these elemental transmissions define precise connective logics and gathering places. Their different emphases on social reality suggest heuristics for redoubling everyday life as a kind of long distance music.

Dirty Water and the Microphone at Pier 6

When, in 1973, Amacher connected a 15 kcl Bell telelink program channel to her studio from the Boston Harbor, she did precisely this. "I lived with it," she said to Jeffrey Bartone in a 1988 interview. By the time Amacher placed her microphone at the Boston Harbor, Pier 6 had been unused for at least a year, and it remained that way for her transmission's three-year span—and, after that, almost a decade longer. As container shipping and industrial terminals obsolesced older harbor infrastructure tied to local seafood and shipping industries, the pier had been transferred from city to state management under MASSPORT in 1972. State-led remediation did not begin until 1979 and as the pier continued to rot during the intervening years, Amacher's microphone could remain unnoticed by city, state, or federal managers.

Pier 6 was built in 1912 and embraced a neoclassical style common in coastline architecture since the 1880s, and its symmetrical and monumental look resonated with elite residential housing of the period. The pier consisted of two long, narrow terracotta buildings that extended from the shore with a pair of administrative buildings on their waterside edges. Amacher's microphone resided in one of these buildings, as shown in Fig. 3.6. The ceiling crumbled, the tiles on the floor upturned. Alongside abandoned fishing vessels, the building simply fell apart into the water and slowly opened to the outside. As deindustrialization churned through inland US cities, the harbor weaves ongoing cycles of ocean-facing industrial abandonment in port cities into *City-Links'* overlapping contexts.

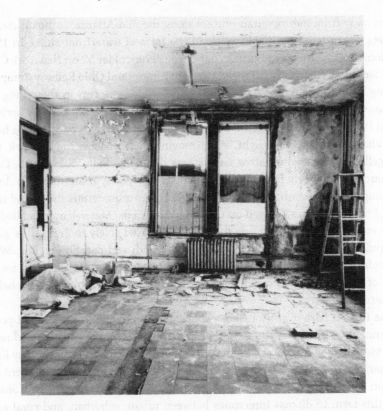

Figure 3.6 Pier 6 at the Boston Harbor. Courtesy of the Maryanne Amacher Foundation.

Amacher's photographs conjure a "modern gothic" often associated with abandoned industrial sites in states of decay and ruin.[32] Throughout the 1970s, steel mill closures were accompanied by questions about stabilization and memorialization, and the results of such debates ranged from infrastructural abandonment to big payday commissions for minimalist sculptors.[33] Amid 1970s structural dislocations and economic uncertainty that scrambled the Boston Harbor's historical reference points in wartime shipbuilding, lucrative shipping, and other maritime heritage, Pier 6 shares historical coordinates with east coast waterfronts that became home to clandestine and heterotopian interventions. Routing supply

[32] Steve High and David W. Lewis, *Corporate Wasteland: The Landscape and Memory of Deindustrialization* (Ithaca, NY: Cornell University Press, 2007).

[33] Kirk Savage, "Monuments of a Lost Cause: The Postindustrial Campaign to Commemorate Steel," in *Beyond the Ruins: The Meanings of Deindustrialization*, ed. Jefferson Cowie and Joseph Heathcott (Ithaca: Cornell University, 2003), 237–56. A case in point would be Richard Serra's *Carnegie* created in 1985 for the Carnegie International and located outside the Carnegie Museum of Pittsburgh's Forbes Avenue entrance.

chains away from metropolitan centers along the mid-Atlantic seaboard created pockets of not-quite-not-public space in the form of waterfront ruins. In 1975, Gordon Matta-Clark carved chunks out of the defunct Pier 52 on New York City's West Side, which had once belonged to the Baltimore and Ohio Railway Company. Gaping holes in the floor revealed the churning Hudson; cuts in the ceiling and the south- and east-facing walls opened the hangar to the sky and the horizon. Titled *Day's End*, Matta-Clark described the piece as an "indoor park" and as home to a "changing sculpture of light." After moving with Amacher to New York, Luis Frangella joined the alternative art systems that Mike Bidlo, Kiki Smith, David Wojnarowicz, and others sustained, for about two years, at another abandoned shipping terminal nearby at Pier 34. Crafted from denim, tennis shoes, and trash bags, life-sized figures lounged on the crumbling steps. Massive murals filled the pier's empty rooms; at least one room was dedicated solely to Frangella's giant, expressionistic torsos painted in black, ochre, red, and cornflower blue. While postindustrial abandonment opened private infrastructure to different formations of belonging, decay could be retrospectively imagined to work on behalf of subcultural projects.

The Boston harbor story makes explicit how technology, capital, and political economy shaped the contexts that artists had carefully expanded to register a viewer's bodily awareness and open-ended participation in everyday life.[34] Neither a living memorial nor a remote land-art paradise, environmentalist Marion Shoard's term "edgeland" is perhaps more apt, to describe Pier 6. Shoard uses this term to discuss interzones between urban, suburban, and rural areas that combine an "anarchic mix of unloved land-use function ranging from gravel workings to sewage disposal plants set in a scruffy mixture of unkempt fields, derelict industrial plants and miscellaneous wasteland."[35] The term also encompasses highways interchanges, warehouses, gravel pits, and waterworks. "Their obvious components," Shoard explains "are things we have been brought up to think of as blots on the landscape."[36] Because urban interzones often tug on threads of disdain, they can be easily swept into discourses that downplay structural histories and accelerate extractive and discriminatory processes. Consider, for example, a pamphlet authored by the Boston Harbor Associates titled, "The Boston Harbor: An Uncertain Future." It contextualizes the harbor's dirty water and unused buildings within a broader fiscal crisis—which Keynesian policy seemed powerless to overcome—and unequivocally held the state responsible. This is a vivid reminder that *City-Links* took place during a reactionary historical moment in which "the turn away from the New Deal and social democracy [begun in] the mid 1970s" was followed by "predatory forms of inequality" that pursued

[34] Lucy Lippard, *Undermining: A Wild Ride through Art, Land Use and Politics in the Changing West* (New York: The New Press, 2014).

[35] Marion Shoard, "Edgelands of Promise," *Landscapes* 1, no. 2 (2000): 74–93.

[36] Ibid., 75.

"accumulation by dispossession."[37] The Associates demanded a fully industrialized port that would raze the early twentieth-century infrastructure located near the harbor's mouth.[38] Only investor-led development, they argued, could successfully carry the harbor's remediation. As the pamphlet began,

> Boston Harbor seems to be alive again—the dilapidated downtown wharves are being renovated into attractive housing and commercial establishments. New parks and museums grace the waterfront, container shipping facilities are filled to capacity and the harbor's oil and gas terminals supply 80% of the Commonwealth's energy needs.[39]

Uncertainty registers in different ways throughout this seemingly no-nonsense account. It leads with complete or nearly finished projects, and confident reports about luxury housing, parks, and museums that tied life at the harbor to real estate markets and middle-class cultures of *Bildung*. The pamphlet took a protectionist approach to waterfront neighborhoods like Charlestown and South and East Boston, and highlighted rising rent prices and degraded environments—but certainly does not acknowledge that these same neighborhoods, in 1974, fought court orders to desegregate public schools.[40] The pamphlet propped up infrastructural protectionism with what Michael Omi and Howard Winant call "code words" (like "family" and "community") central to strategies in the "new right" that sought to rearticulate minority gains as a new form of privilege that impinged on classical liberal concepts of the individual.[41]

The pamphlet casts industrial developments in a different tone and tense. Amid other changes, shipping facilities remained gridlocked in a torpid, progressless present. Threats began. The harbor's inability to handle increased container traffic would compromise the entire state's access to fossil fuel, and, without plans for expansion, Boston stood to lose industrial shipping to smaller coastal towns. With withering accounts of incoming vessels lying at anchor and awaiting service at the overworked terminal, the pamphlet made sure that economic anxiety ripples through the end of its descriptive gesture.

The easy-to-read map in Fig. 3.7 amplifies these arguments. Garish colors, sharp angles, and thick lines slice the urban waterfront into a chaotic mess of shapes that represent zones of federal, state, and municipal control. The pamphlet focuses this administrative complexity on container-shipping facilities, outlined

[37] Michael Omi and Howard Winant, *Racial Formation in the United States* (New York: Routledge, 2015), 69.

[38] The Boston Harbor Associates, "The Boston Harbor: An Uncertain Future" (December 1978).

[39] Ibid.

[40] One focal point in the 1974 desegregation orders was busing plans between Roxbury and South Boston High School. For further analysis of the new right and "anti-busing mobilization," see Omi and Winant, *Racial Formation in the United States*, 192–93.

[41] Ibid, 192.

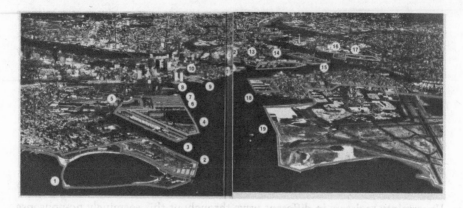

Figure 3.7 Map of public lands in the Boston Harbor, 1978. Amacher's microphone was placed at location #6, also known as "Fish Pier."

in light orange. It addresses the Moran Terminal—marked on the map with the number 12—in detail. Moran was the harbor's oldest container-shipping terminal and, by the mid-1970s, it regularly serviced more than double its capacity in container traffic. It could easily be made to represent the need to expand into state-held areas of the harbor—like Pier 6. As this report slips easily between commercial development and environmental remediation, commercial value and social value become difficult to disarticulate. The pamphlet counted Moran among the state's economic failures and harbor pollution among its cultural, moral, and social ones. Once bundled together, these failures made way for what Anna Tsing calls a "story of decline" in which there can be "no leftovers and no excess."[42] Nothing can remain to impede so-called progress to come. The Associates give narrative form to slow-motion disaster capitalism in which the harbor is first razed in discourse so that its commercial value can be restored completely, fully, and without remainder.

After the Clean Water Act was passed in 1972, the state and city filed exemptions that protracted inaction on the harbor and Charles River through the early 1980s, when the EPA finally denied their waiver applications. Three years after the city of Quincy filed a civil lawsuit that charged the state with environmental neglect, governor Michael Dukakis established the Municipal Water Commission and, in 1985, issued a so-called Master Plan for Boston Harbor that instrumentalized designs for the harbor islands that CAVS Fellow Keiko Prince had drafted in the mid-1970s and that remain unrealized.[43] Upon its inception, the commission

[42] Tsing, *The Mushroom at the End of the World*, 21.

[43] Dukakis announced the Master Plan in response to political pressure. When criticized by George H. W. Bush during the 1988 presidential election about the state of the harbor, Dukakis again republished the Master Plan. Please see "Bush in Enemy Waters, Says Rival Hindered Cleanup of Boston Harbor," *New York Times*, September 2, 1988, Section A, p. 16.

issued a self-statement that narrated their pending clean-up work as an extension and progression of much longer histories of domination. Its narration begins around 1700 and anthologizes colonial networks and trade monopolies through the late nineteenth century, followed by wartime shipbuilding as a synecdoche for mid-century imperial power. By 1985, the commission reiterates what the Boston Harbor Associates' pamphlet stated a decade earlier: when private bulk terminals coexist easily with municipal management, ecological remediation need not rebuke industrial and imperial devastation; instead, it could redistribute their logics of domination in relation to new centers of political-economic power and notions of well-being. A clean harbor could produce political unity by celebrating industrial practices that accelerated environmental damage in the first place, within a broader understanding of deindustrialization as not just economic change but also a kind of social change, which entailed "the obsolescence of the past" and the attenuation of the present.[44] If such a "life" makes the harbor whole again, this is also because—as Elizabeth Povinelli puts it—"capital sees everything as vital."[45]

But across the edgelands and interzones that concerned the Associates, that life could also be made audible in "culturally specific projects," as Amacher well knew.[46] LONG DISTANCE MUSIC moves affects and energies between social locations and creates distinct durative temporalities that gather up synchronous cycles of obsolescence and change. This harbor story reveals that such cycles also create platforms for "reproducing the future," to borrow from Marilyn Strathern, by arranging urban edgelands (piers, seawalls, unused infrastructures), affects (hope, fear), histories of domination (imperialism, protectionism), and other materials (water, sludge, debris) within biopolitical coordinates.[47] Between 1973 and 1976, the Harbor telelink captured precisely the stretch of civic inaction that not only left her microphone undisturbed but also pressed the Associates and CAVS to construe so-called life, at the harbor, within competing frameworks, as we shall see. These material histories constitute the auditory thresholds that made the harbor feed accessible to Amacher and layered its sound world elsewhere as a long distance music.

[44] Kathryn Marie Dudley, *End of the Line: Lost Jobs and New Lives in Postindustrial America* (Chicago: University of Chicago Press, 1994), 59. As cited in Steven High and David W. Lewis, *Corporate Wasteland: The Landscape and Memory of Deindustrialization* (Ithaca, NY: Cornell University Press, 2007), 25.

[45] Povinelli, *Geontologies*, 7.

[46] Vora, *Life Support*, 7.

[47] Strathern as cited in Vora, *Life Support*, 7–8. Marilyn Strathern, *Reproducing the Future: Anthropology, Kinship and the New Reproductive Technologies* (New York: Routledge, 1992).

Tone-of-Place and Three Long Distance Musics
on Tape: *Incoming Night, Blum at Pier 6, May 1975*

On an inside notebook cover, Amacher drew two notations on the five-line staff in precise freehand, as seen in Fig. 3.8. Next to her label "Boston Harbor," the low F# summarizes what she came to call the harbor's "tone-of-place."

> Tone-of-place "experienced," "heard" through the skin, detected by unnamed sensibilities an impression carried through skin— remained—even when not in physical place—having been there a long time—continues, is carried in the self. Tone around you and with you, "I don't like your tone," "I like your tone," "I like the tone of this place."

"I didn't set out to, say 'oh I want to find the resonant frequency . . . or the hidden tones of these places,'" Amacher explained in a 1989 lecture, "but I had it for two and a half years and I realized . . . there it was."[48] Her term "tone-of-place" remains polyvalent. As one way that sounds moved with a person to enlace listening in situ with a distant and no-longer-audible soundworld, it was also already what Amacher would call a long distance music. This particular notebook was otherwise packed with research notes and sketches that Amacher had made not in Boston, but in the Twin Cities in mid-summer 1974 as she prepared three *City-Links* installments at the Walker Art Center: *Hearing the Space, Day by Day, 'Live', Everything-in-Air*, and *No More Miles—An Acoustic Twin*. That notations from the harbor feed tagged along with sketches detailing acoustical shapes and dimensions in Twin Cities sites shorthands the complex roles that tone-of-place played

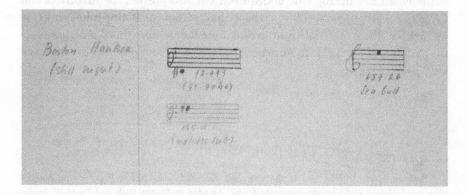

Figure 3.8 Amacher's notation for "tone-of-place" at the Boston Harbor, among notes on site visits in the Twin Cities in summer 1974. Courtesy of the Maryanne Amacher Foundation.

[48] Maryanne Amacher, "Lecture" Ars Electronica, 1989.

across *City-Links* transforming compositional and mediatic circumstances as well as its social and environmental matrices.

While tone-of-place certainly revels in how "bodies are continuously busy judging their environments and responding to the atmospheres in which they find themselves," to borrow from Lauren Berlant,[49] *City-Links* insists that those adjustments bring together distant environments and involve complex embodiments based in historical and technological figurations of durative social contact.[50] The hypothetical first-person speaker scare-quoted in Amacher's text describes how divergent acoustical situations matter to social experience and create circumstances that can uphold social distanciation or reward contact labor. How does a listener experience this linkless long distance music? Unlike the stabilizing tonal hierarchy that R. Murray Shafer ascribes to a soundscape's "key note," Amacher's tone-of-place could mediate remote circuitry, linkless connections, and environmental listening in social time, coordinating multiple long distance connections at once. This conceptual and experiential glue in *City-Links'* utopic contact network, I will argue, enabled Amacher to compose long distance music for recorded media as much as remote circuitry and to activate linkless listening, at the same time. I address their entanglements in this section and revisit, in a later section, tone-of-place in dedicated linkless contexts.

Throughout *City-Links*, Amacher leased dedicated lines on the Bell network to connect remote sites to one or more locations. With a Special Service Order like the sheet shown in Fig. 3.9, she could determine locations with a regional Bell office, which would then send a field engineer to install equalization technology and a phone block to open the connection. Each site required a power source and an enclosed structure; blocks could not be installed in the open air. Leased lines secured point-to-point connections that transmitted sound in one direction only and could create semi-private long-distance networks that did not utilize commercial services on the public telephone network. While leased lines were used in decentralized US corporate communications and transnational financial organizations between the 1960s and 1980s, the 15 kcl program channels that guided Amacher's exhibition strategies in *City-Links* also enabled amateur radio broadcasters to connect with local transmitters and carried Muzak subscriptions that crested in the 1970s.[51] On at least one occasion while planning *Everything-in-Air* and *Hearing the Space* at the Walker Art Center Amacher called Muzak's corporate

[49] Lauren Berlant, *Cruel Optimism* (Durham, NC: Duke University Press, 2014), 15. She is paraphrasing Teresa Brennan, *The Transmission of Affect* (Ithaca, NY: Cornell University Press, 2004). For a further account of how tone "holds together [. . .] values and perspectives" in literary forms, specifically, see Sianne Ngai, *Ugly Feelings* (Cambridge, MA: Harvard University Press, 2005), 38–88.

[50] Rather than the wash of sound that Seth Kim-Cohen would associate with ambience, I will frame "tone-of-place" as a composite part in *City-Links'* social and technological figurations. Seth Kim-Cohen, *Against Ambience and Other Essays* (London: Bloomsbury, 2013).

[51] Malcolm McCullough, *Ambient Commons: Attention in the Age of Embodied Information* (Cambridge, MA: MIT Press, 2013).

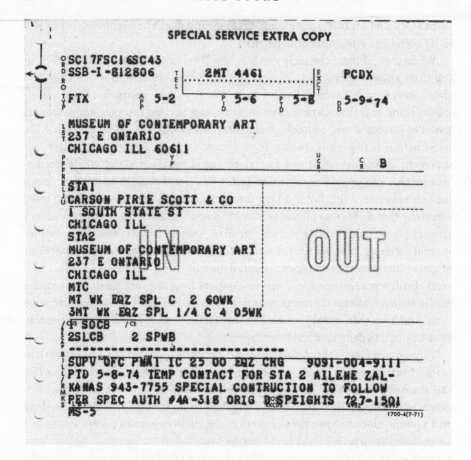

Figure 3.9 Illinois Bell special service orders. Amacher used this link in *City-Links, Chicago, 1974* at the Museum of Contemporary Art. This was a closed transmission through an amplifier and loudspeaker, and is listed as a Series 6000 program channel. Special service orders used seven-digit numbers to distinguish phone blocks from one another.

office for advice about Northwest Bell's leased line pricing and installation protocols in the Twin Cities. At that time, she was also frustrated to learn that Northwest Bell was too busy with leased line installation at a concurrent state fair to field her queries about installation procedures at the Walker Art Center. Public and commercial radio stations used leased lines to broadcast on-site at special events (like fairs or sports games) and to maintain longer-term connections to locations that required frequent interview-based coverage (like a state capitol building).[52] For each line, Bell charged Amacher a small special tariff for non-commercial use as well as standard costs based on air miles between the two points. Once installed,

[52] Conversation with Tom Erbe and the author, spring 2015.

FREQ.	BARE LINE	RIGHT CHANNEL	BARE LINE	LEFT CHANNEL	Combine	STATISTICS:
						TESTER: _____ STEREO CHANNEL DATE: _____
						REFERRED TO: _____ SUBSCRIBER: MIT M46: _____
						ACTION: NEW–TRBL–ROUTING FISH PIER. CKT.# _____
35						RIGHT CHANNEL
50						AMP. STEP
100		−16.6				AMP.** C.O: BAY: FLR:
250		−16.8				IKC. REFERENCE LEVEL:
500		−17.2				EQUAL. VARIABLE 8KC 15K
1000		−17.2				RES:
2000		17.				IND:
3000		16.8				CAP:
4000		16.8				DISTORTION = %MA
5000		16.5				3A/DBRNA 15KC= PROG
6000		16.5				
7000		16.5				LEFT CHANNEL
8000		16.1				AMP. STEP
9000		16.6				AMP.** CO: BAY: FLR:
10000		16.5				IKC. REFERENCE LEVEL:
11000		16.1				EQUAL. VARIABLE 8KC 15K
12000		16.5				RES:
13000		16.1				IND:
14000		16.8				CAP:
15000		−17.2				DISTORTION = %MA
15KC FLAT / DBRN ADJ. PROG.	ACTUAL 23		ACTUAL			3A/DBRNA 15KC PROG

REMARKS:

Figure 3.10 A sample equalization worksheet, like those that Amacher displayed with *City-Links* projects. She used this worksheet in *Hearing the Space* in Boston (1973) and shared it with a Walker Art Center board member while planning 1974 *City-Links* projects.

Amacher's connection simply remained open until she sent another order to close the circuit or change the location that received the incoming feed. In a 1988 radio interview with Jeffery Bartone, Amacher ascribed to these technical conditions a kind of ease that shaded her own experience living with incoming sound and long distance music more generally: "I was always conducting it. I could go to Chicago and get a line connected to my studio and have the sound sent there. And so,

I used the sound in numerous exhibitions. I would just hook another line out of the studio where it was coming."[53]

Amacher often foregrounded these technical supports in her exhibition practice. In a September 1974 letter to Walker Art Center board member Tom Crosby, Amacher explained why she must display Bell hardware and paperwork alongside in the projects she would soon install in the Walker Art Center's auditorium and galleries:

> Whenever appropriate to the situation, I like to make an informative installation, such as the enclosed photograph, with a descriptive caption. [. . .] I do this because listening experiences are so completely oriented to recorded and programmed sound that special efforts are necessary to inform people that this is not recorded, pre-recorded sound, but "live" incoming sound from the environment. I would like to do this for the Walker Auditorium piece, as well as install the equalized circuit box on the visual piece (1 line from LaSalle Court) with sound being prepared for Gallery 3.[54]

Amacher had sent photographs from *Hearing the Space* in *Interventions in Landscape* to the Walker Art Center and the Museum of Contemporary Art in Chicago, which illustrated how she wished the phone block and equalization sheets to be presented. Visitors had to be made aware that they were, in fact, experiencing long distance music and not a pre-recorded or otherwise programmed soundscape composition. After losing the block tags and equalization worksheets she had displayed with *City-Links, Chicago 1974*, Amacher secured replacement copies from Illinois Bell and saved them among worksheets that had accompanied similar installations in Boston, Chicago, and Minneapolis (each also subtitled *Hearing the Space, Day by Day*; one such worksheet is shown in Fig. 3.10). Press coverage from the mid-1970s—as well as more recent criticism—tended to misidentify the technical supports and commercial services that Amacher used to create the *City-Links* projects. As she explained to Crosby,

> Most of the newspaper articles say 15 k.c.—a few just refer to telephone lines. When I describe the piece, I always write, specifically, "New England Bell," "Illinois Bell" 15 k.c. telephone lines or program channels.[55]

[53] Amacher in dialogue with Bartone, reproduced and edited in *Blank Forms Magazine*, Issue 1 (May 2017).

[54] Maryanne Amacher to Tom Crosby, September 6, 1974, Walker Art Center Archives.

[55] Ibid. Amacher's correspondence with Crosby reveals that planning for the Walker projects was, indeed, complex. In ten research days in early August, she selected five locations: the Kenwood Tower, the Canal between Lake of the Isles, Cedar Lake, St. Anthony's Grain Elevators, and Walker Art Center Performing Arts Director Suzanne Weil's house in Hopkins Crossroads, a sweet reference highlighting

Her specifics create a precise contextual matrix. They reference the Bell system explicitly, index its geopolitical coverage in time and place, and detail a special service whose technical supports crosscut domestic telephony and broadcast applications. Some 1970s commentators picked up on this literalist treatment and read the phone blocks as Duchampian readymades.[56] Although Amacher did ask viewers to take Bell hardware at face value, her literalism also explicitly convoked long distance musics whose ongoingness pointed elsewhere—to another phone block, another location, another atmosphere, another listener, another music, another affect, and so on.[57] In *Hearing the Space, Day by Day 'Live'* in Boston, for example, Amacher framed the phone block with *Adjacencies* score pages, attaching imagistic, spectral, and directional associations to the durative synchrony that the block also represented. This exhibition practice insisted on remote circuitry in order to introduce other long distance musics and their mediations. These could become more or less complex proto-diegetic scenarios that involved a listener as not only the feed's receiver, but as a participant in networks that protracted and transmitted long distance music otherwise. Concert-like *City-Links* events also staged this tension.

On Thursday, May 8, 1975, at 11:30 p.m., *City Links #13* began. Amacher routed her Harbor telelink to MIT's Hayden Gallery, where she received the feed and created a live mix using tapes from her *Life Time* collection, as she had done the previous year in Chicago and the Twin Cities. She provided the event with a detailed subtitle: *Incoming Night, Blum at the Ocean Pier Six, Boston Harbor, 11:30 p.m.* Flutist and vocalist Eberhard Blum (then a Creative Associate at Buffalo) was stationed at the pier next to Amacher's microphone and telelink hardware. Between 11:30 p.m. and 2:30 a.m., Blum improvised with Pier 6's soundworld. After the CAs' performances at MIT's *Art Transitions Festival* in September 1974, Blum was, in 1975, among the first to undertake a brief a residency at CAVS, which, coordinated by Amacher, enabled CAs composers to experiment with "[the]

their friendship and Weil's well-known hospitality to artists. A stunning series of difficulties forced her to revise these selections: finding outdoor sites with nearby structures for weather protection posed a significant hurdle (at the Canal), unloaded lines for 15 kcl were not available in some residential areas (at Weil's house), unterminated cable from older telephone connections needed to be removed at the Walker. Misunderstandings between departments at Northwest Bell led to exorbitant price quotes. These technical challenges winnowed *Hearing the Space* to two remote locations: the St. Anthony Grain Elevators and an elevator shaft at the University of Minnesota Heating Plant located at 1180 East River Flats. As she chronicled these challenges, Amacher also described the sites that she was unable to use in suggestive detail. "I felt really bad about the Canal location—the canoes passing through, all the leaves rustling, birds appearing, the trains heard from different points simultaneously, close up, as well as their distance echoes at other sites." This description prioritizes spectral shapes that would emerge amid movement, appearance and disappearance, conveying a strong juxtaposition between distance and proximity that underpinned a crisp experience of auditory dimension that Amacher so valued in environment sound in situ.

[56] See, for example, Cameron Blodgett, "No More Miles," *The Minnesota Daily*, September 1974.
[57] Seth Kim-Cohen, *In the Blink of an Ear*, 37.

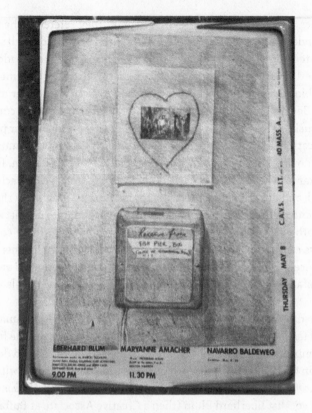

Figure 3.11 Poster for *Incoming Night: Blum at the Ocean Pier Six, Boston Harbor, 11:30 p.m.* Courtesy of the Maryanne Amacher Foundation.

environmental—aural and visual—where their works would be heard" apart from proscenium-bound concert formats.[58] Before posting up at the pier, Blum had delivered a recital at the Hayden Gallery that included John Cage's "45"" for a Speaker" (1954) and Kurt Schwitters *Ursonate* (1922–1932),[59] as listed on the poster in Fig. 3.11.

Renée Levine Packer recalled "an intriguing dialogue between Blum, seagulls and the nighttime shore sounds of horns and wind that surprised listeners with a unique and gentle poetry."[60] Her description fills out the title—*Incoming Night*—in a vivid way. The title evokes an encroaching nightfall that absorbs dusky sunset colors into the inky waterscape. Such a picture courts what Barry Truax calls an "environmental holism," which roots soundscape composition in the ideal of

[58] Levine Packer, *This Life*, 150.

[59] Ibid., 151. The piece became one of Blum's signature works after 1975 performances at Albright-Knox and The Kitchen.

[60] Ibid., 150.

all-embracing openness germane to the post-Cagean continuum.[61] For Truax, this entails a fixed standpoint, a unified location, an uninterrupted period of time, and recognizable sonic sizes, shapes, and dimensions to which listeners could relate "pre-existing knowledge and psychological experiences." *Incoming Night* suggests an intimacy with the romantic waterfront ruin that could fulfill these criteria quite well. Listeners not only catch the harbor in a diaristic mode as it sings in hums and buzzes; they also learn to sing with the harbor in the ways that it also sings to itself. In Blum's performance, whistles, breaths, and vocal sounds underscore how analytics of soundscape remain steeped in ideologies of voice. To return to Delia Casadei's assessment, this intersection prescribes that environmental sound should be "present and intelligible, yet detachable from language" and "traceable back to a [. . .] unrepeatable human body."[62] But like *Adjacencies*, long distance music points elsewhere. To again build on Casadei's questions: What is the place of social tense in this arrangement? What happens when historical figurations of distance refuse to get out of the way? How do these assumptions evacuate technical and material supports but also channel them through other means? Although the title, *Incoming Night*, invokes a vivid sunset, Amacher's extended title, *Blum at Ocean, Pier Six, Boston Harbor, 11:30 p.m.*, adds a contradictory time frame. Dusk would have ended hours before Amacher began *Incoming Night* at 11:30 p.m. The title's imagistic conjuration more aptly names the technical conditions of the feed itself. Transmitted from the phone block at Pier 6, the harbor's sound world would be only and always "incoming."

After *Incoming Night* at the Hayden Gallery, Amacher composed a magnetic tape piece with the same name, which combined recordings from her mono harbor feed and sessions with Blum in an anechoic chamber at MIT. The Center for Creative and Performing Arts in Buffalo had commissioned her, that year, to create new works that marked its tenth anniversary, recognizing her involvement with the CAs during the program's inaugural years. By August 1975, her plans involved at least three recording projects: one with instrumentalists in Buffalo made in February 1975 listed in a late 1980s works list with the title *Presence*, a second with Blum and recordist William Crosby in the anechoic chamber made

[61] Barry Truax's prescriptions for the practice of soundscape compositions entail the following: that the listener be able identify sound sources; that the composers' knowledge of the environment has shaped the composition; that the listener's pre-existing knowledge of environmental and psychological facts be invoked; and that the composition induces a new understanding of the environmental that can be carried over into everyday perceptual habits. Following Truax would mean identifying sounds and sources (vessels, planes, gulls, etc.) and then providing a mix that evokes three-dimensional experience in accordance with a listener's understanding of shapes, sizes and, speeds at which night arrives in the harbor. See Barry Truax, "Soundscape Composition," https://www.sfu.ca/~truax/scomp.html, accessed June 3, 2020. For a critical account of formations of history and narrative that can emerge from these protocols, see Yvette Jackson, "Destination Freedom: Strategies for Immersion in Narrative Soundscape Composition" (PhD diss., University of California San Diego, 2017).

[62] Casadei, "I fatti di Milano," 2.

in May, and another taken directly from the harbor feed.[63] *Incoming Night*'s fixed media version was also a long distance music that took its implication in remote circuitry as a horizon of formal concern and elaboration. Consider a related work. In an expert analysis of Luc Ferrari's *Presque rien No. 1* (1967), Brian Kane shows how the tape piece reveals its claim to environmental holism to be a product of its mediatic circumstances. Though Ferrari clearly broke with reduced listening in favor of an encompassing openness to the sounds of the Dalmatian Coast, Kane observes that he treated those sounds with an emphatic flat mix. "If one listens closely to the mix, the listener may notice that everything is pressed up to the surface and presented with equal audibility and clarity," Kane summarizes. "The cicadas are loud, just as loud as the sounds of lapping water, a sputtering engine, hammering, footsteps on wooden planks, or a speaking voice."[64] Amid what he calls "massive incongruences," Kane reveals that the flatness of Ferrari's mix references the tape on which coastal sounds were recorded and that produced and upheld piece's open, holistic semblance, in the first place.

The *Incoming Night* tape also took its remote mediatic circumstances into account and, by so doing, created auditory thresholds within which the harbor's tone-of-place could make itself felt. In a little under thirty minutes, the tape layers stereo recordings of Blum and mono documents from the harbor feed in a clearly segmental formal design with clear edit points.[65] Blum plays very close to a stereo microphone pair throughout. Amacher pans his contribution to nestle mouth sounds in the left channel while whistles, breaths, tones, and flutters arch through the right. Her stereo placements suggest a left-to-right arrangement of the flutist's mouth and hands across the instrument, conjuring a surprisingly clear visual image of Blum. His sounds control the tape's first segment, which lasts about nine minutes. The flute responds to Blum's hard exhale with a thick, smooth band of high and middle partials that streaks from left to right across the stereo spread. When he breathes in through the instrument, this band becomes thinner and its edges sharper. Whistles add filaments, a low flutter purrs in the right channel. After three minutes, Blum introduces an anacrustic fall from G to E above middle C, an intervallic frame that braces the harbor's tone-of-place at the octave. Only infrequently, he completes the stepwise ascent E–F#–G to briefly disclose this "tone" in the stereo segment. As Blum finds different ways to foreground the speed of air and breath, reference to this falling third persists and he often presents only an E-natural using whistle tones, microtonal inflections,

[63] For fellow artist's description of how Amacher transported sound to create ghostly presences please see Cristina Kubisch, "Time into Space / Space into Time: New Sound Installations in New York," *Flash Art* (Italy) Iss. 88–89 (March–April 1979): 16–20.

[64] Brian Kane, *Sound Unseen: Acousmatic Sound in Theory and Practice* (Oxford: Oxford University Press, 2014), 131.

[65] I am grateful to Andrew Munsey for assisting with this analysis. We monitored the recording through a Mid-Side decoder, listening for differences between the mono and stereo content. In addition, we observed the spectral content on a spectrogram in the iZotope's application RX.

overblowing, and a velvety vibrato-less tone. This small gesture seeds the harbor's tone-of-place without stating it explicitly and creates a diatonic situation within which it registers in a determinate way through the stereo recording's technical and institutional circumstances. Even as the detailed stereo image repeatedly distinguishes itself from the mono feed, Blum's melodies call to the harbor as their veiled receiver.

Hulky chugs become louder and denser in the mono layer and, after nine minutes, the harbor sounds alone for a first, long stretch. Spare and sensuous, the tape's mono portions evoke transforming three-dimensional shapes without the spatial cues Amacher emphasizes so strongly in the tape's stereo layer. A long static period offers droplets, a subtle ringlet in the air, and round avian bleating. Blum re-enters with mouth sounds that reassert extreme proximity. A short flutter-tongue places a pebbly substrate in the right channel. Subsequent mono segments are increasingly active. Diffuse frequency combinations cohere into compact complexes only to disperse again. High-frequency rotations ease in and out of the feed during the tape's densest and longest stretch of pointillistic avian activity. Droplets add grounding pocks while blocks of frequency condense, and churn as through turning themselves inside out again and again. Descending glissandi send banner-like lines streaming through the air. With no fade, the edit is over when a finger presses stop in the middle of another spectral shape.

Though a shared tone-of-place designates one as the other's implied receiver, the edit's juxtapositions assert distinct—perhaps even contradictory—phrasings of distance. The mono segments reprise ways of listening that Amacher associated with remote circuitry and it is not hard to imagine that one is also hearing the live feed, although that was true for neither Blum nor the tape's future listeners. At the same time, the tape's play between extreme proximity in Blum's stereo segments and a mono layer that dramatizes spectral transformation creates two distinct mediatic conditions under which to experience ways of hearing what is "close up" and "far away." No telelink connected the pier to MIT's Building 20 during the recording sessions. However, "Green Weather" and "The Visitor" suggest that such a link need not exist in the first place. Other mediations could link Blum to the harbor, and in this case, his diatonic play with tone-of-place coordinates this jointure which is also a separation. The tape's segmented construction suggests a fictive point-to-point connection between the harbor and the recording session, creating less a duet between Blum and the Boston Harbor and more an ensemble-like play between long distance listenings under multiple mediatic conditions.

In sketches for two *City-Links* events at the MCA in Chicago shown in Fig. 3.12, Amacher again cast the harbor's tone into linkless connections. The MCA billed the pair of events "installation-performances." On Friday, May 11, 1974, at 8 p.m., Amacher created the sound environment *Everything-in-Air* using six tracks of recorded sound from her *Life Time* tape collection in continuous performance. Between 1 p.m. and 4 p.m. the following day, she mixed live feeds in *City Links*,

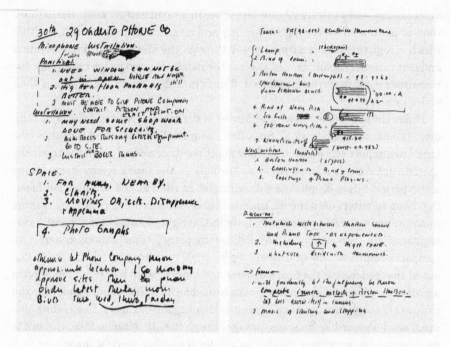

Figure 3.12 Amacher's working notes for *City-Links, Chicago 1974* (May 1974).
Courtesy of the Maryanne Amacher Foundation.

Chicago 1974, Hearing the Synchronicity with the *Life Time* tapes. As co-sponsors of
her visit, Amacher explored sites with students from the School of the Art Institute
of Chicago and worked with students from Art Department of the University of
Illinois at Chicago on installation and video tape recordings at remote location
to accompany the performance.[66] In two sketches for the afternoon performance
shown in Fig. 3.12, Amacher inventoried five frequencies associated with Navy
Pier and sketched the Harbor's low F# on the five-line staff alongside "Tower"
and "Coastings," two characters in the tapes, which could reinforce the composite
six-tone collection that combined Boston and Chicago. Under the heading "form,"
however, Amacher outlines a performance that culminates with the harbor tones,
not Chicago-based feeds. "I will gradually let the frequency be known—the com-
plete inner melody of the Boston Harbor," she wrote, underlining the second frag-
ment for emphasis.[67] This could take various forms. In addition to tapes from the
Harbor feed itself, other *Life Time* recordings added complementary frequency
structures, like "Tower" whose "F# (92.499)" could "reinforce harmonic band,"

[66] Description of the Project and Press Release, Museum of Contemporart Art Chicago Archives.
[67] These notes appeared at exhibition Maryanne Amacher, *"Intelligent Life": Exhibition, Workshop,
Performances,* curated by Bill Dietz, Robert The, Micah Silver, and Axel Weider as part of the DAAD
Berlin Künstlerprogramm in July and August 2012. Photograph by the author.

according to the sketch. As in the *Incoming Night* tape, the harbor's tone could express itself indirectly, inaudibly and in relation to frequency structures in situ.

A second formal note, which references "the magic of starting and stopping," suggests less a definitive superposition of the harbor's melody over the pier's than a dynamic back-and-forth mix, which entangled listening in situ with remote circuity and linkless transmission—not unlike her *Incoming Night* tape edit. As her mix combined the characteristic tones of two different sites, it also would have gradually woven together linked and linkless listenings for the duration of the performance.

This section has considered tone-of-place, *Incoming Night*, and its companion-ate tape with Amacher's own three-part LONG DISTANCE MUSIC as an analytic field guide. These interpretive coordinates reveal an ad hoc communications network that weaves linkless connections into remote circuitry and entangles the harbor's tone with the technical conditions in and through which Amacher came to know it. These projects do not so much end as reconfigure auditory thresholds in relation to long distance music's subjunctivity and route affective resources through alternative conduits to accumulate in unexpected environments and embodiments.

Long Distance Music at the Center for Advanced Visual Studies: "Anywhere City" (1974)

"The river was poisonous," Keiko Prince said, while explaining how she had become involved with the Charles River Project at MIT's Center for Advanced Visual Studies in 1971.[68] Prince was born in Tokyo in 1937 and completed the MFA with a focus on sculpture and urban design at the Tokyo University School of Fine Art in 1962. She moved to Boston in the mid-1960s and, under the auspices of a NEA Visual Arts Program Works of Art in Public Spaces grant, created murals for the Summerthing festival, in 1970. After seeing Prince's work, CAVS director György Kepes invited her to participate in the Charles River Project at the Center.[69] There, she joined a cosmopolitan cohort of sculptors, painters, architects, and urban planners tasked, by Kepes, with designing interventions for the Charles River and Boston Harbor environments. She met Amacher in 1972 during preparations for the CAVS group show *Multiple Interaction Team* that traveled to the Museum of Science and Industry in Chicago. As Prince put it, "Kepes' thing was: What are you going to do? How to revive this environment?" He fostered proposals for massive "civic scale" architectural insertions that integrated

[68] *Ways of Hearing Workshop*, co-convened by Bill Dietz and the author, Philadelphia, Pennsylvania, April 13, 2019. This event was presented by Dustin Hurt and Bowerbird in collaboration with Lawrence Kumpf and Blank Forms.

[69] Conversation with the author, February 20, 2017.

ecological remediation's technical challenges with novel perceptual experiences that expressed its civic value via complex data streams and embodiments. This public art practice rooted in both technocratic management and concepts of the expanded field sought to "revitaliz[e] the deteriorating river environment as a public, open space."[70] Projects realized and unrealized took form in written proposals, sketches, models, and calculations that employed virtual environment design, spatial transposition, and intrasensory modulations that Amacher had also combined to variable ends in *City-Links*.

The Boston Globe opened a 1971 article on CAVS' ongoing projects with the sardonic line, "There's nothing wrong with the Charles River that an active imagination cannot fix."[71] Skepticism coursed through the article, casting artists as dreamy and detached. However, by sidelining art world demands, Kepes believed that the Center would enable artists to carry out research and speculation in dialogue with civic agents. To distinguish her work at the CAVS from concurrent land art and minimalist sculpture, Prince recalled, "You know, talking to Kepes, I [felt] like I was a public worker."[72] Kepes maintained dynamic interdepartmental relationships with MIT engineers and pushed for institutional and individual partnerships with government actors working on the river environment.[73] This contributed to an institutional culture at CAVS in which no idea was to be dismissed as impossible, no matter how wild. Kepes was especially adept at mediating between the fellows' speculations and new interlocutors.[74] He opened a 1971 letter to MIT geologist Frank Press, for example, by demurring, "I hope you don't think I'm too greedy, but I come with a new request here. We have embarked on a rather utopian project here at the Center" before going on to ask if fellows can simply try out a "geophysical air gun at least 34 feet in length," which Kepes had

[70] Keiko Prince, personal website, accessed March 5, 2017.

[71] John Wood, "Up a Laser River with MIT," *The Boston Globe*, October 7, 1971, 16, Center for Advanced Visual Studies Special Collection.

[72] Kabir Carter, Bill Dietz, and the author, in conversation with Prince, May 15, 2020.

[73] After the article "Up a Laser River" ran in the *Globe*, for example, Parks and Recreation Department Commissioner Joseph E. Curtis initiated correspondence with Kepes, which resulted in meetings with Charles River Project members. Letter from Curtis to Kepes, October 13, 1971. See also Letter from Kepes to Metropolitan District Commission Commissioner John Sears, May 4, 1971.

[74] See also Anne Collins Goodyear, "Gyorgy Kepes, Billy Kluver, and American Art of the 1960s: Defining Attitudes Toward Science and Technology," *Science in Context* 17, no. 4 (2004): 611–35. Attempting to secure collaborators , Kepes distinguished the Center's "utopian" gestures from MIT's defense-facing projects and acknowledged straightaway that their plans might strike engineers as "unrealistic." Kepes facilitated connections with the Charles River Recreation Council, Parks and Recreation Department, the Department of Mechanical Engineering, and Metropolitan District Commissioner John Sears, among many others. Fellows, also, coordinated presentations in these fora. For example, in spring 1972, Keiko Prince, Stanley Resnicoff, and Thomas McNulty shared a proposal with Sears that detailed a festival presentation consisting in "a maze of water reeds with pathways that lead to the river's edge [with] photographic panels depicting river life and history placed among the reeds [. . .]" Letter from Prince et al. to Sears, April 11, 1972.

heard Press's department had on hand.[75] "[We] are hoping to create a year-round changing pageantry on the Charles River, with the intention of refocusing attention on its rich aesthetic role in our urban life," he explained, "some of our people are developing a variety of possible ways to animate the water."[76] Even poison water could be coaxed to dance.

Many Charles River Project proposals addressed water pollution directly. Kepes and architect Thomas McNulty proposed water filtration facilities; Nancy Bochenek sketched floating modules for magnetic walkways across the water and McNulty drafted plans for a circular water-borne piazza accessible via tube-mounted bridges that could control runoff alongside a partly-submerged oceanographic pyramid with sculptural pedestrian thoroughfares.[77] For the filtration plant, Kepes recommended a break with forbidding "industrial stereotypes."[78] Filtration processes should be neither enclosed inside a machine's gleaming shell nor tucked away from public view in a remote location on the harbor islands. Instead, its inner workings could be broken down into interlocking cycles and patterns and enriched with historical, aesthetic, and formal associations. "One can visualize," Kepes wrote, "an immense transparent structure that gives visibility to hydraulic processes, a contained but legible ballet of water racing through obstacles of filters, tinted and purified by chemicals, or moving sluggishly in intricate but legible patterns inside transparent containers."[79] Moving water could conjure classical forms like colonnades, arches, vaults, and pillars as much as natural wonders like geysers and waterfalls. Kepes's architectural collage promised the Charles River a place among Europe's storied waterways and crafted comparisons with the Roman aqueducts. The plant's watery kinesis offered a plethora of data streams that, once made "legible," could tie people to situated material histories, environmental processes, and civic futures.[80] For Kepes, "this stability of organization[s] of vision and sense," Orit Halpern explains, "made the content malleable in scale and meaning."[81] One might see the river anew—and as already much cleaner—after having beheld water leap, twirl, and spiral through the plant's filtration process. The plant commits its viewers to the river environment by loading its ongoing, open-ended remediation with perceptual surprises, positive affects, and novel design concepts that reference familiar genres and histories. The plant

[75] Letter from Kepes to Frank Press, Naval Architecture, Hydrodynamics Laboratory, Center for Advanced Visual Studies Special Collection.

[76] Ibid. He also likened the project to the Tivoli Gardens amusement park, constructed in Copenhagen in 1843.

[77] McNulty, "A New Modular Conduit," description and sketches and Bochenek, "Floating Modules," sketches, Center for Advanced Visual Studies Special Collection.

[78] Kepes and McNulty, untitled text, 1, Center for Advanced Visual Studies Special Collection.

[79] Ibid., 3.

[80] Orit Halpern, *Beautiful Data: A History of Vision and Reason since 1945* (Durham, NC: Duke University Press, 2014), 40 and 113.

[81] Ibid., 106.

offered a "living palimpsest in which various historical strata, ancient ecosystems, industrial waste, contemporary ecological intervention would all remain visible and evolve together."[82] Kepes and McNulty's design would not only show that the river's water was of all these things; it would convince people that its disparate materializations and temporal scales could be experienced, all at once by a sensing body. Throughout the Charles River proposals, remediating the environment meant also revitalizing the sensorium in relation to liminal infrastructures and material configurations at the edgelands.

Prince again provides useful historical coordinates. "Back in 1972, we had the energy crisis," she explained, "for instance, my thing was what if we do everything from the energy from nature?"[83] Many Charles River Project proposals introduced viewers to fluctuations in water, air, light, plant growth, and weather conditions as data streams meted out in discrete units of light, shadow, or color whose patterns could be juxtaposed and combined to dramatize ongoing processes.[84] Unlike a second-generation cybernetics, which dreamed that information could be "free from material constraints that govern the mortal world" as N. Katherine Hayles puts it, Kepes prioritized data streams that could deepen peoples' ties to their environments, by revealing patterns that held their composite materialities and histories together at variable temporal scales.[85] In the project "Light and Life Garden," architect Juan Navarro Baldeweg proposed a dark greenhouse-like dome inlaid with prisms whose distributed refractions would produce complex patterns in the plant growth inside.[86] "Light is decomposed by a lens in the color spectrum," he described "[in order to] arrange spontaneously the growth, tropisms, distributions and clusterings of vegetal life."[87] The project staged layered sensory transpositions: sunlight was broken into its constituent parts; plant life expressed those

[82] Savage, "Monuments," 251. Aspects of Kepes's vision align interestingly with more recent approaches to memorializing industrial sites in ways that take into account evidence of their environmental impacts. In this essay, Savage chronicles development proposals for the Nine Mile Run neighborhood of northwest Pittsburgh that treat industrial slag as a both a locus of public memory and a site for community-led environmental intervention.

[83] Kabir Carter, Bill Dietz, and the author, in conversation with Prince, May 15, 2020.

[84] Divergent understandings of environmental remediation emerge across the fellows' proposals. Some embraced Edenic rhetoric to suggest that the Charles could be returned to some kind of "pure" or "pristine" state. In his park designs, Lowery Burgess asserted that "the right to dream is a basic human right" and cautioned that "it is being constantly eroding by the patterns of urban life." Others scrambled perceptual norms and flouted seasonal expectations to induce visitors to imagine the waterfront otherwise. Still others centered pre-colonial environments and knowledge. For the latter, see Prince et al to Sears and Burgess, "Reforestation."

[85] N. Katherin Hayles, *How We Became Posthuman: Virtual Bodies in Cybernetics, Literature and Informatics* (Chicago: University of Chicago Press), 13. See also Halpern, *Beautiful Data*, 95–99.

[86] György Kepes, "Additional Information Related to the Application of the Center for Advanced Visual Studies for Funds from the Massachusetts Council for the Arts and Humanities," October 22, 1971, 3, Center for Advanced Visual Studies Special Collection.

[87] Juan Navarro Baldeweg, "Report, " September 1972, 3, Center for Advanced Visual Studies Special Collection.

patterns in greenish hues, scents, and textures; plants and patterns, together, coordinated seasonal play so that visitors would experience "spring in winter" and "winter in summer," as Kepes summarized in a 1971 grant application.[88]

Prince's designs for *The Shelter—Sun Water Dial* (1972) expressed the river's water and light as a spatio-temporal flux in relatedly seasonal and geophysical terms. At a curve in the river known also as Magazine Beach, she designed two reflective surfaces that extended over the water, like a round floor and ceiling, with a small aperture through which viewers could observe the river water through the glittery enclosure, as depicted in Fig. 3.13.[89] Mirrors on the lower extension would reflect the moving water's patterns onto the screen-like panel above it, at once doubling and inverting the river environment. Using Magazine Beach's latitudinal and longitudinal coordinates, Prince also arranged over 120 prisms on the roof of the structure relative to the sun's position on the horizon.[90] For any hour on any day in each month, Prince calculated exactly how many prisms would be illuminated. Nested seasonal and diurnal cycles would, in effect, switch discrete prisms on and off to create patterns and luminous intensities.[91] Prince emphasized that this would be most dramatic during the Summer and Winter Solstices.[92] "During June, at noon when the sun is highest, only one prism will shine on the *Dial*," she wrote, "In December, at sunset, all prisms on the roof will be shining."[93] In addition to spatial inversions, *Dial* involved sunlight in seasonal juxtapositions whose temporal drama unfolded one prism at a time. In this way, *Dial* created a kind of analog media interactive that made incremental change legible by adding or taking away discrete points of light.[94]

[88] Ibid.

[89] Conversation with the author, February 20, 2017.

[90] Keiko Prince, "THE SHELTER—SUN WATER DIAL," project notes. In her description, Prince links *Dial* to "Tsuki-Mi," a Japanese moon viewing celebration during a mid-autumn full moon based in a shared experience that "acknowledges the cycle of time," as she puts it. While she designed *Dial*'s prisms with sunlight in mind, she also likens their "patterns of reflection" to "the phases of the moon, with the two contrasting areas of light waxing and waning reciprocally."

[91] Ibid., 2.

[92] Ibid., 2.

[93] Ibid., 2.

[94] Similar inversions appear in Lowry Burgess's "The Reforestation of the Charles River: A Concept for a New Park," which proposed a complex chain of parks, fields, earthworks, playgrounds, gardens, amphitheaters, and promontories. To light them, he recommended dispensing with top-down streetlamp-like fixtures and instead placing lights at the base of trees in order to illuminate them from the ground up. Trees would disperse light, and at night they would become sculptures in their own right. In Burgess's park, nightfall did not mean the end of the day but rather an inversion of sunlight's spatial orientation along a vertical axis. "Our basic idea is to make the night light the negative of the day," he wrote. Lowry Burgess, "The Reforestation of the Charles River: A Concept for a New Park," undated proposal, 7. In another project description, Burgess described spatio-temporal inversions at galactic scale. Titled "The Star-Pits," he proposed to dig pits into the ground at depths proportional to the age of light coming from the star cluster Hercules and the Spiral Galaxy Andromeda (respectively, 22,000 and 2,000,000 light years). A mirror and water-prism would reflect sunlight to create "lines of light, or a Star-Pit of the future." Burgess, "Star-Pits Waiting for Light Planes," undated description, Center for Advanced Visual Studies Special Collection.

(a)

(b)

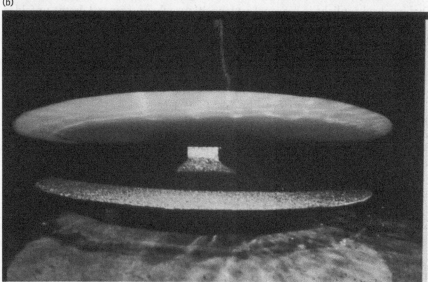

Figure 3.13 Keiko Prince's *The Shelter—Sun Water Dial* (model). Courtesy of Center for Advanced Visual Studies Special Collection, MIT Program in Art, Culture, and Technology and reproduced with permission from the artist. Photos by Nishan Bichajian.

These media insertions entice viewers to experience environmental monitoring as a sensuous, affective charge that crisscrossed sense modalities and intercalated seemingly disparate processes and cyclicities. If only for a moment, bodies became newly intensified in relation to themselves and to materials like light, air, color, heat, water, traffic sounds, or otherwise familiar infrastructure. This, Jasbir Puar writes, is "one definition of affect."[95] This combined practices of "reading the city" associated with older walking encounters of Benjamin and Certeau with computational implantations whose sensory environments grew visitors' competence with media interactives. For the Charles River Project, revivification meant reorganizing the river around reliable zones of intensification that promoted—from myriad and counterintuitive sensory pleasures—a kind of civic coherence around environmental attention and sensible data.[96] Kepes characterized this work as a response to moral demands immanent to the river itself: "The Charles River," he wrote, "is an accusing finger that shows clearly the discrepancy between what is and what could be in our urban life."[97]

In 1973, the Architectural and Environmental Art division of the National Endowment for the Arts (NEA) piloted a grant program titled "City Edges," which addressed what the NEA called "urban boundary conditions," and listed as examples sites like "waterfronts" and "highways," located unambiguously at city edgelands and interzones. As a follow-up to "City Edges," the division committed its 1974 and 1975 funding allocations to a second and larger program titled "City Options," whose proposed projects would unfold, in some cases, over a fifteen-month period, as preparation for the US bicentennial in 1976. In their summary description, the NEA replaced the 1973 program's focus on "edges" with a vaguer and more boosterish prompt that pledged to support "projects concentrating on special settings within cities that provided distinctive character and identity."[98] Amacher submitted an ultimately unsuccessful proposal to "City Options" titled "Anywhere City," listing Luis Frangella and Juan Navarro Baldeweg as co-investigators.[99] In the proposal, Amacher wove together themes from LONG DISTANCE MUSIC, *City-Links*, and *Adjacencies* to create a comprehensive research program that eschewed noise abatement in favor of spectral transportation and reinforcement that wove environmental sound into speculative horizons of compositional possibility. In a proposal that often reads like an artist's statement, Amacher

[95] Jasbir K. Puar, "I Would Rather be Cyborg than a Goddess: Becoming-Intersectional in Assemblage Theory," *philoSOPHIA* 2, no. 1 (2012): 60. See also Brian Massumi, *Parables for the Virtual* (Durham, NC: Duke University Press, 2002).

[96] See also Ann Balsamo, "Digital Humanities Catalyzes Technological Innovation: You'll Never Believe What Happened Next." Paper delivered at Creativity, Cognition and Critique: Bridging the Arts and Humanities, a 50th Anniversary Symposium at University of California Irvine, May 21, 2016.

[97] Kepes, "Charles River Memo," June 28, 1971, 1.

[98] "City Options: Architecture and Environmental Arts," National Endowment for the Arts, i.

[99] Amacher et al., "Sound and the Environment," a background description, accompanying the proposal ANYWHERE CITY, submitted to the National Endowment for the Arts, "City Options."

poses a surprisingly personal meditation on *City-Links, WBFO, Buffalo* as the central impetus for "Anywhere City":

> The experience of creating resonance to the environment through sound first became a vivid reality to me after the 28 hour performance of my radio-broadcast CITY-LINKS, 1967 [also *City-Links WBFO*]. Here, 18 kcl telephone lines transmitted the sound "live" from microphones placed at 8 environments in the Buffalo area to the radio station, where I mixed and composed with the incoming sound in "live" broadcast. I left the radio station, and for over a week walked about in a very different outside world. Cars, planes, which I heard were no longer enemies, harsh elements of sound. There was suddenly music between the world and me. Lyrical links to the environment, as a result of the musical context I had made for those sounds during broadcast. My heightened experience was the result of the intensity and duration of exposure to environmental sound in a new way: I was mixing, "playing" the environmental sound as an instrument for this long stretch of time, and the musical context of this experience was still ringing very much inside me.[100]

Inaudible long distance musics lingered with the composer as would tone-of-place or "The Visitor." "HOW," she asked in all-caps, "TO MAKE THIS EXPERIENCE AVAILABLE WITHOUT THE OVEREXPOSURE THAT IT PROVIDED ME [?]"[101]Although this question impelled Amacher to seek out a musical language based in environmental sound, two early attempts proved unworkable. Reproducing frequency structures proved too abstract and static while what she called "statistical" approaches, which better approximated patterns and cycles in situ, could not capture acoustical characteristics in three-dimensional space. Two insights moved Amacher through this impasse and she explained the roles they would play in "Anywhere City":

(1) To hear what is sounding far-away and close-by simultaneously, thereby reinforcing the extremely interesting and varying auditory dimension and perspective present so positively in the acoustic space of ambient urban sound.

[100] Ibid., 3.

[101] Amacher was referencing Morton Subotnick's studio at New York University's Intermedia Program. See Robert J. Gluck, "Silver Apples, Electric Circus, Electronic Arts and Commerce, in Late 1960s New York," *Proceedings of the International Computer Music Association* (2009). Amacher described the studio as "a fabulous [and . . .] open place that worked out just beautifully. People would just come there." As Subotnick explained, "Since there was no other electronic music studio around where people could just work, I offered them some time in the studio in exchange for doing work [for instance] . . . several of the people did some editing on the commercials I was doing at the time. The studio functioned in a loose way like a kind of collective."

This experience of auditory dimension is rarely present in musical composi-
tions; and never present in our existing radio and TV sounding environments
[...]

(2) To hear harmonic patterns within the complex sound spectra.

At best ambient sound in the urban environment is puzzled-over by archi-
tects and sound planners, and at worst ignored. Both of the above aspects are
positive features, found within ambient noise, and are as yet unexplored in
any fundamental way.

Amacher rearticulates LONG DISTANCE MUSIC's approach to listening in situ
in relation to "ambient noise" and "ambient sound" and supplements this con-
junction with the hands-on spectral knowledge that she had so valued in the per-
cussionists of *Adjacencies*. The "ambi" of Amacher's "ambient" refers less to the
"aroundness" typically associated with immersion's soft embrace than the "both"
of "ambiguous" or "ambidextrous." Her proposed research method elaborated
Adjacencies' pedagogies of spectral attention and turns again to all-caps typogra-
phy to conjure the heightened experiences that her acoustical heuristic could coax
from the so-called "ambient."

> About (2) I would like to make the following remarks. A sounding of the
> musical instrument, the cymbal, for example, when heard at some dis-
> tance approaches noise—but putting your ear close to this instrument,
> you will hear many "melodies" within its complex spectra. Such "melo-
> dies," forms, patterns of frequency, of movement ARE PRESENT IN
> THE COMPLEX SOUND SPECTRA OF OUR URBAN ENVIRONMENT
> AS WELL, AND ARE WHAT IS POSITIVE IN WHAT WE PERCEIVE
> AND KNOW ONLY AS NOISE IN OUR CITY STREETS. THEY ARE
> PATTERNS OF MELODY WITHIN THE COMPLEX NOISE SPECTRA
> OF OUR ENVIRONMENT AND CANNOT REALLY BE PERCEIVED BY
> THE UNAIDED EAR.[102]

Put your ear next to the cymbal, she recommends. Listening to its spectral "melo-
dies" is one way to prepare to listen to an acoustical environment without spend-
ing twenty-eight hours mixing live feeds, as Amacher had done. As an oblique bit
of evidence—or perhaps even an invitation—Amacher submitted a single score
page of *Adjacencies* with her proposal.

Her backstory's acoustical provocations nearly overwhelm what is actually
being proposed in "Anywhere City." What can it mean to project these protocols
"Anywhere," as her title suggests? Amacher chose Boston's Copp's Hill to be what
she called the project's "model site" and sketched three ways to "transplant" its
acoustical characteristics to other locations in the city that she does not name. By

[102] Amacher et al., "Sound and the Environment," 3.

prioritizing sites that would be "crowded, less clear, confused or noisy but [have within them] traces of patterns, similar in harmony, frequency and movement (approaches and disappearances of sounding objects) to that of [Copp's Hill],"[103] Amacher sketched an additive and non-punitive approach to ambient noise through environmental sound-design in situ. Two complementary components in "Anywhere City" would extend these priorities to different mediatic circumstances. She proposed creating sound work for radio, TV, and concert settings that elaborates acoustic dimensionalities germane to Copp's Hill and that would circulate the "model site's" simulacral acoustic across public and private media circumstances. Her third, and perhaps most fantastical, component entailed linkless and speakerless sound projection near the Charles River.

> Placement in the urban environment, sound environments (such as the Charles River example) where there is no apparent architectural solution, which will reinforce and enhance the immediate and perceivable distant sound environment. This will most efficiently and transparently be accomplished (when there is no architectural solution available) as soon as reproduction of sound other than loudspeaker reproduction is available. I think this will be soon—at most 2 to 3 years. Many extraordinary possibilities will then become available.

All three long distance musics that Amacher had formulated in the early 1970s again make themselves felt in this proposal. Although not unlike other CAVS projects in her approach to environmental data streams, Amacher's abiding concern for mainstream mediatic experiences that included in-home transmission rises into sharp relief in relation to her CAVS colleagues. These proposed acoustical palimpsests created dimensional interplay that suggests virtual transport (as she had also imagined *Here* to have done).

Kepes wrote to William Lacy, then-director of the NEA's Division of Architectural and Environmental Arts, to support "Anywhere City" and sketched two theoretical coordinates to help Lacy understand the proposal's strengths and objectives:

[103] Ibid., 5. Amacher had already worked with a Copp's Hill location in an MIT campus exhibition titled *Weather* in November 1973, which took place in the Building 7 lobby at 77 Massachusetts Avenue. It convened CAVS Fellows as well as faculty and students from the Departments of Meteorology and Architecture. At this early stage, Amacher again described her contribution to the show as a "version of *City-Links, Buffalo, 1967*." It was titled *Time and the Wind Places*, and she offered this description: "sound is the weather barometer, as it reflects the changing degree of life and activity in four environments in the Boston-Cambridge area. What is sounding simultaneously at the Fish Pier in Boston Harbor, Copp's Hill and Salem Street in the North End and 'Dazzle' at Harvard Square, will be received at Ms. Amacher's studio, mixed and transmitted 'live' to the Building 7 lobby." She later also numbered *Time and the Wind Places* as *City-Links #5*.

There are two levels of approaching creative tasks related to the transformation of the urban environment. One is on a level of concrete particulars, developing realistic solutions for needed new, vital ways of shaping the environment. The other is to work on a deeper, less legible level and aims to prepare new attitudes in urban life.[104]

Kepes instructs Lacy to treat "Anywhere City" as an exceptional contribution to "new attitudes" associated with this second, "less legible" approach and emphasizes that any project, in truth, combines both "levels." This characterization is both right and wrong. "Anywhere City" had proposed not one but three projects whose concrete particulars addressed ambient noise through public sound art installation and extended the Center's commitment to the riverfront as an edgeland rich with data that could sustain deep perceptual engagement and connection. At the same time, Kepes seems to also have sensed how the proposal reveled in its own tenuous conditions of possibility. What it proposed, in other words, was in part its own rebeginning at another limit. Although unfunded, "Anywhere City" produces something new that remains both productive and foreclosed. This remainder performs the unrealized proposal as a radical sort of ongoingness.

Among the projects that "City Options" funded were museum exhibitions, developments in new arts districts, bicentennial events, and two art centers tied to the Alaska Pipeline for which construction was slated to begin in 1975. What could a "deeper," "less legible," or "preparatory" proposal that also fulfilled the program's mandate look and sound like? This question touches on historical conjunctures between expressive culture and biopolitical management with US cultural policy as its backdrop. "The NEA budget increased by hundreds of percent throughout the 1970s as an extension of the Johnson administration's use of social programs to manage crisis," Toby Miller and George Yúdice explain, which routed economic and political demands away from material redistribution and toward discourses of cultural membership.[105] With expressive culture as a new bedrock, economic and political demands had to pass through increasingly narrow concepts of cultural membership.[106] In Yúdice's words, "everyone was

[104] Kepes to Lacy, January 14, 1974.

[105] Toby Miller and George Yúdice, *Cultural Policy* (London: Sage, 2002), 49. See also George Yúdice, *The Expediency of Culture: Uses of Culture in the Global Era* (Durham, NC: Duke University Press, 2004), 31.

[106] These policy interventions took place between cultural, psychologistic, and political economic register of analysis. During the 1950s, the Area Redevelopment Administration's (ARA) anti-poverty programs responded to economic changes by tracking the movements of jobs in the industrial and fossil fuel industries. Starting in 1961, the ARA tailored job-creation strategies to plant closures and analyzed industrial decline as the root causes of economic poverty. This contrasted mid-1960s programs like the Equal Opportunity Act that brought poverty under psychological and cultural registers of analysis. However, the ARA foundered in other ways. The prospect of job creation collided with traditional divisions of labor whose power-differentiations upheld hierarchies of race, gender, and class, both in the home and across the social field. New jobs often did not register as legitimate

enjoined to take their place within an ensemble of recognized groups or to mobi-lize on behalf of their culture," marking a broader shift away from material redis-tribution and toward discourses of "cultural power."[107] However, Kepes's approach did not exactly align with the ascendant cultural registers of analysis that Yúdice identifies. Although he did not associate the harbor environment with commer-cial acceleration (as the Harbor Associates' pamphlet did), Orit Halpern explains that his approach to remediation vaunted a malleability in urban environments that sidestepped structural impacts of political-economic change, revanchist development, and racial discrimination in the greater Boston area. As she puts it, expressing the city through perceptual and sensory analytic registers "suggested a system with endless capacity for change, interaction or intervention."[108] What Kepes called the "accusing finger" of the Charles River demanded a civic response, and, without state or federal leadership, artists were to furnish perceptual and affective modulations that could both evidence and cultivate civic value at the waterfront edgelands. Proposal after proposal—with Amacher's among them—reveal how inexhaustible the options seem, at that time, to have been.

Data streams that coordinated topsy-turvy perceptual surprises downplayed questions of difference and materialized the sensorium as a site of alternativ-ity on which civic value could be staked prior to or apart from questions about material distribution, political rights, or cultural membership. Civic insertions and low-tech computational embodiments coaxed the sensorium to "act out" in precise ways that enabled a visitor to experience the Charles River's civic worth as though implicated in her own embodied experience without structural factors as a mediating step. In this sense, CAVS projects evoke older notions of aesthetic education, in which "exceptional domains of human experience" could be made to serve this or that project of modernity.[109] But, in another, their circuits could deliver sensuous, data-rich experience to discourses of what Puar calls biopolitical "modulation and tweaking" as much as observation, pleasure, and imagination.

if their positions in labor markets did not also match long-standing hierarchies in which masculin-ist control of the household tracked alongside an upward mobility promised, overwhelmingly, to the white nuclear family. Cold War messaging also had to attribute any substantial change to the free market and downplay the ARA's strategic interventions. On this history, please see Gregory S. Wilson, "Deindustrialization, Poverty and Federal Area Redevelopment in the United States, 1945-1965," in *Beyond the Ruins: The Meanings of Deindustrialization*, ed. Jefferson Cowie and Joseph Heathcott (Ithaca, NY: Cornell University, 2003), 181-200. For another account of intersections between cul-tural and biopolitical management in 1960s and 1970s US politics, please see Amy Cimini and Jairo Moreno, "On Diversity," *Gamut: Online Journal of the Music Theory Society of the Mid-Atlantic* 2, no. 1 (July 2009): 1-86.

[107] Yúdice, *The Expediency of Culture*, 31.

[108] Halpern, *Beautiful Data*, 121.

[109] Cimini and Moreno, "Inexhaustible Sound and Fiduciary Aurality," *Boundary 2*, vol. 43, no. 1 (2016): 19; see also, Jacques Rancière, *Politics of Aesthetics*, 28.

Both suggest, as Tiziana Terranova puts it, a "political rationality" in which "vital processes are from the beginning deeply intertwined."[110]

Although Amacher hedged on the "Anywhere City's" realizability, she did not write, in the proposal, about a "joy" nascent in the city and awaiting expression, as she had done in Buffalo. Instead, the proposal embedded the long-distance sensorium into a speculative approach to the city as a drama of perceptual access. In this sense, the proposal was not exactly "preparatory," as Kepes had put it, to Lacy. Rather, it posed concrete questions about how the long-distance sensorium that materialized in *City-Links* could function within the coordinates set forth by "City Options" and spaces of biopolitics that overlapped at the waterfront edgelands. To this end, the next two sections return to historical embodiments that materialize between long distance music's technological and rhetorical links to long-distance dialing to consider how *City-Links* worked in concert and conflict with biopolitical figurations of communications labor, in the twentieth-century United States.

Telephones, Telepaths, and Other Linkless Listenings: *Presence* (1975)

By 1971, telephones had been undermining ONE PLACE situations for some time and, although Amacher's *City-Links* projects did not traverse the public network, they nonetheless interacted with its figurations. Within a post-Cagean continuum, telephones and broadcast media proved to be reliable tools for attenuating intentionality.[111] In at least one letter, Amacher alerted Cage about New York Bell's new announcement services and provided numbers that he went on to use in *Telephones and Birds: For Three to Perform* (1977), in which three performers used coin tosses to select phone numbers from a list assembled via chance operations. Along with a personal note, she enclosed two quarter-page clippings from a December 1976 issue of *The Village Voice*.[112] One announced "Horoscope by Phone" with a dedicated number for each of the twelve sun signs, and invited callers to "take a horoscope break every day" and to "learn about the person you love most"—oneself. Another advertised Bell's new Dial-a-Plant service with a cartoon in which a droopy-eyed plant reclines in a too-small pot, guzzling soda

[110] Cited in Halpern, *Beautiful Data*, 184. Tiziana Terranova, "Another Life: The Nature of Political Economy in Foucault's Genealogy of Biopolitics," *Theory, Culture and Society* 26, no. 6 (2009): 234–62.

[111] Amacher certainly knew this and urged listeners to attend to Jungian synchronicities that emerged between remote feeds and sounds in situ, as she had told Norman Pelligrini in Chicago prior to her 1974 projects at the MCA. See also Ryan Dohoney, "A Flexible Musical Identity: Julius Eastman in New York City," in *Gay Guerrilla: The Life and Music of Julius Eastman* (Rochester, NY: University of Rochester Press, 2016), 116–30.

[112] Amacher's clippings are dated December 13, 1976. These enclosures and her short note are archived at the John Cage Collection at Northwestern University.

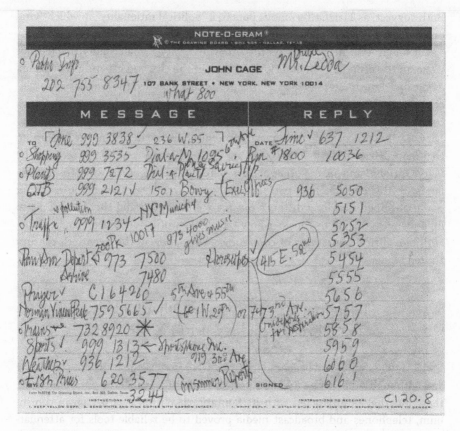

Figure 3.14 Draft list of phone announcements for John Cage's *Telephones and Birds* which includes Amacher's suggestions from their 1976 correspondence. Image courtesy of the John Cage Collection at Northwestern University. Copyright of the John Cage Trust.

and gripping a giant slice of cake. This call-in service promised help with such wayward houseplants: "Plants are as bad as people," the ad reads. At this new number, expert Jerry Baker offers plant care advice along with "samples of his homegrown philosophy."

Cage included "Dial-a-Plant" as well as all twelve "Horoscopes-by-Phone" numbers in *Telephones*, as shown in a draft list in Fig. 3.14. Pre-recorded announcements about New York City traffic, Pan American Airlines timetables, weather, and sports did not require conversation on the part of the caller; after hearing their desired information, the caller simply hung up. In addition to these New York–based announcements, Cage's lists for *Telephones* also included local phone numbers for Rare Bird Alert Networks in Maine, Vermont, and Maryland as well as

Albany, Buffalo, Philadelphia, and Washington, DC.[113] In this same short letter to him, Amacher also made sure that Cage knew about Hollis Frampton's experience with the Dial-a-Bird services in Buffalo.

> Have you seen these Dial-a numbers. Also, Hollis Frampton just told me that there is a wonderful 24-hour Dial-a-Bird in Buffalo (presented by the Buffalo Birdwatching Society). Bird calls and reports change each day! He listened for about 20 minutes and the birds continued their songs! I will remember to get the NASA number just in case.[114]

Amacher provided Cage with a little anthology of other people's calls and announcements that waited on the other end of the line for real and imagined listeners.

"The telephone" arrives already compacted with figural power. Calls remind us how often one can be mistaken for two or more. Amid this uneasy supplementarity, when a call is connected, it reveals that the recipient had never not already been connected to something or someone else in the first place. The challenge of managing this incursion of difference registered in gendered and racialized terms and materialized complex embodiments around distance and transmission. Early twentieth-century advertisements for business telephony assured users that "every Bell telephone is the center of the system."[115] This little soundbite sidelines the daffy, feminine gossip presumed to waste all of her time on the phone as well as a telephonic uncanny's threats to the bounded, integral individual. Instead, the synecdoche ensures the individual's personalized entitlement to the telephone system's technical power and geopolitical reach.[116] In such rhetorical figurations, "the telephone" represented a kind of discursive achievement that, as Jonathan Sterne has put it, could "signal organic unity among a whole assemblage of connections, functions, institutions and people."[117]

However, many not-quite-unpredictable intrusions could tag along with telephonic transmissions. In the mid-1970s, many upstate New York towns were still connected via party lines and one might also recall the nasty hum of the New York City power grid during the 1960s.[118] As Steven Connor notes, telephones users had to become familiar with "good lines" and "bad lines," whose fizzling and crackling indexed an ever-present threat that messages might leak or diffuse into

[113] John Cage, "Phone Number List," John Cage Collection at Northwestern University.

[114] Amacher to Cage, December 1976.

[115] Jonathan Sterne, *The Audible Past: Cultural Origins of Sound Reproduction* (Durham, NC: Duke University Press, 2005), 196–201.

[116] Ibid., 197.

[117] Ibid., 212.

[118] Bob Bielecki offered this helpful comment at *Labyrinth Gives Way to Skin I*, New York, March 2016. The event was co-convened by Bill Dietz and Robert The and presented by Blank Forms at Emily Harvey Gallery.

places other than their intended destination.[119] Party lines and private lines alike were prone to pick up other conversations as a well as public events like concerts, religious services, and civic events streaming across telephone lines.[120] A vast cyborg apparatus attached bodies, materials, and affects to these mediations. In addition to helping users feel welcome amid Bell's forbidding technological infra-structures, the telephone operator's hostess-like role also extended to the immi-nent weirdness of lost or missing calls. Operators nurtured users' faith in the network: regardless of whatever might befall a message during transmission, she would have already left its sender with the impression that she had done every-thing she could to make sure it reached only the ears for which it was intended.

While the heroic operator defended clear, secure lines of transmission, her foil—the telepath—could be made to personify bad, crackly, and fuzzy lines that took in anything and sent it anywhere. Alternative configurations of the senso-rium seemed to spring to life when messages traversed empty space to register, silently, with someone without sound or language as an intermediary step.[121] In "Green Weather," "The Visitor," and "To Glow in the Dark," Amacher had already crafted a collage-like poetics of workaday circuitry, elemental materials, and con-vivial scenes that drew out the sensorium's fuzzier nooks and crannies. Pauline Oliveros's "Pacific Tell" and "Telepathic Improvisation" (1973) also give instruc-tions for receiving, interpreting, and relaying soundless transmissions:

> Find your place in a darkened indoor space or a deserted out-of-doors area. Mentally form a sound image. Assume that the magnitude of your concentration on, or the vividness of this sound image will case one or more of the group to receive this sound imagine by telepathic transmis-sion. Visualise the person to whom you are sending. Rest after your attempted telepathic transmission by becoming mentally blank. When or if a sound image different from your own forms in your mind, assume that you are receiving from someone else, then make that sound image become audible. Rest again by becoming mentally blank or return to your own mental sound image. Continue as long as possible or until all others are quiet.[122]

Soundless transmissions become audible expressions, while "sound images" weave telepathic listening into acoustical listening and vice versa. If the opera-tor's senses channeled precision, pathos, and hospitality into logics of capitalist

[119] Steven Connor, *The Matter of Air: Science and Art of the Ethereal* (London: Reaktion Books, 2010), 197 and 206.

[120] See John Durham Peters, *Speaking into the Air: A History of the Idea of Communication* (Chicago: University of Chicago Press, 1999), 198, 206–7.

[121] Pamela Thurschwell, *Literature, Technology and Magical Thinking, 1900–1920* (Cambridge: Cambridge University Press, 2004).

[122] Pauline Oliveros, "Pacific Tell," in *Sonic Meditations* (Baltimore: Smith Publications, 1974), 5.

accumulation, telepathic sensorium suggests alternative communications networks in operation, at the same time.[123]

So too did Amacher's linkless scenarios. Amid seemingly insurmountable technical snags with Northwest Bell while preparing three *City-Links* installments at the Walker Art Center in 1974, Amacher quipped to Walker Art Center board member Tom Crosby that she considered replacing her telelinked projects with a soundless and linkless transmission from an anechoic chamber at MIT to the Walker Art Center as a last resort. From Boston, she imagined offering a "telepathic sound image." "No environment, no electronic links, no sound, no Northwestern Bell!," read her concluding flourish in a letter thanking Crosby for communicating with the phone company on her behalf. Critic Tom Johnson chronicled one such soundless and linkless event at The Kitchen during its 1971–1972 season (under the music direction of Rhys Chatham). Though he would later write admiringly about Amacher's *Living Sound (Patent Pending)* and her music for Merce Cunningham Dance Company, *Everything-in-Air* and *Remainder*, Johnson caricatures these projects as having fallen victim to their own imaginative excess.[124] Amacher had programmed the 1971 text piece SWEET SALT and EYE SLEEP EAR BREATHE,[125] and Johnson's skepticism about linkless long distance music prompted him to question Chatham's standards for unconventional work in general:

> Probably the strangest event of the season was the program of Maryanne Amacher. For this occasion, the small audience was seated on a carpet in the middle of the room and a meditative atmosphere was established with soft lighting and incense. Then we were handed a program which explained that Miss Amacher's music was being played in Boston and we were asked to try to hear it without the aid of any normal communication system. According to Chatham, three people claimed to have heard the music. But all I could pick up was some occasional shuffling in the hallway and I left that night feeling quite resentful about the whole affair.[126]

As Johnson's remarks on "shuffling" in the hallway suggest, listeners experienced sound in situ while also attempting to sense *Sweet Salt*'s soundless transmission. Two long distance musics again commingle: one that appeals to the ear and another that registers elsewhere. *Sweet Salt* expresses temporal synchrony and

[123] David Howes, *Sensual Relations: Engaging the Senses in Culture and Social Theory* (Ann Arbor: University of Michigan Press, 2003).

[124] See, for example, Tom Johnson, "Maryanne Amacher: Acoustics Joins Electronics," *The Village Voice*, December 15, 1975.

[125] Another text piece from the LONG DISTANCE MUSIC series, EYE SLEEP EAR BREATHE, reads as follows: "We are singing each other's MUSIC. And we know it, even though we do not make a sound."

[126] Tom Johnson, "Someone's in The Kitchen—With Music," *New York Sunday Times*, October 8, 1972.

durative presence as a double sensory mismatch in which sounds' inaudible coupling with the aural is expressed as an even unlikelier coupling with the inside of the mouth, in a title that invokes gustatory sensations. The event asks not so much after what can be heard but about how a linkless transmission might be experienced, in the first place. Long distance music registers as a faint impression on the body's complexly infolded surfaces and coheres through figures that dramatize alternative systems and functions across the sensorium.

As a commission that celebrated artistic exchange between CAVS and the Buffalo-based CAs, Amacher's 1975 projects with Center for the Creative and Performing Arts seemed poised for linkless explorations. At an early stage, Amacher characterized what she would create as "a work relating sound from the environment to musical performance."[127] But by 1975, environmental sound was also already, for Amacher, a long distance music. Recall how, on the *Incoming Night* tape, Blum's melodic gestures provided the harbor's tone-of-place with a diatonic frame that outlined its distant and durative presence and etched a linkless and soundless connection into the tape edit. This tape returned again in another component of the commission to which Amacher gave the suggestive title *Presence*.[128] In the middle of a late-night recording session in Buffalo, a tape reel catches Amacher talking with the tired musicians. "We can't just come in here and expect to be in the state of mind," Amacher states in a pause during a session that had lasted past midnight. The tired musicians agree to do another pass, and to listen together to the *Incoming Night* tape before beginning to play. And so, the recording begins with tape playback, after which the ensemble enters and, for an hour, explores a diaphanous and atmospheric sound world with piano, percussion, flute (Blum again), violin, and oscillators. In a dead-of-night liminality not unlike *Incoming*'s late-night performance, this studio recording suggests a linkless, here-ish, and there-ish connection between Boston and Buffalo. The session could be heard as a response or elaboration on the long distance music contained on the tape, with the harbor's tone-of place also coursing soundlessly through the diatonic sound world that the musicians created that late night in Buffalo. Blum participated in this session and over the course of twenty minutes explores stepwise melodies that touch upon G, A, and B-natural, a suggestive diatonic complement to G, F#, and E lines that he had contributed to the *Incoming* tape. In this late-night session, the music tends toward G and E-natural which enables the violinist to use open strings, resonant double-stops, and natural harmonics with tasto, ponticello, and natural shadings within a spare, delicate ensemble texture. Again, the point here is not to insist that these projects are centric in a traditional sense. Instead, prioritizing tone-of-place reveals how musical particulars connect Amacher's three long distance musics within a personal, idiosyncratic network

[127] Maryanne Amacher, "Recent Individual Projects," 1974 Press Package sent to Walker Art Center in Summer 1974.

[128] Works list, late 1980s.

that combines different materializations of transmission and social distanciation. Like *Incoming Night*, the Buffalo session embraces a diatonic environment congenial to the harbor's tone-of-place and leaves space in its frequency structures for its soundless presence.

Riffing on Derrida's eponymous 1988 essay, literature scholar Nicholas Royle muses that "tele*pathy* is also always *tele*pathy"—for distance always already inhabits "the heart of pathos."[129] Amacher certainly knew as much. Derrida applied this aporia to Sigmund Freud's 1920s essays on telepathy to draw out their anxiety and overinvestment in psychophysical processes that seemed to encroach on analytic expertise. Amid this encroachment, another historical long-distance sensorium makes itself felt. As Freud confronts patients and friends who claim that a telepath or medium has read their thoughts, he admits the possibility of thought transference; wishes and messages may very well traverse the empty space between the bodies of a telepath and her client.[130] Annoyed and scared, he suggests that that the telepath receives messages when she enters a state of suspended attention akin to that which enables an analyst to take in a patient's unspoken or partly spoken parapraxes. Yet, he also explained that she arrived at this state by different means. Her attention becomes unfocused, according to Freud, while she shuffles cards, tosses coins, or carries out astrological calculations. While distracted, her client's unconscious wishes seep through and, by the time she examines the cards, the messages she claims to read in them would have already arrived, through silent and wordless means.[131] She and her client would, then, erroneously credit the oracle.

If only for a moment, the distracted medium unknowingly engages in a "pace of communication [that could be] both more rapid and more efficient than that of language."[132] In search of biomechanical explanations for these wordless transmissions, Freud combined what he called "transformations of the telephone" with speculations about senses rooted in an atavistic "animal past." Both examples were meant to demonstrate that "the telepathic process would be physical in itself except at its two extremes: one extreme is reconverted into the same psychic content at the other extreme."[133] As Akira Lippit has argued, emerging tele-technologies in the late nineteenth and early twentieth centuries abetted a preoccupation with the transmission of ideas between bodies in which biological

[129] Jacques Derrida, "Telepathy," *Oxford Literary Review* 10 (1988): 3–41. See also Marc Redfield, "Review: The Fictions of Telepathy. Nicholas Royle, Telepathy and Literature: Essays on the Reading Mind," *Surfaces* 2 (1992): n.p.

[130] Freud, "Dreams and Occultism," in *The Standard Edition of the Complete Psychological Works of Sigmund Freud, Volume XXII: New Introductory Lectures on Psycho-Analysis*, trans. James Strachey (London: The Hogarth Press and the Institute of Psychoanalysis, 1932–1936), 40–47.

[131] Lacking an analyst's clinical training and humanistic knowledge, the telepath cannot meaningfully interpret these messages.

[132] Thurschwell, *Technology and Magical Thinking*, 125.

[133] Ibid.

and technological processes were employed to explain one another, often exploit-
ing the animal to figure their convergence.[134] Like other theorists of telepathy
that seized on biological modes of transmission, Freud argues that these conduits
evidenced the work of "senses no longer of our consciousness," which redoubled
prehistoric reality in psychophysical life. "Traces of residual animality" remained
imprinted on the psyche and sensorium of each individual.[135] Freud also reached
across animal species for examples of wordless signaling through empty space.
"We do not know," he writes, "how common purpose comes about in the great
insect communities. . . . Possibly it is done by means of direct transference of
this kind."[136] Early twentieth-century insect psychology teemed with provocative
biomechanical explanations for all kinds of nonlinguistic communication, such as
"chemical touch" across distance.[137] By the early 1930s, the study of social insects
had become a touchstone for eugenic arguments about life's disposition toward
hierarchical group formation that, according Paul Weindling, could be leveraged
to counter liberal individualism with proto-fascist ideals of clarity, order, and hier-
archy.[138] Insect populations exemplified how biological types could slot seamlessly
into both a rigid social order and a spontaneous, swarm-like flow. Fast and silent
biomechanical transmission held together layers of "common purpose" along
these lines. Undoubtedly, this terrified Freud. These explanations construct the
telepath's body as an anachronistic patchwork of involuntary receptivities that
gave rise to a unique, speedy kind of passivity. Part-prehistoric, part-animal, part-
telephone, and maybe even part-insect, the telepath cannot *not* transmit and she
cannot *not* receive transmissions. Freud's sketch not only intensified social anxi-
ety about psychic leakage, but it also assembled a chimerical sensorium rooted
in gendered and racialized tropes that epitomized its dubious, even monstrous
conduits.

A long-distance sensorium tangles with a complex historical anthology of lim-
inal couplings of sound with the aural across distance and durative time. In a gen-
eral sense, genealogies of linkless transmission evoke contact labor as a locus of
discipline and accumulation whereby alternativities, in the sensorium, can be at
once produced and foreclosed. For a feminist sound studies or sound art criticism,
it is worthwhile to consider how these risks and rewards play out along gendered
lines and how concepts of life and body are arranged or distributed, along the
way. While Derrida set a chiasmic relay between "tele" and "pathy" into motion,
Amacher provided the aporia with figuration after figuration: as a personage, a

[134] Akira Lippit, *Electric Animal: Toward a Rhetoric of Wildlife* (Minneapolis: Minnesota University
Press, 2008), 23.

[135] Ibid.

[136] Freud, "Dreams and Occultism," 55.

[137] William Mortone Wheeler, *Ants and Some Other Insects: An Inquiry into the Psychic Powers of these
Animals*, trans. August Forel (Chicago: Open Court Publishing, 1904), 33–49.

[138] Paul Weindling, *Health, Race, and German Politics between National Unification and Nazism, 1870–
1945* (Cambridge: Cambridge University Press, 1989).

tone, a drawing, a phone block, a typographical strategy, a taste, a shimmer of light. If telepathy might stoke fear, in other words, about ceaseless and uncontrollable exposure, Amacher's long-distance sensoria take up another fantasy, that is, one of partly-exposed here-ish and there-ish-ness mediated by tone-of-place and other linkless figurations. But against this utopic backdrop, remote circuitry could admit political and technological circumstances that long distance music could not control. Another look at *City-Links* technical supports reveals leased lines entangled with further figurations of long-distance embodiment.

Leased Lines and Direct Distance Dialing: Obsolescing *City-Links*

"Must decide ~~today~~ whether this is possible," Amacher wrote in black felt-tip pen on a bright yellow sheet of paper. "I have too many things to do that are distracting to my work."[139] In August 1989, Amacher researched a transatlantic transmission that would send remote performances from the Times Square subway station and a Kew Gardens studio to Linz, Austria, for Ars Electronica, later that fall. As she explained in the last moments of her lecture in Linz, her plan had been to perform with the New York–based transmissions, combining long distance music to ornament interaural response tones that Amacher would evoke in the ears of her audience in situ. This did not happen.[140] "110 degree heat record in the subway this week," Amacher wrote in a numbered list that summarized her doubts about the project's feasibility. She chronicled negotiations with AT&T and the MTA, and encountered new challenges with telelinks and leased lines. To use the 15 kcl lines that had supported *City-Links* during the 1970s, the feed would have to reach Linz via International Direct Broadband. Alternatively, she could employ UHF and VHF technology, which required a transmitter license and antennae installation on nearby buildings at measured heights—a far cry from the microphone, phone block, and equalization hardware that had previously needed only to be placed inside a stable-enough structure—which would have been easier, she noted, from

[139] Maryanne Amacher Archive, working notes, Box M09-19-09-06.

[140] In her working notes in preparation for Ars Electronica in late summer 1989, Amacher began to imagine alternative events, which included a proposed a telelink connection to the Delphi particle accelerator located underground on the border between France and Switzerland. Onto a newspaper clipping she wrote, "Gottfried [Hattinger]: Top secret (in the event we cannot realize NY → Linz tele concept) What about a line from LEP [Large Electron-Particle Collider]—'the heart of the matter'— possibly to be discovered in September—the missing 'top quark' [. . .] imagine the roar of the accelerators in the tunnels. But probably for security reasons, we will have to find scientist to place the microphone." This note suggested diegetic allusions similar to *Music for Sound-Joined Rooms* and the *Mini Sound Series*. More specifically, it offers an especially vivid example of how Amacher derived dramatic scenarios and aesthetic impacts from technoscientific environments. The article was Malcolm W. Browne, "World's Biggest Accelerator Surges to Life," *The New York Times*, August 8, 1989.

Boston, Long Island, or Providence. For Ars Electronica's Gottfried Hattinger, Amacher distilled a budget for two four-hour-long nighttime transmissions that included installation fees, hourly access per circuit, and air miles that amounted to a little over $11,000.[141] Dated that same day—August 8, 1989—Amacher also clipped a *New York Times* article with the headline "Phone Strikes Slow Customer Service in 3 Areas," which informed her that technicians and installers at NYNEX were on strike. On the newsprint, she drew brackets around a paragraph that announced additional upcoming strike deadlines and possible walkouts in the coming weeks, as she would have prepared the transmission.[142] These notes evidence that long distance music was always subject to changing commercial conditions on which it also tried to comment and intervene.[143]

Although Tara Rodgers cautions against overemphasis on technoscientific and industrial contexts in electronic music studies, *City-Links'* secondary and tertiary entanglements with telephony give rise to complex histories regarding how bodies were resourced and disciplined through contact labor, which have significance for long distance music's rhetorical link to long-distance dialing. While Amacher developed *City-Links* during the 1970s, AT&T was, at the same time, transitioning leased lines from analog to digital circuits in ATM networks, mainframe computers, and remote business environments under the auspices of AT&T's Digital Dataphone Service. This transition obsolesced *City-Links'* primary technical supports and cleared a path for the kind of ubiquitous computing to which Amacher would later respond in *Living Sound (Patent Pending)* and her media opera *Intelligent Life*. By the early 1960s, the post-war research field of management science determined that leased lines could reduce the cost of corporate communications for decentralized companies and globalizing governmental agencies. Sunbelt industries like aerospace, defense, and oil made prodigious use of these lines to connect corporate operations, with Lockheed Missiles & Space Company's Palo Alto, Sunnyvale, Santa Cruz, San Francisco, Vandenberg, and Cape Canaveral locations as model cases. Specialized how-to literature explained how Bell priced lines and showed managers how to produce data that could be used to assess whether or not leased lines would be more cost-effective than commercial long distance. These calculations included air miles, as did Amacher's budgets for *City-Links*, as well as formulas designed by management scientists to compare the cost of commercial long distance versus minutes used over a dedicated link.[144]

[141] Maryanne Amacher, Working Notes, Box M09-19-09-06.

[142] Robert McFadden, "Phone Strikes Slow Customer Service in 3 Regions," *New York Times*, August 8, 1989.

[143] Amacher did not realize this transmission project for Ars Electronica in 1989 and instead presented *2021 THE LIFE PEOPLE: a Four Part Mini Sound Series*, which she described as an "Installation of Sound and Visual Sets."

[144] John E. Hosford, "Optimal Allocations of Leased Line," *Management Science* 9, no. 4 (July 1963): 613–22, p. 620. New data accounted for the percentage of time a link would be used in order to avoid delays resulting from busy signals on dedicated lines during high-volume hours. To compare

Although leased lines were not the most up-to-date telecommunications option by the mid-1980s, globalizing agencies recognized their utility for establishing de facto private networks that standardized services, divorced from national or regional infrastructure needs and regulations. They were adopted by the 1973 Society for Worldwide Interbank Financial Telecommunications (SWIFT)[145] to automate the transmission and receipt of international financial messages and, in 1975, by the Aeronautical Fixed Telecommunication Network to standardize transnational service without involvement in local laws or infrastructure.[146] "Extensions of service," Felipe Noguera wrote in a stringent 1993 critique of privatized telecommunications, would otherwise have been "preceded by painstaking negotiations regarding operating authority, availability of circuits and compliance with national laws." As Noguera explains, these mandates had especially uneven structural impacts in post-colonial contexts, where they paved the way for private foreign monopolies and multinational cooperatives to purchase state monopolies that had been publicly funded during the 1960s and 1970s.[147]

Managerial strategies that assessed call volumes and costs against commercial long-distance relied on data generated on computerized consoles called the Traffic Service Position System (TSPS). To handle increased call traffic immediately following WWII, labor historian Venus Green explains, Bell replaced their iconic cordboards and implemented, by the mid-1960s, computerized dial-switching equipment on TSPS desktop consoles.[148] How this technology regularized operators' eyes, ears, and fingers diverged sharply from bodily comportments at the switchboard and remade new disciplinary structures into resources for communication products. While Bell had begun expanding the long-distance service Direct

with the commercial long distance, management science invoked data on commercial usage generated by long-distance switchboards.

[145] Julien G. Thomka-Gazdik, "International Cooperatives—Users of Private Leased Lines," *Jurimetrics* 25, no. 1 (Fall 1984): 94–104. As described in the technical literature this effort aimed to "study, create, utilize and operate the necessary means of telecommunications for transmission and delivery of private, confidential and personal information and financial international messages between the members of the cooperative association."

[146] Felipe Noguera, "'Beyond Structural Adjustment: Implications of the Privatization of Telecommunications in the Political Economy of the Caribbean," Presented to the Caribbean Studies Association Conference, Kingston, Jamaica (May 1993), 10–15. Colonial telephone networks were owned by government administrations and dedicated to external communication with colonial home offices. As Noguera reports, by 1993, 70% of the world's population and 20% GDP owned just 7% of the world's telephones. When colonial governmental monopolies became post-colonial state monopolies in the 1960s and 1970s, internal infrastructure was developed using public funds and debt-driven financial policy.

[147] According to Noguera, cooperatives like CANTO (The Caribbean Association of National Telecommunications Organization) allied state, public, and private entities in Latin America and the Caribbean in order to roll back foreign monopolies and adapt appropriate technologies for regional self-reliance.

[148] Venus Green, *Race on the Line: Gender, Labor, & Technology in the Bell System, 1880–1980* (Durham, NC: Duke University Press, 2001).

Distance Dialing (DDD) in the early 1960s, the TSPS accelerated its reach and
enabled customers to place a wider range of call types without operator assis-
tance. Selling this service as a new kind of proximity referred social knowledges
that had constituted earlier instances of long-distance telephony to newly auto-
mated and semi-automated processes. Material details bring these transforma-
tions into sharper relief. *The Bell System Technical Journal* touted the new system's
lean, customizable hardware and underscored its continuity with older models
of customer service, which cast personalized attention as telephony's central
affective product and suggested that contact labor would still enrich operators'
lives in the new computational environments.[149] "Operators can give customers
their undivided attention," a text devoted to physical design assured, "when calls
are connected to their positions."[150] But biopolitical concerns—about automa-
tion, surveillance, deskilling, and technological obsolescence—dominate other
sources. Even a book-length history commissioned by Bell for the US centen-
nial chronicled operators' frustrated response to the TSPS programmable fea-
tures in the early and mid-1970s: "just a few years ago, an operator was called
upon to 'build up' calls to distant points by choosing the best route," states an
anonymous interviewee. "Now, with TSPS, that is all done automatically."[151] At
the cordboard, an operator would have written a ticket after connecting a call,
but the TSPS detected all key actions and required only that the operator enter
billing information on a numbered keypad that recorded to memory the call type,
time, and charges clocked by a digital ticker at the top of the console.[152] As Green's
work on keyboard-based embodiments at the TSPS has shown, operator's audi-
tory and visual responses, repetitive motions in the hands and wrists were dis-
ciplined by the second in clock time and collected as data that could be used to
sell other products (like corporate leased lines). Many operators decried the loss
of "old cord-board closeness with other operators" as a "more lonesome job" and
some demanded to record their own voices for semi-automated services in order
to insert audible traces of their social knowledge into a system that had appropri-
ated it in the name of efficiency.[153]

How the TSPS distributed calls enabled managers to assess and discipline effi-
ciency in new terms.[154] Operators sat side by side in office-like centers with up to
124 TSPS consoles that could route incoming calls directly to unoccupied posi-
tions.[155] As the Bell technical journal explains, "the TSPS recorded call traffic in

[149] W. R. Baldinger and G. T. Clark, "Physical Design," *The Bell System Technical Journal* 49, no. 10
(December 1970): 2685–709.

[150] Ibid.

[151] John Brooks, *Telephone: The First Hundred Years* (New York: Harper & Row, 1975), 338–39.

[152] Green, *Race*, 215–17.

[153] Brooks, *Telephone*, 338.

[154] R. J. Jaeger Jr. and A. E. Joel Jr., "System Organization and Objectives," September 14, 1970. All
articles appear in *The Bell System Technical Journal* 49, no. 10 (December 1970): 2417–43.

[155] Green, *Race*, 216–17.

fifteen-minute intervals and generated a statistical picture of system workloads," which made it possible to configure operators into teams, whose size could vary relative to call volumes as indicated by TSPS data.[156] To these newly flexibilized operators, Bell applied the new job title "Customer Service Specialist," which Green argues, marked a slippage from work to service that enhanced managerial control at the intersection of data and efficiency; to be seen less as workers than servers is to be made easy to disassemble, reassemble, and exploit as a reserve labor force, often comprised disproportionately of workers already vulnerable to revanchist urban development and protectionism.[157] Green has also tracked how desegregation in the Bell System worked in tandem with the expansion of Direct Distance Dialing at the TSPS. The TSPS was part of a computational infrastructure that entrenched what she calls "technological segregation."[158] "By continually restructuring the narrow margin between deskilling and automation," Green explains, "new technologies presented opportunities to African American operators—only to close them again," as programmable features accelerated the encroachment of technological obsolescence.[159] "New technologies," Kalindi Vora and Neda Atanasoski summarize, "have historically designated what kinds of labor are considered replaceable and reproducible versus what kind of creative capacities remain vested, privileged populations and spaces of existence."[160] This was certainly the case in mid-1960s US telephony at the TSPS, where contact labor took place at a dense intersection between disciplinary enclosure and

[156] The complete account reads, "All positions on the TSPS are treated as members of one large team of operators to gain efficiency in service. There are several benefits. When the team size exceeds 120 operators, it is possible to achieve 92 percent occupancy, which has been established as an objective for operator services. Also, the full access of all trunk units to all occupied operator positions is valuable during light loads because all traffic can be sent to a small group of operators. This permits all but one group to be completely shut down during the lightest loads." R. J. Jaeger Jr. and A. E. Joel Jr., "System Organization and Objectives," *The Bell System Technical Journal* 49, no. 10 (December 1970): 2417–43. A series of articles in *The Bell System Technical Journal* 49, no. 10 (December 1970). The *Bell Technical Journal* outline the function of the TSPS and often explicate the hardware and software from the standpoint of the operator, suggestively—though surely unwittingly—poised for a feminist reworking.

[157] See Donna Haraway, "A Cyborg Manifesto: Science, Technology and Socialist-Feminism in the Late Twentieth Century," in *Simians, Cyborgs, and Women: The Reinvention of Nature* (London: Free Association, 1991), 127–48. For a complementary account of engagement with the racialization of technological precision work in electronics manufacturing in relation to mobility in Indigenous labor history, see Lisa Nakamura, "Indigenous Circuits: Navajo Women and the Racialization of Early Electronics Manufacture," *American Quarterly* 66, no. 4 (December 2014): 919–41.

[158] Green, *Race*, 195–226.

[159] Ibid., 250–54. "Operators also described harassment on the job through high production quotas, rigid absentee control plans, and excessive supervision," Green explains. Pressure to meet large call volumes at extreme speed intensified racial scapegoating both between operators and between operators and customers.

[160] Neda Atanasoski and Kalindi Vora, "Surrogate Humanity: Posthuman Networks and the (Racialized) Obsolescence of Labor," *Catalyst: Feminism, Theory, Technoscience* 1, no. 1 (2015): 4.

statistical monitoring that upheld biopolitical management along gendered and racialized lines.

While planning the telelink event that went unrealized at Ars Electronica in 1989, Amacher followed labor disputes between the Communications Workers of America (CWA) and NYNEX, the Baby Bell that covered New York and New England after the Bell system break-up 1982. In 1970s reports on workplace issues, the CWA reveals a dire picture in which mounting uncertainty prior to divestiture merged with deep and long-standing anxiety around automation. Intensified concern about deskilling and a sense, among some operators, of being barred from standards of quality in their work, gave rise to workplace experiments that attempted to rebalance work, service, and social value. Formalized in a 1980 collective bargaining agreement, the CWA piloted Quality of Work Life (QWL) programs, which tasked coalitions of workers, union stewards, and managers to address workplace issues on a project-by-project basis.[161] As a bulwark against automation and deskilling, however, some QWL projects relied on precisely the adaptability and willingness to move between projects that underpinned the managerial prerogatives made possible at the TSPS, in the first place.[162] QWL programs countered Bell's biopolitical management of reserve and surplus labor with in-house approaches to social connection that were often cast as discourses of self-help and self-management.[163] In some QWL programs, health and safety concerns were offloaded onto volunteers, while relaxation tapes and other instructional videos became part of employees' unpaid work time.[164] QWL initiatives also included volunteer services, enrichment activities, and educational programming. Teams coordinated community service and evaluated worker responses to "Rev Up!"—another collectively bargained program that offered free adult education to employees.[165] While some projects could take place during on-the-clock "miscellaneous time," they were often pushed into non-paid work time. This also drove

[161] Communication Workers of America, *Managerial Initiatives*, 1–2. Communication Workers of America Records at the Taminment Library and Robert F. Wagner Labor Archives.

[162] While Bell executives targeted management style, the CWA insisted instead on a tiered QWL structure that centered union stewards, included management, and facilitated decision-making by "natural work teams" that studied issues around automation and staffing.

[163] Attenuated distinctions between private and professional lives and the valuation of autonomy, creativity, and self-management that characterize these newly "flexible" projects are strikingly consistent with how Boltanski and Chiapello analyze the "third spirit of capitalism since the 1980s." Luc Boltanski and Eve Chiapello, "The New Spirit of Capitalism," *International Journal of Politics, Culture and Society* 8, nos. 3–4 (Spring–Summer 2005): 161–88.

[164] Case Description: Columbus, Ohio Operator Service, 8. Communication Workers of America Records.

[165] Case Description: Columbus, Ohio Operator Service, 9, 11, and 12. Communication Workers of America Records. The CWA insisted on a tiered structure in which stewards charged groups called "natural work teams" to study specific, shared workplace situations like Evening and Night Shifts in collaboration with selective collaboration with managers. Participants reported working on speed-based arithmetic drills.

a wedge between the operators' status as what Vora calls a "data form"—which would be useful to capital and could be measured in terms of productivity at the TSPS—and older affective products that were ghosted into interstitial QWL activities. This also committed workers to a suite of projects that, as Luc Boltanski and Eve Chiapello put it, effaced oppositions between "work and not-work, steady and unsteady work, and paid and unpaid work."[166]

This section glimpses how the kind of control Jasbir Puar calls "modulation and tweaking"—that is, flexibilized and team-based work at the TSPS and the commercial information it gathered—moved "vital energy" into long-distance products and QWL workplace projects that could at once nourish and exhaust their participants. Regularization and computational management at the TSPS reveal a situated politics of life within what I have, in this chapter, called long-distance embodiment and a long-distance sensorium. Again, exploration across *City-Links* technical supports reveals cycles of obsolescence and change entangled in its long-distance projects. From this episode, let's return to another *City-Links* project in which Amacher pairs the shape-like spectra we met in her Cambridge studio with visual supports and transports listeners again into another partly fictive long-distance network.

Televisions and Mirrors: *No More Miles—An Acoustic Twin* (1974)

In a letter dated July 14, 1974, Amacher responded to an invitation from Walker Art Center performing arts coordinator Suzanne Weil with enthusiastic reflections on how well her sound work would fit into the upcoming video art group show titled *Projected Images*.[167] This was the first gallery exhibition of the Walker's newly established Film/Video Department, and it thematized a robust break with the cinematic screening room. The exhibition catalogue described a "group of environmental works that depend upon specific light sources for their

[166] See Vora, *Life Support*, 53, "The transformation of the agent into her data form requires the suppression of her real form and yet results in the enhancement of the real form's life chances because it gives her access to global flows of capital and labor demand."

[167] The spatial components of the projects that Amacher staged in the Walker Art Center's auditorium will be discussed in Chapter 5 as an extremely early precursor to structure-borne sound. Between September 28 and November 3, 1974, three *City Links* projects ran concurrently at the Walker Art Center. A detailed look at the projects finds this subjective experience emplotted into audiovisual logics that could hold together physical and virtual space in real time. In *Hearing the Space Day by Day, 'Live,'* Amacher routed two live feeds into the Walker's auditorium, where they remained unattended through October and early November. In a concert-like late-night event on September 29, 1974, Amacher mixed these feeds with her *Life Time* tapes and titled the 10:30 p.m. performance *Everything-in-Air*, as she had done to distinguish two similarly intersected projects in Chicago earlier that same year.

existence" and celebrated a move away from standard projection conditions and darkened enclosures and toward luminous contingencies in the Center's interior gallery spaces. After assuring Weil that "the idea of the exhibition interests me very much," Amacher invoked a dreamy poetics to address its curatorial gestures directly. "Because of auditory dimension and perspective," she explained, "the sound I make is often experienced as seen. Ambience and time becoming image to memory. A place memory is seen in."[168] Indeed, this gesture evokes the spectral shapes and appearances that she had observed in *Tone and Place (Work One)*. For *Projected Images*, Amacher supplied these shapes with concrete audiovisual supports, using technical and conceptual ingredients that would soon become central to *MSJR* and *MSS*: coordinated spectral shapes and sightlines that created focal points in built space, visual references whose uncanny or distorted relation to the remote feed coaxed viewers to reckon an audiovisual contract in characterological and story-like terms, and a sculpture that routed such guesswork through art historical coordinates. Amacher's press release reprised her response to Weil word for word and clinched its audiovisual desires with another characteristic sentence fragment cast as an ongoing action—"Perceiving aurally as 'image.'"[169]

For the piece, which she titled *No More Miles—An Acoustic Twin*, acoustical study in the Walker's Gallery 3 guided her approaches to projection and telepresence. "This was a particularly difficult space to think about," Amacher wrote candidly in a one-page-long "Note on Photo Documentation." To explain, she reviewed her working methods in *City-Links* more generally: "I try to produce sound at 'room' level or lower," she explains, "so that it might be perceived at a level with other sounds present in the room—a situation where boundary between loudspeaker sound and local sound is ambiguous." At the Walker, this balance would have to contend with low frequencies that billowed upward from the Museum's first-floor entryway and information desk. In her working notes, Amacher describes "a great mass of sound coming from below," and continued,

> Very echo. Train station environ. Low frequency blur all the time. Only cries of children distinct sound from open balcony. And almost all sound enters the space from the museum. All completely hard surfaces. Audible sounds: footsteps clear and low hum of voices. Doors open and closing.[170]

For these clicks, hums, and blurs, Amacher sought out what she called an "an acoustic twin," or a remote site with "similar acoustic characteristics to those of the gallery space at the Walker." This logistical and conceptual perspicacity shaped

[168] Maryanne Amacher to Sue Weil, July 14, 1974.

[169] Maryanne Amacher, *Hearing the Space, Day by Day, 'Live,' a sound environment prepared for the space of Walker Art Center Auditorium* (press release).

[170] Maryanne Amacher, undated working notes, Box H10-07-09-05.

No More's audiovisual and quasi-diegetic features. At downtown LaSalle Court, Amacher found an "Arcade [that] was small, with a similar number and grouping of people passing through," noting that "voices, footsteps and other sounds in the Arcade corresponded acoustically to those heard in the gallery spaces." "By coincidence," she noted "the only secure place to make a microphone installation in the Arcade was at a Budget Rent a Car booth." While her published texts give a general synopsis, her research sketches suggest a more tightly constructed palimpsest. In addition to acoustical affinities, as Fig. 3.15 suggests, Amacher imagined one-to-one mappings between the two architectures:

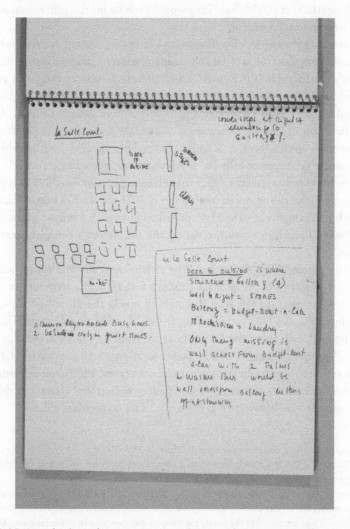

Figure 3.15 Amacher's working notes pair architectural spaces at LaSalle Court with the Walker Art Center galleries' floor plans and *Projected Images*' exhibition layout. Courtesy of the Maryanne Amacher Foundation.

> In LaSalle Court,
> Door to outside is where staircase to Gallery (4)
> Wall to right = STORES
> Balcony = Budget-Rent-A-Car
> To Rockne's [Krebs] piece = Laundry
> Only thing missing is wall across from Budget-Rent-A-Car with 2 [illegible] in Walker this would be wall across from balcony, cutting off at stairway.[171]

This inventory redoubled the Budget kiosk and four other LaSalle structures in twinned locations at the Walker. They would each be for the other what Amacher called "the room in the mirror."

The receiving phone block was housed in a sculpture created by CAVS Fellow and friend Luis Frangella that attached the transmission's audiovisual play, in part, to Man Ray's photograph "The Driver." Early twentieth-century reference points in Dada and Surrealism emphasize how, as art historian Ina Blom has argued, Dada privileged image transmission over other telecommunications media in "fantastical and furiously optimistic statements" about tele-technology.[172] No More, as we shall see, plays up this tension. A white plywood box housed the phone block and speaker and what Amacher called a "window-mirror" rested atop the 29"x29"x48" structure, beckoning viewers to gaze into the sculpture at roughly eye level—not unlike a vitrine, as the complete sketch in Fig. 3.16 shows. On two adjoined sides atop the box, Frangella attached two paned widows with a mirror at the diagonal that reflected their hinge point, creating the illusion of a complete rectangular enclosure.

Into the mirror, Frangella etched "The Driver" and an illuminated but imageless television was to be set at least thirteen feet from the structure so that the small screen's reflection fell atop the etching inside the mirror-window, shown in close-up in Fig. 3.17. As Amacher explained, this alignment "created an apparent TV image," such that "the Driver [was] in front of the TV screen, as though 'projected' in open space."[173] While sketches in Fig. 3.18 suggest that No More should have been approached from parallel staircases, additional drawings show the window-mirror box nestled against a gallery wall so that viewers could see the mirror's unreflective backing on at least one of its windowless sides.

[171] Maryanne Amacher, undated working notes, Box H10-07-09-05.

[172] Ina Blom, "The Touch through Time: Raoul Hausmann, Nam June Paik and the Transmission Technologies of the Avant-Garde," Leonardo 34, no. 3 (2001): 211.

[173] Maryanne Amacher, "Notes on Photo Documentation: NO MORE MILES," an installation of sound and image, Walker Art Center, Minneapolis, Minnesota, October–November 1974. In the mid-1970s, Gallery 3 was connected to the Lobby via an open staircase (shown in the diagram); the Gallery has since been enclosed, though still has a corner window, which is usually covered but in rare cases, used in exhibition contexts. Many thanks to Jill Vuchetich, Archivist and Head of the Walker Art Center Library and Archives, for this explanation.

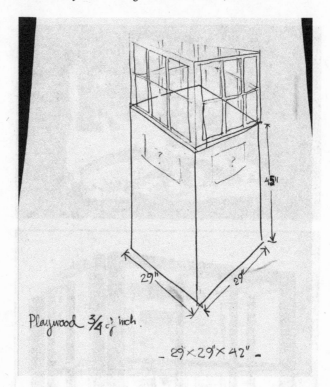

Figure 3.16 Luis Frangella's sketch of rectangular wooden box with mirror window.
Courtesy of the Walker Art Center Archives.

Amacher studied the acoustic twins' cycles and patterns and at an early stage, and imagined the pairing of quieter intervals in the gallery with the Budget kiosk's busiest periods and the gallery's densest hours with a second feed from the hushed Therron Dayton Arcade. This would illustrate that the acoustic twins did not share similar sounds per se, but instead redoubled one another's spectral structures and dimensions. Amacher coupled these mismatches with analyses of acoustical levels and sight lines in order to distill an audiovisual approach to spectral shapes in the remote feed. "Could certainly hear little boy on steps," Amacher wrote in her working notes, "thus if had footsteps at La Salle Court high level, like projected image on steps. There would often be no one on steps, only sound heard." Amacher imagines the remote feed to be "projected" onto the stairwell so that audiences could check its ghostly telepresence against the Walker's goings on. To this end, she prioritized percussive events that cut through the Walker's low-frequency wash and emphasized the sounds of footsteps and the voices of children and women in both locations. "Can hear children going up visible stairway across from balcony," she detailed. Onto the stairs, the feed would project remote spectral "images" in sound.

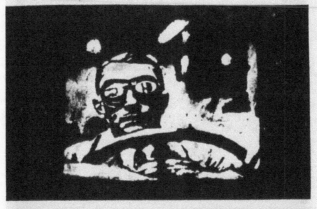

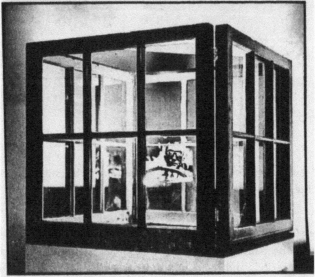

Figure 3.17 Frangella's Man Ray etching and 3-D effects suggested by the television's reflection in the mirror window.

Looking into the sculpture's mirror-window created further audiovisual couplets that paired the remote feed with both "The Driver" and the gallery's reflected image. Chatter from the Budget kiosk occasionally touched upon driving, cars, road trips, mileage, and other commercial details of a rental car business. Student journalist Cameron Blodgett described, "a host of peculiar muffled noises—high heels clicking in [*sic*] a hard floor, the ring of a cash register, doors opening and slamming, assorted coughs and sneezes."[174] Budget's customers occasionally found Amacher's microphone, and their taps sent bangs and thumps echoing

[174] Cameron Blodgett, "No More Miles," *The Minnesota Daily*, September 1974.

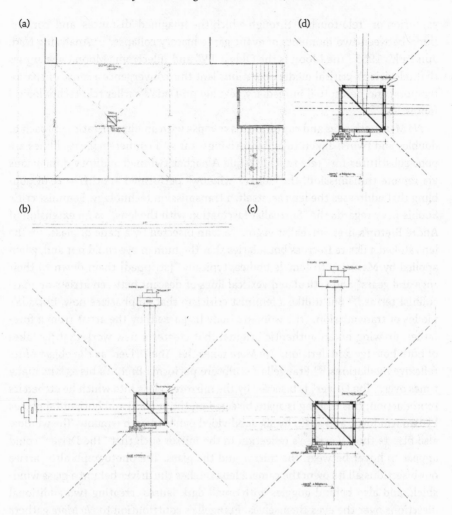

Figure 3.18 Sketches of possible placements for *No More Miles'* sculptural component, phone block, television screen, and its reflection in the sculpture's mirror window. Courtesy of the Walker Art Center Archives.

through the Walker's gallery. "I've gotten in on a lot of small conversations," gallery attendant Dan Dales recalled. "Sometimes you hear people bitching at each other, sometimes you can't understand what's being said. I plan to slip over there soon and get a few words of my own in."[175] These audiovisual couplings with "The Driver" are rather on-the-nose—they are "about" driving, after all —but this part-joke also rewards art historical inquiry. Ina Blom argues that a1960s electronic arts characterized their continuity with Dada and Surrealism as a somatic

extension or "tele-touch," "through which the imagined 'distances' and 'connections' between two moments of avant-garde history collapse."[176] Analyzing Nam Jun Paik's 1965 "The Moon is the Oldest TV" and "Electronic Moon," she argues that television's critical media operations lent this convergence a sense of spatio-temporal and perceptual immediacy, leaning on Dada's earlier tele-technological fantasties.[177]

No More both cites and ruptures this collapse with an idiosyncratic approach to doubles and twins. Taken together, driving a car and connecting leased lines are poor substitutes for "tele-touch." While Amacher twinned auditory dimensions via remote transmission, the "mirror window" performed another sort of doubling that addresses the lens as, itself, a transmission technology. Feminist critic Sophie Levy regards the "Surrealist fascination with the lens," as an extension of André Breton's first Surrealist vision: "a man bisected by a pane of glass."[178] The lens stoked a desire to cross boundaries that the human eye could not and, when applied by Man Ray to female bodies, typically "[stripped] them down to their cogs and gears" and articulated vertical lines of descent between artists on masculinist terms.[179] But unlike a feminist criticism that emphasizes how, in Dada's modes of transmission, "the woman's body [is passed] by the artist from a forefather, drawing on an authentic original that creates a new work that partakes of both homage and derision," *No More* takes the "The Driver" as the object of its reflexive mediations.[180] Frangella's sculpture performs Breton's bisections many times over: "The Driver" is bisected by the mirrored glass into which he etched its reproduction; this etching is again bisected on the vertical and horizontal planes by two windows, and again by six subdivided panes in each window. The window also bisects the TV screen's reflection in the mirror such that "The Driver" could appear to hover between the mirror and the glass. The photograph also carries out bisections all its own: the camera lens catches the driver behind a glass windshield and also behind goggles with small dark lenses, creating two additional bisections over the eyes themselves. Frangella's contribution to *No More* gathers up mediatic circumstances that include the photograph, the lens, the hand and the televisual image.

[176] Blom, "The Touch through Time," 215.

[177] Ibid.

[178] Sophie Levy, "Man/Ray: The Camera as (Bachelor) Machine in Surrealist Photography," *Fictions of the Machine*, http://www.columbia.edu/itc/french/blix/machine/abstracts2.htm, accessed July 1, 2020.

[179] Ibid.

[180] Kirsten Hoving Powell, "Le Violon d'Ingres: Man Ray's Variations on Ingres, Deformation, Desire and de Sade," *Art History* 23, no. 5 (December 2003): 722–99. Powell writes that modernist avant-garde histories might be understood through their frequent deployment of obscene or dirty jokes in which women's bodies become anchors for patriarchal bonds between men. See also Eleanor Roberts, "Charlotte Moorman and 'Avant-Garde Music': A Feminist History of Performance Experimentation," in *Performance, Subjectivity and Experimentation*, ed. Catherine Laws (Leuven: Leuven University Press, 2020), 159–63.

Blom recommends an interpretive approach that treats Dada's historical transmission fantasies as both models and materials for intermedial extrapolations, beginning in the 1960s. This approach returns again to competing materializations of distance and constitutive frameworks of body. *No More* certainly plies the televisual transmission that Dada prized as the "differential specificity of a medium that, rather than simply overcoming distance, seems to somehow short-circuit the notion of distance itself."[181] Rather than broach distance, she explains, as "the timing of calls and responses on the telephone," television does so "directly into the vision it transmits," conjuring "immediate intensity" in multiple places at once without deferring also to questions of timing and density (i.e., telephonic "calls on the line" or "air miles" between leased line connections). However, *No More* features precisely the telephonic transmission against which, Blom explains, Dada vaunted television's immediacy.[182] The piece's audiovisual logics stage complex and divergent long-distance materializations: the image cites historical desires associated with televisual spatial collapse while the remote feed indexes telephonic time and space, its others. In a later reflection on the piece, Amacher enfolded this tension into narrative involvements and included herself among them: "the space between the wall—the diagonal. Looking there I found Man Ray saying something about this place. He is a man who knows places like I know sound. Miles don't count when you find him."[183] Auditory "tele-touch" belongs to Amacher and visual "tele-touch" to Man Ray amid the palimpsested bisections that Frangella applied to his hovering telepresence.

Conclusion

Interacting with *No More* as a diegetic puzzle approaches its audiovisual construction as an open-ended narrative transport. This chapter has perhaps done something similar with *City-Links*, in a broader and more experimental sense. Held together by the linkless tone-of-place as much as remote circuitry, *City-Links* assembles a complex and comprehensive program in long-distance connectivity that opens onto an anthology of contemporary and historical tele-technological media. *City-Links* paired a here-ish and there-ish kind of presence with alternativities in the sensorium, which moved affects and energies between social locations and registered concurrent and overlapping cycles of abandonment and obsolescence. Its conceptual reach and durative pressures suggest many figurations that can be inhabited with interpretive gestures related to life in a sound.

[181] Blom, "The Touch through Time," 212.

[182] Ibid.

[183] In the group show *Boston Celebrations: Part One*, Amacher did display the mirror-window sculpture, this time with the harbor feed, and thus apart from the "acoustic twin" around which she had built the initial installation at the Walker.

The long-distance sensorium emerged as a kind of heuristic that, amid cycles of obsolescence and displacement, registers platforms for reproducing value that dedicated particular processes and sensory differentiations to the work of transporting vital energy over distance. While *Adjacencies* had asked, "how worlds of sound could be joined," *City-Links* and LONG DISTANCE MUSIC located the question in relation to technological and historical supports that made its biopolitical edges more explicit. To the spectral shapes and auditory dimensions that support these quasi-diegetic meditations on distance, Amacher would also add another complex dimensionality that again electrified questions about life in a sound: the third ear.

Eartones and Third Ears

These tones are subliminally experienced in all music by the lis-
tener, who is not really conscious they are being created; and
sound in the ears is a source of much of music's pleasure.

In Amacher's musical narrative, there is a conscious recognition of
the "listener's music."[1]

—Amacher, *handwritten note on The Biaurals: A Mini
Sound Series, 1990*

I think it's unfortunate that all of this has been so buried as "psy-
choacoustic phenomena" . . . and called that. Again I get back to
this, as musicians and composers we're supposed as, kind of, dum-
mies [to be] just . . . writing these things and not to know how
they affect any of us.

—Amacher, *lecture at Ars Electronica, 1989*

So it is not the fault of the author if his aphorisms fail to be
understood. Or rather his only mistake is to have believed that his
future reader would not be strong enough to take up his writing
once more and make it his own.[2]

—Sarah Kofman, *Nietzsche et la métaphore*

[1] Amacher, Working notes for *The Biaurals: A Four-Part Mini Sound Series*. This 1990 mini-sound
series took place on September 14, 15, 21, and 22 at the Fleisher Art Memorial in Philadelphia, com-
missioned by Electrical Matter, an electronic arts festival that marked the bicentennial of Benjamin
Franklin's death. In unpublished project summaries, Amacher proposed to provide the audience with
a pair of "biaurals"—like "bifocals"—that audiences could use as "fake ears" to experience ways of lis-
tening that layered multiple spatial configurations at once. As an auricular equivalent to "bifocals," the
"biaurals" animated perceptual geographies that would be responsive to sound, in sharp focus, at a dis-
tance, and up close at the same time. Like *Mini Sound Series* projects from 1985 forward, *The Biaurals*
included video projections and vibrant visual presences. See Miriam Siedel, "Performance Piece Debuts
at Fleisher," *Philadelphia Inquirer*, September 21, 1990. Seidel's review is quite vivid: "Complex striated
masses of sound rose and fell in minutes-long crescendos and decrescendos, sometimes overlapping
with other sound structures. Some basic sounds were like the thundering of blood in the ears or other
inner-body sounds. These seemed to relate to Amacher's ongoing interest in reconstructing the sounds
one hears in the head while listening to external sounds. Sometimes these sounds pulsed; occasionally
a massive chord surfaced."

[2] Sarah Kofman, *Nietzsche and Metaphor*, trans. Duncan Large (Stanford, CA: Stanford University
Press, 1994), 116.

Wild Sound. Amy Cimini, Oxford University Press. © Oxford University Press 2022.
DOI: 10.1093/oso/9780190060893.003.0004

Introduction

One might wonder, when thinking of Amacher's declaration, "I want to make a music..." what ears she thought would hear it. By the time she had started this note based on Haraway, Amacher had established solid practical and conceptual groundwork that centered auditory processes as horizons of compositional possibility. Response tones would stream from the inner ear to enlace audio in built space. Neural phenomena would add low frequencies that were not present in cochlear biomechanics. Extremely high frequencies could activate the pinna, or outer ear, as a locus of dimensional play. Amacher crystallized these knowledges in the 1970s autodidactic research program she titled *Additional Tones* and documented her process in a ninety-seven-page workbook that included source studies in acoustics, psychophysics, and otology as well as the experimental conditions under which she tested findings, in that literature, against her own listening. Charged with genealogical intensity, Amacher wrought her own questions about composition and embodiment through their epistemic fault lines. Not two ears, but many, and in complex segmentations and combinations.

Consider the first track on the album *Sound Characters (making the third ear)*. "Head Rhythm 1" offers starry tone bursts layered in charmingly straightforward patterns. This character's overall feel is quartal. From both the left and right channels, dyads alternate in short, five-pulse patterns punctuated by an anacrustic pause. But "Head Rhythm 1" also plies the stereo spread's outer edges. In the right channel, the layers reach four octaves above middle C, with eighth- and sixteenth-note patterns blazing by at about 140 to the quarter note.[3] The slower left channel shares its lowest stratum with the right's, and it adds a stepwise line that flits between its higher layers at 105. "Head Rhythm 1" spins through the room in a three-against-four pattern, creating a texture pocked with negative space. As clicks and pops proliferate, something slightly disconcerting might begin to fill the space between the tone bursts. One's inner ear perhaps starts to feel warm; a little buzz in the ear catches one's attention. Individual frequencies come into focus, short gestures and melodies perhaps coalesce. These are what Amacher called "eartones," "ear-borne sounds," "additional tones," or "ear dances" and, on this record, perhaps a "third ear."

Though she was quick to assert their ubiquity in listening, the *Additional Tones Workbook* evidences a highly personal engagement with these interaural sounds that details their epistemic complexity as much as their experiential allure. Amacher materializes these buzzes and hums amid an ad hoc genealogy of interaural sound whose contestations wrought extreme and often emotionally charged responses from researchers in music composition and otology as much as physics

[3] For an exemplary analysis of "Chorale 1" and "Dense Boogie 1," also featured on *Sound Characters*, please see Jonathon Kirk, "Otoacoustic Emissions as a Compositional Tool," *Proceedings of the International Computer Music Conference* (2011), 316–18.

and information theory from the late 1940s through her historical moment. A genealogy of bodily awareness comes through Amacher's slow, patient process of assimilating—and sometimes rejecting—these knowledges and the figurations of sound, life, and bodily matter they carried with them. Eartone music creates intermediary perspectives from which listeners can access novel calibrations of sensory information that electrify the relevance of the senses—and the cochlea in particular—across new spaces of meaning and value. Listening to Amacher's so-called third ear music can be a profoundly personal experience; scholars, artists, critics, and fans describe it as thrilling, scary, and strikingly intimate, by turns, and such testimonies carry Amacher into discourse as a kind of codebreaker, uniquely capable of unlocking secrets in a person's listening. What mediations undergird this awareness and intimacy? How are its perspectival seams established or stabilized? On what material or historical supports do they rely? How do these delimitations brook difference, deviation, miscalculation, or superaddition?

While the workbook reveals how Amacher combined compositional protocols and autodidactic knowledge about the auditory pathway, it also anthologizes contested treatments of the ear that entail complex assumptions about its relationship to bodily matter. These collisions set an early stage for the narrative involvements, in *Music for Sound-Joined Rooms*, *Mini Sound Series*, and *Intelligent Life*, that take assumptions about auditory thresholds as their diegetic and audiovisual impetus, as we shall see in Chapter 5. The term "third ear," which appears in an often-quoted album essay in *Sound Characters*, remarks on how such a process could be figured in just a word or two. On the one hand, the biomechanical figuration seems obvious enough. The response tone evoked by two incident tones would be their third. However, the divergences and enhancements to which Amacher devoted her research were far more complex than this. For this work, the third ear provides a suggestive metaphor: a third ear materializes two extant ears poised to exceed themselves and, in this sense, attunes listening to its own plasticity. But that attunement also gathers up constitutive frameworks for life; in other words, a third ear also figures the coming into consciousness of interaural sound, as an experience shot through with affective and biopolitical valence that arranges suppression, subliminality, pleasure, erotics, and epistemic exclusions across power-differentiated circumstances in the acoustical sciences. Amid an otherwise tight focus on texts that Amacher wrote, read, and studied, the third ear calls for a decidedly conjectural treatment that maps its metaphoricity across historical, disciplinary, and social coordinates and deepens the affective charges that Amacher attached to the eartone's impacts. This effort turns up not one third ear, but many. Across the feminist deconstructive philosophy of Sarah Kofman and the work of lay psychoanalyst Theodor Reik—whose 1948 *Listening with the Third Ear* popularized the term—the third ear suggests an analytics of power that extends across Amacher's working method and attaches frameworks of body and life to a listening whose perspectives on auditory thresholds remain anything but self-evident.

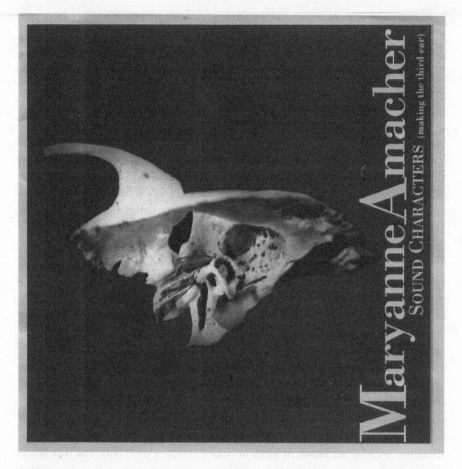

Figure 4.1 Album cover, *Sound Characters (making the third ear)* (Tzadik, 1999). Design by Ikue Mori. Courtesy of Tzadik.

Stereoscopic Cochlea and "Live Space" on Paper

One third ear registers amid visual drama that takes place between the album cover and the booklet that accompanied Amacher's *Sound Characters*, shown in Fig. 4.1. The stereoscopic images of desiccated inner ears that appear there and inside the accompanying booklet came from the collection of her friend Scott Fisher. Fisher became a CAVS Fellow in 1975 and collaborated with Amacher throughout the 1980s on increasingly complex visual environments in the *MSJR* and *MSS* series. At the Center, Keiko Prince characterized Amacher, Fisher, Luis Frangella, architect Juan Navarro Baldeweg, and herself as a "midnight crew," whose close friendships crystallized amid their late-night work habits.[4] In his stereoscopic

[4] Conversation with the author, March 2017.

photo series "Eye in Time," Fisher created a low-tech mediatic approach to critical infrastructural change in Boston, consonant with the Center's overall goals, which brought together his expertise in virtual environment design and three-dimensional imaging. Initially engaged with the demolition of an early twentieth-century ice storage building located in Boston's North End, "Eye and Time" became a multi-component sculptural collage with stereo photographs taken during in-progress demolition at multiple sites.[5] The project applied temporal difference and historical pressure to the stereo viewer's traditional association with spatial collapse and virtual transport.[6]

Stereo viewers had, since the 1870s, capitalized on optics research that explored how the production of composite images depended on differences in how each eye sees.[7] In nineteenth-century viewers like those Fisher collected, two slightly different images of the same object or scene would be presented next to one another, spaced to match the distance between the eyes.[8] Their composite image redoubled the anatomic structure of the observer's body and demonstrated the thesis, emerging in optics research at the time, that "realism presupposes perceptual experience essentially to be an apprehension of difference," as art historian Jonathan Crary explains.[9] Once fused, the two-dimensional pair gives the impression of three-dimensional depth. As though affixed to the eyes themselves, stereo viewers sucked the perceiver into a scene that "no longer appeared to have an intelligible or quantifiable location" in the space around them.[10] Stereoscopy imbued this composite third image with a strange, energetic crispness that one scholar shorthands as "Victorian virtual reality."

With the paired stereo photographs that made up "Eye in Time," Fisher modified this trick using two images taken in a single location, but separated by days or years. This created strange dimensional effects. For example, only unaltered infrastructure pictured in both photos would leap into three-dimensional perspective. Fisher remarked on how such composites looked unusually solid, sharp, and "crystalline."[11] As he put it:

[5] Scott Fisher, "Interview" with Mimi Ito, and Joi Ito, November 11, 2003. Personal copy shared with the author.

[6] Fisher exhibited "Eye in Time" at a group exhibition with CAVS Fellows titled *Boston Celebrations: Part One* at the Institute of Contemporary Art Boston from March 18 to April 29, 1975. In the show, Amacher exhibited the *No More Miles* mirror window with a feed from the Boston Harbor.

[7] James Staebler, "The Stereograph: The Rise and Decline of Victorian Virtual Reality" (MS thesis, Ohio University, 2000); Jonathan Farina, "'Dickens's As If': Analogy and Victorian Virtual Reality," *Victorian Studies* 53, no. 3 (Spring 2011): 427–36.

[8] See Jonathan Crary, *Techniques of the Observer: On Vision and Modernity in the 19th Century* (Cambridge, MA: MIT Press, 1990), 119–26.

[9] Ibid., 120.

[10] Ibid., 124.

[11] Fisher, "Interview," 3.

So everything that still was the same, like the street, sidewalk, some trees, and some other building next to it, when fused in the stereo viewer, would come out in depth. It would create that sort of crystal-line 3-D stereoscopic effect. But the stuff that was no longer there, the building itself, and some cars that had moved, would kind of flicker back and forth between the two eyes.[12]

Anything that had changed during the elapsed time between Fisher's photographs lacked a correspondent double in the second photo. These parts of the image would neither lock into three-dimensions nor appear straightforwardly two-dimensional; instead, they would hover, or flutter in the space of vision. Absent infrastructure haunted the composite image and connected an ad hoc archaeology to the unresolvable visual effect. "The idea was to fuse them [the images]," he explained, "but obviously you can't." For Fisher, this impasse could give rise to a perceptual and historical drama that played the spatial difference between how each eye sees against temporal differences through which infra-structural changes could become sensible. In a handwritten description draft, he described that drama as "subliminal," "relief," and "surrender" in turns:

> Out flow of subliminal spaces in the 'relief' of dedifferentiation—from the tension of synoptic solidity returning to zero disparity of the hori-zon—the ritual of binocular spatial disparity surrendering to temporal disparity and memory—the eye in time.[13]

Attending to "Eye in Time" accentuates that Amacher's eartone research crystal-lized not only through the study of auditory processes, but in tandem with active knowledge of stereoscopic imaging, sensitive to affective and narrative dynam-ics that could articulate perceptual tricks, at the same time, as a kind of histori-cal inquiry. In the long description for their 1975 co-taught course, "Live Space,"

[12] Fisher also explained how the project expanded to encompass additional sites. "I also did a lot of research to find out where all the bricks, stone, and granite that made the building came from," he stated, "and I traced them back to a couple quarries and plants in the New England area, mostly in Maine. I began documenting these locations with stereo photographs. And went the other way to find out where the demolition debris was dumped. Most of it went into Boston Harbor or was used for other landfill. I was trying to set up a kind of cycle of how this material came out of the earth, leaving the negative space of the quarries and then was reformed into the solid shape of this building. The third part of all this was that there was also a large tower next door for this big power plant that was built in 1900. And this photographer had shot a panorama from the top of the tower as it was being built. I got permission to climb to the top of this tower and match the same panorama that he had done. So I had an image set that was taken in 1908 or so, and I had another set of images taken in 1975 from the same location. So that was yet another viewpoint of this space to show how things had changed from then to now."

[13] Scott Fisher, "Eye in Time - 3," 1975, handwritten draft, Center for Advanced Visual Studies Special Collection, MIT Program in Art, Culture, and Technology.

Fisher and Amacher, along with Luis Frangella and Juan Navarro Baldeweg, imagined "cross-sensory explorations," which would combine stereo visual environments with changing auditory dimensions and spectral shapes:

> Cross-sensory explorations between stereo vision and auditory dimension. The making of stereo visual spaces for interior and outdoor environments. Exchange of "live" space conditions through observation and reproduction. Perception over time—approach and disappearance of what is sounding in the environment. After images, physiological resonances. Tuning—to the body, to the environment. Acoustic spaces of felt sound phenomena, experience either subliminally or making recognizable direct physical resonance to the body. Composite mental images of immersion in space, as in stereo vision; direct physiological experience of an acoustic space, as distinguished from the perception of an acoustic space, aurally, as "image"—patterns within air. Current research and bibliography to be discussed.[14]

Long distance music's dimensional play and tone-of-place's quiet profusions make themselves felt within this description. Fragment by fragment, the text seesaws between the visual and the auditory. With each registral shift, a new way to experience auditory dimension attaches to one or more of stereoscopy's visualizing tricks. This description brings together little audiovisual pairs whose contrasting logics of proximity, distance, and density might overlay one another or entangle built environments. "Live Space" added to Amacher's dimensional explorations a catalogue of hypothetical audiovisual logics.

Another kind of "live space" emerges from the stereoscopic images that appear in the *Sound Characters* CD booklet. Their visualizing tricks dramatize the triplication of the ear as an experience of audiovisual dimension. The album's cover greets prospective listeners with a stereoscopic image of a single, desiccated cochlea. Its subtle grays, browns, and greens almost quiver against the inky black background. A complete, two-part stereo viewer appears across the booklet's middle two pages, as shown in Fig. 4.2. Hold the booklet at arm's length, unfocus your gaze, and look just beyond the page. A third cochlea emerges, floating between and, seemingly, in front of the printed two; in the composite image, the inner ear's shaded regions, caverns, and craters appear bracing and sharply defined. "The degree of depth and solidity" in such images, Fisher explained, could be almost "unbearably [. . .] hyper-solid."[15] When this three-dimensional image emerges, the booklet delivers its own kind of "live space" on paper. Between the single cochlea that appears on the album cover and the stereoscopic pair that appears inside, the

[14] CAVS Course Catalogue Description, 1975. Center for Advanced Visual Studies Special Collection, MIT Program in Art, Culture, and Technology.
[15] Fisher, "Interview," 4.

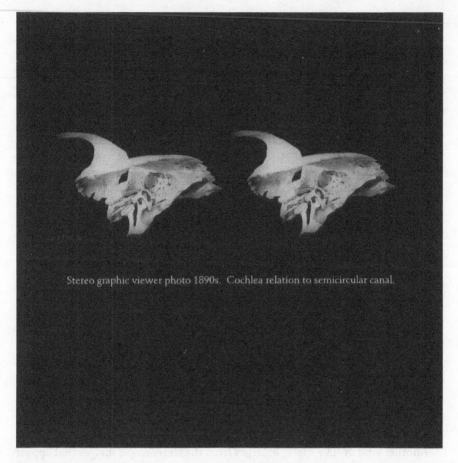

Stereo graphic viewer photo 1890s. Cochlea relation to semicircular canal.

Figure 4.2 Inside album cover, *Sound Characters (making the third ear* (Tzadik, 1999).
Courtesy of Tzadik.

booklet becomes itself a dramatic exposition of how the space of vision diverges
from the point from which we see.[16]

For nineteenth-century viewers, as for Fisher and Amacher, stereoscopic
images tended to evoke powerful surges of emotion. The experience dislodged a
viewer from a quantifiable real-world location and, at the same time, also froze
her in place. At the time, psychologists characterized this paradoxical double
movement as "the climax of all in giving the emotions of actual sight."[17] Thought
to have been based in electricity, this affective effulgence remade observers'
immobility into a kind of virtual movement that actually transported them into

[16] Crary, *Techniques*, 127–28.

[17] Albert E. Osborne, *The Stereograph and the Stereoscope: With Special Maps and Books forming a
TRAVEL SYSTEM* (New York: Underwood & Underwood, 1909), 27.

the stereo viewer's scene. Fifteen psychologists endorsed stereoscopic imaging in 1905, along these lines:

> It is possible for a person to lose all consciousness of his immediate bodily surroundings and to gain, for a short time, at least, a distinct state of consciousness or experience of location in the place represented. Taking into account certain obvious limitations, such a lack of color and motion, we can say that the experience a person can get in this way is such as he would get if he were carried unconsciously to the place in question and permitted to look at it.[18]

These "unconscious" conveyances crisscrossed disciplinary boundaries and commercial forms. Souvenir viewers chronicled world's fairs; they brought bourgeois observers up close to industrial forms and manufacturing environments.[19] Series of images called "tours" carried viewers into global transportation and communication industries with an overwhelming focus on images of colonized lands that could be seen—via stereoscopy—as claimable from afar. Amacher's pair of cochleas, in the *Sound Characters* booklet, epitomized the stereo viewer's medical applications, which could give students a close, long look at tiny bits of human anatomy. The images separate the cochlea from the surrounding matter and transport the observer into its world, as though she could be infolded into her own ear.

But unlike the immobile transits described by early twentieth-century psychologists, stereoscopic imaging's affective intensifications and transporting allusions can also be folded back over a viewer's standpoint on images in situ, as Fisher had done in "Eye in Time." Similarly, *Sound Character*'s companionate stereo viewer suggests quite a lot. It implicates eartone music in modes of storytelling that Amacher associated with conceptual and audiovisual transport "to a world where the listener can go," that, at the same time, redoubles novel and partial intermediary perspectives on listening in situ.[20] In the eartone music, in other words, interaural dimensional play fractures and recombines the points from which one hears in relation to additional points in the sound's diffusion. Amacher devotes a short, often-cited essay in the booklet of *Sound Characters* to how a listener will experience sound characters that bring her "Third Ear Music" into being:

[18] Quoted in Brenton J. Malin, *Feeling Mediated: A History of Technology and Emotion in America* (New York: New York University Press, [2014]), 82–83. According to Malin, this statement bore the headline "Nationally Known Psychologists Endorse the Stereograph" in the magazine *Around the World with Burton Holmes* and its statements about the stereograph were endorsed by Seashore, George Ladd, and George Herbert Mead.

[19] Ibid., 94. See also Staebler, "Victorian Virtual Reality."

[20] Maryanne Amacher, "Untitled Notes," in Bill Dietz, "Rare Decays," in *Tube Dust Drone—Brückenmusik 1995–2015*, ed. hans w. koch and the Therapeutische Hörgruppe Köln (Cologne: BRÜCKENMUSIK, 2016), 79–86.

When played at the right sound level, which is quite high and excit-
ing, the tones in this music will cause your ears to act as neurophonic
instruments that emit sounds that will seem to be issuing directly from
your head. In my concerts, audiences discover music streaming from
their head, popping out of their ears, growing inside of them, grow-
ing out of them, meeting and converging with the tones in the room.
Tones "dance" in the immediate space of their bodies, around them like
a sonic wrap, cascade inside the ears and out to space in front of their
eyes, mixing and converging with the sound in the room. [. . .] These
tones are a natural and very real physical aspect of auditory perception,
similar to the fusing of two images resulting in a third three-dimen-
sional image in binocular perception. I believe that such response tones
exist in all music, where they are usually registered subliminally and
are certainly masked within more complex tones. I want to release this
music which is produced by the listener, bring it out of subliminal exis-
tence and make it an important sonic dimension in my music.[21]

Amacher lavishes attention on the spatializing effects a listener might expect to
experience when in the presence of such sound characters. Tones will stream out
of your ears; they will interact with sounds in the room. Along this tangled, seam-
like meeting point, distance and proximity will change places again and again.

But what of this third ear? Tucked into parentheses on the album cover, the
tiny text, "(making the third ear)," seems almost to scamper off at the upper-right
corner. A third ear confronts the two extant ears with a destabilizing figuration,
as though seeking in them some specific yet unnamed liminality of bodily mat-
ter. *Sound Characters* introduces a few different third ears and provides each with
visual styles and narrative allusions. In the album title, the gerund "making" in
"making the third ear" sweeps the listener up in an ongoing process, not unlike
the characteristic sentence fragments that appear often in her other writing. But
in this essay, Amacher also trades the common noun "third ear" for the proper
noun "Third Ear Music." When nouns modify other nouns, their resulting genitive
construction can confuse relations of belonging and priority. A "*Third Ear* Music"
suggests a music that belongs specifically to triplications of the ear; and a "Third
Ear *Music*" suggests a third ear that functions in a specifically musical way.[22] What
conditions hold the two together, given their ambiguities of belonging? What
physiologies get swept into this appealing—if cryptic—figure? What liminalities
of sound and body does it foreground or foreclose?

[21] Maryanne Amacher, "Liner Notes," *Sound Characters* (Tzadik, 1999).

[22] This discussion builts on Naomi Waltham-Smith's meditations on the ambiguities of the genitive.
Naomi Waltham-Smith, "The Sound of Biopolitics," colloquium talk at University of California San
Diego Music Department, September 20, 2016.

Intervals and Interchanges in "Head Rhythm 1" and "Plaything 2" (1999)

Eartones can be a striking, powerful personal experience and one might explore their entwinements with room-bound playback in many ways. In "Head Rhythm 1," stark differences between the left and right channels guarantee that one's movements through built space reveal points of special intensity and attenuation. "You might not know how close you are to a speaker," Dietz once put it, "until you find yourself standing right next to one."[23] Many of Amacher's students learned from her to attach a second resonating chamber to their heads by curling their hands around their ears with the palms facing forward. The hands add resonant space to a listener's body, as though carving an additional stopping point on the auditory pathway into thin air; opening or closing the hands changed this DIY resonator's size and shape which would add another tone and dimension to a listener's experience of distance and proximity in motion.[24]

For about three minutes, the glittery first character in "Head Rhythm 1" and "Plaything 2" delivers Amacher's Third Ear Music. Dyads leap through the room; eartones dance across the basilar membrane. Like the flip of a switch, a second character enters this polyphonic environment. A churning mass, thick with overtones fills the previous character's latticework of buzzes and tone bursts. It overwhelms them. The eartones are first to go, as the second character's complex timbre gradually masks their fizzy hums. As oscillating quartal and stepwise patterns continue to fade, there is a palpable feeling of negative space where eartones had been, just moments before. This second character controls the remainder of the track, which is three times the length of the opening eartone music. Overtone-rich waves surge across the stereo spread and hover around Dbs, Fs, and Abs near middle C; this second character disperses the first by resetting the terms in which sound meets the aural. While "Head Rhythm 1" took place, as the title suggests, in or around a listener's head, "Plaything 2" traverses the entire auditory pathway, if not also the shoulders, back, torso, or viscera. Although this track has been written about more frequently than almost any project in Amacher's corpus, commentary focuses overwhelmingly on the eartone music, which lends itself so well to personal testimony and description.[25] Much is lost by setting this second

[23] Bill Dietz, Pre-Concert Remarks on Amacher's *Glia* (2005), Institute for Contemporary Art, London, May 31, 2019.

[24] Conversation with Stefan Tcherepnin, Spring 2011.

[25] For an admirable comprehensive account, see Gascia Ouzonian, "Embodied Sound: Aural Architectures and the Body," *Contemporary Music Review* 25, no. 2 (August 2006): 69–79. As an exercise in "embodied analysis," Ouzonian describes auditory dimensions and listening in situ with a narrative staging that emphasizes virtual transport to dramatic effect. Ouzonian listens to *Sound Characters* in its entirety, while parked in her car near a San Diego beach where tourism and military training commingle. In the near-hallucinatory descriptive fantasia that ensues, listening to *Sound Characters* sharpens her awareness of US imperial power while specters of ecological collapse entwine

character aside, however.[26] Its conjunction with the eartone music epitomizes questions about how interaural complexes could give rise to larger musical forms, which animated Amacher's *Additional Tones Workbook*.[27]

The workbook shows how Amacher carried out the careful, serious task of acclimating herself to new discourses and terminologies, while holding extant research accountable to her own listening experiences and musical questions. This work gave rise to original schematic tools and first-person tone studies focused on perceptual processes and formal questions. She took detailed notes and re-drew diagrams; to these, she added personal annotations that touched on specific pieces, experiences, and compositional problems. As she tested experts' findings, Amacher continually reminded herself to stay focused on learning about how to make "'changes' in the flow."[28] To a page of notes on Juan G. Roederer's college textbook, *Introduction to the Physics and Psychophysics of Music*, she adds this hand-written note to herself. "Remember," she writes,

The whole question—i.e., one reason why I stopped—was to learn about 'changes' in the flow. How to make them. I had no real basis for

a tourism-industrial complex supported by racialized and gendered divisions of labor. Compare the vivid presence and pressure in Ouzonian's account to phantasmatic characterizations in Barbara Ellison and Thomas Bey William Bailey, *Sonic Phantoms: Composition with Auditory Phantasmatic Presence* (London: Bloomsbury, 2020), 198–99. See also Alan Licht, "Maryanne Amacher: Expressway to Your Skull," *The Wire* 181 (March 1999). In contrast, Nate Wooley reports that "There's no way for me to deal with Maryanne Amacher's music." See "Guide to American Weirdos," *The Wire* (June 1980), https://www.thewire.co.uk/in-writing/the-portal/nate-wooleys-guide-to-american-weirdos, accessed May 10, 2020.

[26] Consider Brandon LaBelle's evocative account, which describes "a listener within a spatiality that penetrates as well as absorbs the body." This compelling spatial emphasis does not address how perceptual geographies participate in horizontal relationships central to Amacher's workbook research. See Brandon LaBelle, *Background Noise: Perspectives on Sound Art* (New York: Continuum, 2006), 173. Nina Eidsheim's vivid description also downplays temporal flow and horizontal constructions. "Amacher worked with frequencies distributed through the space in such a way that the body itself would function like a speaker." See Nina Sun Eidsheim, *Sensing Sound: Singing and Listening as Vibrational Practice* (Durham, NC: Duke University Press, 2015), 202n47. Kyle Gann also treats eartone music as self-standing in an effusive review, writing that "several ear-splitting textures intend to elicit 'otoacoustic emissions,' sounds inside your ears and not in the music; they dance right at your eardrums and wheel through your head. All previous sonic spectacular discs are hereby rendered obsolete." Kyle Gann, "Maryanne Amacher: Sound Characters (1999)," *Village Voice*, August 17, 1999,. For another "eccentric" characterization, see also Gann, "Improper Ladies: Women Composers Shatter the Glass (Ceiling)," *Village Voice*, December 12, 1995. Tropes of secrecy tend to merge with testimony about the material force of Amacher's eartone music and structure-borne practices, discussed at length in the next chapter. "Maryanne is one of the best kept secrets of the Cage/Tudor scene," says Paul D. Miller, aka DJ Spooky. "She was one of the first people of that set to really deal with heavy bass, electronic bass, crazy bass." See also Paul C. Jasen, *Low End Theory: Bass Bodies and the Materiality of Sonic Experience* (London: Bloomsbury, 2016).

[27] Maryanne Amacher, *Additional Tones Workbook IV*, 1976/rev. 1987.

[28] Amacher, *Workbook*, 39.

this. Emotional was not enough. Last 2 years began to make some small sense of form: starting with Buffalo piece.[29]

In what did this "flow" consist? This question guides the workbook and informed how Amacher crafted experimental conditions in concert and in conflict with her heterogeneous sources. How, in other words, could one organize incident sounds such that their vertical relationships to response tones could also give rise to horizontal changes whose flow crystallized a sense of form?

Driving the workbook are difficult, personal questions about what can count as a legitimate or "real basis" for developing any one of these components. One might imagine, as a case in point, the often-unremarked transition linking the sparkly flow of "Head Rhythm 1" with the searing, visceral wash of "Plaything 2." By the mid-1970s, Amacher was certainly not alone in researching auditory structure and function as a backstop for compositional strategy. Yet, her study's auto-didactic character emphasized its distance from a classical computer music centered at IRCAM or Bell Labs. For example, it neither leveraged psychoacoustic insight to guarantee communicative thresholds for complex counterpoint, nor took up frequency analysis as a tool for voice-encoding related to compression's industrial applications.[30] Again and again, Amacher looks to threshold phenomena for clues about formal change. Her notes are nuanced and granular; taken together, they evidence an emerging, personal vocabulary for categorizing incipient changes and spatial confusion. When Amacher jots down ideas for small tweaks, local enhancements, and structural additions, "changes in the flow" seem, already, to be making themselves felt.

Her decidedly schematic strategies can also illuminate "Head Rhythm 1'"s three-minute expanse of eartone music. Let's start with a series of diagrams that appear early on in the workbook. For the intervals of the fourth, fifth, and octave, Amacher calculates frequencies associated with specific points along the auditory pathway.[31] By "IN THE ROOM," she means the tones present in audio playback; by "IN THE EAR," she means byproducts of cochlear frequency processing that facilitate the perception of primary tones and activate additional locations on the basilar membrane.[32] By "NEURAL," she refers to processes that take place in the

[29] Amacher, *Workbook*, 39.

[30] See Georgina Born, "Science, Technology and the Avant Garde," in *The Sound Studies Reader*, ed. Jonathan Sterne (New York: Routledge, 2012): 419–26 and Jonathan Sterne, *MP3: The Meaning of a Format* (Durham, NC: Duke University Press, 2012), 32–60. See also Christoph Cox, "The Alien Voice: Alvin Lucier's North American Time Capsule, 1967," in *Mainframe Experimentalism: Early Computing and the Foundation of the Digital Arts*, ed. Hannah B. Higgins and Douglas Kahn (Berkeley: University of California Press, 2012): 170–86. While Amacher worked with hearing research that was also instrumentalized to this end, she pursued a quite different end result: incident complexes whose additional tones proliferated unstable thresholds.

[31] Amacher, *Workbook*, 6–9.

[32] William M. Hartmann, *Signals, Sound and Sensation* (New York: Springer, 1998), 511.

IN THE AIR	IN THE EAR	NEURAL	PROCESSING: NEURAL-EAR
			Fo--Fc(D)
			Fo--Fc(S)
			Diff. Interval
4th			
F1 = 329cs	Fc1 = 121cs	FB = 30cs	
F2 = 450cs	Fc2 = 208cs	Fo = 110cs	
(440)	Fc3 = 87cs		
= 10			

Figure 4.3 Additional Tone Calculations from Amacher's *Additional Tones Workbook.*
Courtesy of the Maryanne Amacher Foundation.

auditory cortex and includes, here, pattern recognition and fundamental detection (labeled Fo) as well as beating phenomena, which produce tones that can be "heard" beneath the audible range. Fig. 4.3 shows Amacher's calculations for the fourth plus ten cents.

Using standard arithmetic, Amacher calculated three interaural frequencies for each dyad in her study. When f2 represent a higher frequency than f1, fcs will be the frequencies with which the basilar membrane responds to an incident dyad.

(1) Simple difference tone: (f2—f1) = fc1
(2) Lower cubic difference tone: (2) f1—f2 = fc2
(3) Cubic tone difference: (3) f1—(2)f2 = fc3

These interaural tones hover at least two octaves below their inciting, air-bound dyad. Given their registral disparities, such responses are sometimes described as "falling out" of their evoking tones. In the order on they appear in her list, they deliver microtonal variants of B2, G#3 and F2. Neural tones thicken this collection and extend its lower range, adding another A2 to the incident fourth. Amacher's list establishes the conceptual importance of these locations and frequencies, apart from their obvious audibility. By 1975, clinical otologists agreed that only the first two difference tones in a potentially infinite series were important for hearing, with the lower cubic difference tone (LCDT) as the most audible among them when tuned between the ratios 1:1—1:3.[33] Amacher's list insists on a third interaural tone that, though perhaps less audible, could nonetheless participate in a "real basis" for making "changes to the flow."

[33] Ibid., 514. On the first page in her workbook, Amacher notes this range, explaining that "when F2 increases from unison toward the 5th, 4th and octave, Fc2 and Fc3 decrease in pitch and are most easily heard between 1.1F1 and 1.3F2."

```
INTERVALS LIST

1.  interval between 2 tones outside:(x)

2.  interval cominations in ear     : (y)

3.  intervals between x and y (air and ear).
                     NEURAL    AIR
4.  intervals between z (Fo and outside) AND x

5.  intervals between z and y; Fo and Fc
```

Figure 4.4 Intervals List from Amacher's *Additional Tones Workbook*. Courtesy of the Maryanne Amacher Foundation.

In a second list, titled "Intervals," Amacher creates dyadic combinations using these seven frequencies, as shown in Fig. 4.4. Though this list cannot yet account for the "temporal differentiation" that inserts the eartones of "Head Rhythm 1" into room sound's negative space, it details the intervallic environment that gives rise to their interplay.[34] Because Amacher's calculations tack frequency to precise segmentations of the auditory pathway, combining those frequencies, in her "Intervals List," means coupling their respective locations as well. To this end, she proposes five interval types.[35]

The variables x, y, and z represent the locations "ROOM," "EAR," and "NEURAL." Interval types 1 and 2 compare two or more frequencies that sound in a single location. But types 3, 4, and 5 link each tone in the room to each tone in the ear and then link each tone in these locations to additional events in the brain. According to this five-part scheme, two tones in the room and five additional tones in other locations should yield at least eighteen distinct intervals that differently combine frequency and response location. The "Intervals List" imagines the ear as a kind of prismatic simultaneity whose component parts brook wild re-combinations apart from their normative function for hearing.

Let's return to "Head Rhythm 1" with this list as an interpretive tool. Consider, for example, three dyads lodged in the left channel and separated by four octaves.[36] An eighteen-part intervallic complex would emerge from each oscillating fourth. Taken together, each dyad's interaural frequencies hover around an Eb pitch

[34] Responses from different parts of the basilar membrane reach the ear canal at different times. In this way, they become "temporally differentiated" from both their primary tone stimuli and from each other. Hartmann, *Signals*, 511.

[35] Amacher, *Workbook*, 5.

[36] Registral spacing forecloses audible eartones between each octave.

class and provide this opening blaze with bass-like pulsations multiple octaves below x-space's lowest dyad.[37] Interaural responses move the registral floor of "Head Rhythm 1" into the inner ear; a dyadic approach to interval type 3 would find a leap-like oscillation between x and y space. Yet the right channel throws a wrench in the left's intervallic consistency. Adding the stepwise tone creates two new room-bound dyads, each generating another unique, eighteen-part thicket of intervallic connections comprising far more heterogeneous interaural frequencies than the left's Ebs in y-space. Though y-space teems with microtonal variants that combine with x-space near the fourth and the octave, the right channel's added frequency introduces a wilder intervallic complex that works against the left's beam-like doublings at the octave in x-, y-, and z-space.[38] No mere counting exercise, an "Intervals List"–based analysis illuminates how "Head Rhythm 1" differently coordinates the auditory pathway's relation to itself.

Amacher also chronicled additional auricular sensitivities that do not appear in the "Intervals List," as revealed by the sketch shown in Fig. 4.5. These explorations come into focus through additional figures that she re-drew from her sources and peppered with notes and questions.[39] While the "Intervals List" prioritized frequency analysis in the brain and cochlea, these sketches identify threshold levels between auricular structures themselves. Color-coded notes map frequency ranges in x-space to component parts. One might emphasize, for example, a range that maximizes the passage of energy from the air to the cochlea; across both channels, the highest tone bursts of "Head Rhythm 1" fall within precisely this range. Above 8000 cycles per second, however, the cartilaginous pinna takes over sound localization, creating a secondary responsive intensity. Alongside the "Intervals List," this diagram demonstrates how an intervallic complex in the brain and inner ear could be inflected by incident sound that addressed an entirely different threshold in auricular anatomy. Such configurations make up what Amacher would later call a "perceptual geography"—the distributed interplay between threshold levels at which auditory structures respond differently to specific frequency structures in time.

This little map opens up a way to think about auditory processes as themselves partial perspectives on incident sound. Some processes can be left to function as usual while others can be pushed to extraordinary levels. "Let the ear be the 'mechanical' instrument being played," Amacher summarized in handwritten

[37] Indeed, Amacher remarked on such registral arrangements in more general terms, which speaking to an audience at Ars Electronica in 1989. "When you look at the octave in music, [. . .] when [tones are] one octave apart, we have the tones that are sounding in our ears. Let's say it's two Cs and one octave above, and then we created a C, G and E. Adding one other octave, there's an A and a G. But when you have the octave plus five, the tones that we are creating in our ear, all of the tones are a C."

[38] See also Gary S. Kendall, Christopher Haworth, and Rodrigo F. Cádiz, *Computer Music Journal* 38, no. 4 (Winter 2014): 1–2; and Brian Connolly, "Playing the Ear: Non-Linearities of the Inner Ear and their Creative Potential" (Ph.D. diss., Maynooth University, 2016).

[39] Amacher, *Workbook*, 50.

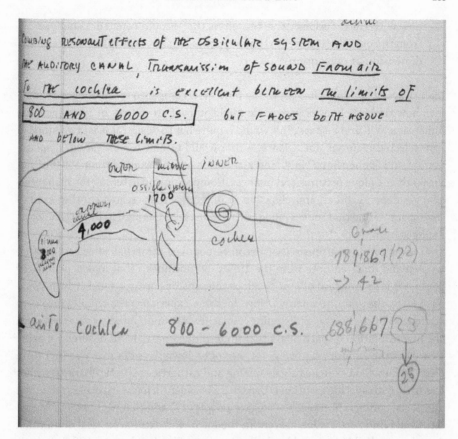

Figure 4.5 Amacher's sketch of auricular structures with corresponding frequency ranges. Courtesy of the Maryanne Amacher Foundation.

notes, and "let the neural be more complicated."[40] Another option, she continued, would "let neural continue to function as it did in regular music 'automatic' but be held in its complete relationship to other mechanical in the ear. Tune the neural now to ear processor or instrument."[41] Though Amacher never tires of reminding readers and listeners that cochlear responses are constitutive of any listening experience—remarkable or not—she does not simply reprise their utility for auditory perception. Instead, she seeks to compose what she calls "interchanges" between "pre-selected material" and the "experiential systems generating [experiences for listeners]."[42] A little supplementary play takes place during such "interchanges"; any given segment can function as a part of and in excess to the complete auditory pathway. For example, Amacher writes,

[40] Ibid., 47.
[41] Ibid., 47.
[42] Ibid., 47.

now with these "issues": the awareness that I could construct changes from the outside (timbre) to that happening inside, to displacements of dimension of perception.[43]

Many ways of making "changes to the flow" now come into focus. Amacher imagines how timbral changes in x-space might impact structures of frequency and dimension in y- and z-space. This would require her to design at least two kinds of "pre-selected material" for x-space. A first would establish her desired "displacements" and "dimensions" in y- and z-spaces; a second would ornament (but not mask) their unique features and nuances. Composing and listening for such interchanges depends on an apprehension of difference that creates another kind of "live space"—one that moves along with listeners' bodies and, in important ways, emerges from them.[44]

"I want to make a music that becomes popular," Amacher jotted in a handwritten and undated note from the 1990s. It continues, "that makes people cry because it is so 'unheard of'—it develops too sensitive areas, a music which awakens you to the stain, to energy." How does one experience the coming into consciousness of these ways of listening? Amacher was undoubtedly concerned with the fine resolution of particulars that underpinned partial and differential experiences of the auditory pathway. Yet, her note downplays discovery as its raison d'être and instead sketches a galvanizing and cathartic aesthetic charge that has less to do with specific emotions than with a broader turn toward others for solace and social contact. "A music that makes people cry" and that also became "popular" would find social value nascent in the intra- and extra-acoustical drama that Amacher studied in her workbook. But in what will this value consist? To borrow from Michelle Murphy, Amacher's note suggests approaches to the auditory pathway as a "collective binding of profoundly uneven relations of porosity and exposure" that critically questions how bodies are made to look and sound "as though they operate as solo units."[45] What form these interventions would take, however, was no forgone conclusion; how displacements in the ear could or could not call forth what Amacher called "sensitive areas" had to be critically delimited. In the performative frameworks *Music for Sound-Joined Room* and *Mini Sound Series*, Amacher maneuvered the material experience of the ear's divergence from itself into critical and dramaturgical frames that stoked ethical consideration for how

[43] Ibid., 48.

[44] Indeed, at this stage, Amacher's remarks on the results of her experiments are quite effusive. "Acknowledge the mechanism. Reinforce and construct," she writes, "MAKES EXPANSIONS OF THE MELODIES WITHIN—SO BIG—PROPORTIONS ARE STRANGE." This suggests a three-part recipe for composing with auditory processes: (1) Attend to an auricular structure, (2) Select frequency complexes that reinforce its workings, (3) Construct additional complexes and tunings that enhance that experience of reinforcement. Ibid., 47.

[45] Michelle Murphy, "What Can't a Body Do?," *Catalyst: Feminism, Theory, Technoscience* 3, no. 1 (2017): 1–15, 6.

those divergences could register across variable social locations and how "care for bodily difference" would be taken up or foreclosed amid those transits.[46] If these projects imagine "worlds where listeners can go," one might ask what, in those worlds, an ear will be presumed to be, and, in them, what an eartone will be presumed to be able to do.

Coils and Doublings in *Labyrinthitis* (2008)

Nearly fifty years after Amacher commenced her research program, interaural sound remains a provocative object of compositional and artistic desire. Interaural sound promises an "active ear," which can be hard to resist as an obvious affront to the audiovisual litany and as obscure but charged auditory material that can seemingly be refined in expert hands. Danish composer Jacob Kierkegaard, for example, has amassed a small but concentrated body of work along these lines.[47] His *Labyrinthitis* (2008) materializes interaural responses within contrasting histories, topologies, and concepts of body. On September 2, 2007, sixteen speakers traversed the ceiling at the well-funded and tourist-friendly Medical Museion in Copenhagen. Cast grandly, Kierkegaard's installation cascaded from great architectural heights downward toward listeners.[48] Starting near the 9 o'clock position on the ornate cupola ceiling of the Museion's scientific theater, speakers fan out from left to right at proportionally greater distances from the window's center. Over the dome's concentric structures, the array traces a spiral that, though incomplete, sends the gaze curling across the ceiling. This sculptural arrangement figured Kierkegaard's working process, which entailed studying his own eartone responses in an anechoic chamber and redoubling their frequency structures in fixed media playback. One might imagine this project as a riff on some of US experimentalism's favorite stories, as Douglas Kahn has also noted. Like Cage in the anechoic chamber, Kierkegaard revels in his own biological potentials within a sealed enclosure. As though doubling the Cagean primal scene, Kierkegaard projects those potentials into built space where it, then, recapitulates, such that listeners can then revel in their own response tones, as evoked by Kierkegaard's. To Alvin Lucier's caricature of a composing mind in *Music for Solo Performer* (1965), Kierkegaard adds a funnily realistic introduction to a composing ear. Sound springs directly from the composer's ears and draws, from the audience's ears, a

[46] Ibid., 4.

[47] In a new work for voices titled *Eustachia*, Kierkegaard recorded spontaneous otoacoustic emissions from members of the Danish Choir Aarhus Pigekor and "interpreted" the collection in a choral arrangement for the singers to perform. https://fonik.dk/works/eustachiaforvoices.html, accessed December 2, 2019. Spontaneous otoacoustic emissions (abbreviated SOAEs) emerge from electromechanical stimulus in the cochlea without an evoking incident tone.

[48] Douglas Kahn, "Active Hearing: Jacob Kierkegaard's *Labyrinthis*," http://fonik.dk/works/labyrinthitis-kahn.html, accessed March 30, 2020.

sound all their own.[49] This private communication streams like a direct line from Amacher's x-space to y-space.

But as Amacher's workbook makes clear, intervallic details matter. A strict, recursive process controls Kierkegaard's forty-minute, fixed-media version, which consists entirely of dyads tuned to the ratio of 1:1.2, used by otologists to test the inner ear's microphonic responses.[50] This omnipresent ratio creates a strikingly consonant sound world, within which Kierkegaard composes with a single interaural frequency: the Lower Cubic Difference Tone (LCDT), which is valued, in clinical settings, for its conspicuous audibility. To evoke it, he employs long, sustained tones. Languid gestures would have swept downward from the spiraling speaker array. Leaving time for a listener's inner ear to respond, *Labyrinthitis* next introduces, in the room, a frequency calculated to match the interaural LCDT. For a moment, the same tone sounds in the room and in the listener's cochlea. When a second room-based frequency enters—this one, again, tuned to the 1:1.2 ratio—the resultant dyad produces yet another interaural LCDT. Kierkegaard's playback repeats these procedures again and again. With each doubling, shared frequencies coil between x- and y-spaces. These doublings suggest the shell-like topology of the cochlea; and if, at the Museoin, listeners were to look toward the ceiling in search of a sound source, the speakers' spiral figuration would refer them to the cochlea, yet again. Though Kierkegaard's compositional strategy engages only a single response tone, this audiovisual logic suggests that it should be heard as a metonym for cochlear function itself.

In a 2011 essay, composer and computer music researcher Christopher Haworth centers *Labyrinthitis* in an inquiry into interaural sound as an impetus in formal development.[51] Interested as much in deepening his own art practice as analyzing extant bodies of work, Haworth considers the question that drove Amacher's workbook decades earlier: What constitutes change and contrast on the plateau of interaural aesthetics? "Head Rhythm 1" does not fare well in his survey. Haworth assesses its eartone-based expanse as little more than a "disorienting effect" with no obvious connection to the second character, "Plaything 2."[52] In *Labyrinthitis'* dyad-centric construction, he finds what he believes to be a more straightforward and cogent approach. Formal strategy makes explicit its

[49] Andrew Dewar, "Reframing Sounds: Recontextualization as Compositional Process in the Work of Alvin Lucier," Online Supplement: Lucier Celebration, *Leonardo Music Journal* 22, no. 1 (November 2012): n.p.. As part of Lucier's immediate working environment, Andrew Dewar has noted his use of the EEG was consistent with an overall approach that repurposed everyday objects. Kierkegaard's spectacular staging runs counter to this observation and monumentalizes the clinical context that Dewar argues should be viewed in relation to Lucier's biography and through an interpretive framework derived from Lucier's working methods.

[50] See Hartmann, *Signals, Sound and Sensation*, 511.

[51] Chris Haworth, "Composing with Absent Sound," *Proceedings of the International Computer Music Conference* (2011), 342–45.

[52] Ibid., 343.

basis in the ear's biomechanics; as Haworth explains, the "ear tells the piece which frequency to introduce next."[53] Formal coherence means not trying to do too much, apart from holding fast to one's fidelity to the ear. To this end, Haworth doubles down on Kierkegaard's metonymic allusions; a structure staked explicitly on response tones invites listeners to "hear hearing taking place."[54]

However, a single LCDT seems barely adequate to this figural conceit. After all, this tone's basis in clinical discourse should not be lost to interpretive work. It is less "the ear" as such than "the ear" as regularized via the LCDT's role in hearing assessment that dictates what pitches come next. Consider the title's eponymous suffix -*itis*. Typically, this word ending indicates inflammation or irritation in the body part to which it has been affixed. Labyrinthitis describes swelling in the inner ear or vestibular nerve that can cause vertigo, nausea, and ringing in the ears. But the suffix can also become a vehicle for humor or sarcasm when used in fictitious afflictions; an -*itis* gives fatuous explanations an air of diagnostic certainty. Kierkegaard's eponymous -*itis* is not fictitious, but his title does attach a clinical etiology to the installation that, strictly speaking, does not correspond to its interaural processes. However, this mismatch also enhances the piece's didactic mode of address. If one simply tracks its dyads, the title's eponymous -*itis* will explain its formal strategy and perspective on cochlear function. Perhaps Haworth's "hearing of hearing" is instead a "hearing" of clinical protocols from a fixed formal standpoint.

Haworth's comments suggest that "Head Rhythm 1" and "Plaything 2" failed establish a clear standpoint from which the ear could lead formal processes. But which ear would have done so? Using Amacher's workbook to analyze Kierkegaard's installation yields some strange insights, as shown in Tables 4.1a and 4.1b and discussed in more detail subsequently. For any single dyad in *Labyrinthitis*, Amacher would calculate five additional tones to Kierkegaard's one.[55] The full "Intervals List" then enables her to combine points on the auditory pathway and compose for their thresholds and displacements. Such configurations need not defer to air as sound's primary means of transmission, though Amacher certainly could do so, if she felt the resulting enhancements would induce "changes in the flow." Compare this with Kierkegaard's approach. By prioritizing exclusively x- and y-space, Kierkegaard creates a stable point from which listeners can track doublings in motion. Kierkegaard's single tone constructs a markedly detached, almost disembodied experience of self-observation. Like an isolated point, this single frequency wends in and out of the body, as though through an empty shell. Though one could probably say that both

[53] Ibid., 343.

[54] Ibid., 344.

[55] These tables use a single dyad that falls within *Labyrinthis'* frequency range as a heuristic, in keeping with Amacher's schematic workbook calcutions. To that dyad, they apply the formulas that she uses in the workbook to calculate interaural and neural frequencies. However, because Kierkegaard's employs the whole number ratio 6:5, some beating phenomena may not readily apply to his installation's frequency structures.

Table 4.1a **(Amacher)**

ROOM		IN EAR		NEURAL	
1	329	fc1	40	fo	82
1.2	394.8	fc2	289	fb	
		fc3	249		

Table 4.1b **(Kierkegaard)**

ROOM		IN EAR		NEURAL	
1	329	fc1	none	fo	none
1.2	394.8	fc2	289	fb	none
		fc3	none		

These tables show how Amacher's research methods can be used to analyze other compositions that work with interaural frequencies. This application clarifies how interaural sound can materialize conflicting ways of understanding how to compose for "the ear."

composers do let "the ear tell them [what to do] next," this would require the caveat that these are very different "ears" with different things to "tell." And amid this proliferation of ears, one also might begin to wonder about Amacher's "third."

Life in a Third Ear and Its Figurations

The third ear is a figure of speech; it is a metaphor, but a metaphor for what? A quick look finds this riddle-like triplication attached not only to Amacher's music but also to a vast array of unrelated auditory experiences. A third ear adduces limits in our two extant ears and promises, in their overcoming, a newly nuanced, intimate sensorium that seems to serve a wide range of musical, relational, and commercial contexts—seemingly almost always for the better. The figure's reach encompasses musical groups (The Third Ear Band), record labels (the house music-focused Third Ear Records), language learning programs ("The Third Ear: You Can Learn Any Language"), meditation apps ("Third Ear: Meditation through Sound and Spoken Word"), and business practices. Published in American Express's "Business Trends and Insights" article series in August 2013, an essay titled "The Third Ear: A Powerful Tool for Becoming a Better Listener" lodges whatever a third ear actually does at the heart of good business leadership.

The third ear owes its breezy association with intuition, sensitivity, and awareness to Freudian lay analyst Theodor Reik's 1948 book *Listening with the Third Ear: The Inner Experience of a Psychoanalyst*, which is most often credited with introducing the term.[56] One of Freud's favorite lay analysts, Reik joined the Institute of the Vienna Psychoanalytic Society in 1924 and, in 1938, moved to New York, where he founded a non-medical psychoanalytic training institution shortly after the publication of the book. Reik also wrote extensively about music—a kind of exemplar of the "broad humanistic learning" that Freud valued in lay analysts.[57] In his 1951 *The Haunting Melody*, for example, Reik carries out a psychoanalysis of musical symptoms by employing his substantial music historical knowledge as well as his personal connections to *fin-de-siècle* Viennese musical culture.[58] Reik embraces two goals in *Listening with the Third Ear*. Without jargon or specialist nomenclature, he would offer popular audiences an unadorned reflection on his analytic techniques, successes, and failures. Reik also uses the book as a platform to address aspiring analysts directly. As the text flows unsystematically between autobiography, anecdotes, advice, and admonitions, he exhorts young analysts to learn from his examples and to teach themselves through the contingencies of practice. This would have been nothing new to a psychoanalytic community in which Reik was known for rejecting "the very possibility of a formalized theory of technique."[59]

In 1972, French philosopher Sarah Kofman also responded to something called a third ear in a book-length study titled *Nietzsche et la métaphore*.[60] This study reflects her commitment to feminist interpretation and underlines her singular position amid the so-called French Nietzscheans.[61] Working in relative isolation, Kofman left aside the grand Nietzschean doctrines that occupied Deleuze and Foucault and prioritized instead what translator Duncan Large calls compact

[56] Theodor Reik, *Listening with the Third Ear* (New York: Farrar, Straus and Giroux, 1975), 144–56.

[57] George Makari, *Revolution in Mind: The Creation of Psychoanalysis* (New York: Harper Perennial, 2009), 459.

[58] For example, see Theodor Reik, *The Haunting Melody: Psychoanalytic Experiences in Life and Music* (New York: Da Capo Press, 1953). Reik researched Mahler prior to immigrating to the United States in 1938 and portions of *Melody* build on Freud's notes about Mahler, after having met him for a single consultation in 1910.

[59] Makari, *Revolution in Mind*, 459.

[60] This was Kofman's second book and she would go on to publish almost thirty more, as well as many articles that, as Pleshette DeArmitt summarizes, deal with philosophical, psychoanalytic, literary, feminist, autobiographical, and Jewish topics. Her work has not been widely received in Anglophone contexts, and for a fittingly interdisciplinary introduction, please see Tina Chanter and Pleshette DeArmitt, eds., *Sarah Kofman's Corpus* (Albany: SUNY Press, 2008).

[61] See Duncan Large, "Introduction," in Sarah Kofman, *Nietzsche and Metaphor*, trans. Duncan Large (Stanford, CA: Stanford University Press, 1994), ix–xxi. As Large explains, she presented an initial version of the book in Derrida's seminar on philosophical method at the École Normale Supérieure during the 1969 academic year but strenuously objected to being characterized as a "Derridean" acolyte of any kind. Ibid., xviii–xix.

"microtextual analyses" that work unapologetically on the surface of Nietzsche's texts.[62] With ferociously close work on Nietzsche's metaphorical habits trained on specific figures—like beehives, spider webs, and thousand-eyed things— Kofman's analyses attuned to how a text's genealogical disposition comes through its metaphoric style. Nietzsche's "deliberate use of metaphor" became a kind of toolbox for unworking common wisdom regularizations of life, engaging readers in deliberate perspectival experimentation with respect to how life, body, and the senses can be configured.[63] In these experiments, the third ear would have a number of roles to play.

While both Kofman and Reik draw on Nietzsche's writing about the third ear, their citational practices differ in important ways. Kofman's textual analyses call forth a great deal of material, quoted at length. Dense with block quotes, her book's pages look like collages in which the two philosophers' voices intertwine. Reik simply attributes the short phrase "with the third ear" to Nietzsche's *Beyond Good and Evil*, but neither quotes nor interprets the long, scary passage where it appears.[64]

What torture books written in German are for anyone who has a *third* ear! How vexed one stands before the slowly revolving swamp of sounds that do not sound like anything and rhythms that do not dance, called a "book" among Germans! Yet worse is the German who *reads* books! How lazily, how reluctantly, how badly he reads! How many Germans know, and demand of themselves that they should know that there is an *art* to every good sentence—art that must be figured out if the sentence is to be understood!

That one must not be in doubt about the rhythmically decisive syllables, that one experiences the break with any excessive severe symmetry as deliberate and attractive, that one lends a subtle and patient ear to every *staccato* and every *rubato*, that one figures out the meaning in the sequence of vowels and diphthongs and how delicately and richly they can be colored and change colors as they follow each other—who among book-reading Germans has enough good will to acknowledge such duties and demands and to listen to that much art and purpose in language?[65]

[62] Ibid., xxii. Indeed, Kofman was not received in the United States, in the late 1970s, alongside Derrida, Foucault, Deleuze, and other French theorists. This includes, for example, the 1977 issue of *Semiotext(e)* titled "Nietzsche's Return" that avowed "an incessant critique of Unity, Self, stability, etc." In it appear Foucault's "Nietzsche, Genealogy, History," Deleuze's "Nomad Thought," and Derrida's "Becoming Woman," alongside cartoons, collages, punk lyrics, and other illustrations that poked fun at establishment figures in Nietzsche studies, like Walter Kaufmann. Sylvère Lotringer, Chris Kraus, and Hedi El Kholti, eds., "Nietzsche's Return," *Semiotext(e)* 3, no. 1 (New York: Polymorph Press).

[63] Kofman, *Metaphor*, 42.

[64] Reik, *Listening*, 144.

[65] Friedrich Nietzsche, "Beyond Good and Evil," in *Basic Writings of Nietzsche*, ed. and trans. Walter Kaufmann (New York: Random House, 2000), 372.

The third ear pins interpretation and understanding to writing's sonic and musical aspects. Hearing the "art" of any sentence means following how its words and phonemes have been fitted together. Articulation, rhythmic patterning, and timbral transformation lead the third ear into a text's nooks and crannies; there, it has to be "subtle and patient" to get a feel for things. While Reik does not confronts this nationalistic rant's distinctions between good and bad German readers, he instead seizes on an analogy between the movement of musical forces in writing and the impressions registered by the analyst's unconscious in the clinical session. He absorbs Nietzsche's confidence in a third ear's capacity for enhanced understanding and deploys it on his own terms.

Reik's book garnered overwhelmingly positive reviews when it was released. A short essay in the *New York Times* titled "Friendly 'Third Ear'" described the book's accessible style as a manifestation of Reik's honest, intuitive, empathic (but unsentimental) character.[66] In lieu of jargon and specialized terminology, he imbues the otherwise unsystematic study with an elegant, relatable unity by referring multiple assumptions in his clinical practice to the workings of the third ear as such.[67] As Reik explained,

> He who listens with the third ear hears also what is expressed almost noiselessly, what is said pianissimo. There are instances in which things a person has said in psychoanalysis are consciously not even heard by the analyst but are nonetheless understood or interpreted. There are others about which one can say: in one ear, out the other and into the third.[68]
>
> One of the perculiarities of the the third ear is that it works in two ways. It can catch what other people do not say, but only feel and think; and it can also be turned inward. It can hear voices within the self that are otherwise not audible because they are drowned out by the noise of other conscious processes. The psychoanalyst who hopes to recognize the secret meaning of this almost imperceptible, imponderable language, has to sharpen his sensitivity to it.[69]

[66] Anthony Bower, "Friendly 'Third Ear,'" *New York Times*, August 18, 1948, Section BR, 6. "[This is] obviously a man who possesses the 'third ear,'" the reviewer reported, in a write-up that emphasized Reik's analytic sensitivity and feelingful prose without compromising his masculinist expertise.

[67] This includes, for example, the rule of free-floating attention. As Alan Bass explains, "in order for one unconscious to affect another without going directly through consciousness, the analyst must give equal weight to everything the patient says and to whatever comes to his or her mind while listening." Reik refers these processes to the third ear as such. See Alan Bass, *Interpretation and Difference: The Strangeness of Care* (Stanford, CA: Stanford University Press, 2006).

[68] Reik, *Listening with the Third Ear*, 145.

[69] Ibid., 146–47.

Reik leads with a listening that valorizes exceptional meanings located at acoustical thresholds, where sounds hover "pianissimo" or "almost noiseless."[70] But the third ear's figurative triplication conjures a listening that need not remain beholden to the ears and extends its perceptual ambitus to include sight, gesture, smell, and so on. When Reik instructs analysts to attend to "the peculiarity of glancing, the gesture of a hand, the smell of perfume," he stresses that all of this will come through the third ear; to "glances," "hands," and "perfumes," the third ear listens.[71] However, this is no perceptual geography. As Phillipe Lacoue-Labarthe explains, Reik's third ear regularizes any impression of another person's outer surface as, specifically, an unconscious perception. Listening becomes, he writes, "the paradigm (not the metaphor) of perception in general."[72] In one sense, the third ear moves listening into an expansive mode. However, as perception's common root, this expansion collapses unconscious perception, conscious perception, and analytic interpretation into listening, as their mutually exclusive mode. Consolidating these processes in a third ear absolves Reik from having to articulate their inter-implications or to provide additional metaphors to distinguish them from one another. Whenever something moves between conscious and unconscious perception, the third ear will have enabled its passage, for Reik. Far from common wisdom empathy, the third ear reifies listening, sensing, and interpreting within a paradigm that disembodies the other person whom it also hears.[73]

[70] Indeed, the third ear works in more than "two ways" throughout the long, often-quoted passage above. While Reik cautions that some analyses will remain intractable if the analyst cannot turn the third ear on himself, consider the many relays that this ear also secures: it connects the patient to the analyst; it connects the analyst to listening; it connects listening to perception; it connects perception to interpretation; it connects interpretation to both conscious and unconscious impressions.

[71] Reik, *Listening with the Third Ear*, 153.

[72] Philippe Lacoue-Labarthe, "The Echo of the Subject," in *Typography: Mimesis, Philosophy, Politics*, ed. Christopher Fynsk (Cambridge, MA: Harvard University Press, 1989), 162.

[73] Steven Connor takes a suspicious approach to what he calls "acousmania," an extension of Sterne's audiovisual litany that understands listening and sound to ceaselessly promise new research objects, new modes of attention, and new methods that can go beyond traditional "inspection" and "analysis." He worries about interdisciplinary authority in field formations that valorize listening as an empathetic asset. For Connor, Reik's third ear epitomizes these errors. Even as it appears to secure intersubjective connection, the third ear belies disciplinary applications that "pitilessly remits others' sounding to intelligibility." He continues, "the *concept of the third ear* [. . .] depends upon the deafening of those who are subjected to the operations of listening, while themselves being reduced to the emitters of sound that they cannot themselves properly hear." In contrast, I have attempted to draw out the third ear's figural qualities—that is, to precisely sideline it "as a concept" (or paradigm)—and extrapolate the expressive utility that Kofman identifies in it. See Steven Connor, "Sadistic Listening," Sawyer Seminar, Harvard University, April 14, 2014. Steven Connor, Acousmania, http://stevencon nor.com/acousmania.html, accessed April 16, 2017. Lecture given at *Sound Studies: Art, Experience, Politics*, CRASSH, Cambridge, July 10, 2015.

Kofman's third ear works much differently. It is certainly a metaphor—not a paradigm—but it will also not answer the question "a metaphor for what?" with which I opened this section. Such a question presumes that metaphor compares unlike things to one another in order to transport the uncommon into the common in the name of clarification and understanding. Kofman insists otherwise. For her, such transports are also comparisons of power. Across the Niezschean corpus, she groups the third ear among metaphoric tactics that prioritizes subordinate terms in order to unsettle capillary forces and rhetorical habits that not only hold the common in place, but obscure its forgotten basis in metaphor, in the first place.[74] Kofman shows that metaphor is simply the action of articulating life in a specific and partial way in order to multiply the perspectives that formerly subordinated terms can take on their component parts. This work is precise and intentional. Writing with metaphors touches on the regularization of life and, for this reason, it is work of "formidable seriousness."[75]

Metaphors that compare the senses, Kofman shows, channel their companion terms toward bodies and materials. Such couplings practically guarantee crisp, provocative disparities in power. [76] As Kofman illustrates, Nietzsche's penchant for "reinscribing the meaning of a text and its clarity into the senses" comes through metaphors that transport cognitive actions into historically denigrated

[74] I realize that this treatment of Nietzsche cuts against the grain of critical applications in theoretical sound art research, which seek to detach sound from textual analysis and instead embrace a naturalist and materialist approach to its differential flux. In this, I include my own earlier reading of "Head Rhythm 1," which emphasized the expressivity of matter but engaged only eartones, despite the complex perceptual geographies of which they are a part, in Amacher's workbook. I am eager to complicate this approach with an unabashedly textual and figural treatment that proliferates as complexly as did Amacher's own perceptual geographies. More precisely, Kofman's analysis suggests that any claim to access auditory thresholds as material flux is also always already shaped, carved, and assembled in figurations that channel enrichment toward some bodies and not others. This is why she employs metaphors that favor their subordinated terms among crucial genealogical tools. While this or that individual metaphor may not have material effects per se, they can test the limits of how sound is materialized in spaces of thriving and attenuation.

[75] Kofman, *Metaphor*, 102.

[76] In an essay about her performance series *Vaginated Chairs* (2016), Miya Masaoka employs the third ear to capture a phenomenology of embodied knowledge. She invokes Amacher's cochlea-centric perceptual geographies as a reference point for music she transmits via vaginal inserts that, she states, creates a heightened sense of "vibrational movement and spatiality," which addresses both the anatomical body and a co-constitutive intertwinement with the "flesh" of the world as described by Merleau-Ponty in the unfinished essay "The Intertwining—The Chiasm." This gives rise to "a theory that addresses how we know what we know from our lived experience, as well as our considerations of past critical practices employing procedures such as bodily self-focus, multimodal spatiality, strategic awareness, integrated sensorial listening, and our imagined collective future." See Miya Masaoka, "The Vagina Is the Third Ear," *The Drama Review* 64, no. 1 (Spring 2020): 2–7. As a feminized anatomical metaphor, Roshanak Kheshti attends to invagination as an analytic of difference, power, and intersubjectivity. Extending Derrida's *The Ear of the Other*, she links listening and invagination as an event that "perceives difference and mutually constitutes the self in relation to this difference thereby marking the subjectivity of what is heard in relation to race and gender." See Kheshti, *Modernity's Ear*, 91–94.

processes.[77] The third ear functions within a web of such constructions and relays. Although the "small third ear is the artistic ear which [. . .] is capable of hearing (understanding) an incredible (unheard) language incommensurable with vulgar language and its logic or metaphysical presuppositions," it is also the case that,

> To become intelligent is to become like an animal, to learn to read with the caution, with the slowness, the transformative and assimilatory capabilities of an animal, without attempting to swallow too fast, to digest nothing. A cautious, assimilative and transformative [process of] rooting around in language.[78]

The third ear is small and sharp, but also slow and plodding. While it first transports textual interpretation into the body, a second transport moves that body into the stomach and a third casts it into loamy earth, in which one can "root around." Comparisons aggregate and perspectives multiply. Musical listening seizes literary understanding and both are then enfolded into the gustatory experiences of ruminant animals. Gradually, the third ear effaces any hard and fast "[distinctions] between action and contemplation."[79] However, Kofman explains, this does not entail submitting restless transits to dialectical systematization— that is, determining what a third ear's metaphorics are "for" or "about." Instead, metaphors unleash a charge or shock that moves composite things into new perspectives on the hierarchies of which they once were a part. Metaphoric styles can touch on the "splendor of surging life"; while concepts cannot describe such movements, deliberately crafted metaphors can register their comparative impacts and transits.[80]

The senses are haunted by metaphors, as well. "Vision," "hearing," "smell," and "touch," Kofman notes, are nothing more than familiar and synoptic metaphors for a dizzying array of perspectives on light's coupling with the visible, sound's coupling with the aural, or other conjunctions in the sensible. These metaphors regularize the life of sensation; they ensure that sense experience appears natural and materially grounded. But this also entails mistaking effects for causes: for Kofman, "vision," "smell," "touch," and "hearing" arrive late to explain an action that has already taken place in a sensing body.[81] The action of "sight" comes first, Kofman writes, and the sense of "vision" follows; the action of "scent" comes first, and the sense of "smell" follows. Some metaphors can short-circuit these mistakes before they happen. A third ear "listens," but it does so apart from "hearing"; a thousand eyes "see," but they do so apart from "vision." Imagine also

[77] Sarah Kofman and Françoise Lionnet-McCumber, "Nietzsche and the Obscurity of Heraclitus," *Diacritics* 17, no. 3 (Autumn 1987): 48 and 50.

[78] Ibid., 50.

[79] Kofman, *Metaphor*, 110.

[80] Ibid., 107.

[81] Ibid., 42.

tasting with one's hands, reading with one's nose. The point is not to actually try doing these things; rather, by highlighting a constitutive gap between actions and sense modalities, metaphors ensure that the subversion of scripted hierarchies remains an ineradicable possibility. Metaphors can redirect the figural force that holds bodies together toward marginal perspectives on life and other lively things. To this end, Kofman is especially fond of juxtapositions between "different spheres."[82] Such metaphors stymie causality and priority and instead emphasize that what holds their terms together is primarily an "aesthetic relation."[83] For a moment, metaphor provides this constitutive gap with poetic form and aesthetic impact. While dramatizing the constraints of stabilizing, regularizing metaphors (the ear), additional metaphors (the third ear) insist that there need not be a strict correspondence between these actions and "the materialities they seem to extrude."[84]

Kofman recommends bad-mannered, "insolent" metaphorical styles.[85] Why? Metaphors confront the regularization of life and, at the same time, dramatize a profound impropriety at the heart of sensation and perception. Consider how easily the third ear slips between reading, writing, musical listening, and nutritive rumination. When a metaphor retrieves life's splendor from the most intractable, seemingly natural regularizations, it delivers what Kofman calls "the unheard-of." Metaphorical style should aspire to this condition, she recommends. The point is not simply to create something new, but instead to multiply wild, unlikely perspectives that pull dominant terms to the brink of incomprehensibility. Metaphors can coax concepts into revealing their basis in other metaphors, moral prescriptions, and other errors or faulty approximations. By so doing, metaphors innervate a text's genealogical disposition in relation to a wide range of bodies, materials, and vitalities.

For Theodor Reik, the third ear guarantees definitive answers, but for Kofman the third ear cannot even guarantee that there will ever be only three. Instead, it calls for still wilder metaphors that can further decondensate the actions, perspectives, couplings, and sounds that regularize "the ear," in the first place. Suggestive alignments with Amacher's material interventions come into focus. With Kofman, her research shares a commitment to perspectival readjustment; one calls for an insolent poetics, the other for a delicate choreography of displacement and enhancement. The third ear registers how these perspectival adjustments arrive already laced with imaginative excess. But as also a genealogical disposition, the third ear remains concerned with how that excess will be used to shore up ideas about what an ear is and what it can or cannot do. After all,

[82] Ibid., 42.

[83] Ibid., 42.

[84] Elizabeth Povinelli, *Economies of Abandonment: Abandonment and Belonging in Late Liberalism* (Durham, NC: Duke University Press, 2013), 109.

[85] Kofman, *Metaphor*, 112.

these are not merely performative deployments. As Elizabeth Povinelli sum-marizes, a "discursive construction of materiality shapes, cuts and assembles a given formation in the material world," but it never does so without leaving some "unintegrated, errant aspect of materiality," which must persist as a condition of possibility for further iteration.[86] Between her primary sources and early inter-locutors, Amacher encountered many such remainders, excluded or occluded by competing figurations of interaural sound as well as skeptical responses to the interplays and displacements that the *Additional Tones Workbook* enabled her to create. To explore these episodes in the archive, Kofman's insolent genealogical sensibility proves surprisingly useful.

"A Phantasm Coming from My Head!" and Other Interaural Genealogies

At the Mary Ingraham Bunting Institute at Radcliffe College between 1978 and 1979, Amacher became, again, a "jolly good fellow." She had begun to draft a tech-nical essay that summarized her *Additional Tones* research in 1977 and, in 1979, delivered a version in a colloquium talk at the Institute titled "Psychoacoustic Phenomena in Musical Composition: Some Features of a 'Perceptual Geography.'" She opened the talk by also destabilizing one of its central terms: "This work isolates certain characteristics belonging to the so-called psychoacoustic phe-nomena: tone sensations we create in our ears and brain, in response to many intervals in music," the first sentence reads. Why "so-called"?[87] Attaching eartone responses to objects of disciplinary specialization, Amacher suggests, at once obscures and delegitimizes the relational evocations through which they are expe-rienced in music, more generally. "As musicians and composers, we're supposed to be, kind of dummies," she later remarked, "writing things [but] not to know how they affect us." When Amacher published her colloquium talk in 2008, she provided an updated preface that described the sources she had studied in the meantime and reflected on how her earlier work might have gone differently, had she been able to draw on these insights. Eartones make their first appearance, in Amacher's preface, as disqualified knowledge: "My writing is somewhat timid, and also conservative due to my critical MIT advisors," Amacher confides, "who were concerned that readers might possibly suspect these descriptions to be more a

[86] Povinelli, *Economies of Abandonment*, 109.

[87] Maryanne Amacher, "Psychoacoustic Phenomena in Musical Composition: Some Features of a Perceptual Geography," in *Arcana III: Musicians on Music*, ed. John Zorn (New York: Tzadik, 2008), 14. In 1977, Harvard had committed to educating all undergraduate women students and rededicated the former women's college to postgraduate programs for women researchers. Amacher held a Fellowship in the category "Performing Art/Music/Drama" and among her colleagues were writers, sculptors, and scholars, including feminist microbiologist and science studies scholar Bonnie Spanier with whom Amacher became close friends.

phantasm coming from my head!"[88] In this opening gesture, she draws the reader close and invites them to side with her eartones and, by proxy, their own.

Like any research process, Amacher's involved all sorts of belated connections, little solecisms, and minute deviations. This is not to say that she made mistakes. Her commitment to certain citational fields, instead, tended to draw forth their liminality, fragmentation, and tenuous qualifications. In order for "things to have value to us," Foucault famously wrote, a "whole series of knowledges" need to be disqualified as "nonconceptual knowledges, as insufficiently elaborated knowledges: naïve knowledges, hierarchically inferior knowledges, knowledges that are below [a] required level of erudition or scientificity."[89] Strictly speaking, genealogy's grey and meticulous work should recover these disqualifications and use them to break concepts into the capillary power relations they uphold. But as Amacher sifted through acoustical, ontological, and psychophysical research publications, she seems to have caught struggles for qualification in medias res across subfields full of false starts, competing claims, and pointed elisions.[90]

Unnamed skeptics—who thought this was all in her head—further complicate the picture. Scott Fisher identified the central culprit as Marvin Minsky, the arch-symbolist AI theorist, with whom Amacher became acquainted during her time at the Center for Advanced Visual Studies.[91] During a 2001 talk, Amacher recalled a barrage of questions she had put to him years earlier:

> Why do we seem to need music? Why do people like experiencing music? Why do people enjoy experiencing the same rhythms, melodic patterns, over and over again, day after day, even year after year? Why

[88] Amacher, "Psychoacoustic Phenomena," 10.

[89] Michel Foucault, "Nietzsche, Genealogy History [1971]," in *Language, Counter-Memory and Practice*, ed. Donald Bouchard, trans. Donald F. Bouchard and Sherry Simon (Ithaca: Cornell University Press, 1977): 139–64.

[90] An extended genealogy would also attend to Giuseppe Tartini's empirical observations of the *"terzo suono,"* or third sound, from which he derived a fundamental bass for major triads. For a detailed account of Tartini's study as an intervention in early modern neo-Platonism and instrumental pedagogy, see Keir GoGwilt, PhD dissertation in progress. GoGwilt locates the *terzo suono* within broader contestations about nature and taste among early modern violinists whose encyclopedic treatises dealt with instrumental pedagogy as much as aesthetics, acoustics, philosophies, and theories of hearing and the body. For Tartini, the *terzo suono* supported a staunch naturalist position. As GoGwilt explains, "his *Treatise on Harmony* clearly reflects ideals of the Arcadian Academy, and sought to rescue musical taste from baroque tendencies involving florid ornamentation, instead returning to a neo-Platonic notion of music's affective powers. He revered the *terzo suono* for its capacity to evidence the confluence of nature and divine number and a primordial unity between art and nature that underpinned his commitment to reconstructing the ancient Greek modes."

[91] Conversation with the author, September 13, 2017.

is so much taken for granted about music, when at the same time there
is so little understanding of its operations?[92]

"He later wrote a paper," she reports. "And I wrote a fictional screenplay, set some
years in the future, addressing a number of these questions."[93] Minsky's text was
titled "Music, Mind, and Meaning"; Amacher's "screenplay" was the conceptual
and narrative treatment for her unrealized media opera *Intelligent Life* which, as
we shall see in Chapter 5, developed a mediatic and diegetic format that could
redouble eartone responses as narrative involvement in a fictional technoscience.
As N. Katherine Hayles put it, "the development of information theory after
WWII left as its legacy a conundrum: even though information provides the basis
of much of contemporary US society, it has been constructed never to be pres-
ent in itself."[94] This conundrum registers powerfully in Minsky's paper. Despite
craggy humanists' commitment to first-person narration, he argued, computa-
tional approaches stood to shed light on old, intractable questions about music's
appeal; symbolic approaches to complex processes need not oppose subjective
feeling. Because "so little of music is present in any single moment," he asserts,
listening must keep track of how large structures have been built from small
ones.[95] The essay orbits again and again through the first four bars of Beethoven's
Fifth Symphony, re-narrating the patterns in which subsequent events reveal
them to have been a part. This evidences "map-making" processes—that is, a dia-
lectic that sifts patterns from randomness in real time by checking new features
against earlier material whose significance becomes clearer along the way. When,
for Minksy, "we can hear our minds rehearsing what was heard," listeners can,
however briefly, access pattern-matching processes that could never have become
present in themselves.[96] Therein lies music's pleasure.

Yet, Hayles's conundrum remains. While hands-on activities—like listening
to Beethoven—provide a kind of access to the pattern processors that make up
what Minsky called the "society of the mind," this computation involves a con-
cept of intelligence staked on "the manipulation of tokens in an abstract historical
space," as digital artist and theorist Simon Penny puts it.[97] No ongoing engage-
ment with the material world or embodied perceiver, these expressive exercises

[92] Maryanne Amacher, "'The Future of Music: Credo #2:' A Panel Discussion on Cage's Influence
with Maryanne Amacher, Allen Kaprow, James Tenney, Gordon Mumma and Alvin Curran," in
Supreme Connections Reader, ed. Bill Dietz (unpublished, 2012), 207–18.

[93] Ibid., 208.

[94] N. Katherine Hayles, *How We Became Posthuman: Virtual Bodies in Cybernetics and Informatics*
(Chicago: University of Chicago Press, 1999), 25.

[95] Marvin Minsky, "Music, Mind, and Meaning," *Computer Music Journal* 5, no. 3 (Fall 1981): 28–44.

[96] Ibid., 33. See also his later overview of Amacher's work. Marvin Minsky, "Maryanne Amacher,"
Kunstforum International 103 (September–October 1989): 255.

[97] Simon Penny, "The Desire for Virtual Space: The Technological Imaginary in 1990s Media Art,"
unpublished, 2009.

will disappear into precisely the information they made legible in the first place.[98] It would be especially wrong, Minsky argues, to look for pattern processors in the auditory or visual systems themselves. For processors, he elaborated, this is useless book learning:

> Thus space-builder [another processor] like an ordinary person, knows nothing of how vision works, perspective, foveae, or blind spots. We only learn such things in school: millennia of introspection never led to their suspicion, nor did meditation, transcendental or mundane.[99]

While Amacher's workbook certainly insists otherwise—with eartones as a central case in point—in it, she also responded to research in psychoacoustics that engaged critically with the symbolist position in other ways. In the workbook's longer autodidactic stretches, Amacher engages with Juan G. Roederer's textbook *Introduction to the Physics and Psychophysics of Music*.[100] As it happens, Roederer and Minsky shared speaking gigs on the NASA lecture circuit and each saw, in cybernetics, an interdisciplinary program that could easily include Western art music. A keyboardist—like both Minsky and Amacher—Roederer tacks his interest in teaching acoustics to his life-long study of organ playing, listing his teachers and often citing early organ construction in discussions of contemporary psychoacoustic phenomena.[101] Otherwise, his path through Cold War physics cleaved unsurprisingly close to industrial and military applications. After completing university in Buenos Aires in 1951, he joined a research group focused on cosmic rays, then the forefront of high-energy nuclear physics, and in 1977 joined the Geophysical Institute at the University of Alaska Fairbanks, a major player in the Reagan-era push for geophysics research aimed at resource extraction in the Alaskan Arctic and buttressed by deregulated energy markets.

While teaching at the University of Denver during the early 1970s, Roederer turned his attention to "the study of neuropsychological mechanisms responsible for the processing of acoustical information."[102] During this period, he produced an undergraduate physics textbook that synthesized his neuropsychological research with an introduction to the physics of sound and music, which Amacher included among her sources in the *Additional Tones* research program.[103] Though

[98] While Minsky likens the processor "space-builder" to a craftsperson, the material supports that underpin the analogy—measurements, jointures, the body and techniques of the worker—merely serve to make sensible abstract spatial processing. Observing spatial construction would be, as Hayles suggests, also an exercise in looking through it.

[99] Minsky, "Meaning," 37.

[100] Juan G. Roederer, *Introduction to the Physics and Psychophysics of Music* (New York: Springer, 1975).

[101] Roederer, *Introduction*, 42.

[102] Roederer, *Introduction*, ix.

[103] Drafted with an undergraduate physics curriculum in mind, the book is now in an 11th edition. Commentary on the book resonated with Cold War civic projects that merged vanguard science with popular forms in order to ensure that the general public would be conversant with new research as an

it promises an introduction, the book is also organized around pointed interven-
tions, key among them the claim that "the central nervous system does play a
far more active role" in auditory processing than most studies acknowledge.[104]
Without saying so, Roederer also encloses challenges to the arch-symbolist posi-
tion in this argument. In the following passage, and others like it, Roederer
attaches discrete information processors to events in the auditory cortex. "Some
neurons are found only to respond to time change of stimuli," he writes, "oth-
ers to a whole complex of particular spatial configurations or time patterns of
the stimulus (*feature detectors*)."[105] Roederer brings information processing into
a strikingly intimate relation with perception's material substrate—neurons sim-
ply *are* feature detectors. For the arch-symbolist Minksy, symbolic manipulations
should never be correlated with perceptual functions—much less specific points
or events.[106] For Roederer, however, these correlations evidenced the nervous
system's "active" contributions to auditory processes. Yet, because he privileges
points on the auditory path that can be most readily tacked to informational con-
cepts, the inner ear gets lost along the way. In order to dive directly into neural
processes, Roederer begins in the middle of things. Imagine, he instructs, that
the eardrum is already in motion. Roederer leans on now-familiar constructions
of the tympanum as indifferent to the mechanical energy it transmits and makes
clear that his book will not offer a sustained study of frequency analysis in the
cochlea or cochlear hydrodynamics and electrophysiology.[107] When he does deal
with cochlear responsivity, he ascribes to it an indifference and passivity histori-
cally associated with the eardrum itself. True "active" hearing resides in neural
responses and, regardless, he reassures readers, the rest has already been well
enough worked out by others.

When Amacher enthusiastically reports on immersing herself in newer oto-
logical literature in her revised preface to "Psychoacoustic Phenomena," it is not
hard to imagine that research, at last, filling Roederer's omission. *Introduction*
simply did not deliver accounts of cochlear function that Amacher could have
used to counter her "skeptical advisors." In this context, eartones arrive doubly
masked—first, by complex timbres in most music and, second, by Roederer's bias
toward neuropsychology. As a result, Amacher's idiosyncratic descriptions of inte-
raural sound appear as a kind of measure of this distance between her listening
and her sources. But Roederer's break with Minsky's symbolism was perhaps not
lost on her, either. Questions about what constitutes an "active" component of

expression of US imperial power. The dust jacket, for example, emphasizes the text's usefulness for
"any musician and scientist" as well as "psychologists, musicians and . . . the informed layman." See, for
example, Roederer's comments in "The Psychophysics of Musical Perception," *Music Educators Journal*
60, no. 6 (February 1974): 20–30.

[104] Roederer, *Introduction*, vii.

[105] Roederer, *Introduction*, 48; see also 139.

[106] Penny, "The Desire."

[107] Roederer, *Introduction*, vii.

auditory processing ripple through her 1979 colloquium talk and updated preface. Roederer argues for the nervous system; Amacher, for both the cochlea and the nervous system, in complex relations of enhancement and displacement. By distributing "activity" among these points on the auditory pathway and, in an important way, as a matter of partial perspective, she establishes conceptual ground upon which to excoriate Minsky's arguments about pattern recognition. Eartones do not recede into information's elusive presence; rather, they unleash sound in the body of a listener and reveal how listeners might respond to music with music. Countering Minsky, Amacher suggests that music's appeal lies in the open-ended and context-dependent ways in which eartones enact this invitation. A share of music's pleasure, in other words, lies with the interaural responses it evokes and with the situated circumstances of their evocation—that is, how such sounds interact within the arrangements of tense that comprise a listener's epistemic standpoint.

As Amacher deepened her knowledge about cochlear biomechanics, her new sources also illuminated other researchers' discipline-specific experiences with interaural sound's unstable epistemic qualifications. Amacher favors former otologist Thomas Gold's 1948 paper on electromechanical energy and cochlear responses. Why, he asked, should "36 kilocycles be coming out of somebody's ears?"[108] in the absence of any incident sound whatsoever. After a wartime interval with the British Radar Group, Gold joined Cambridge University's Zoology Department, where he continued to research auditory processes. The perilymph liquid inside the cochlea is so viscous, he ventured, that its dampening effect on incoming mechanical energy from the middle ear should render it insufficient to fire the auditory nerve. Drawing on models from radar, he argued that the cochlea both receives and amplifies incoming sound, like a regenerative receiver. Incoming mechanical energy provokes a tiny electrical field that re-ups mechanical action in the hair cells on the basilar membrane. This electro-mechanical action worked like a volume knob that "turned up" all incident sound equally. Invoking the ear as a synecdoche for the cochlea, he declared that "the ear is not a passive but an active receiver."[109]

To this account, Amacher adds otologist David T. Kemp's 1977 experimental demonstration. With a microphone threaded into his own ear, Kemp amplified and recorded spontaneous electromechanical impulses in the cochlea, also known as spontaneous otoacoustic emissions.[110] Kemp's research emphasized

[108] Thomas Gold, "Hearing. II. The Physical Basis of the Action of the Cochlea," *Proceedings of the Royal Society* 135, no. 881 (December 1948): 492–98.

[109] Ibid. This is no longer accepted; the cochlear calibrates amplification relative to the amplitude of incident sound.

[110] H. Gustav Mueller, "Probe Microphone Measurements: 20 Years of Progress," *Trends in Amplification* 5, no. 2 (June 2001): 35–68. Early methods of clinical measurement involved putting the entire microphone—about 4mm by 5mm by 2mm—into the ear canal by the eardrum of the patient. As Kemp put it, "Only one physical model seemed to fit the facts. It was that near to threshold levels

their "pre-synaptic" character and used SOAEs, in his clinical practice to assess the "presence and operation" of the cochlear amplifier in his patients, apart from its utility for the auditory nerve.[111] While the cochlear amplifier does instigate a synaptic response, Kemp clarifies, some mechanical energy travels back toward the middle ear. When that energy scuffs the tympanum and middle ear from the opposite direction, it registers as "sound," despite failing to complete the auditory pathway.[112] Although Amacher composed with evoked responses and not SOAEs, both research narratives materialized differently "active" ears whose meanings and values she could recombine with other figurations.

The recondite character of otology's research objects had, since the early twentieth century, been used to justify the field's low status among the medical sciences.[113] Against this backdrop, elusive SOAEs lent themselves to dramatic narration that fused disciplinary obscurity with emotionally charged tropes of discovery.[114] Successfully amplifying OAEs prompted Kemp to praise the "impressive spiral construction" of the cochlea and recall with fondness its inaccessibility, which had stymied ear medicine since the 1860s.[115] "It was an incredibly long shot," he wrote, "but in June of 1977 I put a microphone into my ear canal just to check. Through the microphone came distortion products, spontaneous tones and echoes! The incredible turned out to be true!"[116] Gold tells his story rather differently. In a 1984 essay titled "The Inertia of Scientific Thought," he rebukes the hearing sciences for dismissing his account of spontaneous pure tones and crafts a fragmented story that puts interaural sound into discourse as a disruptive, even visionary research object poised to confront a small-minded, disciplinary bully.[117] The conditions under which Gold and Kemp verified interaural sound also imbued it with precise meanings and values. While Kemp loads OAEs with positive affects pertinent to improved audiological care in the clinic, Gold's story

the healthy cochlea behaved like a reverberating and resonating auditorium enhanced by a strange PA system prone to feedback howl and distortion!"

[111] David T. Kemp, *Understanding and Using Otoacoustic Emissions* (London: Otodynamics, 1997).

[112] Ibid.

[113] Jonathan Sterne, *The Audible Past: Cultural Origins of Sound Reproduction* (Durham, NC: Duke University Press, 2003), 54–55.

[114] Diana Taylor, *The Archive and the Repertoire: Performing Cultural Memory in the Americas* (Durham, NC: Duke University Press, 2003).

[115] Sterne, *The Audible Past*, 56.

[116] David T. Kemp, *Understanding and Using Otoacoustic Emissions* (London: Otodynamics, 1997).

[117] Thomas Gold, "The Inertia of Scientific Thought," *Speculations in Science and Technology* 12, no. 4 (1990): 245–53. Gold also seemed to downplay research precedents and earlier sources. Apart from the SOAEs that he reported, little else was new about Gold's regenerative receiver model. For a detailed account of earlier research on electrical impulses in the inner ear please see Mara Mills, "Hearing Aids and the History of Electronics Miniaturization," in *Oxford Handbook of Mobile Music Studies* (Oxford: Oxford University Press, 2014), 267. See also Mills and Jonathan Sterne, "The Cat Telephone," http://morethanhumanlab.tumblr.com/post/93762079735/the-cat-telephone-by-jonathan-sterne, accessed July 26, 2015.

suppresses these sensitivities, as though they await a newly authoritative narration that would veridicate their complexly differentiated processes as much as his own claims to have discovered them.

The scenes on which both Gold and Kemp stake their investment in SOAEs again reprise questions about narrating how one experiences the coming into consciousness of interaural sound. Their theatrical accounts take on the generic form that Diana Taylor calls "scenarios of discovery," or "formulaic, portable, repeatable and often banal paradigm[s]" that iterate claims on matter and experience within logics of hierarchy, possession and epistemic control.[118] While "discovery is the raison d'être of science," as Roshanak Kheshti notes,[119] its theatrical scenarios generate transitive effects that can reproduce elsewhere. Consider, for example, how Gold's and Kemp's accounts provide epistemic authority with narrative form that suffuses technical and clinical spaces with affects like wonder, desperation, elation—even aggression and resentment—so that their discoveries about interaural sound arrive already immanent to extant categorizations and hierearchies. Sound studies, Kheshti argues, iterates its own versions. She notes that the subfield's capacity to attend to embodied difference has been "curtailed by an epistemological looping within 'the primal scene of discovery' where so many scholars drawn to this emergent field have to repeat in one way or another such a discovery for themselves as the requisite right [*sic*] of passage into sound studies."[120] With this, she writes, "sound studies risks becoming just another system of taxonomy taking stock of, organizing and hierarchically ordering the sonic world much like the material world has been."[121] Similarly, the durable post-Cagean injunction to search out "all sound" persists despite thoroughgoing critique. The sweeping performative "all sounds" must hold something in reserve so that there are always more sounds awaiting discovery as raw material that composers and artists can subject to expert refinement. How might one scramble epistemological loops that route sound, and interaural sound in particular, through scenarios of discovery? The diegetic gestures that animate *Music for Sound-Joined Rooms* and *Mini Sound Series* add critical and fictive coordinates that bridge this question across the research problems and processes documented in her workbook. While the otologists' backstories corroborate Amacher's tussles with disciplinary authority and gendered skepticism to an extent, she also does not fully iterate their scenarios. As participatory formats in which interaural sound comes into consciousness within a conceptual and fictive diegesis, *MSS* and *MSJR* counter loop-like discovery scenarios with speculative conditions under

[118] Taylor, *The Archive*, 57.

[119] Roshanak Kheshti, "Toward a Rupture in the *Sensus Communis*: On Sound Studies and the Politics of Knowledge Production," *Current Musicology* 99–100 (Spring 2018): 13.

[120] Ibid., 12.

[121] Ibid., 13.

which common wisdom taxonomies and hierarchies cannot easily take hold. Returning to the workbook finds the groundwork for such perceptual geographies in Amacher's deepened approach to threshold experiences between the three spatial intensities that comprise her "Intervals List."

"OBSERVE:POTENTIAL": Inside the Tone Scans

> With a tuning close to the octave or fourth and you arrange the beats so that they become very slow, there are many patterns. People experience many shapes. Now, I had always done this [laughs] when I was composing and I had many strange names for these effects. People hear spirals, they heard curves—they heard various shapes. At first without doing it consciously, I had been able to create the very nice melodies [. . .] in terms of taking simple intervals and hearing certain shapes. I had made tapes that were basically the same timbres, the same music really, except for slight changes in phase, with these shapes, that could be very steady—that could move just a little bit.
> ——Amacher, lecture at Ars Electronica, 1989

In the "Tone Scan" section of her workbook, Amacher returns to questions of form and development. Her methods seems, at first glance, simple enough: she chose an interval or unison, studied its dimensional features in x-, y-, and z-space, and then added a third frequency in order to track how it transformed the ongoing intervallic complexes. These minute changes opened onto the compositional task of "enhancement" and "displacement." Fig. 4.6 shows one page from this section in the workbook, which is a total eighteen pages in length.

Her leftmost columns list specific tone combinations and track their locations on corresponding tapes. The rubric "CHARACTERISTIC" notes a combination's dimensional or intervallic profile; "OBSERVE:POTENTIAL" summarizes its effect in synthetic, subjective terms and chronicles possible additions. This two-part process again works at "making changes to the flow." Consider the notes with which Amacher concludes a study focused on near-unison tone combinations. She gives herself the following instructions:

> Continue experiments here; almost still unison with 3rd tone making pattern. Consider, think about this. Seems 3rd tone needs to animate.

> Need to give more thought about the possibilities here; combination of 3 tones near unison and resultant patterns. How choice is made, particularly for the 3rd tone.

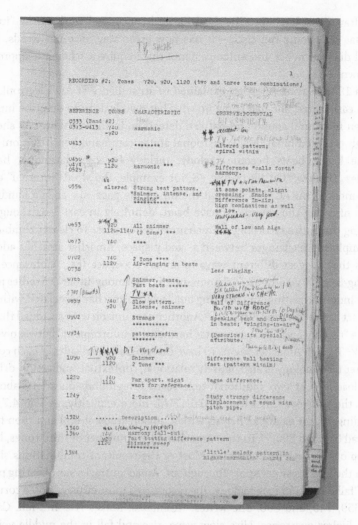

Figure 4.6 Two pages from Amacher's "Tone Scans" that contain her notes on frequency combinations at 740, 920, and 1120 hertz. Courtesy of the Maryanne Amacher Foundation.

(2) which combination of unison and octave tunings
 (a) their difference
 (b) categories
 (c) names
 (d) how to register and organize them for creation of the melodies
 (e) what combinations and speeds make the cross patterns.

Jotted down about midway through her tone scan studies, this note anatomizes the principles of enhancement and displacement that she elsewhere attached to

hand-drawn ear diagrams. The dyad-focused conceptual work of the "Intervals List" has now come full circle—it has now given way, in other words, to new liminal displacements and enhancements that require a schematic approach all their own.

In a 1989 lecture, Amacher explained to an audience at Ars Electronica that, at this early stage, she had come up with her own lexicon to describe interplays between interaural sound and pattern detection, in these studies. As she cycles through tone combinations, transitional states command her attention: "walls" become beats; beats become melody; melody becomes harmony; harmony becomes "shadow." On Recording #8, for example, the word "internal" appears often under CHARACTERISTIC; at the top of the page, she adds a handwritten note confirming the sounds to have been "definitely in ear!"—as though sum- marizing the entire recording's dimensional tendencies. To clearer combinations that emphasize exchanges between x- and y-space, Amacher attaches additional figures that suggest different ways to enhance x-space (i.e., "difference-in-air," "ringing-in-air," "wall-in-air," "shadow-in-air," "harmony-in-air"). Studies near the octave induce "coasting" or "coasting out," which Amacher associated with a beat- ing effect between y- and z-space.[122] Another near unison with an added third tone yields a "ringing aura" that suggests "harmonic reinforcement" between y- and z- space.[123] Though Amacher seems to have categorized the results of each combina- tion, her terminology is also densely relational, contextual, and action-oriented.

A close look at two additional tone scans foregrounds questions about tun- ing in the category OBSERVE:POTENTIAL more explicitly, as Fig. 4.7 shows. Recording #6, for example, begins with a unison study at 659 and then turns to the dyad 659 and 890.[124] To this, Amacher adds a number of third tones, listed at the top of the page for reference. Most of the resultant combinations sit nicely within the LCDT's sweet spot. Throughout, Amacher tracks slow beating patterns and a "fall out" difference melody. The recording's most effusive notes correspond with 659, 740, and 890. She writes, "Animates. Makes rise and fall. Can tune to the higher overtones. Nice slow wave, rise and fall in the middle voice (3rd tone 890)."[125] Amacher uses both the traditional language of counterpoint and an ambiguous gesture toward animacy to parse changing relationships in vertical terms. On Recording #7, Amacher stays with the frequency 659 and reflects on tuning a third tone to construct intervals between x- and z-space that elaborate a beating pattern.

659–840 to 960 have a higher voice-like quality. Attention should be given to the selecting 3rd tone—or the interval forming with the

[122] Amacher, *Workbook*, 30
[123] Amacher, *Workbook*, 31.
[124] Amacher, *Workbook*, 30–31.
[125] Ibid.

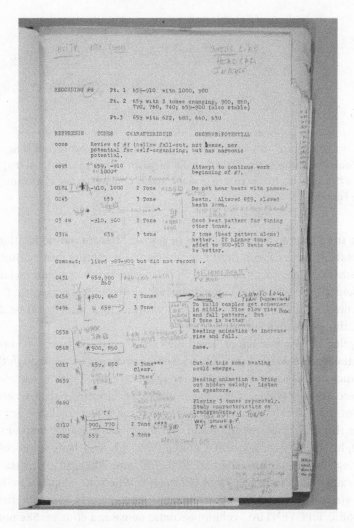

Figure 4.7 This page from the "Tone Scans" chronicles another tape that documents a wider range of frequencies, included closely tuned dyads. Courtesy of the Maryanne Amacher Foundation.

2-note beat pattern—appropriate to the characteristic; also on which will help induce the characteristic. RETURN TO THIS AREA.[126]

Ideas about tuning recur throughout her study, typically in response to notes in her "CHARACTERISTIC" section. When she labels trichordal complex 329, 659, and 480 "harmonic and beautiful," she admits to being a little unsure about "how to build further." She asks, "What needs to be added?" and wonders about

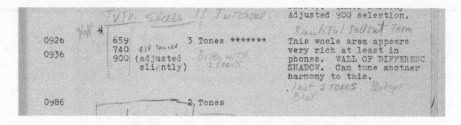

Figure 4.8 In this scan, Amacher studies an intervallic complex that combines, in x-space, a fourth and whole step. Note that she suggests tuning an additional frequency in x-space to a complex that occurs in y- and z-space. Courtesy of the Maryanne Amacher Foundation.

tuning a third tone to a response tone in y-space. Her formal explorations also paired beating patterns with rhythmic questions. Of another dyad on Recording #7, Amacher outlined these next steps: "[d]iscover where it can enter. A fast Core within something; or perhaps a moving out with lower or more complete [?] could 'catch' onto its rhythm."[127] New rhythmic patterns in x-space could be derived from beating phenomena in z-space.

Analyzing the conjunction of "Head Rhythm 1" with "Plaything 2" in relation to both the "Intervals List" and "Tone Scans" proves suggestive. Though there is no instance in the scans that maps directly onto "Head Rhythm 1's" construction, these pages provide a meticulous context for narrating enhancements and displacements that take shape between the two characters. The Tone Scans suggest that this could include tuning and rhythm (y- and z-space), contour (x- and y-space), harmony (y- or z-space). Combing through Amacher's workbook finds her testing the frequencies 900, 850, 770, 760, and 740 against the static 659 on Recording #8, as shown in Fig. 4.8's excerpt. When she couples a fourth and a whole-step—the basic intervallic framework for x-space in "Head Rhythm 1"— her "OBSERVE:POTENTIAL" column becomes dense and effusive. She notes the possibility of tuning "another harmony to this."

Thick with distortion, "Play Thing 2" presses the Eb-ish center of "Head Rhythm 1" down the whole step, for a new, Db-ish registral floor. Instead of creating additional reinforcement for the eartones of "Head Rhythm 1," Amacher opted for textures, timbres, and frequencies that refer their perspectives to other areas of the body. Recall the right channel's third tone—that tricky near-Db that proliferated intervallic complexity—relative to the left's quartal doublings near the octave. With respect to frequency, "Head Rhythm 1," already contained precisely the material in x-space that enabled the formal liquidation of y-space and its referral to x- and z-space. "Plaything 2" underscores that a decision has to be made. The head's pulsating refraction conjures the expressive inner body and "Plaything

[127] Ibid.

2" rises to meet the sinusoidal blaze so characteristic of the piece's opening. In Amacher's large-scale composing-out of interrelations between x-y-space and x-only space, the head meets the viscera.

Conclusion: *The Levi-Montalcini Variations* (1992)

The question of the third ear has no univocal answer, but rather functions as a disruptive operation, unsettling any aesthetic discourse that would master it. But such disruptions aggregate and configure in strange, if specific ways. A small dose of genealogical attention across sources, interlocutors, and practices finds interaural sounds attached to many kinds of bodily awareness. Their genealogical constitution catches variable numbers of tones—and ears—imbued with different significance. For Minsky, a distraction from symbolic tokens; for Roederer, a distraction from neuronal action. For Kierkegaard, a cochlea; for Haworth, a formal guarantor. For Kemp, a clinical triumph; for Gold, a mistake that his contemporaries will never live down. For Amacher, the third ear perhaps summarizes the demanding course of study whose commitment to "displacement" and "enhancement" juxtaposed such ears with one another, with her own as their meeting point.

In her "Concept Summary" for *The Levi-Montalcini Variations*—an unrealized commission for the Kronos String Quartet from 1992—Amacher proposed a research program that "visualized the audience as an instrument now joining the string quartet."[128] Her working method, as we shall see, built on the workbook's research program in suggestive ways. Rita Levi-Montalcini was a molecular biologist who, in 1986, was awarded the Nobel Prize in Physiology or Medicine for her research on a protein called "nerve growth factor," which activated many cellular processes but had long been devalued in research that prioritized seemingly more agential drivers of cell growth, like DNA or plasmids. "She suggests a view from the margin," feminist science studies scholar Bonnie Spanier wrote in 1995, invoking Evelyn Fox Keller's signal work on gendered tropes in cell biology qua so-called active and passive functions in the nucleus and cytoplasm.[129] "The questions [Levi-Montalcini] asked," Spanier continued, emphasizing her radical work, "opened outward onto a range of possibilities of unknown biological functions for molecular entities [. . .] and emphasizes the complexity of understanding these molecular entities in dynamic interaction with their specific contexts."[130]

[128] Maryanne Amacher, "Concept Summary" for "THE LEVI MONTALCINI VARIATIONS" for the Kronos String Quartet, July 1992. Although Amacher drafted portions of the project, the "VARIATIONS" were never completed, and the commission went largely unfulfilled.

[129] Evelyn Fox Keller, *Making Sense of Life: Explaining Biological Development with Models, Metaphors, and Machines* (Cambridge, MA: Harvard University Press, 2002).

[130] Bonnie Spanier, *Im / Partial Science: Gender Ideology in Molecular Biology* (Albany: SUNY Press, 1996), 112.

A microbiologist herself, Spanier and Amacher had become friends at the Bunting Institute, where Spanier had begun an oral history interview project focused on women in science which blossomed into her book-length feminist analysis titled *Im / Partial Science: Gender Ideology in Microbiology*.[131] Fractured with the back-slash, her title dramatized internal relationships between objectivity, marginality, and partial perspective in a feminist epistemology that Amacher would have encountered reading Haraway's essay "Situated Knowledges," if not also elsewhere. Amacher's dedicatory title electrifies a shared concern with what Spanier calls "unknown biological functions" whose marginality could be reworked as a critical asset—and, as we shall see, as a diegetic and aesthetic one, for Amacher, as well. Like the workbook, Amacher's proposal for the *Levi-Montalcini Variations* outlines a complex exploration of auditory functions that, in this case, would have as its context and impetus not only her own hearing, but also that of the audience and string quartet. "Interactive scenarios will be developed in a series of Variations," Amacher wrote, "composed for ACOUSTIC SPACE: String Quartet and Recorded Sound; and INTERAURAL SPACE: "Ear-Born Sound and Head-Born Sound."[132] In tandem with recorded sound, "lead thematic characters" played by the quartet would evoke interaural shapes, colors and rhythms while another recorded component that Amacher called "ENHANCER MUSIC" would ornament their interaural interchanges via intensification and displacement. Taken together the project aspired to realize an "intelligence," as Amacher put it, that brooked interaural drama as also interaction within what she called a "virtual sound world," where the listener, composer and quartet would "meet" and commingle. As its "ghost writer," she explained, "the Quartet and Audience create the SONIC DIMENSION which I have prepared from the composition."

In her "Concept Summary," Amacher worked toward this "virtual sound world" in eight research phases that parallel her workbook's forms of study in radically expanded form. In initial stages, "Interval Studies," would enable Amacher to establish, develop, and isolate "tone colors" and "melodic shapes" between x-, y-, and z-space; using MIDI to synthesize the string quartet parts, she would next experiment with ENHANCEMENT MUSIC to generate "reinforcing" characteristics, in keeping with her earlier Tone Scans. From this research "major themes will be selected as models," which Amacher could then share with Kronos as a "pre-score;" the Quartet would, then, record this preliminary notated material and the recording would become the basis for further study and revision. In this crucial process, she explained:

> Lead thematic structures for the Variations will be composed for Kronos to play in the recording session, along with some important characteristics in the Recorded Sound that will be prepared. The Recorded

Sound will include the ENHANCER music and synthetic instrumental timbres.[133]

What began (in her workbook) as a schematic, two-step research process, Amacher here reimagined as a vast plan for experimentation that entangled her ears with the quartet's, and those of the audience. With a pre-score recording hypothetically in hand, Amacher would have undertaken complex, interdependent revisions in the final research phase with special emphasis on "the uniqueness of the Quartet's style of playing," as she put it. With a new spate of "Interval Studies"—this time, using the Kronos Quartet's "pre-score" recording and not synthesized sources—recorded music and enhancer music would be reworked to choreograph interactions within perceptual geographies that would converge in the *Variations'* "virtual sound world."

This project was not realized. Yet, it was also less a composition, in the first place, than a research program, which systematically integrated the ensemble into an experiential working method led at every stage by interaural drama. While the workbook certainly catches Amacher's autodidactic focus in an exploratory—and often understandably defensive posture—this proposal reworks its methods into a robust and systematic approach to collaboration within which interaural sound would be not only constitutive in the earliest stages but also comprise the virtual meeting point toward which the project aspired. Seemingly fascinated by the possibility of interaural sound as a kind of sociability, experimental presentational formats enabled Amacher to engage interaural enhancement on determinate social or historical ground. Across *MSS*, *MSJR*, and *Intelligent Life*, its acoustical force moves into discourse across technoscientific, juridical, commercial, and political economic registers of analysis. Yet these more robustly narrative genres build on what Amacher's workbook had already shown—that is, that the eartone's apparent plasticity arrives already compacted with many constitutive frameworks. If the third ear conjures a feminist genealogy of life, *Living Sound (Patent Pending)* asks after the political, social, and juridical dramas though which its transits of energy might be mapped.

[133] Ibid., 18.

5

Amacher's House for Strange Life

The briefs present a gruesome parade of horribles. Scientists, among them Nobel laureates, are quoted suggesting that genetic research may pose a serious threat . . ., or, at the very least, that the dangers are far too substantial to permit such research to proceed apace at this time. We are told that genetic research and related technological developments may spread pollution and disease, that it may result in a loss of genetic diversity, and that its practice may tend to depreciate the value of human life. These arguments are forcefully, even passionately, presented; they remind us that, at times, human ingenuity seems unable to control fully the forces it creates—that, with Hamlet, it is sometimes better "to bear those ills we have than fly to others that we know not of."

—Chief Justice Warren E. Burger

"More details available at lunch?," says Amacher. "Strange and mysterious biological intelligences—what is it that really interests them? Scarcely conscious of the energy moving around them (the physics of the world they inhabit) [. . .] And even stranger, to appreciate and value the makings of what and where they are, is considered the domain of something called SCIENCE, a field of 'foreign study'—(not to be experienced by broker, lawyer, artist)."

—Maryanne Amacher, *Living Sound (Patent Pending)*

Yeah, but it's a conceptual sound piece.

—Sergei Tcherepnin, *responding to the author, Fall 2016*[1]

[1] Conversation with the author October 2016. In a co-run seminar with Dietz, I discussed her reference to the Supreme Court case *Diamond v. Chakrabarty* in the title *Living Sound (Patent Pending)* with the participants. Tcherepnin's response reminded me that whatever connection one might want to make between the installation and the case would have to address *Living Sound*'s sonic presence and perceptual geographies. I take Tcherepnin's caveat seriously, throughout this chapter, to imagine the ways in which *Living Sound* reflexively dramatizes its conditions of audibility. All shortcomings are my own.

Wild Sound. Amy Cimini, Oxford University Press. © Oxford University Press 2022.
DOI: 10.1093/oso/9780190060893.003.0005

(a)

(b)

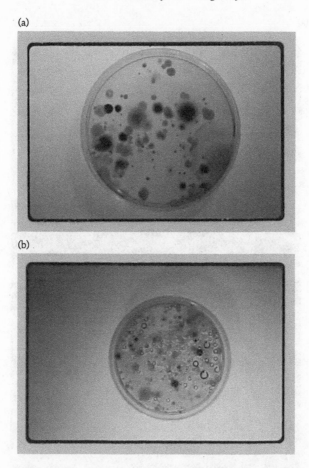

Figure 5.1 Two petri plates as displayed in *Living Sound (Patent Pending)*. Courtesy of the Maryanne Amacher Foundation.

Introduction

"Something was growing inside." Bacterial cultures dotted petri dishes and, if nourished with optimal sound food, would continue to grow, as they seem to do in Fig. 5.1. Clustered inside the empty house, they waited into the late night for visitors to find them. Or not. Illuminated that 1980 June night with spot-lights, the St. Paul house, which overlooked the Mississippi River, became the set of Maryanne Amacher's *Living Sound (Patent Pending)*. The house, shown in Fig. 5.2, had belonged St. Paul Chamber Orchestra conductor Dennis Russell Davies. Earlier that year, Davies left St. Paul for Stuttgart, where he became General Music Director at the Baden-Württemberg State Opera. Cleared of furnishings and personal effects, the mansion proved an exceptional working environment.

(a)

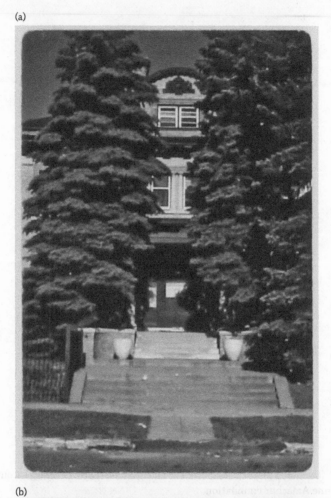

(b)

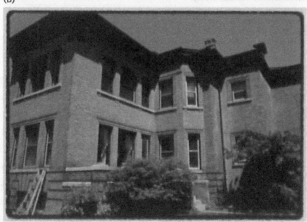

Figure 5.2 Front (a) and side (b) views of Davies house at 223 Grotto Street in St. Paul. Courtesy of the Maryanne Amacher Foundation.

Hour after hour could be spent tweaking loudspeaker placement and studying the minute sonic changes that resulted.

In *Living Sound*, Amacher put new concepts and methodologies into practice. The house was ideal for working with what she called "structure-borne sound"—key for *Music for Sound-Joined Room*'s critical take on both concert and installation-based formats. Amacher experimented with idiosyncratic speaker placement to send sound into built structures and only secondarily into the air. Speakers might face an exterior wall, lay flat on the floor, or point into the corner of an empty room. As sound surged into ceilings, stairs, or doorways, the house acted as a kind of filter, which could shape or carve stereo playback in three dimensions.[2] Structure-borne sounds might hulk in a corner, hover at ankle-level, curl at your elbow, or beckon you to turn a corner. These moving cues created a participatory staging that broke with both the disciplined frontality of the proscenium-bound concert and sound installations of undetermined, seemingly endless, duration. When the audience "enters the sets" to become "part of the scene," their movement through structure-borne sound would become inextricable from a narrative's unfolding. As the first instance in the series that Amacher would call *Music for Sound-Joined Rooms*, *Living Sound*, Amacher wrote, was to represent a "new genre":

> In "MUSIC FOR SOUND JOINED ROOMS" (1980) the architecture of a building—an entire house or rooms, walls and other features—is used to create the sound structures and to evolve stories with scenes and episodes, which are dramatized by the music and sets (including photography, graphic, video and projected images, lighting and furniture, sculpture and texts). The idea is to create an atmosphere that gives the drama of walking into a cinematic close up and being part of the scene, surrounded by its sounds and images. The audience walks into the world of the story—enters the sets. I used architectural features of a building to create intensely dramatic sound experiences which cannot be created any other way: a form of sound art that uses the architecture of rooms specifically TO MAGNIFY THE EXPRESSIVE DIMENSIONS OF THE MUSIC*. With the dramatic concepts of these works, I wish to create a new genre for experiencing sound, distinct from minimalist and more passive installation forms, as developed in the 1970s and 1980s.[3]

Amacher composed with structure-borne sounds as though they were characters in a drama that guided listeners through audiovisual conjunctures. She

[2] Stucture-borne sound, in *MSS* and *MSJR*, was "only ever in stereo." I am grateful to Bill Dietz for this clarification.

[3] Maryanne Amacher, "Project Notes: Music for Sound Joined Rooms [undated]," in *Supreme Connections Reader*, ed. Bill Dietz (unpublished, 2012), 76–78. The asterisk refers readers to another text titled "Direction of Work about the Big Waves of Structure Borne Sound" (1983).

combined musical selections from her tape collection in a dynamic live mix, which localized sonic shapes in relation to props like newspaper clippings, photographs, objects, video monitors, and projections to create "points of special focus" in built space. As visitors lingered with these points, they also gathered "clues" that actively emplotted a story into transforming perceptual geographies. No mere container or even an instrument per se, the house was at once a setting, a character, and a way of listening in *Living Sound*'s structure-borne diegesis. "The house," Tom Johnson reported from St. Paul, "was screaming."[4]

Speckled petri dishes were among many clues that Amacher had placed throughout the house. But what was the "story" of *Living Sound*? To the extent that it cohered in listeners' curious comportments, this question stokes imaginative guesswork. And so this chapter does not reconstruct a story per se, but rather maps tools of analysis and articulation that underlay the conditions of possibility for Amacher's diegetic "walk-in" formats. But this means wending between strange fictive worlds and historical conjunctures that imbued with meaning and value the clues that Amacher documented and wrote about in the decades that followed. *Living Sound* was a complex, ironic, and often funny work of fiction that redoubled auditory thresholds as impetus for speculation. Visitors not only walked into the story: their listening became a protagonist in its fictive world. As such a protagonist, Amacher's clues arranged listening within figurations of cellular life, laboratory-based aesthetics, and speculation. So, too, did local discursive entanglements with Davies and the St. Paul Chamber Orchestra, which threw *Living Sound (Patent Pending)*'s historical and fictive mediatic conditions into sharp relief.

A Supreme Court ruling from June 16, 1980, had given Amacher cause to enthuse about the piece's lilting title: "I was thrilled to learn that the Supreme Court passed the law to patent laboratory-created life forms just a few days later!"[5] She remarked on this coincidence in her published writings well after the turn of the millennium.[6] The 5–4 decision in the case of *Diamond v. Chakrabarty* determined that laboratory-created life forms would be eligible for patent under the US Code's existing provisions. The case concerned a bacterium that biochemist Ananda Chakrabarty had packed with four plasmids from different bacteria. The super-powered microbe metabolized crude oil and bulked up on protein that could feed aquatic life. The case's path through the US courts started in 1972, and in the weeks before the Supreme Court's decision, *Newsweek* and *Rolling Stone* tracked its progress under headlines like "Boon or Nightmare?" and "Safe Houses

[4] Tom Johnson, "The Empty House," in *The Voice of New Music, New York City 1971–1988: A Collection of Articles Published in Village Voice* (Digital Edition), ed. Tom Johnson and Paul Panhuysen (New York: Editions 75, 2014), n.p.

[5] Maryanne Amacher, "Project Notes."

[6] See, for example, Amacher's published talks "Thinking of John Cage," and "Lecture" in Lucier's collection *Eight Lectures on Experimental Music*.

for Strange Life."[7] Similarly unsubtle headlines carried media accounts of rapidly proliferating biotech ventures and overstated commercial applications for microbiological products. Frenzied questions about the decision's implications raged in popular and specialist contexts alike—they touched on, for example, the commercialization of basic research, the expanded reach of proprietary knowledge, the deregulation of venture capital, and Edenic anxiety about living things' natural integrity. Writing for the majority, Chief Justice Warren Burger mocked this "parade of horribles." Amici were simply wrong, he implied, to believe that the decision would deliver biogenetic life to private enterprise at inestimable cost to local knowledge, social worlds, and environments.[8] The decision required only the narrowest view of what "Congress meant by the words used in the statute" and regardless, he continued, it lay far beyond the court's "competence" to respond to these hypotheticals.

As a work of fiction, *Living Sound* counts among expressive forms that textualized changing social discourses of life on the cusp of Atlantic neoliberalism. Fascination with the clone, revulsion at the hybrid, and constructions of saintly or demonic cellular liveliness cleaved close to biopolitical frameworks for gender and race and to durable scenarios in which global transits of vital energy could be stabilized and naturalized.[9] Late 1970s' debates about whether "test-tube babies" would have "souls" barely concealed backlash against queer kinship and non-heteroreproductive forms of care.[10] Immortal cell lines were figured in monstrous and promiscuous terms that recapitulated racist tropes in biotechnological contexts.[11] The possibility of "immortal life in a test tube" or "a monster in the pyrex" counted among the "parade of horribles" that Burger dismissively satirized in the court's decision. Feminist literary scholar Priscilla Wald shows how protectionist gestures enfolded longstanding biopolitical materializations of gender and race into technoscientific figurations.[12] The patent, Donna Haraway argues, should be counted among these recapitulations. "Like the stigmata of gender and

[7] Priscilla Wald, "Replicant Being: Law and Strange Life in the Age of Biotechnology," in *New Directions in Law and Literature*, ed. Elizabeth S. Anker and Bernadette Meyler (Oxford: Oxford University Press, 2017).

[8] *Diamond v. Chakrabarty*, 447 U.S. 303 (1980).

[9] See, for example, Patricia Melzer, *Alien Constructions: Science Fiction and Feminist Thought* (Austin: University of Texas Press, 2006); Alexis Lothian, *Old Futures: Speculative Fiction and Queer Possibility* (New York: New York University Press, 2018); Sandra Jackson and Julie E. Moody-Freeman, eds., *The Black Imagination: Science Fiction, Futurism and the Speculative* (New York: Peter Lang, 2011); and Priscilla Wald, "Cells, Genes and Stories: HeLa's Journey from Labs to Literature," in *Genetics and the Unsettled Past: The Collision of DNA, Race and History*, ed. Keith Wailoo, Alondra Nelson, and Catherine Lee (New Brunswick, NJ: Rutgers University Press, 2012), 247–65.

[10] Wald, "Cells, Genes and Stories," 247.

[11] For more on this case, see Alexander G. Weheliye, *Habeas Viscus: Racializing Assemblages and Black Feminist Theories of the Human* (Durham, NC: Duke University Press, 2014), 74–88.

[12] Wald, "Cells, Genes and Stories," 249.

race, which signify asymmetrical, regularly reproduced processes that give some human beings rights in other human beings that they do not have in themselves," she writes, "the copyright, patent and trademark are specific, asymmetrical, congealed processes—which must be constantly revivified in law and commerce as well as in science."[13]

Living Sound's walk-in format suggests powerful and difficult interactions with fantasies about laboratories, microbes, and patents in partly real and partly fictive auditory contexts. To understand the walk-in format as, in part, a virtual incursion into such ultraspecialist worlds, this Chapter connects *Living Sound* and *Intelligent Life* with early structure-borne efforts, in the mid-1970s, and Amacher's unrealized FM Stereo project titled *Saga*, which articulated remote feeds as fictive environments with narrative allusions, in 1976. Questions about thresholds, displacements, and reinforcements—which, in the *Addition Tones Workbook*, unfolded on mostly compositional terrain—return in *Living Sound* in relation to shifting discourses on life and fictive extrapolations on an emerging biotechnology industry.[14] To stage these thresholds as also fantasies and figurations of life (and of life in a sound, specifically), *Living Sound* convoked heterogeneous registers of analysis: law, science fiction, astronomy, acoustics, Western art-music history, and so on. A walk-in *mise-en-scène* tells a story about the liminality of living matter through the liminality of auditory thresholds and embeds both in contemporary spaces of biopolitics with which its clues work in concert and in conflict.

A Walk into *Living Sound (Patent Pending)*

In the New Music America festival's program book from 1980, one will find neither a bio or artist statement from Amacher herself. Although her contribution was chronicled in local and national press, it persisted as a hazy sort of presence in these official documents.[15] Printed schedules for the festival listed the installation as, simply, a "sound event" and when it does appear by name, it did so under the heading *Research and Development*, a provisional post-*City-Links* titling convention that Amacher used in the late 1970s and early 1980s for some *MSJR* projects. After the fact, however, Amacher penned an evocative account in the third person that described visitors' interactions with structure-borne sound and provided

[13] Haraway, *Modest_Witness*, 90.

[14] See Rosi Braidotti, "The Politics of 'Life Itself' and New Ways of Dying," in *New Materialisms: Ontology, Agency, and Politics*, ed. Diana Coole and Samantha Frost (Durham, NC: Duke University Press, 2010), 201.

[15] In the schedules that appeared in Twin Cities papers, *Living Sound* was instead titled *Research and Development*.

partial backstories to her audiovisual clues and to the phrase—*Patent Pending*—which appears, typewritten, multiple times in *Living Sound*'s set dressing. Into domestic architectures of intimacy that typically organize work, leisure, and hospitality according to age and gender type, Amacher threaded her structure-borne speculative fiction. She wrote:

The "MUSIC ROOM," where Davies' two grand pianos had been, was now a "home laboratory." On the floor were twenty-one petri plates, with "something" growing in them; two aluminum instrument cases, marked FRAGILE, with labels: TRAVELING MUSICIANS BEING PREPARED (Living Sound, Patent Pending), and THE MOLECULAR ORCHESTRA (Living Sound, Patent Pending); TV storyboards referring to "symbiotic aids," "companions for enhancing recognition," "sound feed energy," "Making new scores."

The "LIVING ROOM" was largely devoted to an extract about "The Third Men" from Olaf Stapledon's 1930 evolutionary romance *Last and First Men*. A passage from the book, often cited by Amacher in recent work, we presented here—so small that the reader had to move very close to see it. It read in part:

cultures enduring sometimes for several thousand years, which were predominantly musical. . . . The third species was peculiarly developed in hearing, and in emotional sensitivity to sound and rhythm. Consequently . . . the Third Men themselves were many times undone by their own interest in biological control, so, now and again, it was their musical gift that hypnotized them.

The "HALLWAY" exhibited photographs for a proposed sound installation in sixteen one-hundred-foot-tall grain towers. (These corresponded to Stapledon's "housing" for "the great brains," created by the Third Men.)

In the "SUN ROOM," leading to the garden, a cassette played Dr. Frank Drake's inaugural speech for the Arecibo radar transmitter. A message will be sent, Dr. Drake announces, describing life on earth to inhabitants of distant stars. "The message is now being passed out among you," he says, "and a more detailed description of it will be available to you at lunch."

Meanwhile, the entire ground floor of the house was full of a spectacular sound—incredibly loud, and unbelievably dense. It poured out of giant loudspeakers, circulating throughout the rooms, out the doors and windows, down the hill, past sedate Victorian mansions. It seemed to contain energy in all frequency ranges at once, yet never approached white noise. A visitor who stepped "off limits" into the kitchen was literally slammed up against the refrigerator by the force of energy. Others felt themselves pushed, as if by acoustic pressure, out into the garden, where the entire house was, sounding as a gigantic instrument. There

they could notice a second sound, emanating in low, quiet waves from
the basement (a second piece of music: NIGHT BREAK). And through the
windows, there could be seen, projected on the basement wall, the same
quote about neutrinos that had been in the "MUSIC ROOM."[16]

"There were odd visual things around the house," she told Alvin Lucier's "Introduction
to Experimental Music" class on November 7, 1995.[17] Amacher devoted about two
paragraphs, in her talk, to reconstructing *Living Sound* for the students. "I had petri
dishes and a funny text on music stands about making violins,"[18] she stated. She
sketched the *Diamond v. Chakrabarty* ruling, calling it a "synchronous event," and dis-
cussed in detail the speeches about the 1974 Arecibo transmission that she had used in
Living Sound. Breaking with an overall light tone, she heaped scorn on how the speak-
ers framed the initial attempt at communication—a binary-code message addressed
to extraterrestrial life—at the newly resurfaced radio-radar telescope.[19] "The program
director [House representative John W. Davis] said, 'We are standing in the most pow-
erful spot in the world.' Then he said, 'More details will be available at lunch.' Everyone
applauded, as if they were at a concert. It was silly. This incredible thing was going on.
They were sending signals billions of light years away and he said such stupid things.
We hadn't even made it to breakfast."[20] As Amacher's closing one-liner suggests, what
made Davis's words so "stupid" was a causal but chauvinistic nationalism that claimed
vast spatio-temporal dominion as though taking a midday meal. Her ironic remark
connects stupidity with a structural inability or unwillingness to delimit an embod-
ied epistemic standpoint amid twentieth-century, technoscientific figurations that
would reveal its knowledge to be partial and asymmetrical—even contaminated. In
her notes on Haraway's "Situated Knowledges," Amacher underlined Haraway's pithy
recipe for such work: "to name where we are and where we are not."

[16] Though the text is written in the third person, the author's voice is recognizable as Amacher. It
appears in part without citation in a 1981 *Omni* magazine article on Amacher by Tom Hight. Thank
you to Alec Mapes-Frances for calling attention to the Hight article.

[17] Maryanne Amacher, "Untitled Lecture," in *Eight Lectures on Experimental Music*, ed. Alvin Lucier
(Middletown, CT: Wesleyan University Press, 2017), 54.

[18] Ibid., 54.

[19] Blanchard Hiatt, "The Great Astronomical Ear," *Mosaic: The National Science Foundation* 11, no 1
(January/February 1980): 30–37.

[20] Representative John W. Davis (GA-D) was chairman of the House subcommittee on Research
and Development and delivered the keynote speech at the Radar Telescope dedication and, with his
wife Bridget David, announced the message's initial transmission. Professor of astronomy at Cornell
University, Dr. Frank Drake initiated Project Ozma in 1959 with the goal of "tuning in" to alien broad-
casts and developed the so-called Arecibo message that was transmitted in November 1974. Drake had
worked with Cornell colleague Thomas Gold to pitch the resurfacing plan to the NSF and shepherded
the telescope to civilian supervision. Drake brought the telescope under the responsibility of Cornell
University in 1971, but Gold severed ties with the project shortly thereafter. Andrew J. Butrica, *To See
the Unseen: A History of Planetary Radar Astronomy* (Washington, DC: The NASA History Series, 1996),
https://history.nasa.gov/SP-4218/ch4.htm, accessed August 31, 2020.

This exhortation also organizes *Living Sound*'s diegetic involvements: clues entangle human listening with that of fictional life forms, attach vital energy to plural material forms, question access to laboratory-based enhancements, and intervene on popular biospheric imaginaries. Although Amacher does not address the questions about commercialization, capitalization, and proprietary knowledge that oriented *Diamond*'s jurisprudence, her "walk-in" format created a fictive and critical experience of involvement in technoscientific processes that reimagines how its methods and materials can be experienced by non-specialists. As Haraway put it, "patent is a semiotic and practical step blocking non-proprietary and nontechnical meaning from many sites: labs, courts and popular venues."[21] What sort of meaning did Amacher's clues unblock, and what sort of "venue" was *Living Sound* in the first place?

Earwitness accounts add variable reports on clues and structure-borne sound to Amacher's own. In remarks titled "The Empty House," Tom Johnson acknowledges *Living Sound*'s interpretive richness but does not attach his response to a single clue or prop.[22] "Vacant houses are strange places," he wrote, "They have no raison d'être. Yet this particular empty house, filled so passionately with this particular roaring, began to take on so many layers of symbolism that I have still not managed to decide on my favorite interpretation."[23] By contrast, Neely Bruce lavished interpretive attention on the petri dishes in particular. "Nobody knew exactly why they were there," he noted; "Was it simply the image of growing biological material?"[24] With David Tudor as his reference, Bruce ventured that "a composer could use biological engineering techniques to grow his or her own amplifiers, for example. I think Maryanne had that image somewhere in mind as a possibility. It was that far out, futuristic."[25] Others who ventured inside remarked

[21] Haraway, *Modest_Witness*, 82.

[22] Johnson also reports entering the house only after some hesitation: "I held my hands over my ears as I went in, but as I passed into adjacent rooms on the ground floor, upstairs, and out onto the terrace, the volume became bearable, and the sound became more and more interesting. At first I had perceived little more than an undifferentiated roaring, but gradually I moved deeper into the sound, picking out complex sliding movements, shifting bass tones, and some of the countless other pitches that oscillated all over the spectrum. I also began to discern radical differences as I moved from one room to another." Johnson remarked retrospectively that his report on *Living Sound* and others on the work of Meredith Monk, Pauline Oliveros, and Frederic Rzewski were "short and without enthusiasm"—as he felt that the general press had begun to cover new music by summer 1980.

[23] Tom Johnson, "The Empty House."

[24] Lucier, *Eight Lectures*, 53.

[25] Ibid., 45. For an rich treatment of self-organizing and autopoietic frameworks for life in David Tudor's work with a focus on modular devices and feedback networks, please see You Nakai, "Hear After: Matter of Life and Death in David Tudor's Electronic Music," *communication + 1* 3, no. 1 (September 2014): 10–32. Nakai strikes a compromise between autopoiesis and object oriented ontology—he describes the latter as the former "written in reverse"—and concludes that, the life in a sound that one might find in Tudor involves an "immanence of life [that] is located neither inside an object, nor inside a process, but inside the oscillation between processes and objects."

To experience the works, one stands, walks, sits, listens, looks
and reads, individually, in personal time, rather than in the
group time of a stage audience. Sound shapes are found in the
air, we stop to listen, as we look at paintings on a wall.
Stopping renews, charges attention. Walking, we feel the sound
move around and through us. Images function as stopping spots,
SPOTS of special focus, and are intended to trigger thoughts,
stimulate dormant energies. Images and words become the clues,
characters, and script we shape, together with the sound. Where
we find the tones and images – the way we might first see from
the corner of an eye, bend down to read, notice then look close,
see the wall, consider we might be in a human laboratory, imagine
we are traveling in a fast and silent car, – are critical to
the experience I am creating.

Figure 5.3 Typewritten text excerpt from Amacher's "Project Notes: Music for Sound
Joined Rooms." Courtesy of the Maryanne Amacher Foundation.

vividly on how uneven concentrations of sonic energy moved them like pinballs
through the house but reported seeing no clues inside.[26]

In a two-page text titled "Project Notes: Music for Sound Joined Rooms,"
excerpted in Fig. 5.3, Amacher explains how audiovisual correlations in *MSJR*
were to function, and outlines the listener's epistemic standpoint in detail.[27] No
longer beholden to the "group time of a stage audience," visitors should interact
with the scene in "personal time," she recommends. Framed grandly within the
proscenium, the evening-length concert enacted a spatial and temporal discipline
that cast a musical work downward from the stage toward listeners.[28] *Music for
Sound-Joined Rooms* instead rewards an unfocused gaze or sideways glance that
catches, at first, something indistinct: "the way we might first see from the corner
of an eye, bend down to read, notice then look close, see the wall, consider that we
might be in a laboratory."[29] These clues involve listeners in a "come hither" mode
of address, slowly assembling complex associations and perceptions that can be
experienced as a kind of virtual transport into the story.[30] Looking at photographs
that document Amacher's HOME LABORATORY—with these "Project Notes" as
an analytic field guide—suggests hypothetical itineraries through the room, with
detail and abandon. In Fig. 5.4, one such photo supplies a synoptic look at clues
that could "first [seen] out of the corner of an eye," and so on.

[26] Conversation with the author, March 16, 2015, Rome, Italy.

[27] Maryanne Amacher, "Project Notes".

[28] Frisch, *Nineteenth Century*, 53.

[29] Amacher, "Project Notes." Though Amacher likens the experience to looking at "paintings on a
wall," *MSJR* and *MSS* do not play into museums' encyclopedic aspirations or sacral genealogies.

[30] In her artist statement about her *TOPOS* installation series, Keiko Prince called her own work
"walk-in film," to capture audiences' movement through space as a kind of cinematic transport. Please
see Keiko Prince in conversation with Amy Cimini, Bill Dietz, and Kabir Carter. "Afterword—'Even

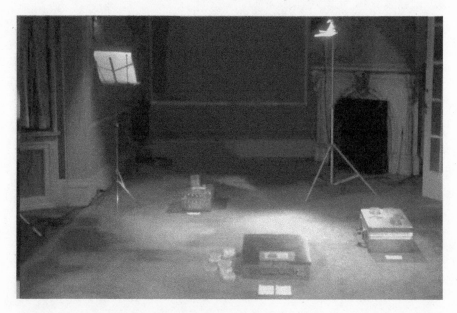

Figure 5.4 View of *Living Sound*'s "Home Laboratory" in Davies's former music room. Courtesy of the Maryanne Amacher Foundation.

A reasonably well-lit music stand grazes a windowless wall, facing the room's darkest corner. On the stand sat a DNA photostat—not musical notation. If the music stand beckoned visitors to nestle next to the wall, the spotlight also nudged them toward the center of the room around which Amacher had placed three instrument cases with petri plates, some empty and some coated in bright red agar. By crouching down to look into the dishes, one would also encounter typewritten text. Set atop the leftmost case, the photos in Figs. 5.5 and 5.6 suggest how close the visitor might need to be in order to read further: "THE MOLECULAR ORCHESTRA 'Living Sound' (Patent Pending)"—as structure-borne sound perhaps also crept along the floor toward the wall on the photo's left-hand side.

Closest to the center of the room was another instrument case with empty petri plates strewn to one side and a TV storyboard, on the floor, with text nestled inside all four boxes, as seen in Fig. 5.7. Reading this much text at ankle level gave visitors time to register sonic shapes that might hover along the floor or condense in corners, as waypoints amid shifting auditory dimensions that also "charged attention" or "triggered thoughts" about cellular lives at various analytic and mediatic scales.

Though a storyboard's round-edged boxes would usually contain images and its square boxes text, Amacher's, shown in Fig. 5.7, featured only textual clues, which carry the visitor deeper into a chimerical word. These clues attach perceptual geographies to fictional processes and describe the microbial agents that hold them together. From inside the petri dishes, microorganisms prepare to fill a few

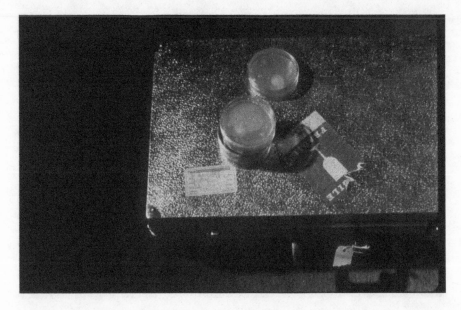

Figure 5.5 Petri plates displayed on instrument cases in *Living Sound (Patent Pending)*. In the photograph shown in Fig. 5.4, this case appears in the near right. Courtesy of the Maryanne Amacher Foundation.

different roles: they are "New Musicians," they are "The Molecular Orchestra," they require "New Environments," they are "Microorganismal Stimuli" for the enhanced recognition of additional tones. This tiny companion species will enhance our ability to recognize eartone responses which suggests that *Living Sound* is, in an important way, "about" the fictional life to which eartone music might give rise.[31]

Enhancing the ear's responsive relation to incident sound remains a structuring conceptual principle across Amacher's work and exceeds her *Additional Tones* research to reproduce in other contexts. Once a chasm between eartones

Monsters Need Sleep," in *Maryanne Amacher: Selected Writings and Interviews*, ed. Cimini and Dietz (New York: Blank Forms Editions, 2020), 391.

[31] Amacher used storyboards like the one pictured in Fig. 5.7 in heterogeneous ways, few of which paired images and text in the traditional sense. Thinking inside a televisual frame seemed to provide a useful formal heuristic for sequencing material. Indeed, on my first visit to the Kingston Archive, I looked at sketches for her 1991 *Petra* for two pianists—performed by Amacher and Marianne Schroeder at the 1991 World Music Days in Zürich—in which Amacher had sketched character-like blocks of notated material onto the "screen" portion of the storyboard pages. However, other writing suggests that Amacher imagined the storyboard as a blank screen onto which sound could project ghostly images. In a December 1, 1979, performance at The Kitchen titled *Research and Development*—discussed later in the chapter—Amacher informs the audience that she has chosen texts (read, in this case, by Cage) that should be "thought of as images appearing on [an] empty storyboard," an invitation to fantastical audiovisual play.

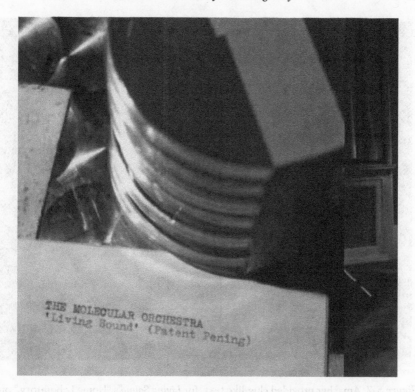

Figure 5.6 Close up of label that reads "THE MOLECULAR ORCHESTRA" and "Living Sound (Patent Pending)" next to stacked petri plates. In the photograph that appears in Fig. 5.4, this is the leftmost case in the image. Courtesy of the Maryanne Amacher Foundation.

and their potential enhancements opens, many kinds of things surge in to fill it. The eartone evidences a figurational promise that draws together phrasings of life across disparate historical and social locations. "Promises and promising suffuse the life sciences," writes anthropologist Mike Fortun. He attends to a general economy; "promises occur everywhere in language," he explains "and mark an impropriety that can inhabit everything"—a gene, a cell, a text, a sound, and so on.[32] While Fortun's study concerns intersections between genomics and finance during the Human Genome Project's early stages, its theoretical frame proves generative to *Living Sound*.[33] Eartones can assume many anticipatory postures, and their enhanced recognition can always be promised again and again. These promises unfold within concrete fields of practice, which, in the workbook, involve

[32] Mike Fortun, "Genomic Scandals and Other Volatilities of Promising," in *Lively Capital: Biotechnologies, Ethics and Governance in Global Markets*, ed. Kaushik Sunder Rajan (Durham, NC: Duke University Press, 2012), 331.

[33] Ibid., 335.

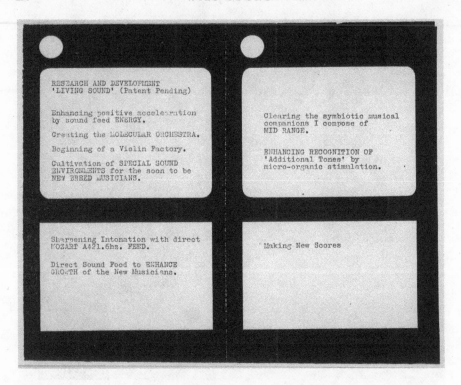

Figure 5.7 Amacher provided clue-like text, for *Living Sound*'s "Home Laboratory," on this TV storyboard. Courtesy of the Maryanne Amacher Foundation.

compositional protocols and, in *Living Sound*, converge on speculative formations in the biological sciences. "Matter promises," Fortun writes, "harboring excessive capacities and thereby offering itself to us and our technoscientific infrastructures for their becoming but also (promises) to exceed every technoscientific tool that will be invented to handle the 'truth' of it."[34] What promises does matter make on the plateau of interaural aesthetics?[35] If such a promise guarantees that a thing on whose behalf it works cannot coincide with itself, *Living Sound* supplies that non-coincidence with an unstable and experiential narrative form rooted in clues that catch both whimsical and vast forces at work.[36]

[34] Ibid., 352.

[35] These questions take inspiration from Fortun's and have been adapted to center the eartone as *Living Sound*'s protagonist.

[36] See also Shoshana Felman, *The Scandal of the Speaking Body: Don Juan with J. L. Austin or Seduction in Two Languages* (Stanford, CA: Stanford University Press, 1980), 3–5; 6–11.

The Tribute at 223 Grotto Street

"We have many interesting spaces in the Twin Cities which might interest you," Libby Larsen informed Amacher in a letter from January 1980 in which, as New Music America's Installation Coordinator, she invited Amacher to present "one of her works" at the festival in June.[37] Larsen went on to describe the spaces she had in mind and subsequent correspondence detailed stops and starts in a site-selection process that culminated in another clue that, as we shall see, ushered still more life forms into *Living Sound*'s microbial drama. Amacher considered a wide range of sites, in early planning stages. "Are you aware of the Butler Square Atrium?," Larsen asked Amacher. "We wondered how you might feel working with that space."[38] While thick masonry had served the massive warehouse during the apex of rail transportation, by 1971, renovations capitalized on Butler Square's urban location as a new commercial and retail space.[39] Amacher proposed three alternatives; two were sites she had used in her installations 1974 at the Walker Art Center. She asked Larsen to take new photos at the St. Anthony Grain eleva-tor where she had installed one of two telelinks for *Everything-in-Air* and *Hearing the Space*, but Larsen mistakenly visited the St. Anthony Main neighborhood.[40] Upon receiving the photographs, Amacher was incredulous and skeptical that the abandoned mill site had been so thoroughly redeveloped in the meantime: "Is St. Anthony's Elevator now REALLY St. Anthony Main?"[41] Amacher then suggested working again at the LaSalle Arcade, "where my installation NO MORE MILES was," she explained; "I have a series of photos from there already."[42] Finally, she suggested a new site, which, unlike the commercial arcade and the edgelands around the elevator, lent itself to luxe conviviality: "Would you be able to check out the Commodore Hotel?," Amacher asked. "Would they be willing to participate in the Festival?" The 1920s residential hotel, located in a quiet St. Paul neighbor-hood, would have enabled Amacher to work in large lobby spaces, a dining room, two lounges, and two bars decorated in iconic art deco style. "There are several really nice lounge rooms there, and in June, could be nice."

[37] Libby Larsen to Maryanne Amacher, January 4, 1980. Walker Art Center Archives. Larsen also mentions to Amacher that David Behrman, Alvin Lucier, Joel Chadabe, David Means, Homer Lambrect, Liz Phillips, Leif Brush, Paul Demarinos, David Tudor, and Richard Walters had also been asked to participate.

[38] Ibid.

[39] Amanda Lsnikowski, "Butler Square," Society of Architectural Historians: SAH Archipedia, https://sah-archipedia.org/buildings/MN-01–053-0044, accessed August 18, 2020. By 1980, the heavy and small-windowed ground floor had been renovated into glass atrium suffused with natural light and readied for commercial tenants.

[40] Larsen to Amacher, January 29, 1980.

[41] Amacher to Larsen, February 4, 1980, Walker Art Center Archives.

[42] Ibid.

The Walker's Performing Arts Director Nigel Redden facilitated photography at the St. Anthony Elevators later that spring. Like Pier 6, this episode coincided with cycles of infrastructural abandonment. Changes in grain storage and transportation obsolesced the elevators between 1925 and 1976—at which point Elevators 1 and 2 no longer met standards of worker health and pollution control, and only Elevator 3 remained operational despite similar deterioration.[43] Amacher's 1974 *City-Links* projects had taken place in an interstitial period during which the elevators' owners prepared to sell them to the International Minerals and Chemicals Company (IMCC). When the sale was completed, in 1977, IMCC razed Elevator 2, left Elevator 1 to continued decay, and stored a potassium compound in Elevator 3.[44] This edgeland had indeed been transformed since Amacher had come to know it in 1974, but not in the way that Larsen's photographs prompted her to imagine. On April 12, 1980, Redden wrote to IMCC to request that Amacher be permitted to visit the elevators to take photographs, as "part of a work she will be doing under the auspices of Walker Art Center." "Ms. Amacher would like to take photographs or make a videotape using the Elevator building on five or six occasions between now and the end of June," he wrote. "The photographs would be used for artistic purposes and would not include the identifying logos of IMCC or St. Anthony Elevator."[45] These photographs reappeared in *Living Sound* as fictive clues that also cited her back-and-forth working process. Recall that, "in the 'HALLWAY,'" she wrote in the long description quoted previously, visitors might encounter an "exhibition of photographs for a proposed sound installation in sixteen 100-foot-tall grain towers." This expanded reference—another proposal or promise—would also be redoubled within frameworks for fictional life in *Living Sound*'s walk-in diegesis.

Living Sound has the final word in the essay "Progressive Programming: Minnesota since the 40s," with which *Minneapolis Star* critic Roy Close concludes the NMA program book. It details how the Walker and the St. Paul Chamber Orchestra (SPCO) under Davies cooperated, between 1972 and the spring of 1980, to create progressive concert experiences whose upshot was a "large, receptive audience" for experimental music in the Twin Cities, which now hung in the balance after Davies's departure for Stuttgart.[46] The essay casts this narrative in monumentalizing and worried tones. But, in a final paragraph, Close suggests that *Living Sound* gives readers reason to "take heart."

> In the final analysis, however, the institution from which the most will be expected is the Walker Art Center. Whether the Walker is prepared

[43] St. Anthony Elevators Collection, Hennepin History Museum, https://hennepinhistory.org/wp-content/uploads/2020/04/HHM_B531-St.-Anthony-Elevators.pdf, accessed August 18, 2020.

[44] Ibid.

[45] Redden to Roth, April, 12, 1980, Walker Art Center Archives.

[46] Roy Close, "Progressive Programming: Minnesota Since the 40s," *New Music America Program*, 13.

to assume an even greater role in bringing new music to the community remains to be seen. But those who believe in augury may take heart from this festival—the largest presentation of experimental music in the Twin Cities, by the Art Center or anybody else—and especially from one of its ongoing events: Maryanne Amacher's installation *Research and Development*, an homage to Dennis Russel Davies, placed for the duration of the festival in Davies' now-vacant house.[47]

This preview tasks *Living Sound* to mediate between two cultural institutions—the Walker and the SPCO—on the cusp of uncertain futures. In Amacher's installation, he suggests, one can hope to glimpse something new, yet to come. Close instructs the reader to imagine it as both an homage and prognostication, but what futures might *Living Sound* usher through this rhetorical aperture?

Though commentators who had also reviewed New Music New York in 1979 wrote approvingly of the non-concert-based work that took place in the Twin Cities, Close centers the proscenium-bound concert and its institutional supports in a progress narrative with Davies as its key protagonist. After his appointment to the SPCO in 1972, Davies initiated the experimental, chamber-music-focused "Perspectives" series at the Walker. The series formalized institutional ties and deepened the orchestra's commitment to contemporary repertoire, while also creating contexts in which orchestral musicians could work closely with composers and where cautious audiences could be introduced to unfamiliar repertoires. For each subscription concert, a "Perspectives" event, presented at the Walker, "previewed" the orchestra's weekend offerings and Close credits this institutional cooperation with informal, intimate, and small-scale concert experiences that built audiences for experimental music. To illustrate this point, Close prints in his essay the complete, ten-concert 1977–1978 "Perspectives" season, which featured evenings with Meredith Monk, Laurie Anderson, John Cage, programs that paired the music of Henry Brant and Elliot Carter with Brahms, Fauré, and Beethoven, as well as a two-day festival of contemporary music by members of the Minnesota Composers Forum.[48] Close's chronological sketch covers this interval but does not mention the Walker's Performing Arts Coordinator Suzanne Weil in a concert list that includes The Sonic Arts Group, Musica Elettronica Viva and the Philip Glass Ensemble, Pauline Oliveros, Steve Reich, and leaves out her curatorial work with dance, theater, and rock musicians as well as her "Jazz at the Guthrie" series.[49]

[47] Ibid., 17.

[48] While Walker director Martin Friedman's commitment to bringing the center's performance programs into alignment with its collection and exhibition policies began in 1961, Suzanne Weil, as Coordinator between 1969 and 1976, created lasting program frameworks for the center's commitment to performance, concerts, and theater.

[49] See also Sumanth Gopinath, "Music for Solo Museum: Minimalism, Rock and the Walker Art Center," paper presented at the Society for American Music, McGill University, Montreal, CA, March 25, 2017.

Amacher's 1974 *Everything-in-Air* suited this concert-focused narrative well enough. Nestled between an evocative account of Max Neuhaus's New Year's Eve underwater concert and still more highlights from the Walker's 1977–1978 season, Close touches upon the 1974 exhibition *Projected Images*, highlighting Amacher and Morton Subotnick, who had each presented both concerts and installations at the center that year. Here, Close describes the pieces and reviews some basics about in *City-Links*, more generally:

> In 1974, the Walker presented Maryanne Amacher's environmen-
> tal piece, "Everything in Air," which combined live sounds from two
> remote outdoor locations selected by the composer; the performance,
> in the Art Center auditorium, consisted of the mix.[50]

Everything-in-Air was undoubtedly the most concert-like of the three *City-Links* projects that Amacher has staged at the Walker that fall, which had also included *No More Miles—An Acoustic Twin* and *Hearing the Space, Day by Day, 'Live.'* *Everything-in-Air* began at 10:30 p.m. on September 29, 1974, and lasted three hours, during which Amacher mixed tapes from the *Life Time* collection together with Scott Fisher performing remotely at the St. Anthony Elevators—as she would go on to do, in 1975, with Blum at Pier 6 in *Incoming Night*. She applied the title *Hearing the Space* to the same feeds, which visitors could hear, unattended and ongoing, in the auditorium whenever it was not in use between September 29 and November 3. For Close, *Everything-in-Air* was a useful plot-point in a concert-focused narrative, given its dual compatibility with longer-duration exhibition practices.[51] Close leans on *Everything-in-Air* to construct the festival's prehistory and again on *Living Sound* to imagine what the Walker and SPCO partnership would become after Davies departure.

Amacher reappears in additional Twin Cities press that covered Davies's work, and in some cases gave him outsize credit for the festival itself. "It's hard to imagine the Festival taking place without him," Allen Robertson wrote in early May, a little over a week before Davies's last concert with the SPCO, and ventured that "if it weren't for his pioneering during the 1970s, the Festival wouldn't be happening at all."[52] "To this point," Robertson wrote,

[50] Close, "Progressive Programming," 14.

[51] A New York–focused history penned by *New York Times* critic John Rockwell preceded Close's second Twin Cities–based account, in the program, followed by brief artists' statements that addressed specific works, practices, and general trends in varied combinations. Indeed, Rockwell had already written about Amacher's work, and she quoted him in her press release for *Research and Development* at the Kitchen, December 1, 1979: "Most composers operate within the comfortable middle area of the dynamic range: not Maryanne Amacher. . . . Miss Amacher's sounds may seem abrasive at first, but one soon realizes their quite extraordinary richness and provocativeness. What she really is a sound mystic. But she hasn't so far disappeared into a private world that she's lost the gift of communicating with us."

[52] Allen Roberston, "Chamber Orchestra Won't be the Same; Davies Started a Music Adventure," *Minnesota Star*, May 3, 1980. This was also the case in coverage prior to Davies departure, starting

one of the sound installations during NMA will be up in Davies' empty house at 223 Grotto Street, St. Paul. Composer Maryanne Amacher will wire the empty rooms and the ghostly sounds emanating from closets, around corners and down stairways will serve as a tribute to Davies' unstinting commitment to living music.[53]

Writing during the Festival a few weeks later, John Bream framed Amacher's work similarly in a comprehensive writeup for the *Star*.

Maryanne Amacher pays homage to Dennis Russell Davies, the music director of the SPCO with a sound system designed for Davies' house at 223 S. Grotto Street, St Paul using speakers concealed in the living room and electronic manipulation of natural sounds.[54]

Exaggerated attachments to recent events at the SPCO give *Living Sound* an odd bearing in these writings. Davies's legacy threatened to overwhelm *Living Sound* as much as it also vested the piece with an expectant charge. Competing notions of artistic production commingle inside the rubrics "tribute" and "homage," especially alongside the celebratory keywords "new," "living," and "contemporary" that critics attached to Davies. Musicologist Marie Thompson has applied feminist theorizations of social reproduction to discursive formations in so-called contemporary music that intersect what she calls "the now" with "the new" in order to evoke claims on futurity and, at the same time, disavow their basis in reproductive work.[55] Modernist valorization of productivity, in other words, brackets reproduction from its conception of the contemporary and retrenches long-standing gendered and racialized divisions of artistic labor within musical discourses.[56] Notions of "homage" or "tribute" flirt with these figurations. Indeed, an "homage" undertakes a kind of reproductive work—that is, it should deliver a faithful, even surprising, summation of the honoree's meanings and values— that also reveals, among those meanings, something unreproducible. An "homage," in other words, renews distinctions between creative and reproductive work and, at the same time, subjects itself to their hierarchies. Local press framed *Living Sound* unambiguously, in these terms. However, there is also another version. Throughout *MSJR* and *MSS*, Amacher evoked popular narrative forms with

in early May 1980. More than two months before the festival opened, the *Star* linked its coverage of Davies's last concert with additional announcements about the festival, again connecting Amacher's so-called sound work to the conductor.

[53] Roberston, "Chamber Orchestra."

[54] Jon Bream, "New Music in the Key of Fun," *Minnesota Star*, June 16, 1980.

[55] Marie Thompson, "Sounding the Arcane: Contemporary Music, Gender and Reproduction," *Contemporary Music Review* 39, no 2 (2020): 273–92.

[56] Ibid.

heightened stretches of diegetic musicality, such that listeners "walked into" a structure-borne "story" that foregrounded the speculative technical and social conditions that underpinned its conditions of audibility, in the first place. *Living Sound* was no exception. Connections to Davies and the orchestra counted among many possible nodal points through which *Living Sound*'s diegetic involvement could take shape. More than a tribute or homage, as we shall see among Amacher's clues, *Living Sound* will move Davies and the orchestra into a diegesis in which listening takes place within real and fictive constitutive frameworks for life that cut obliquely across creativity and reproduction with the eartone as their protagonist.

CLUE I: "MID RANGE" Microbes and Other Creative Recyclers

> I am deeply intrigued by what I do not understand. And there is much I do not understand about music! Very basic questions concern me! Sometimes I don't believe that I really am a composer because I am trying to do just this—to understand what I do not as yet understand but what I am deeply intrigued by.
>
> For me, one of the very useful features of working in electronic instrumentation has been the opportunity of hearing sounds experientially and working with them in real time. Listening and observing sound structures very much like a microbiologist observing cell structures for many hours, looking at the "life within," to discover and understand its special features, order of shapes and unique intelligence, before composing new theories or rearrangements.[57]
>
> —Maryanne Amacher, as told to Simone Forti

Speaking very much as a composer in the subjunctive, Amacher reprises her ethics of "not understanding," and invokes cellular life as a metaphorics for the inner structure of sounds, or what, in *Adjacencies*, she might have called their "shimmer." Her laboratory scene, in *Living Sound*, decondensates this metaphor and stages its component parts in a dramaturgy that asks, explicitly, what looking at a microbial life and experiencing additional tones have to do with each other. "The new scientist is both like and not like the alchemist," wrote Marilyn Strathern in 1992.[58] She was responding to a British television program that

[57] Maryanne Amacher, "Perceptual Geographies: The Interplay Between the Tones that Sound in the Room, in the Ears and in the Head," as told to and edited by Simone Forti. In *Supreme Connections Reader*, 184.

[58] Strathern quotes an exchange between Chris Langton (Los Alamos National Laboratory) and Dann Hills (Thinking Machine Corporation) at length, in order to analyze how they perform consensus around what can be brought together under the rubric "life" in their hybrid enterprise. "You start with a living thing and you start taking it apart and you see what parts it has and how all these parts fit

aired in the summer of 1990, featuring a discussion on the topic of artificial life between US scientists based at the Los Alamos National Laboratory and the UK-based Thinking Machines Corporation. "The speakers—experts in their fields," she writes, "bring together characteristics or properties that will have properties of their own, including the capacity for replication, which turns them into 'life forms' of a kind."[59] These composites secure the "hybrid idea that gives its name to the enterprise: artificial life."[60] Similarly, Amacher's HOME LABORATORY stokes desires to experience such composites up close and, with clues that similarly delimit capacities and properties, generates another "hybrid idea"—*living sound*—that cites microbial life as a privileged platform for reproducing social and cultural projects. Yet, as Strathern puts it, "a decision has to be taken on what kind of social relation is desirable as a consequence of the biological one."[61] The clues propose many ways that human listeners can relate to the fictive microbes through a kind of auditory kinship that played ironically with recent fantasies about their plasticity, creativity, and reproductivity. *Diamond v. Chakrabarty*'s prehistory provides a paradigmatic case and throws into relief diegetic involvements whose clues mix and match sound, listening, and metabolic pathways.

Microbiologist Ananda Mohan Chakrabarty, was an expert in so-called exotic metabolisms.[62] As "creative recyclers," bacterial metabolisms provided microbiological solutions for remediating environmental pollutants, with crude oil chief among them.[63] In 1970, Chakrabarty joined Irwin Gunsalus's University of Illinois biochemistry lab to study a sludge-dwelling microbe that metabolized camphor as its food source with a degradation pathway linked to free-floating loops of DNA called plasmids.[64] Unattached to the bacterium's main chromosome, these bits of genetic material can move horizontally between bacteria and yield varied concentrations across microbial habitats with seemingly limitless adaptive and interactive properties, expressing, for instance, resistance to heavy metals

together and try to derive some general principles of the logical organization of those parts. It's OK up to a point, but you take . . . it apart further and all of a sudden you don't have life anymore. In a sense what we're working on is an alternate form of biology, because it sort of might have been biology. One problem with biology is we only have one example of the earth having evolved. . . . We're using the computer to simulate imaginary biological worlds and we say "what if," and we can do experiments that would really be impractical to do with a biological system." Strathern, *Reproducing*, 2.

[59] Ibid., 1.

[60] Ibid., 2.

[61] Ibid., 27.

[62] Born just a year after Amacher, Chakrabarty completed his Ph.D. at the University of Calcutta in a lab focused on the life cycles of bacteria that recycle nutrients in soil. Douglas Smith, "Mr. Pseudomonas," *Medium*, October 23, 2015, accessed October 10, 2019, https://medium.com/lsf-magazine/mr-pseudomonas-198a5eddc47.

[63] Melinda Cooper, *Life as Surplus: Biotechnology & Capitalism in the Neoliberal Era* (Seattle: University of Washington Press, 2008), 21–25.

[64] Irwin Gunsalus had studied the bacterial genus *pseudomonas putida* since 1959, which Chakrabarty had also worked on in his Ph.D. research.

or the capacity to degrade toxic substances.[65] Within a year, Chakrabarty joined another former student of Gunsalus at General Electric (GE) as the manufacturer sought to enter the then-burgeoning market for bioengineered environmental products.[66] Even industrial pollution could appear vital from the perspective of capital. GE's shift toward biotech underscored a broader shift in manufacturing sectors, in which industrial polluters pursued profits in new biological products aimed at environmental remediation.[67] But after having watched the disastrous SS *Torrey Canyon*'s oil slick in 1967, Chakrabarty queried whether the degradation of hydrocarbons might be expressed by genes on plasmids.[68] A complementary cocktail of plasmids, he found, could metabolize oil's carbon-containing molecules and pack on cell mass that could feed marine life. After reporting plans to present his research at an international conference, GE's in-house patent lawyer Leo MacLossi filed a provisional patent application on Chakrabarty's behalf.[69] US Patent Commissioner Sidney Diamond granted the application to patent the technique that Chakrabarty used to extract and consolidate plasmids, but rejected the second application that pertained to the bacterium itself. And so the bacterium's itinerary through the courts began, in 1972.[70]

Microbial odds and ends threaded new notions of life into industrial applications. As Melinda Cooper summarizes, microbes suggested supercharged vital components—like genes, plasmids, and isolable proteins—that seemed to defy constraints that held whole organisms in place and could enter new and reinforcing relations of productivity.[71] News about fossil bacteria as well as the discovery of habitats clustered around superheated deep-sea vents dramatized microbial metabolisms in extreme environments.[72] Microbes that could tolerate—and even flourish—in extreme environments, for example, posed new questions for organic chemistry. If, as Cooper suggests, "these microbes could transform

[65] Plasmids are especially ubiquitous in *pseudomonas* and some species can handle an extreme diversity of plasmids with incompatible properties. Alexander M. Boronin, "Diversity of Pseudomonas Plasmids," *FEMS Microbiology Letters* 100, nos. 1–3 (December 1992): 461–67; Smith, "Mr. Pseudomonas."

[66] Daniel J. Kevles, "Ananda Chakrabarty Wins a Patent: Biotechnology, Law, and Society," *Historical Studies in the Physical and Biological Sciences* 25, part 1 (1994): 111–35.

[67] Ibid., 114. At GE, Chakrabarty was officially assigned to a research project to use bacteria in industrial feedlot bioremediation. "When the EPA and Green Movement pressed chemical, manufacture and agricultural industries to internalize the cost of their own waste production," Cooper explains, many turned to commercializable microbial products to mitigate economic losses. See also Cooper, *Surplus*, 16 and 23.

[68] Smith, "Mr. Psuedomonas."

[69] Kevles, "Ananda Chakrabarty Wins a Patent," 117.

[70] For decades, however, the Patent and Trademark Commission had relied on relevant sections of the US Code to avoid a ruling on the patentability of laboratory-created organisms.

[71] Cooper, *Surplus*, 34.

[72] Stefan Helmreich, "What Was Life? Answers from Three Limit Biologies," *Critical Inquiry* 37, no. 4 (Summer 2011): 683–89.

inorganic matter into organic compounds, it became legitimate to query their role in the geological evolution of the earth."[73] She highlights how James Lovelock's popular 1967 "Gaia hypothesis" credited seemingly inexhaustible microbes with creative responses to "catastrophic pollution events."[74] Lovelock's work, as Cooper explains, casts microbes as liveliest in crisis and plastic to the extreme. Consider Dorion Sagan and Lynn Margulis's rhapsodic summary from 1995: "Over time, more and more inert matter has come to life," they wrote, narrating matter as a vital, self-regulating body and "an aggregate, emerging property of the many gas-trading, gene-exchanging, growing, and evolving organisms within it."[75] Microbes did not just thrive among pollutants; they seemed never to die so much as join metabolic processes already ongoing in another composite body.[76] These immortal recombinations further underwrote capitalistic intensifications in which industrial applications could be rephrased as extensions of horizontal gene transfer in other environments, foreshortening links between biospheric contexts and biotechnological products.[77] These vitalities could seem to have been created by inventors and, at the same time, set outside of knowledge or history and loosed across the deep time of biospheric evolution.[78] When Amacher imagined that structure-borne sound was "larger than life," she did so at a time when life was being newly narrated as something that could always promise to become larger than itself. Given this double inflection, Sheila Jasanoff suggests, the "lively" could easily shade into the "dynamic and commercially-value laden" and vice versa.[79]

A biopolitical sleight of hand that overlays fossils and extremophiles with market-bound, laboratory-created remediators figured microbes as though there were always already both—and perhaps more. Like any other iconic technoscientific object, as Kaushik Sunder Rajan puts it, a microbe can be many things—"a collection of institutions, laws, normative structures, practices and ideologies."[80] Chakrabarty's microbe materialized during an onslaught of Reagan-era, top-down policy initiatives, which aimed to place the very notion of life at "the heart of

[73] Ibid., 34. See also Lynn Margulis and Dorion Sagan, *What is Life?* (Berkeley: University of California Press, 1995), 21–25.

[74] Cooper, *Surplus*, 36. Consider also, as Cooper explains, that Lovelock combines this limitless growth with a "blatant stance against environmental regulation of any kind."

[75] Margulis and Saga, *What is Life?*, 23.

[76] Cooper, *Surplus*, 39.

[77] Stefan Helmreich, "Trees and Seas of Information: Alien Kinship and the Biopolitics of Gene Transfer in Marine Biology and Biotechnology," *American Ethnologist* 30 no. 3 (August 2003): 345, 346, and 348.

[78] Haraway, *Modest_Witness*, 88.

[79] Sheila Jasanoff, "Taking Life: Private Rights in Public Nature," in *Lively Capital: Biotechnologies, Ethics and Governance in Global Markets*, ed. Kaushik Sunder Rajan (Durham, NC: Duke University Press, 2012), 179.

[80] Sunder Rajan, "Capitalization," 17.

biogenetic capitalism as a site of financial investment and profit."[81] Venture capital, emboldened by the *Diamond v. Chakrabarty* decision and freed up by financial deregulation, flowed toward high-risk biotech startups and public-private alliances.[82] Historian of science Susan Wright highlights social, political, and epistemic transformations not unlike those Amacher criticized in the Arecibo dedication. Once uncoupled from "refereed knowledge" and remade as proprietary trade secrets, Wright explains, claims about future applications could be exaggerated in the popular press, at once occluding scientific knowledge from public view and deepening assumptions that science is too difficult for anyone other than a specialist to understand.[83] Amacher, too, railed against this premise in her 1980 remarks on *Living Sound*.

As a tiny companion species that enhances our ability to recognize eartone responses, Amacher would have her own semi-fictive microbes access human hearing to complex ends, in *Living Sound*. "When in the presence of music," she wrote,

> we seem to be biologically endowed with the need to create to respond
> to music by making new additional tones within our ears and brain
> (almost as another instrument joining the orchestra). Coded to respond
> this way to music, we need now to create new codes—codes that will
> aid us in really consciously recognizing our activity, enhance recognition of our creative response to music. I think we could experience a
> strong new energy because we would be releasing what has been for so
> long suppressed by subliminal perceptions.[84]

Additional tones unleash desires, energies, creativities, and new musics. In a sense, this passage embraces what Elizabeth Wilson calls a "way to talk about biological experience more candidly, less suspiciously" without also endorsing its power to determine form, politics or aesthetics.[85] What sort of object is the eartone when its responses and activations can, as Wilson puts it, be woven into

[81] Rosi Braidotti, "The Politics of 'Life Itself' and New Ways of Dying," in *New Materialism*, ed. Diana Coole and Samantha Frost (Durham, NC: Duke University Press, 2011), 201. Sunder Rajan explains how *Diamond v. Chakrabarty* worked in tandem with the 1980 Bayh-Dole Act, which permitted and nearly obliged researchers in public universities to patent their work, especially biotechnological products from public research institutions like University of California San Francisco and University of California San Diego. One result, as Melinda Cooper has argued, was the emergence of "a new academic personage, the academic-scientist entrepreneur, and a new form of public-private alliance, the joint-venture startup, in which academics and venture capitalists come together to commercialize the results of public research." Cooper, *Life as Surplus*, 27.

[82] Sunder Rajan, "Introduction," 2–5.

[83] Susan Wright, "Recombinant DNA Technology and Its Social Transformation, 1972–1982," *Osiris*, no. 2 (1986): 303–60, 335, 356–60.

[84] Maryanne Amacher, *Living Sound (Patent Pending)*.

[85] Elizabeth Wilson, *Gut Feminism*, 26–27.

"intrabiological" and "extrabiological" traffic?[86] Amacher's clues route this question through wild figurations. Recall the fragmentary clue, "clearing the symbiotic musicians I compose of MID RANGE," which appears on the storyboard featured in Fig. 5.7. Amacher elaborated in detail, in a project proposal for a version of *Intelligent Life* presented to de Appel co-directors Wies Smals and Josine van Droffelar in the early 1980s. Her proposal outlines four components: a small magazine, a collaboration with the "Music for Day" program at the Stedelijk Museum, a complete or partial production on radio or television, and, as what she calls "the major 'transmission form,'" "a series of digital laser discs—video with audio, and audio alone."[87] This was a rare case in which Amacher entertained working with a then-new recording format, and she declared, in a subsection of the proposal titled "The Head Stretch": "finally, such media exists which can match the sensitive range of our responsive energies. The digital laser disc has a dynamic range of [up to] 85–120dB. Consider what a 'HEAD STRETCH' this range in intensity can create! The most subliminal of 'felt' sound, to the most intensely powerful can now be reproduced."[88] She further elaborated:

> Most of the music now circulating the world, really <u>ALL</u> that most of
> us experience from recordings has a dynamic range in sound intensity
> of barely 40dB—the capacity of the cartridge "record." I think if this
> sound-music environment surrounding us much of the time as the
> GREAT MID-RANGE MIND we have been living in. Or like living in a
> basement with constant artificial illumination and never being able to
> experience the many changing degrees of light, our eye/minds/bodies
> "enjoy" recognizing.[89]

[86] Ibid., 28.

[87] Maryanne Amacher, "Dear Wies and Josine," in *Maryanne Amacher: Selected Writings and Interviews*, ed. Cimini and Dietz (New York: Black Forms Editions, 2020), 253–62. Consider also this excerpt, quoted in Cimini and Dietz's introduction to the *Selected Writings*. "Over the years, whenever I considered making a 'record,' I had to reject the idea. [. . .] Since all of my work is about the sensitivity human beings—biological intelligences—really have, but <u>may</u> not <u>be conscious of</u>, why should I make 40 minutes of sound, to be thrown on a turntable, while any number of automatic activities are being performed (by the listener)? [. . .] Totally compelled to give attention to these discoveries about mind, perception, and the physical nature of sound, rather than to accommodate ideas to MUSICAL or RECORDING FORMATS, I went ahead and developed these sound worlds, even though there were only limited ways at the time— performances and installations—to communicate them. I decided not to let <u>thought</u> or <u>investigations</u> be dominated by constraints of what I knew to be nearly terminal technologies. What has resulted is really a "new music," where many "ways of hearing" and "being with sound" can exist—experienced up to now only by audiences attending performances/installations I've created."

[88] Amacher, "Dynamic Range: 'The Head Stretch,'" 1.

[89] Ibid.

"The Head Stretch" amasses rhetorical questions that highlight perceptual geographies she imagined such a format could afford. "Is the sound barely audible? Seeming to touch the skin receptors only—the cochlea seems to 'feel' untouched."[90] Of *Living Sound*, she asks, "Is the apparent sound volume 'larger than life,' e.g., is it as powerful as a gigantic sounding house?"[91]

Although Amacher prescribes exact decibel ranges, MID-RANGE involves complex intra- and extrabiological dispositions that regularize the senses and body. While "The Head Stretch" anticipates a promising recording format, *Living Sound* creates a fictive acoustical biosphere whose interventions on MID RANGE would take place at environmental and cellular levels. Taking the clue seriously suggests that these microbes have been readied to take on a massive acoustical remediation project that would metabolize oversaturated intensities and frequencies and produce new ones that give rise to unheard-of perceptual geographies. If *Living Sound* delivered a self-consciously visceral sonic force, it did so as part of a story that was, in important ways, "about" the conditions under which factical structure-borne intensity can be experienced and dramatized fictional microbial functions as one speculative solution. The ferocious sound world that "seemed to contain all frequencies at once" was also part of the story, as such.[92]

Enchanted Cablecasts and Structure-Borne Sound: 1974–1979

"I don't know the rules really," Amacher told Jeffrey Bartone of KAOS 89.3 FM, when speaking about structure-borne sound in a 1988 interview, "it's an intuitive thing." It's unclear whether Amacher leaned on her ethics of suspended understanding, in this conversation, or instead preferred not to say more. In addition to the vivid case she shared with Bartone, this section takes a second look at *Everything-in-Air* and the unrealized transmission project *Saga* designed for Manhattan Public Television in 1976 to consider nascent architectural and narrative involvements that provided auditory thresholds with diegetic frames.[93] In 1975, Amacher was commissioned to create repertoire music for the group dance

[90] Ibid., 4.

[91] Ibid.

[92] Amacher, *Living Sound (Patent Pending)*.

[93] Some critical responses to her *MSS* and *MSJR* works center architectural staging in longing terms to emphasize their challenging and often unreproducible demands. In 2000, for example, Kyle Gann described Amacher as "one of the most original sound-installation composers, who is rarely heard because her works take up entire buildings." While this is certainly true, another version can also attend to how their conceptual and diegetic supports could be experienced. Indeed, Amacher maneuvered her *MSJR* and *MSS* practice between visual art, literature, new music, and academic research as well as her active knowledge of remote transmission to create dramaturgical arrangements that articulated fictive worlds and referred to musicological, art historical, and technoscientific conditions

Torse, choreographed by Merce Cunningham for his company.[94] As a simultaneous but independent work in keeping with the company's Cagean paradigm, she created the electronic music *Remainder* (complete title is given in the notes).[95] After the premiere at the McCarter Theater in Princeton, New Jersey, in early January 1976, Amacher traveled with the company to the Teatro Nacional in Caracas, Venezuela.[96] In conversation with Bartone, she wrapped an evocative description of the performance into broader reflections on "intuitive" aspects of structure-borne sound:

> "Structure-bone" is when you get the sound to travel through, let's say, wood or stone or another material. For example, once in an old theater I was performing with the Merce Cunningham Company a repertoire work. It was an old horseshoe theater in Caracas and we had not-good loudspeakers. I just suddenly decided to put these speakers into the horseshoe, there were only two of them and it was incredible, what happened! (laughs) I mean, sound was coming out of every balcony! The American ambassador there came up to John Cage, who was also there performing and he hadn't really read the program and he said, "Oh your music has changed so much, I've heard all of these angels!" (laughs) Because there was like choirs coming out of all these balconies because the sound had gotten into the structure of this shape and into this wonderful old building, and that's what I'm talking about.

that could bring them into being. See Kyle Gann, "It's Sound, It's Art, Some Call it Music," *The New York Times,* January 9, 2000, Section 2, p. 41.

[94] Amacher also presented evening-length sound works at Cunningham's Events #100 and #101 in March 1974, which included *Everything-in-Air,* as well as *Labyrinth Gives Way to Skin* at the Roundbout Theater in 1975. Cunningham described the events as "complete dances, excerpts of dances from the repertory, and often new sequences arranged for the particular performance and place," and musicians contributions were often similarly improvised and ad hoc. For *Labyrinth,* Amacher created an extraordinarily subtle live mix using oscillators and pre-recorded tapes. See Cimini and Dietz, eds. in *Maryanne Amacher: Selected Writings,* ed. Amy Cimini and Bill Dietz (New York: Blank Forms, 2020), 175–81. Please see also Fiona Meade and Joan Rothfuss, eds., *Merce Cunningham: Common Time* (Minneapolis: Walker Art Center, 2017).

[95] The complete title Amacher gives as *"Remainder. "18.] R [] D [+ An Afterimage. (Also used as a classifier of seeds.)*"* with the footnote "*Hollis Frampton, A STIPULATION OF TERMS FROM THE MATERNAL HOPI." A Repertory Sheet dated January 7, 1976, instructs that the title and footnote must appear in full on printed programs. The sheet also indicates that *Torse* could run for variable lengths between 15 and 45 minutes. "Repertory Sheet—TORSE" (January 7, 1976), Merce Cunningham Archive at the New York Public Library.

[96] For a review of the premier, see Daniel Webster, "Cunningham Group Danced with Joy," *Philadelphia Inquirer,* January 17, 1976. Webster writes, "Maryanne Amacher provided a tape collage as a score to run parallel with the dance. Her score developed low roars and sea sounds and electronic heavings that sounded like the deep breathing of a trance."

[. . .] But some places . . . there are a few really incredible places you run into where you can really sense this out and do it. Like this place I mentioned in Caracas, was one I could just sense that something wonderful would happen without too much trouble— that, with any kind of junk box speaker, you know, that wasn't too badly off, I could make something happen. I don't know the rules really, so it's an intuitive thing. It's going to the space, finding these kinds of spots where the sound can sort of take on its life, traveling through the structure, one way or another. And then you find that, or know that, you're able to place the speakers. And so I never like to work with a lot of speakers, because I would prefer to get the sound alive in the architecture. I now believe that the architecture can make magnifying really expressive dimensions in music in a way that you can't do any other way. I mean hopefully we might be able to make simulations but I don't know how you could make simulations of these things yet. I mean, you certainly can't in these crude delay things—such as multi-channel spatialization, panning, simulations of dimensions, or acousmatic sound. That's something else.

I think the oddest response I ever got to my music was—and I can't imagine this ever happening in the United States—it happened in Vienna after one of these *Music for Sound-Joined Rooms* works. Someone said that they really questioned whether it was such a good thing to have music like this because maybe you wouldn't need anything else if you could just live in this experience. And maybe that wasn't really so good socially (laughs).[97]

From the ambassador who mistakenly credited Cage with Amacher's angelic audio to the Viennese listener eager to live inside *MSJR*'s walk-in worlds, many enchantments come through this account. "Getting sounds into the structure" involved listeners in magnified "expressive" dimensions that, she averred, could not be simulated by other technological means. Amacher did not tell Bartone where exactly she placed her two speakers in the Teatro's horseshoe frame, as shown in floor plan in Fig. 5.8, and spoke instead of a "incredible place" where she "sense[d] that something wonderful was about to happen."

Completed in 1881 alongside a cluster of monumental projects seated in the Southern sector of Caracas, the Teatro exemplified the Ministry of Public Works' adoption of Western-European-style iron structures in a so-called modernized building practice.[98] Its design encouraged visitors to wonder at these modern

[97] Amacher, interview with Jeffrey Bartone, 1988.

[98] The ministry was founded in 1874 under President Gúzman Blanco. Steve Ellner and David J. Meyers, "Caracas: Geopolitical Feudalism," in *Capital City Politics in Latin America*, ed. David J. Meyers and Henry A. Dietz (London: Lynne Reyner, 2002). See also Leo Name, "Caracas and

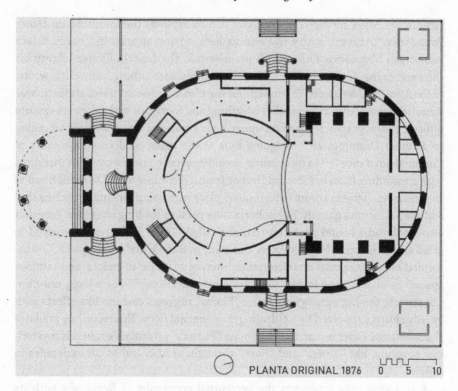

PLANTA ORIGINAL 1876 0 5 10

Figure 5.8 Floor plan of Teatro Municipal.

materials and employed cast iron finishings like trusses, columns, and handrails so that visitors could experience the look and feel of this structural material up close.[99] The 1,300-seat theater reflected a concurrent expansion of European concert venues, and the semicircular horseshoe with tiered loges facilitated the see-and-be-seen kind of spectatorship that had long been a part of opera-going's appeal.

After the 1976 performances in Princeton, Caracas, and New York, the MCDC performed *Torse* in Sydney, Perth, Adelaide, Tokyo, Vienna, Bonn, The Hague, and elsewhere in the United States through 1979, although Amacher did not join these further tours.[100] While a fifteen-minute-long excerpt appears on the

Mérida, Venezuela: Coloniality, Space and Gender in the film *Azul u no tan rosa*," in *Urban Latin America: Images, Words, Flows and the Built Environment*, ed. Bianca Freire-Medieros and Julia O'Donnell (New York: Routledge, 2018).

[99] The Teatro also employed electrical lighting to illuminate its balconies. Similar details recurred across Blanco's public works projects, enfolding the Teatro into a seemingly consistent look shared across other social and political locations in the city.

[100] I am grateful to Dietz for underscoring this point in our seminar on *Torse* at Bread and Salt in San Diego in January 2018.

ten-disc set *Music for Merce: 1952–2001* (which explores the Cunningham Dance Foundation archives), a fifty-five minute-long version appears in Charles Atlas's two-screen film dance *Torse*, which premiered at the Lincoln Center Library for the Performing Arts in 1978.[101] "*Remainder* is almost nothing," one critic wrote, of the *Music for Merce* edit.[102] Throughout the film, one does at times strain to hear Amacher's music over the sound of breathing and footwork as the dancers execute difficult choreography focused on upper-body positions that provided, according to Jennifer Dunning, an "intriguing look at the ballet-modern components of Cunningham dance."[103] In its opening, sound hovers at a near inaudibile threshold with a recording from her Boston Harbor feed; a recording with Eberhard Blum in the anechoic chamber conjures its tone-of-place with complementary breaths that add spatial focus; a ghostly 14 kilohertz tone persists for long stretches. Amacher also employed a sound character that she called "Tower," which was recorded in 1968 at the Niagara Mohawk Power Company in Buffalo and, as she put it, "transformed later for special characteristics internal to those of indoor and outdoor spaces" (and also used in her *Life Time* tape collection).[104] For a long, ten-minute stretch, the high-energy character "Phena" suggests eartone-like effects with speedy chirps supported by a pulsating, low-registal floor. This recording predates the *Additional Tones* research and, though "Phena's" provenance remains mysterious, it recurs, like "Tower" and "Here," throughout *MSS* and *MSJR* in decades to follow.

A technical note intersects the perceptual geography of *Remainder* with its nascent structure-borne arrangements.[105] It also gives rare instructions about how to project Amacher's music without her first-hand supervision. "Sound should hover indefinitely in the space," the note in Fig. 5.9 reads. To achieve this, one should "choose 4 spkrs which do not point directly at the audience." The parenthetical that follows gives examples of ways that might be accomplished

[101] Amacher, Works List. Robert Carl's review describes *Remainder*'s phantomic presence and interprets this threshold experience as a difficult-to-articulate interstice between sound art and music. He writes, "Maryanne Amacher's *Remainder* is almost nothing sonically; it seems to be a faint reverberation of some other sounds, whose presence has been stripped away and whose nature we can only vaguely imagine. What remains are the edges of a husk of sound. In short, there is as much sound art here as there is what we might call 'music.'" Robert Carl, "Review: *Music for Merce 1952–2009*," *Fanfare*, July/August 11 (2010): 519.

[102] Ibid., 519.

[103] Anna Kisselgoff, "Dance: A Classic by Merce Cunningham," *New York Times*, January 21, 1977, 48. See also Anna Kisselgoff, "Merce Cunningham, The Maverick of Modern Dance," *New York Times*, March 21, 1982, section 6, p. 23, and Jennifer Dunning, "Dance: Torse by Merce Cunnigham," *New York Times*, March 1, 1980, p. 11.

[104] *Hearing the Space, Day by Day 'Live'*, November 7, 1973 through June 7, 1974. *Interventions in Landscape* at the Hayden Gallery, April 10 through May 11, Press Release. Versions of "Tower" also appear on *Sound Characters* (1999).

[105] I am grateful to Bill Dietz for calling my attention to this document.

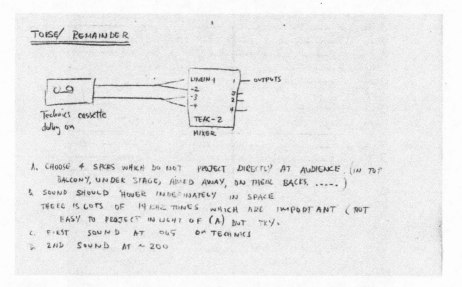

Figure 5.9 Playback and speaker placement instructions for *Remainder* (author unknown). Courtesy of the Maryanne Amacher Foundation.

but dissolves into an ellipsis. The note is also forthright about the fact that its instructions work at cross purposes: "There is [*sic*] lots of 14khz tones which are important (not that easy to project in light of (A) but try)." As Amacher had noted that same year in her workbook, the outer ear takes up sound transmission and localization for frequencies higher than 8khz. Long stretches bathed in 14khz tones downplay the cochlea and lavish sustained focus on the outer ear's skin and cartilage. This auricle-centric perceptual geography contrasted a structure-borne gambit that would "hover" in air.

Amacher also experimented with architectural mediations in the installation-performance *Everything-in-Air* at the Walker, back in 1974. Detailed notes outline the work she did "to prepare the space," prioritizing spectral and spatial illusions that would complicate a listener's awareness of the event's multi-sitedness, as Fig. 5.10 suggests.[106] Amacher used two amplifiers for the long-term *Hearing the Space Day by Day 'Live'* installation and added two more for the *Everything-in-Air* performance. For *Everything*, she nestled speakers in corners and close to solid

[106] As Amacher put it, the project aimed to "explore some corresponding conditions of boundary and illusion . . . existing between selected sounding material and the physical possibilities within and out-side the immediate structure of the performance space." Amacher, Press release: "EVERYTHING-IN-AIR," a sound environment prepared for the space of the Walker Arts Center Auditorium, Minneapolis Minnesota.

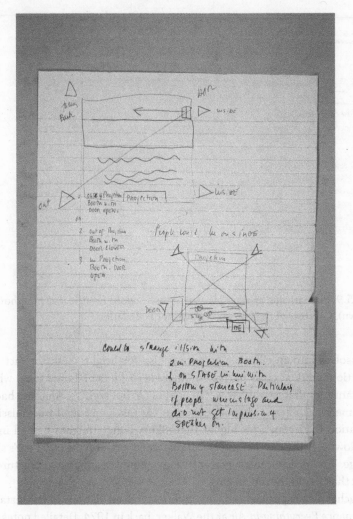

Figure 5.10 Amacher's sketches and note on speaker placement in *Everything-in-Air* at
Walker Art Center auditorium. Courtesy of the Maryanne Amacher Foundation.

substrates, like doors, stairs, and walls in various combinations.[107] Her lists of
possible placements prioritizes sightlines and architectural enclosures:

For Performance in Auditorium

(1) Could put two Altecs in control room and open doors
 (a) Only one door open, check other side

[107] Amacher's EQ settings for *Hearing the Space* skewed toward the treble end of the spectrum with
the bass turned down almost to zero, according to her sketches.

(2) 2 behind wall on stage
(3) Or maybe one onstage, maybe all in projection room
 (a) 1 off stage door 1 in back area[108]

In this unapologetically acousmatic scenario, Amacher prioritized audiovisual mismatches that could disorient physical space, acoustical shapes, and auditory dimension.[109] "Could do strange illusion with 2 in projection booth. 2 on stage in line with bottom of the staircase," she noted. "Particularly if people were onstage and did not get impression of speaker on."[110] Speakers in the projection booth would do the same. "Sound is experienced here more as 'appearance' into the space rather than as continuous non-stop audible flow within this space," her press release read. Architectural staging made this doubly so: a spectral appearance in the feed would also generate an acoustical appearance in not-easily-locatable physical space. Although Amacher did not yet fully prioritize "get[ing] sound into the structure," she did "prepare the space" with architectural and audiovisual illusions in situ that intensified the conceptual boundary play integral to long distance music.[111]

In a 1976 project proposed for Manhattan Cable TV titled *Saga*, Amacher began to merge long distance music's conceptual concerns with episodic formats. Amacher's plan was to broadcast a nightly mix between 11 p.m. and 4 a.m. based on seven remote feeds from sites in New York City that she would correlate with locations in Arthur C. Clarke's 1956 novel *The City and the Stars*. *Saga* afforded a serial framework for the long durations and diurnal cyclicities that Amacher had used to dramatize the subjunctivity of environmental sound. In other words, this fictive crucible provided subjunctivity with narrative form without compromising her commitment to live transmission.

> The work is best understood as a SAGA, with sounding spaces and special musical personae. For the receiver, a particular "adventure" of the SAGA would be in receiving "live" patterns from one of more sounding

[108] Amacher, working notes, Box H10–07–09–05.

[109] Press Release, *Everything-in-Air*.

[110] Amacher, working notes, Box H10–07–09–05; additional instructions read "Move right loudspeaker behind exit door on stages" and "Left loudspeaker behind projection wall. Face speaker to back wall—not projection wall."

[111] Press Release, *Everything-in-Air*. Amacher's complete text reads: "Sound is experienced here more as 'appearance' into the space rather than as continuous non-stop audible flow within this space. Hearing the space—what is distant, what is local, clearly and simultaneously: hearing over time—approach and disappearance of what is sounding in the environment: vibration in air heard minutes before the actual sound of a train is heard; changes in air vibration as different phenomena approach the site: birds sensing these changes in air—their anticipation, announcement of arrivals and disappearances, before the sound of the change is heard at the site. Hearing the synchronicity. Live. As it is. Patterns within air."

environment at the same time, e.g. the Tower, The River, The Ancient
Floor, The Ocean, The Abandoned Mill.[112]

Between the spring of 1976 and the fall of 1977, Amacher routed a remote feed
from Pier A in Battery Park to her studio at 140 Pearl Street and incorporated it
into multiple projects, much as she had done with the Boston Harbor feed. In *Saga*,
the Pier A telelink would fill the role she called "The River" in Clarke's speculative
diegesis. "The SAGA is the ongoing life of these spaces and the music which flows
between them," she explained, "evolving within the city for six weeks the energy
of the night and the patterns hidden there." In early planning stages, Amacher
determined the cost of sending seven lines to her studio on Pearl Street and a
stereo transmission to Manhattan Cable TV's East 23rd street location. Initial
plans included five weeks to research and three for production, but timelines
began to stretch into the ten- and twelve-week range, according to her working
notes. She budgeted for work with five musicians, including Rhys Chatham, Jon
Gibson, Garret List, and Peter Gordon, and her notes suggest that each person
would appear twice and in variable combinations, located at a different remote
site each time.

On September 10, 1976, Amacher wrote to John Cage requesting a letter of
support as she prepared an application to the NEA's Public Media Program to
support the project.[113] Her enthusiasm for its diegetic frame shines through the
gentle apology with which she opens her letter: "I got a little carried away describ-
ing scenes from Arthur Clarke's book on the phone when we last talked and I'd
like to apologize for talking so much when I said I would not and you had so much
work on your mind!"[114] Amacher also reports having received, from MCTV, the
"final word" that *Saga* will be broadcast from 11 p.m. to 4 a.m. every night for six
weeks and that MCTV will be, she enthused "introducing stereo cable FM pro-
gramming with [my] project!" In place of a normal antenna, a subscriber could, at
the time, pay $1 per month for an FM cable that delivered an improved signal-to-
noise ratio and increased stereo separation. Amacher emphasizes that hers was
the first proposal that MCTV had received to work with this service. "Apparently,"
she explains, "they have just begun to think about finding ideas." She continued,
"maybe it will be a little difficult for them, because they really cannot simply dupli-
cate FM radio broadcasting, there is no need; and maybe this is where we can

[112] Amacher to Cage, September 10, 1976, John Cage Collection at Northwestern University.

[113] In 1977, Amacher received a $5,200 grant from the NEA in the General Programs category,
but the MCTV Public Access broadcast was not realized. National Endowment for the Arts, *Program
Report: 1977* (Washinton, DC: NEA, September 1978). Amacher did, however, present events titled
Listening at the Boundary: A Scenario from a Sound Saga on May 26 and 27 at The Kitchen, which as
she described, "developed themes—mind perceiving sound, music, time from the writings of Arthur
C. Clarke, Olaf Stapleton and Gene Wolf."

[114] Amacher, Letter to Cage.

make an advance move to change a few things." Activating this FM bandwidth could serve both artists, Amacher suggested.[115]

Although MCTV Director of Community Access Bob Mariano cast Amacher's proposal as a potential watershed moment in public broadcasting, his arguments invoked different constituencies than did William Siemering's reflections on *City-Links WBFO*. Mariano's supporting letter to the NEA's Director of Public Media Programs gestured toward "[putting people] in touch with the texture of their city," but his focus was mostly on how *Saga* would dramatize the underused FM bandwidth. Prior to 1976, subscribers received only weather reports and public service announcements over FM cablecast; however, Mariano hoped that *Saga* would stimulate other artists and win more subscribers to the service. "Since our public access channels became available in 1971," he wrote, "we have occasionally had the opportunity to work with artists for special programming," reminding the NEA's Director that MCTV was prohibited by law from programming its own channels.[116] For Mariano, *Saga* suited technical, legal, and artistic figurations at the station especially well.

Amacher seems to have concurred. "I think good musical activity could follow for others," she wrote to Cage, and imagined how listeners might use the FM bandwidth to practice new ways of listening at home and in "personal time," as she later put it. She also seized the opportunity to imbue this new technology with speculative drama and narrative momentum and, to that end, explained to Cage its diegetic entanglements with *The City and the Stars*.

> For my work, there is almost no other way to develop the kind of empty spaces that we both miss, silences, like the time between the appearance and sounding of the seagulls at the harbor difficult to make in audience auditorium situation, where people are sitting, waiting 5 to 10 minutes for the next sound; here it can really happen without the anxiety. (Maybe later "waiting" and listening in the auditorium will be enjoyed more).
>
> Musically, besides the political, spiritual analogy to Arthur Clarke's book, I am very much dedicated to this work because if the "way out of Diaspar" did initiate FM cable programming in the US it would certainly be astounding.

[115] At the time Amacher wrote to Cage, she worked in a space at PS 1, which she described as an "old schoolhouse with studios for artists." "The spaces are marvelous," she tells him, "and because of the stone and the stillness at night, a wonderful feeling of a country house is present." Her works list includes a 1976 project titled *The Double Room* in a group exhibition titled *Month of Sundays* at PS 1 Institution for Art and Urban Resources in October—November 1976, which she described as a "room installation: photographic works series, drawings and documentation of the Boston Harbor Telelink Installation."

[116] Bob Mariano to NEA Director of Public Media, September 17, 1976.

In this explanation, Amacher wove the transmission into the turning point of Clarke's book. *The City and the Stars* takes place in a distant future and involves two cities distinguished in sharply dualistic terms. Diaspar is a hypertechnological "smart" city where work, like street cleaning and food preparation, is carried out by computational surrogates that sustain its inhabitants' eternal existence. The story unfolds from the perspective of Alvin, a human visitor, who reconstructs the history of wars and invasions that had given rise to Diaspar and barred its inhabitants from leaving or communicating outside its bounds. He also finds that Diaspar remains unaware that another city flourishes nearby. Lys is a rural economy whose telepathic and psionic residents live short but rich intellectual and artistic lives. With help, Alvin accesses Diaspar's central computer system and learns that the cities had once been linked by an underground transport system— a system that still exists, although only a single secret entrance remains. Alvin travels through the connective system and finds Lys on the other side. After facilitating a meeting between the cities' councils, which reveals their complementarity, Alvin returns to space. Amacher summarizes this forgotten ingress and its hidden social connections as "the way out of Diaspar."

Consider some doublings that transport this story into the listener's home. Across a six-week span, *Saga* would protract the novel's turning point such that listeners could, in an important way, experience Alvin's "way out" over and over again. If the cablecast played the role that the secret transport system did, in Clarke's story—as Amacher suggests, to Cage, it should—Diaspar's "secret" connections would move listening between city and the home in a new kind of experiential time. In this sense, *Saga* would not adapt Clarke's novel so much as redouble its key diegetic revelation— one that, all at once, reveals new technologies, perception, and social entanglements—as a narrative involvement that reworked auditory thresholds. At this early stage, *Saga* presages later fictive and episodic dramas, like *Living Sound*, that Amacher invested with "the potential [. . .] to develop alternative modes of engineering and technological development."[117] After all, following the "way out of Diaspar" means also leaving behind a fictional world of "enchanted" technologies that do things for privileged human subjects and moving, instead, into a more uncertain field of social connection that is subject, in Amacher's remote feed, to the drama of real-time durations and synchronicities.[118]

Titles and subtitles remain slippery in Amacher's work series and these late 1970s and early 1980s projects are no exception. In 1979, Amacher began to

[117] Neda Atanasoski and Kalindi Vora, *Surrogate Humanity: Race, Robots and the Politics of Technological Futures* (Durham, NC: Duke University Press, 2019), 4. As they put it, "Technological futures tied to capitalist development iterate a fantasy that as machines, algorithms, and artificial intelligence take over the dull, dirty, repetitive, and even reproductive labor performed by racialized, gendered, and colonized workers in the past, the full humanity of the (already) human subject will be freed for creative capacities."

[118] Ibid., 4.

use the title *Research and Development* for both telematic projects and *Music for Sound-Joined Rooms* events. This heading seemed to announce a new, in-progress work series distinct from *City-Links*, and delimited conceptual terrain in the "walk-in" formats, which Amacher described, at the time, as "installation[s] of music and sets with performances."[119] Between 1980 and 1981, Amacher paired *Research and Development: Music for Sound-Joined Rooms* with the subtitle *Living Sound (Patent Pending)* three times, adding cities and dates in parenthesis to each instance: in 1982, *Living Sound (Patent Pending, Lugano 1982)*; in 1981 *Living Sound (Patent Pending, Vienna 1981)*; and in 1980, *Living Sound (Patent Pending, Minneapolis, 1980)*.[120] This strategy creates coherence across this burgeoning corpus but insists that each instance remain irreducible to another.[121] While *Research and Development: Music for Sound-Joined Rooms* featured titled subcomponents though 1982, Amacher crystallized the multi-episode *Mini Sound Series* format in 1985, which articulated long-range formal continuity across narrative episodes over a multi-week span. To this end, Amacher provided each mini sound series with a unique title—like *Sound House* (1985), *The Music Rooms* (1987), or *Stolen Souls* (1988)—followed by the subtitle "A Mini Sound Series" and, then, with unique titles for each episode. *Sound House*, for example, featured six overlapping "features," listed on the program shown in Fig. 5.11.[122] While the two walk-in series *MSJR* and *MSS* shared formal, material, and methodological principles, they suggest two distinct narrative strategies—one self-standing, the other "to be

[119] Prior to New Music America in June 1980, the *Research and Development* events at both The Kitchen and Sala Borromini in Rome listed the subcomponents "Neurophonic Exercises," "Spotlight the Missing Fundamental," "It Grows an Arm," "The Critical Band," and "Manipulation of the Missing Fundamental."

[120] In Vienna, she listed three additional evening-length episodes whose titles and themes coincided with the later Mini Sound Series and the multiformat proposals that, starting in 1979, bore the title *Intelligent Life*. Many interpretive and historiographic challenges arise amid this chronological sketch. She rooted these events in time and place—for example, Vienna, 1981; Lugano, 1983—underscoring that they were not performances of an integral work and that structure-borne sound would underpin their formal and narrative structures. This does not indicate that identically titled projects shared sonic material or characterological drama. Structure-borne protocols guaranteed that any instance would entail distinct sonic shapes and perceptual geographies that could orient a viewer's comportment in relation to multimedia clues in variable ways. Among addition overlaps were "The Sound Sweep," a reference to the short story by J. G. Ballard, which appears again in *Sound House*; "The Webern Car," which reappears in name in a draft treatment of *Intelligent Life* for television and radio simulcast; and "Spotlight," appeared in *Research and Development* in Amacher's initial announcement at The Kitchen in December 1979.

[121] For a recent accounts of *Music for Sound-Joined Rooms* projects please see the following: Nora Schultz, "Top Ten" (Gravity, 2006) *Artforum* 46, no. 8 (April 2008): 193–94; Christina Kubisch, *Artforum International* 45, no. 4 (December 2006): 74, 10; Brandon LaBelle, "Short Circuit," *Contemporary*, nos. 53–54 (2003): 66–71.

[122] For Capp Street Project director Kathy Brew's account of Amacher's work on *Sound House*, please see Kathy Brew, "Through the Looking Glass," in *Women, Art and Technology*, ed. Judy Malloy (Cambridge, MA: MIT Press, 2003), 87–101.

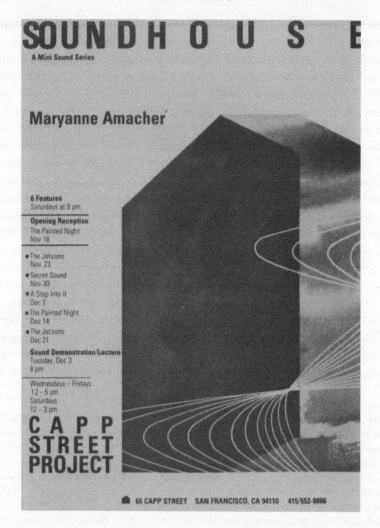

Figure 5.11 Program cover for *Sound House: A Six-Part Mini-Sound Series* at Capp Street Project, November 16–December 3, 1985. Courtesy of the Maryanne Amacher Foundation.

continued . . ."—that could address different conceptual questions and presentational constraints.

Amacher announced the new series *Research and Development* prior to a performance on December 1, 1979 at The Kitchen. That night, *Research and Development* stoked diegetic associations using textual materials that would reappear, that coming summer, in *Living Sound*. Rearticulating methods rooted long distance music and *City-Links*, Amacher announced that "incoming live sound will be mixed with other sources, recordings that have resulted from *Tone and Place (Work 1)* and several other installation-performance works which linked spaces

distant from each other."[123] Amacher routed her Pier A feed first to her Pearl Street studio and then, on to The Kitchen. At the pier, George Lewis improvised, "relating his sounds to impressions he is receiving at the time," as she put it; in Amacher's studio, Cage read text excerpts and Amacher mixed the incoming feeds in situ.[124] Another virtual transport begins to take hold. *The Textbook of Aviation Physiology*, Charles Darwin's *The Voyage of the Beagle*, Olaf Stapledon's *First and Last Men*, and her own 1977 talk "Psychoacoustic Phenomena"—texts that would, in part, intensify an audience's awareness of their own listening—combined historical and fictive life forms in disparate temporal and spatial scales, while Lewis's remote performance was to move listeners out of their implicit situation such that, as Amacher wrote, "we listen outside the place our body sits in."[125] In *Living Sound*, these connections reappear in clues that listeners were to locate for themselves. The next two sections work closely with two such clues and re-enter the installation's fictional world, this time with close attention to its music historical and juridical supports in *Diamond* as well as their extrapolations in another clue, excerpts from Stapledon's book. Returning to the typewritten text that appeared on the TV storyboards reveals an approach to diegetic involvement that conjoins human and microbial perceptual geographies. Excavating Stapledon's narrative casts a critical and even sardonic tone over the installation and reprises questions about narrative framing and biopolitical control.

CLUE II: Orchestral Metabolisms and Unheard Microbial Music

Next to the petri plates in the HOME LABORATORY staged in Dennis Russel Davies music room, Amacher had placed storyboards that listed what the microbes

[123] She also lists recordings from many long-distance projects from the 1970s: Listening at Boundary (Stadsschouwerberg, Corps de Garde, Groningen Holland); NO MORE MILES (Walker Art Center and ICA Boston); EVERYTHING-IN-AIR (MCA Chicago and Walker Art Center Minneapolis); HEARING THE SPACE, DAY BY DAY, "LIVE" (Walker Art Center Minneapolis, Hayden Gallery Cambridge); CITY LINKS CHICAGO 1974 (MCA Chicago); CITY LINKS (Boston-NYC-Paris), WBAI New York, Radio France Musique.

[124] Amacher, Press Release for Research and Development at the Kitchen, December 1, 1979. Indeed, Amacher undertook a number of events at The Kitchen between 1972 and 1988 which included a benefit for the Cardew family on May 25, 1982; the commission of "Intercept" for Voice of the Nation radio broadcast during the 1982–1983 season and "The Music Rooms" for the *Imaginary Landscapes* festival of electronic music curated by Nicolas Collins in 1988. See Tobler Lugo, "Spaces and Fests," *Performing Arts Journal, LIVE performance art magazine* 6, no. 7 (1982): 120 (Review); Noah Creshevsky, "Imaginary Landscapes," *Newsletter—Institute for Studies in American Music* 19, no. 2 (Spring 1990): 6; Peter Watrous, "Review," *New York Times*, Late Edition (East Coast), February 28, 1988.

[125] Amacher, Press Release; see also John Rockwell, "Music: Miss Amacher," *New York Times*, December 3, 1979.

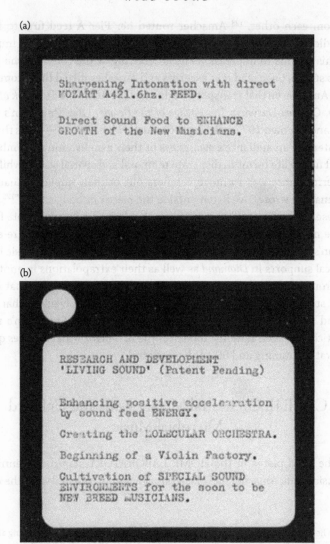

(a)

Sharpening Intonation with direct
MOZART A421.6hz. FEED.

Direct Sound Food to ENHANCE
GROWTH of the New Musicians.

(b)

RESEARCH AND DEVELOPMENT
'LIVING SOUND' (Patent Pending)

Enhancing positive acceleration
by sound feed ENERGY.

Creating the MOLECULAR ORCHESTRA.

Beginning of a Violin Factory.

Cultivation of SPECIAL SOUND
ENVIRONMENTS for the soon to be
NEW BREED MUSICIANS.

Figure 5.12 Two boxes from TV storyboard displayed in *Living Sound*'s Music Room /
"Home Laboratory." Courtesy of the Maryanne Amacher Foundation.

were doing inside, as shown in the two boxes excerpted in Fig. 5.12. They were not
only listening to the installation's ferocious structure-borne sound, but they were
also preparing to make a fictive music all their own. Another way to put it is that
Amacher designed a speculative perceptual geography for the microbes as such.
What might sound and listening become, one could ask, amid the hypothetical
bits of vitality that Amacher counted among myriad "biological intelligences"?

In both her text "LONG DISTANCE MUSIC" and *Additional Tones Workbook*,
Amacher generated numerous schematic lists of auditory sensitivities that could

be combined and reinforced in practice; in *Additional Tones*, this included the air, the ear, and neural processes, and in "LONG DISTANCE MUSIC," remote circuitry, distanciated linkless and soundless sensitivities as well as listening in situ.

In a 1990s handwritten note, Amacher again posed the question "where does sound come from?" and responded with another list that synthesizes these originations and adds three more.[126] As we will see, *Living Sound*'s clues activate all seven locations and distribute them, in the diegesis, to both human and microbial listeners.

(1) sound in the room
(2) sound in the head
(3) sound in the ears
(4) as sensed by the body (arms, legs, elbows)
(5) remote locations (different atmospheres)
(6) remote times—a "simulation"
(7) as other life forms hear them; as they originate in auditory perception of other animals: elephants, bats, owls, etc.

Diegetic involvement, in other words, depended on how these ways of listening are attached to factical structure-borne sound and to fictional audiation, expressed by the storyboard and other clues. The list summarizes the shapes and intensities associated with structure-borne sound as "sensed by the body"—such as "sound circling your nose" or hovering so close that one might "raise a hand to touch."[127] Yet, the storyboard also insists that sound "originates in the auditory perception" of the microbes and embeds, in this fictive listening, sounds as they also originated in both "remote times" and "remote places," for example, the common-practice period of the so-called First Viennese School. Using terms germane to her earlier approach to tone of place during the 1970s, she explained in 1985 that "additional acoustic dimensions are created as SETTINGS [that] the Sound Stars inhabit, the environment they meet and interact in—THE CHANGING ACOUSTICAL ATMOSPHERES OF THEIR WORLD. Simulations suggest the scent or tone of such places; created as unique, imaginary atmospheres."[128] The "tone" of Mozart's Vienna lingers with the microbes, but not their human visitors. These distinctions provide fictive life forms and human visitors with concrete audiovisual roles to play in a story that generates speculative conditions under which their partial and distinct claims on its sound world could converge: eartones. Taking these fictive thresholds seriously distinguishes "entering the story" from simply walking through the installation.

126 Cited in Dietz, "Rare Decays."
127 Amacher, "As Told to Forti" and "The Head Stretch."
128 Maryanne Amacher, "About the Mini Sound Series."

Microbes pepper the scene with an anachronistic and distanciated listening that plays up an extreme plasticity underpinned by their apparent value in 1980s technoscience and capitalization. The clues channel then-new microbial enthusiasm into music-historical time, where the liveliness of gene-trading microbes makes itself felt in whimsical and unsettling ways. If microbes did not so much die as become other kinds of things, why couldn't they become something that experienced historical ways of listening? This hypothetical laboratory scene returns to musicological figurations of the orchestra, a reminder that local press had taken pains to frame the installation as an "homage" to Davies's work with the SPCO. But the clues instead gave the microbes a two-hundred-year head start. By way of a "direct feed," microbes have long been soaking up the A at 421.5 Hz, standardized by Vienna piano manufacturing and immortalized in Mozart's apocryphal tuning forks. Even the orchestra could be made to work on behalf of perceptual geographic desires. To this end, the storyboard straddled heterogeneous meanings: its orchestra could be a metaphor, an institution, a lineage, a deferral, a wish, a satire.[129] While the clues clearly reserve an inaudible sound world for its fictional microbes, these orchestra-based clues infuse the scene with traditional concepts of sonic coherence and timbral splendor that invoke the orchestra's composite string section specifically.[130] As a discrete concept in eighteenth-century aesthetics, an "orchestral sound," as Emily Dolan explains, "relied on concepts of instrumental timbre as it was explored via a body of trained musicians, including players of wind instruments in numbers and varieties that expanded the palette of sound available to the composer."[131] A listening that reveled in this apparent immediacy also reflected the orchestra's conceptual consolidation as at-once a coherent kind of sound and a composite variety of timbral combinations.[132] Another take on a microbe's plasticity, this clue creates a collage-like time capsule that restages its acoustical promises as music-historical fiction to conjure future auditory worlds. What if reveling in orchestral sound was also a way to revel in one's own eartone responses?

Amacher instrumentalized Western art music to create diegetic involvements in other "walk-in" contexts, as well. Consider the *The Music Rooms: A Four-Part Mini Sound Series*, produced at the DAAD Gallery in Berlin between February 19

[129] Though Amacher does embrace a collage style associated with postmodernism, she is less interested in mining historical styles for their "euphoric" intensity than in dramatizing that intensity through ways of listening that often involves complex technoscientific figurations. For a canonic account, see Frederic Jameson, *Postmodernism, or the Cultural Logic of Late Capitalism* (Durham, NC: Duke University Press, 1991), 279–96.

[130] See Emily I. Dolan, *The Orchestral Revolution: Haydn and the Technologies of Timbre* (Cambridge: Cambridge University Press, 2013).

[131] Ibid., 16.

[132] Dolan has shown how this concept of instrument, in orchestral discourse, informed the work of eighteenth-century inventors, and connects the orchestra to scientific discourse on timbre over nineteenth-century idealist philosophy.

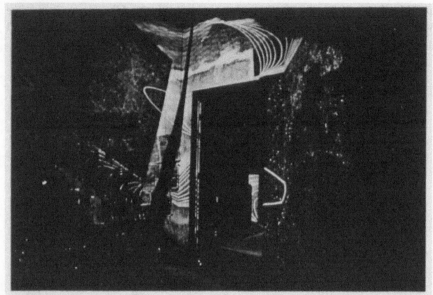

MARYANNE AMACHER, Installationsansicht von "THE MUSIC ROOMS", eine vierteilige "Mini-Sound-Serie" (19.2. - 25.3.1987), DAAD-Galerie, Berlin. Eingangswände mit Zeitschriften der Berliner Popmusik-Presse

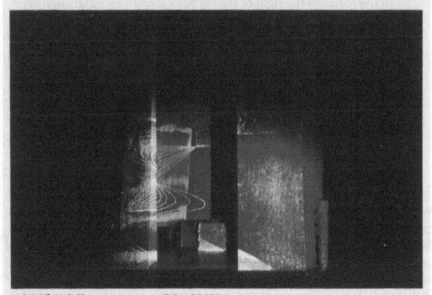

MARYANNE AMACHER, Installationsansicht von "THE MUSIC ROOMS", eine vierteilige "Mini-Sound-Serie" (19.2. - 25.3.1987), DAAD-Galerie, Berlin. Gold stammt von "Rheingold", aus der Requisite der deutschen Oper Berlin

Figure 5.13 Two photographs from *The Music Rooms: A Four-Part Mini-Sound Series*, February 20–March 15, 1987 at the DAAD Gallery. Courtesy of the Maryanne Amacher Foundation.

and March 15, 1987. Fig. 5.13 shows two photographs. Like *Living Sound*, *The Music Rooms* foregrounded material traces that caught an art music tradition and its institutions in states of transition, even disarray.

> In the inner alcoves of the MAIN GALLERY ROOMS, to the right and left of the entrance murals, OLD LEGENDARY PROPS FROM THE GERMAN OPERA WAREHOUSE installed casually as though partially abandoned. With the exception of the GOLD BRICKS from "Das Rheingold," these mythic objects are badly worn, look abused and sad, discarded. The room at the left is kept very dark, except for masked light from the projected "theme images." Entering the scene in darkness, one looks very close to identify the items, or read their name tags. Three small pedestals from the opera (looking very cheap) hold the Severed Head of Johannes (modeled to look like a lead singer with this role) on its silver platter ("Salome"), [. . .] and two small lyres from "Orpheus"; on the floor a pile of 40 swords from "Siegfried"; a mask from "Montezuma." Dividing the space, a large plastic mirror, in an ornate wooden frame from "Lulu."
>
> In the rooms to the right of the entrance murals, an installation of light and image at the alcove's doorway, creating changing entrances to the smaller rooms; Gold Bricks from "Das Rheingold," the only opera prop; a large photographic text; and a video monitor close to the floor on a small island. At times, fast sequences of video cuts projected a series of light flashes through the doorway, into darkened areas of the adjoining space. "THEME IMAGES"—seen as still video faces in these rooms, with a twin or complementary optical image projected in a scene in the other room, on the opposite side of the Gallery—"viewed" this world of music's heroes and myths—the conquered themes of historical and pop music fantasy.

While *Living Sound* intensifies a promissory complexity embedded in late twentieth-century discourse on microbial life, *The Music Rooms* reviews its own historical wreckage.[133] No orchestras are augured for eartone enhancements or other biological promises. Instead, in *The Music Rooms*, visitors watched projected faces survey the rooms, as though wondering how to "potentialize remains" that play up their own historical discontinuity.[134] This is another reason that the

[133] Amacher often referred to J. G. Ballard's short story "The Sound Sweep" and included, in her draft for the media opera *Intelligent Life*, a character (Ray Alto) with the same name and role in Ballard's story. Interestingly, in a 1981 article in Omni magazine by Tom Hight, Amacher is described as employing "left-over sounds" in *City-Links, WBFO, Buffalo* as "inspired" by "The Sound Sweep."

[134] Christine Ross, *The Past is the Present; It's the Future Too: The Temporal Turn in Contemporary Art* (London: Continuum, 2013), 14; cited in Bishop, *Museology*, 20.

"living music"—for which one critic heartily praised Davies—could never have been also the "living sound" that Amacher staged in his empty home. A speculative walk-in format that emphasized historical conjunctures effectively barred what Peter Osborne calls the "operative fiction" of the contemporary, on which local discourse rested Davies's legacy.[135] Such intense and sometimes humorous juxtapositions invoked historical constructions of heightened musicality in order to deepen a conviction that additional tones enclosed forms of pleasure and participation that not only haunted contemporary art music but also exposed it to other forces.

Asking "where does sound come from?" amid Amacher's walk-in fictions reveals that many such points lie on the far side of human auditory thresholds. Though critical interpretation often wants to see and hear everything, *Living Sound* creates dramaturgical conditions in which "entering the story" means also suspending disbelief that parts of its sound world are accessible solely to fictive organisms.[136] Description, in other words, will have to mark its inability to access how sound "originates" in fictional microbial and extraterrestrial listeners around whom the story is also scripted. Archival tapes find two sound characters associated with *Living Sound* with overwhelming regularity and, with one addition, these characters recur in the seven-minute edit that appears buried at the end of the third disc of *Ohm: Gurus of Electronic Music* (2000), flanked by John Chowning's *Stria* (1977) and Robert Ashley's *The Wolfman* (1964).[137] The excerpt begins with the Boston Harbor's thick hum in mono, through which two additional characters enter to carry the complete excerpt. As character that Amacher called "Spirals" orbits stereo field, its compact spectral band traces a thin, ovaloid line around a vast hunk of negative space. Gentle, irregular fades introduce *Here*—once a model companion to *Adjacencies*, *Here* is now a character in *Living Sound*—and fills "Spirals," as though already germinating inside its core.[138] In the mid-1960s, Amacher had begun to associate *Here*'s twirling spectral contrasts with a kind of virtual transport. *Here* could conjure a fuzzy, capacious sense of place that combined "where

[135] Peter Osborne, "The Friction of the Contemporary," in *Anywhere or Not At All: Philosophy of Contemporary Art* (London: Verso, 2013), 13–35; cited in Bishop, *Museology*, 18.

[136] Talal Asad, "Free Speech, Blasphemy, and Secular Criticism," in *Is Critique Secular?: Blasphemy, Injury, and Free Speech* (New York: Fordham University, 2013), 14–57.

[137] On Amacher's complexly labeled tapes, many short excerpts suggest experiments with tape collage as a way of convening specific sound characters. This instance does not represent the event's complete duration, and its combination of characters appears many time, elsewhere. *Ohm: The Early Gurus of Electronic Music: 1948–1980* (Ellipsis Arts, 2000).

[138] One reviewer described this excerpt as a "massive, droney void," and, at a talk in 2016, one audience member queried whether it, "[was] too simple for sustained analytic attention." While both responses illustrate how Amacher's music is often put into discourse as visceral and intuitive, this chapter and the previous one suggest that questions of form and development remained immanent to how she created such perceptual geographic impacts. http://pitchfork.com/reviews/albums/2106-ohm-the-early-gurus-of-electronic-music-1948-1980/, accessed December 5, 2015.

you are" with "where you have never been before," as she had written in Urbana.[139] Amacher used the tape as though it imparted its sound worlds to other places, other people, and future listenings. Moving into *Here*'s spectral complex accelerates involvement in a story that distributes its audibility across life forms, auditory thresholds, and historical mediations.

Rather than correlate two or more locations via their co-implication in the durative present, as did long distance music, *Living Sound* teems with auditory thresholds whose corresponding life forms entangle disparate histories, institutions, temporalities, and social tenses that treat a single location as though it were at the same time somewhere else entirely. The scene accomplishes its no-tech kind of virtual transport without having to come face-to-face with computer hardware— let alone having to do so on an artist's nonexistent budget—with no input devices or codified interaction procedures. Sound shapes connect clues; *Here*'s sound world attaches to inaccessible auditory thresholds; structure-borne sound defies the MID RANGE against which the fictive scene works. "While personal computing was new and rapidly in transition," as Simon Penny puts it, "aspirations fueled by science fiction and 1970s technophilic hangovers often outstripped existing technology and theoretical contexts."[140] *Living Sound* introduces a discourse of virtuality that eschews the separation of patterned information from a material substrate. Instead, this magical architecture tells its story about auditory thresholds by enacting their fictive, historical, and aesthetic entanglements and staging that enactment in relation to contemporary spaces of biopolitics.

CLUE III: *Diamond v. Chakrabarty* among the Third Men

> Two days after the close of LIVING SOUND (Patent Pending), the Supreme Court provided an "after sound." Its <u>Diamond v. Chakrabarty</u> decision ruled that laboratory-created life forms are indeed eligible for patent. That same week, another news article announced that discovery of the oldest biological cells ever found on earth had compelled scientists to date the beginning of life on Earth 1.2 billion years earlier than had previously been supposed.
> —Maryanne Amacher on *Living Sound (Patent Pending)*

Amacher remarked on *Diamond v. Chakrabarty* two days after *Living Sound*—and two decades later, as well. "I was thrilled to learn that the law passed to patent laboratory-created life forms," she said in 2001. In fact, *Diamond v. Chakrabarty* did not create a new law but took interpretive action on an old one. Yet, Amacher's mix-up touched on precisely the jurisprudential question that animated the

[139] Amacher, undated working notes related to *Adjacencies* (discussed in Chapter 2).
[140] Simon Penny, "The Desire for Virtual Space: The Technological Imaginary in 1990s Media Art," unpublished, 2009.

case: Could the Supreme Court alone rule on the patent or was new legislation required to extend existing statutes to include living things?[141] The judicial and legislative prerogatives at issue in *Diamond v. Chakrabarty* gave rise to articulations of life that corresponded to two opposing approaches to its political management. After all, as Kevles underscores, "intellectual property laws were obviously not written with biotechnology in mind." Up to 1980, Section 101 in the US Code had been revised only once since its framing in 1793 by Jefferson and Madison; that 1952 revision simply replaced the older term "art" with the twentieth-century synonym "process."[142] Competing amicus briefs articulated the life of the bacterium to be either compatible with either an accelerated ruling in the juridical or the slower work of new legislation and congressional study.[143] In the first scenario, biotech startup Genentech simply stated that the bacterium was not really alive. Likening the bacterium to a "dead chemical compound" or a "carbuerator," their brief invoked "compounds of matter" and "machines" that had been covered by 101 since the eighteenth century and leaned on old tropes to describe machines and living things in terms of one another. To demand legislative action, The People's Business Commission (PBC) appealed to a univocal notion of life that cut across microbes, multicellular things, mammals, and human beings.[144] Because 101's authors could in no way have foreseen its application to living things, the PBC called for legislative updates that took late twentieth-century technoscience explicitly into account.[145] Divergent inflections cast the bacterium to be both alive and not alive, new and old at the same time.

Additional clues in *Living Sound* take on questions about biological control more or less directly. Both come from Olaf Stapledon's 1930 novel *Last and First Men*, a speculative future-history that Amacher also calls an "evolutionary romance," after Stapledon's mid-century admirers. Amacher described photographic clues— images from the St. Anthony elevators—in her long, third-person account, and excerpted additional textual clues directly from the novel. Both resonate with a reconstruction of the *Diamond* case along biopolitical lines and amplify thresholds

[141] Ultimately, the dissent argued that the decision on Chakrabarty's bacterium fell far outside the purview of the court and should be addressed by Congress.

[142] When *Diamond v. Chakrabarty* reached the Supreme Court in 1980, 101 read as follows: "Whoever invests or discovers any new and useful process, machine, manufacture, or composition of matter, or any new and useful improvement thereof, may obtain a patent therefore, subject to the conditions and requirements of this title."

[143] The dissent, signed by Brennan, White, Marshall, and Powell, stated that Congress is better equipped to "resolve the complex social, economic, and scientific questions frequently involved in [extending the scope of patent law]." Both the majority and dissent agreed that any changes to 101 would require "the kind of investigation that legislative bodies can provide but courts cannot."

[144] Daniel J. Kevles, "Ananda Chakrabarty Wins a Patent: Biotechnology, Law, and Society," *Historical Studies in the Physical and Biological Sciences* 25, part 1 (1994): 111–35.

[145] Jasanoff, "Taking Life," 179.

and fantasies that make up the life of *Living Sound*'s hybrid enterprise. Here, Amacher quotes Stapledon's prose:

> cultures enduring sometimes for several thousand years, which were predominantly musical......The third species was peculiarly developed in hearing and in emotional sensitivity to sound and rhythm. Consequently......the third men themselves were many times undone by their own interest in biological control, so now and again, it was their musical gift that hypnotized them.[146]

With exaggerated six-point ellipses, she creates textual fragments that present fictive musical and biotechnological epochs in alternation. Stapledon (1886–1959) was Professor of Philosophy at the University of Liverpool between 1925 and 1950, and his speculative fiction extrapolated political futures through the Cold War ideological clashes that he experienced during his lifetime.[147] *Last and First Men* was his first novel; it was followed by three more, including the sequel, *Last Men in London* (1932). Though favorably received by British middlebrow literary circles and vaunted by H. G. Wells and later Arthur C. Clarke, *Last and First Men* remains a difficult read.[148] Leslie Fiedler calls it a "dismal catalogue of failed political predictions" that trades in Victorian racial tropes tied to equatorial regions and northern latitudes.[149] The book excoriates US mass culture and satirizes a British political economy staked on "hoarding and the gold-standard," ceaselessly iterating the perils of industrialization, worker exploitation, and resource extraction.[150] Stapledon embraced anti-bourgeois and anti-capitalist positions, but remained skeptical of "complacency and materialism" in the English Labor Movement and his fictional workers' utopias centered spiritual and artistic priorities in unabashedly organicist terms.[151] A close look at the excerpts Amacher employed as clues reveals precisely one such a moment, which teeters, in the novel, between vital

[146] Maryanne Amacher, *Living Sound (Patent Pending)*, 7.

[147] Andy Sawyer, "Olaf Stapledon," https://www.liverpool.ac.uk/philosophy/olaf-stapledon/, accessed November 18, 2020.

[148] For an account of literary circles in which Stapledon was especially appreciated, please see Clive E. Hill, "The Evolution of the Masculine Middlebrow: Gissing, Bennett and Priestly," in *The Masculine Middlebrow, 1880–1950: What Mr. Miniver Read*, ed. Kate MacDonald (London: Palgrave MacMillan, 2011), 38–55.

[149] See Stapledon, 10–96. For a counterargument, please see Andy Sawyer, "Who Speaks Science Fiction?," in *Speaking Science Fiction*, ed. Andy Sawyer and David Seed (Liverpool: Liverpool University Press, 2000), 1–5.

[150] Robert Casillo, "Olaf Stapledon and John Ruskin," *Science Fiction Studies* 9, no. 3 (November 1982): 308.

[151] Casillo, "Olaf Stapledon," 307. See also Justin Armstrong, "Archaeologies of the Future: Review," *Politics and Culture* 2 (2006), https://politicsandculture.org/2009/10/02/justin-armstrong-archaeologies-of-the-future/, accessed April 14, 2020.

art, industrial instrumentalization and biopolitical control.[152] In a book that chronicles successive generations in epochal time, these clues highlight the Last Man's descriptions of the Third and Fourth Men.

"You cannot believe it," the Last Man tells the reader. A future intelligence conveys the story in backward projection from two billion years in the future to an unknowing and unnamed twentieth-century author who committed it to paper, believing that he concocted an original work of fiction. "This book has two authors," the Last Man instructs readers, "one contemporary with its readers and the other an inhabitant of an age which they would call the distant future."[153] The book turns on this conceit. In an homage to H. G. Wells's experiments with astronomical magnitudes, the Last Man pleads with the reader to accept an omniscient perspective on earth-bound life that scales between groups and individuals with chilling ease: "Do but entertain . . . the ideas that the thought and will of individuals may intrude, rarely and with difficulty, into the mental processes of some of your contemporaries."[154] Though the narrator's cool tone evokes a feeling of narrative stability, the book founders on incomplete episodes whose temporal magnitudes serve little diegetic purpose. Amid the narrator's "insistence on omniscience as antithetical to narrative art," science fiction critic John Huntington puts it, "an underlying vacuum makes itself felt." As he elaborates, "I am not saying that the problem is the unreality of the future; the issue is much more intrinsically narrative than that. The fiction of the Last Man's comprehension deprives the real of its specific and individual weight and interest."[155] Like technoscientific dreams of "infinite vision," as Haraway put it, omniscience collapses under the explanatory power with which Stapledon vests it in a text that often feels, "as though it were built on nothing."[156]

[152] Stapledon introduces successive humanoid types using a narrative formula that recapitulates normative developmental frameworks—birth, growth, maturity, and decline unto death—at the level of the individual, the group, society, species, and also between successive species as the book leaps through time in ten thousand year units. Stapledon casts each epoch's devolution as a consequence of its social success and entropic cycles recur relentlessly through the text, creating what Fredric Jameson calls a tone of "satisfied fatalism."

[153] Stapledon, *Last and First*, 7.

[154] Ibid., 7.

[155] John Huntington, "Remembrance of Things to Come: Narrative Technique in *Last and First Men*," *Science Fiction Studies* 9, no. 3 (November 1982): 263.

[156] Ibid., 263. By asking the reader to accept this combination of telepathy and textualization, the Last Man sets their mediations outside the text. Despite referencing the human scribe who has ostensibly penned the book, this writing never makes itself felt, in the diegesis. Unreliable mediations haunt the text. Has the Last Man been lying about the second author all along? Has the second author caught on to the fact of the Last Man's telepathic transmission? Has the second author become lost in the transmission and fused his voice with that of the Last Man? While Stapledon evokes a literary tradition that gives special narrative treatment to telepathic connections across temporal, biological, or linguistic difference, that narrative becomes vacuous and unreliable, in turns.

However, these fault lines make good fodder for dramaturgical interven-
tion. *Living Sound*'s clues fill this narrative "vacuum" with sounds, characters,
and processes that weave Stapledon's fragments into a walk-in narrative, flout-
ing his insistence that the story is pitched beyond a human reader's capacity to
reason by analogy with her own historical moment. Amacher's excerpts sketch
entropic cycles that, in the book's tenth chapter, interweave sensual aurality
and possessive haptocentrism. The Third Men embody a ferocious dualism that
plays out anthropomorphic projections of hearing and ear morphology along-
side a co-constitutive infatuation with living things, which becomes the basis of
what Stapledon calls "the vital arts"—the Third Men's fascination with relation-
ships between life forms that gives rise to competing vitalisms. Stapledon casts
the Third Men's social antagonisms as an extrapolation of their "semic" material
and takes an aesthetic and sometimes prurient pleasure in their alien morphol-
ogy. Feeling, communication, and spatial apprehension are relocated from the
eyes to the ears which were, for the Third Men, "expressive both of temperament
and passing mood." "[Their ears] were," the Last Man continues, "immense, deli-
cately involuted, of a silken texture and very mobile."[157] To the ear's concentrated
expressivity, Stapledon adds "great and lean," tool-like hands with "six versatile
fingers" and on their heads "six antennae of living steel."[158] These haptic senses
pair hands-on manipulation and touch at a distance, merging sensitive hearing
with mediumistic strivings that brings about the Third Men's destruction at the
hands of the Fourth. Hoary are the entropic cycles that unfold in the chapter
that follows. A first epoch centers on horticulture and animal husbandry, mov-
ing toward biological intervention at the level of what Stapledon called the "germ
plasm"—a nineteenth-century term that wrongly associated hereditary material
with gametes alone. Practicing what the Last Man calls "perfection by the hands"
becomes, for the Third Men, a path toward the fractious worship of life as a kind of
vital plasticity. Wars ensue. One side defends interspecies sympathy as the ethical
and epistemic basis for biological insight while the other exalts psychic and senso-
rial intensification from detached, god-like perspectives.

 Living Sound's clues do not quote the difficult stretches of prose that chronicle
these conflicts. Instead, Amacher chose excerpts that reproach the Third Men and
describe a second entropic decline that involves music and the ears.[159] Music did
not so much replace these dubious vitalisms as establish as a proxy through which
they could be elaborated apart from biological intervention—at least for a time.

[157] Stapledon, *Last and First*, 145. He continues, "Hearing was so developed that a man could run
through a wooded country blindfolded without colliding with the trees. Moreover the great range of
sounds and rhythms had acquired an extremely subtle gamut of emotional significance. Music was
therefore one of the main preoccupations of this species."

[158] Ibid., 145.

[159] Ibid., 149. In Stapledon's words, "so intense was their experience of [music], that they were ready
to regard it as in some manner the underlying reality of all things [and] they would seem to themselves
to be possessed by the living presence of music."

The Third Men pursued an organicist "spontaneous musical expression" within which new factions take root. A clunky religious analogy introduces the schismatic improvising prophet "God's Big Noise"—a name that Amacher also used for *MSS* and *MSJR* characters—imprisoned by the Holy Empire of Music, who exercised exegetical control over his teachings and practices for thousands of years. In this musical theocracy, fringe groups returned to biological intervention to create new composers, singers, and listeners with murderous designs all their own. As the Third Men's musical fascinations return to the hideous practice of "perfection with the hand," Stapledon's prose conveys a cool determinism.

"We need not watch the stages," the Last Man inveighs, through which the Third Men tamped down sadistic factionalism and introduced "orthodox principles" and "co-operative enterprise," which regulated and democratized the vital arts. Practiced, in some form, by nearly everyone, such arts "filled new niches" with "types of every order, from the most humble bacteria."[160] A brief respite from the narration's icy tone, these passages describe cooperative and interwoven ecologies in the vital arts with imagistic richness.[161] For this short utopian interval, the vital arts are practiced without competition, secrecy, or proprietary claims. Aesthetic pleasure gives rise to both a social organization that values interspecies parity—even mutual admiration—and unalienated labor.[162] Enter the Fourth Men. Alternating musical and biological periods soon pointed toward a synthesis in mediumship prefigured in the Third Men's sensory makeup. Some Third Men sought to increase mediumistic powers in all individuals, but a small group attempted to channel "the whole vitality of the organism into [. . .] brain-building,"[163] working in secret before their programs were adopted as official policy. Using telepathic debris, the Third Men created "Great Brains" so massive that giant concrete turrets had to be built to house them. The Fourth Men carry out hideous experiments on the Third Men, which yield the simian Fifth Men and initiate subsequent epochs of artificial life whose vanishing point will be the Last Man. The Fourth Men's turrets appear among *Living Sound*'s clues, as Amacher description explained:

[160] Ibid., 152–53. The Last Man marvels at a "vast system of botanical gardens and zoological gardens, interspersed with agriculture and industry" reminiscent of *fin de siècle* world's fairs, complete with juried exhibits of "improved grains, vegetables, cattle, herdsman's dogs or a new micro-organism with some special function in agriculture and digestion."

[161] This section works within a traditional elemental frame that arranges living things in relation to air, water, earth, and fire, and sketches a mutual admiration between humans, domesticated creatures, and other animals.

[162] Fredric Jameson, *Archaeologies of the Future: The Desire Called Utopia and Other Science Fiction* (London: Verso, 2005), 127–30.

[163] Stapledon, *Last and First*, 167.

The "HALLWAYS" exhibited photographs for a proposed sound instal-
lation in sixteen 100-foot-tall grain towers. (These corresponded to
Stapledon's "housing" for the "great brains," created by the "Third Men.")

The so-called Home Laboratory rearranges Stapledon's chronicle in suggestive ways.
While Amacher's excerpt calls attention to Third Men's damnable impetus toward
biological control, the walk-in scene combines musical and biotechnological contexts
that, in the novel, Stapledon presents as distinct and successive entropic cycles. This
textual palimpsest combines the Third Men's most utopic stretches with their most
destructive. Taking these particular clues seriously as, also, diegetic conceits means
imagining that *Living Sound* is some version of Third Men's story—perhaps near the
cusp of a being "undone" by their vitalist thrall, but perhaps also poised to open onto
a utopian scene that lies beyond the scope of Stapledon's text.

The Third Men's final (and most stable) interval, with horticulture and animal
husbandry, moves Stapledon's stubborn organicism into a historical and biopo-
litical frame. Passed in the United States in the same year *Last and First Men* was
published, the 1930 Plant Patent Act was central among *Diamond v. Chakrabarty*'s
precedents.[164] When Chakrabarty filed his application, patents for biological mate-
rial were typically managed using what had been known since 1889 as the "prod-
uct of nature rule."[165] It distinguished techniques for modifying natural products
from the discovery of those products in the first place—which, in the end, did not
protect the commons so much as encourage future extraction.[166] Prior to 1930,
the rule had also barred patents on asexually reproduced plants because at that
time, as Kevles explains, asexual cultivars could not be reliably determined to
have descended from an invented combination or to reproduce "true to type."[167]
By the 1930s, however, new descriptive practices enabled more consistent deter-
minations, which could be "disclosed specifically enough to be identically repro-
ducible."[168] Plants' asexual reproductivity now aligned with descriptive norms
under which the "product of nature rule" could distinguish what in them could be

[164] Daniel J. Kevles, "Patents, Protections, and Privileges: The Establishment of Intellectual Property
in Animals and Plants," *Isis* 98, no. 2 (June 2007): 323–31.

[165] The precedent involved two patent applications: one for a process of extracting a fiber from pine
needles and a second for the pine needle itself. The US Commissioner of Patents granted a patent for
the former but not for the latter.

[166] For a feminist account of copyright that prioritizes the commons please see Margaret Chon,
"Postmodern 'Progress': Reconsidering the Copyright and Patent Power," *DePaul Law Review* 43
(1993). As the Product of Nature Rule reads, "merely determining the composition of trees in the for-
est was not a patentable invention any more than to find a new gem of jewel in the earth would entitle
the discoverer to patent all gems which should be subsequently found."

[167] Kevles, "Chakrabarty Wins," 112. See also Glenn E. Burgos and Daniel J. Kevles, "Plants as
Intellectual Property: American Practice, Law, and Policy in World Context," *Osiris* 7 (1992): 82–83.
Patent law required that "an invention be disclosed specifically enough to be identically reproducible."

[168] Kevles, "Chakrabarty Wins," 112.

made "dynamic" and "commercially value-laden."[169] The Plant Patent Act of 1930 enshrined a coupling of "description with control," which enabled horticultural professionals—as well as amateurs—to define their inventions and thus "enforce their rights" in them.[170] The Act came through a Depression-era Republican Congress, which billed patents for asexually reproduced plants as a kind of Farm Aid and aimed to roll back government assistance by incentivizing entrepreneurial individuals to bring proprietary plants and seeds to market.[171] The legislation thereby created a new kind of patent-holding personage—the "discoverer-inventor"— who embodied increasingly porous relationships between products of nature, commercial value and proprietary knowledge.[172] Within this figure, the passage from "steward of nature" to "author of nature" could be foreshortened, if not rendered entirely indistinct.[173]

In *Diamond v. Chakrabarty*, the Patent and Trademark Office invoked the 1930 Plant Patent Act and the 1970 Plant Variety Protection Act as historical evidence that Congress had responded to challenges to 101 and the product of nature rule with new legislation—and newer things, like micro-organisms, should be handled no differently.[174] But a Republican majority saw no reason to delay: "innovation would win out," as Burger wrote in the 5–4 decision, which sidelined legislative prerogatives and issued the swift decision that would accelerate venture capital investments in high-risk biotech startups.[175] "The fact that Chakrabarty's bacterium was alive has no bearing on the application of 101," Burger wrote.[176] In the decision, Burger uses 101 to grant the patent to a living organism but suspends the law's ability to recognize the organism as precisely living.[177] Writing for the majority, the opinion casts life into a zone of indistinction: 101's putative indifference to contested constitutive frameworks for life positioned those frameworks at once inside and outside 101's prerogatives. This point, here, is not to decry a

[169] Jasanoff, "Taking Life," 180.

[170] Haraway, *Modest_Witness*, 88.

[171] Cary Fowler, "The Plant Patent Act of 1930: A Sociological History of its Creation," *Journal of the Patent and Trademark Office Society* 9 (September 2000): 634. As developments in biological specificity carried agricultural imperialism across the United States and the Caribbean basin, descriptive technologies underpinned the diffusion of new varieties as well as control of the plants themselves. See also Burgos and Kevles, "Plants as Intellectual Property."

[172] See Kevles, "Patents," 330 and Burgos and Kevles, "Plants as Intellectual Property," 82.

[173] Haraway, *Modest_Witness*, 90. Quoting the Act, Fowler also underscores, "The Plant Patent Act offered rights to anyone who, 'has invented *or discovered* and asexually reproduced any distinct and new variety of plant'" (Fowler's emphasis). Fowler, "The Plant Patent Act," 641.

[174] As far as the PTO was concerned, chemists and plant-originators made the same kind of things: new compositions of matter: "the part played by the plant originator in the development of new plants and the part played by the chemist in the development of new compositions of matter."

[175] *Diamond v. Chakrabarty*, 447 U.S. 303 (1980).

[176] *Diamond v. Chakrabarty*, 447 U.S. 303 (1980).

[177] Burger's majority opinion makes explicit what the case's precedents had long assumed: "a living organism is not always a natural product." See Kevles, "Chakrabarty Wins," 112.

juridical intervention on some Edenic notion of life itself. Instead, the decision recapitulates what Foucault calls a paradigmatic double movement in biopolitics. Life must be sought, throughout this story, "in the dual position [...] that placed it at the same time outside history, in its biological environment and inside human historicity, penetrated by the latter's techniques of knowledge and power."[178] The redoubling lies at the crux of how, for example, Rodgers hears "life" in a sound as at the same time "biopolitics" in a sound.

"Imagine my surprise when the Supreme Court 'responded' with an after-sound!" Amacher remarked, employing her own compositional term to create a wild connection to *Living Sound*. Amacher used "aftersound" to describe a thresh-old between audible and remembered sound which could be ornamented with new sounds that protracted liminal ways of hearing. Imagine *Diamond v. Chakrabarty* as a comparably uncertain entwinement that extends *Living Sound*'s fictive world and retrospectively imbues it with historical import. Clues drawn from the Third and Fourth Men give credence to a reading that would indict *Diamond* as a tech-nology of "biological control" as well as an alternative version with utopian allu-sions that eschewed proprietary knowledge.[179] The walk-in format suggests many incursions along these lines, not least the rogue scientist whose ad hoc opera-tion attempted to wrest interaural experience from specialists and move it across other figurations.[180] Amacher's remark that the case "responded" to her piece sug-gests an epic counterfactual fantasy.

Acoustical Research as Dramatic Form in Amacher's Other Laboratories

> It was as if the [eartone] responses belonged to the bodies of sci-
> entists only and were not what other bodies were made of.
> ——Maryanne Amacher, *Intelligent Life*

[178] Michel Foucault, *Security, Territory, Population: Lectures at the Collége de France, 1977–1978*, trans. Graham Burchell, ed. Michel Senellart (New York: Picador, 2007).

[179] As Melinda Cooper chronicles, the court's decision in *Diamond* also spurred policy initiatives that routed federal support away from public health and instead into biotechnological research. Cooper, *Surplus*, 28–29.

[180] Laboratory-oriented sound studies often dramatizes similar questions. Historian Cyrus Mody seeks to denaturalize how specialized meanings of laboratory sound become part of experts' pre-reflective embodiments. To coax specialists to hear sound's epistemic functions anew, Mody sug-gests a Cagean experiment with detached self-observation modeled on 4'33". Cyrus Mody, "The Sounds of Science: Listening to Laboratory Practice," *Science, Technology & Human Values* 30, no. 2 (Spring 2015): 186. Consider also Ernst Karel's *Heard Laboratories*, which offers unprocessed, long-take recordings from research environments at Harvard University. Karel provides written notes for each edit point, making explicit the chasms that separate listening from "technical meanings" that the recording also indexes. Ernst Karel, *Heard Laboratories*, AND /OAR, ANDO35, 2010, compact disc. Noting that this didactic gambit succeeds to the extent that it also dramatizes its partial failure, one

Clues indicate little about where *Living Sound*'s HOME LABORATORY came from or who was in charge. In popular press reporting on *Diamond v. Chakrabarty*, Chakrabarty's lab is often narrated as a site of free, unalienated work where a young, eager researcher worked tirelessly on a long-term passion project after hours and without any obvious reward in the offing.[181] Other tellings linger condescendingly on Chakrabarty's unfamiliarity with US patent procedures, casting his eagerness to present research findings without proprietary bulwarks in place in imperial and paternalistic terms. *Living Sound*'s do-it-yourself laboratory environment staged in the hilltop mansion—still redolent with Davies social and cultural prestige—perhaps seems funny, quixotic, or terrifying, in turns. While laboratory scenes can court an uncritical sense of awe, this one left many suggestive holes in its picture and hits upon contradictory sensibilities, somewhere between hobbyist play, semi-public demonstration and semi-private pet project.

Though *Living Sound* coincided with a burgeoning 1980s feminist science studies, tactical art practices that dealt explicitly with proprietary biotechnological knowledge cohered about a half decade later. Beatriz da Costa traces their emergence in the United States to media art practices that, throughout the 1970s and 1980s, had progressively enfolded computer science and engineering into its toolkit.[182] The use of microorganisms became one of its main areas and took a wide range of forms.[183] By 1990, for example, "painting with bacteria" involved metabolisms that produced colored pigment and controlled cell growth on paper.[184] As da Costa points out, such projects easily blended into admiration for technoscientific power or formalized pathways for commercial research.[185] In 1986, artist Joe Davis and geneticist Dana Boyd inserted into *E. coli* a synthetic plasmid coded with a graphic icon and declared the result—which they called "Microvenus"—to

reviewer noted that "[t]he perception that science is too difficult for anyone other than a specialist to understand is socially ingrained in those separated from the discipline on an everyday life basis. The walls of the division of technical labor seem unbreachable." www.thewire.co.uk/articles/7828/, accessed November 1, 2015.

[181] Smith, "Mr. Pseudomonas."

[182] Beatriz da Costa, "Reaching the Limit: When Art Becomes Science," in *Tactical Biopolitics: Art, Activism, and Technoscience*, ed. Beatriz da Costa and Kavita Philip (Cambridge, MA: MIT Press, 2008), 367–70.

[183] She traces this sensibility to computer hobbyist magazines, from the 1970s, bulwarked by programmers' new roles in biotechnology research. "From the culturing of naturally occurring bacteria and fungi, through the use of bacterial products," SymbioticA's public lab reminds, "working with these organisms [. . .] can be performed in non specialist environments using easily obtained and off the shelf items."

[184] Ali K. Yetisen, Joe Davis, Ahmet F. Coskun, George M. Church, and Seok Hyun Yun, "Bioart: Trends in Biotechnology," *Trends in Biotechnology* 33, no. 2 (2015): 724–34. Installation artist Armando de la Torre called my attention to this source via the reading list for the Art+Bio Collaborative's CULTIVO Field Residency Program in summer 2019. See http://www.artbiocultivo.org/, accessed April 6, 2021.

[185] da Costa, "Reaching the Limit," 373.

be the first artwork created using techniques of molecular biology.[186] Enthralled by astrobiology, the pair had attempted to design radar transmissions but, amid technical and institutional complications, turned instead toward message-delivery via biological carriers.[187]

But rather than pursue expert status, da Costa recommended that artists turn to hobbyism and do-it-yourself approaches to scientific experiment.[188] Similarly, Amacher often decried the term "psychoacoustics" for the specialist barriers of entry it implied: "as though [response tones] belonged to the bodies of scientists alone and were not what other bodies were made of."[189] *Living Sound* had, indeed, materialized eartones in and as wild relations: sounding among "other bodies" also involved figurations with fantastical access points, between cells, violins, orchestras, law, and omniscient aliens. All of this catches critical demands at work in Amacher's commitment to composing for the auditory pathway. What knowledges create and uphold auditory thresholds? How do those thresholds move between social locations? How are they popularized, naturalized, or mined for profit? How are they absorbed or figured in others' stories, myths, or dreams?[190]

Living Sound was not the only fictive laboratory environment that Amacher created. The first episode in her media opera *Intelligent Life* (1979–1981) culminates in an exuberant tour of the fictional Supreme Connections research laboratories and throughout the episode, Amacher delights in dramatizing science-in-the-making with powerful gestures that open the laboratory to public investigation. The opera takes place in 2021, which, as Amacher highlights, is the bicentennial of Hermann von Helmholtz's birth. Over the course of nine, thirty-minute episodes, the media opera chronicles the music research and entertainment company Supreme Connections LLC through its main personages and their ongoing projects. In the first episode, we meet Aplisa Kandel, Supreme Connections' president, and Ty Choline, a lead investigator on one of the company's major projects. As she had done in *MSJR*, *MSS*, and even earlier, in *Saga*, Amacher structured *Intelligent*

[186] Yetisen et al., "Bioart," 725.

[187] Ibid. For this purpose, the cell became little more than a vehicle for information that could be nothing but indifferent to its material substrate.

[188] da Costa, "Reaching the Limit," 376. The collective Critical Art Ensemble (CAE) channeled exhibitions and performances toward civil disobedience, focused on GMO agriculture, the Human Genome Project, reproductive technologies, genetic screening, and biological warfare. As Yetisen et al. explain, "CAE member Steve Kurtz was detained by policy for suspected bioterrorist activity when three kinds of microorganisms were found in his residence." See Yetisen et al., "Bioart," 730.

[189] Amacher, *Intelligent Life*, "Treatment," 24.

[190] For a study that explicitly centers themes of "biophilia" and "biotechnophilia," please see Lauren Flood, "Building and Becoming: DIY Music Technology in New York and Berlin" (Ph.D. diss., Columbia University, 2016) and especially the chapter "The Aesthetic Virus: Experimental Instrument Building as Biophilia and Citizen Science." Although themes of virality and contagion are not exactly central to *Living Sound*, Flood's focus on "biophilia" is apt for interpreting projects that insist on making living systems legible and sensible by implicating them in aesthetic, juridical, and speculative registers of analysis.

Life around ways in which, in this case, in-home viewers would "enter the world of the story." This meant, in an important way, not just understanding or following Aplisa and Ty's research-centric conversations, but experiencing research, as the characters did. As she explains:

> The audience is able to experience the vivid sound world with the characters AS THEY CREATE THEM. In conventional television, audiences would only hear about them as the story "talked" about them.
>
> An enveloping, magical architecture in the home is created. The room becomes many new kinds of places. The result from the specific interplay composes between the TV image, TV sound and FM stereo sound. A completely new kind of theatrical experience is SHAPED, one that can not be created for stage production, movie theaters, conventional simulcast radio-TV or TV alone.[191]

By designing *Intelligent Life* for television broadcast and a second FM stereo transmission via radio or an FM channel like the one Amacher had planned to use, in *Saga*, Amacher sought a new kind of home theater environment that could enfold her audience into the diegesis—they would experience the characters' sound worlds "as they create them."[192] Episode one explicates how Supreme Connections came into being. For years, Variation Maker Scripts had gotten better and better at composing in the styles of Johann Sebastian Bach, Wolfgang Amadeus Mozart, Steve Reich, and others.[193] To these computational scripts, composing meant organizing notes and recombining sound structures. Their music was everywhere and left nothing up to the situated standpoints of listening bodies who heard it. Until listeners abandoned Warner Brothers for Supreme Connections, there simply were no neural dances, no interaural melodies, no layered perceptual geographies, nor virtual meetings in interaural space.[194] Amacher provided this further background:

> The Old Warner Brothers, and a number of other companies of this kind have totally collapsed because they did not anticipate the power of NEW SONG and the consequent demands of the increasingly conscious listener. They continue to produce their silicon pattern developers without taking into account the CREATIVE RANGE OF MUSIC SENSITIVITY or the BIOCHEMICAL EFFECTS OF THIS MUSIC. Their

[191] Amacher, *Intelligent Life*, "Theater in the Home," 7.

[192] Ibid.

[193] For an account in which Amacher imagines the applications of these technologies to her own music, please see her lecture at Ars Electronica, 1989.

[194] Amacher also reused "the way out of Diaspar" to describe Supreme Connections' break with this older entertainment industrial complex.

securities were completely tied up in 1st Order Artificial Intelligence products—such as Pattern Variation Developers.[195]

Supreme Connections restored music to its listeners by way of original and highly situated events of sound and listening. Specialized playback systems tracked and ornamented listeners' eartones in real time. Programs reconstructed what historical idioms would sound like in the ocean or to non-human animals. Enchanted architectures of customizable audio popped up in cars, homes, and city environments. Old, endless-duration sound installations based on fixed media playback were finally slated for remediation.

Most of episode one takes place in Aplisa's car. During the drive, she and Ty troubleshoot their recent projects and create music for Ty's eartones using a custom car stereo console designed by Aplisa. Their exchanges are dense and technical but the pair's romantic and professional rapport imbues the scene with a gentle relatability. This scene eschews plot-driven action in favor of information delivery. Viewers learn about Supreme Connection's past and present and, via Aplisa's console demonstration, experience their own eartone responses as also part of the diegesis. The point, in this first episode, is not to set a long-range plot into motion per se—though without comparably detailed treatments for subsequent episodes, this is hard to assess—but to establish experiential involvements, for the at-home viewer, as the pair prepares to arrive at the lab. For example, when Aplisa creates eartone enhancements for Ty, as depicted on the storyboard shown in Fig. 5.14, she also ornaments the listener's eartones, which they experience as both Ty's and their own. In yet another way to "enter the story," the listener becomes momentarily also an onscreen character via their inner ear.

Throughout her 1980s writings about *Intelligent Life*, *MSS*, and *MSJR*, Amacher identified popular media formats as key generic supports for introducing listeners to new sound experiences. "I wanted the kind of engaging format television had developed," she writes, with all the "ready made mind stuff . . . as a form, the Mini Series is powerful and challenging, yet up to now, only television develops it."[196] As a narrative format and commercial product, the TV miniseries' peak spanned the 1980s. Studios channeled tens of millions of dollars into productions based on US-centered historical epics (*The Winds of War*), science fiction (*V*), romances (*Lace*), and orientalist fare (*Shōgun*), billing their run of episodes as unmissable television events with high production values and richly emotive content. It is not hard to imagine *Intelligent Life* as such an event. Amacher also looked to older genres that had created commercially successful entertainment by dramatizing work environments and technical demonstrations. Amacher, at times, likened *Intelligent Life* to an "old Hollywood musical," invoking the 1930s backstage

[195] Amacher, *Intelligent Life*, "Background to the Intrigue."
[196] Maryanne Amacher, Working Notes for Mini Sound Series.

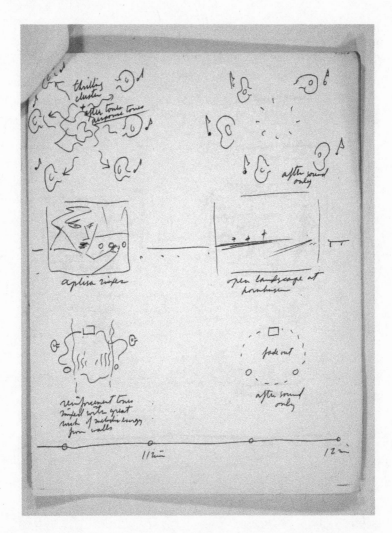

Figure 5.14 Intelligent Life's three-part storyboard, or "Sound Treatment." A timeline runs across the bottom of the page and three components of the drama appear along the left-hand side: "theme," "action," and sound. The "sound" panel reveals how audio will be distributed via TV and radio speakers in the simulcast. The "action" panel details what will appear on the TV screen and "theme" summarizes the auditory experiences and concepts that at-home viewers are to experience as also those of the onscreen personages. Note the little ears, that represent Ty's eartones and Aplisa's gaze toward the in-home audience during this eartone-focused segment. This part of the treatment is not penned in Amacher's handwriting and the artist is currently unknown. Courtesy of the Maryanne Amacher Foundation.

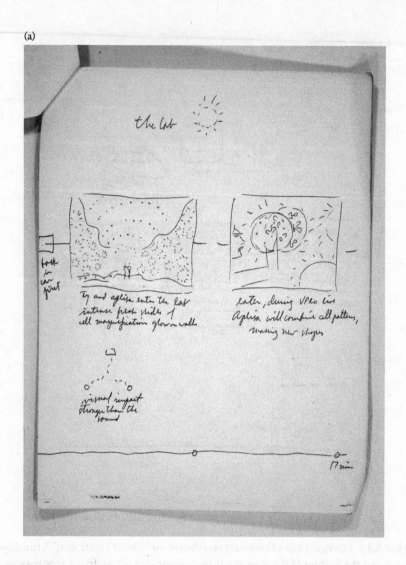

(b)

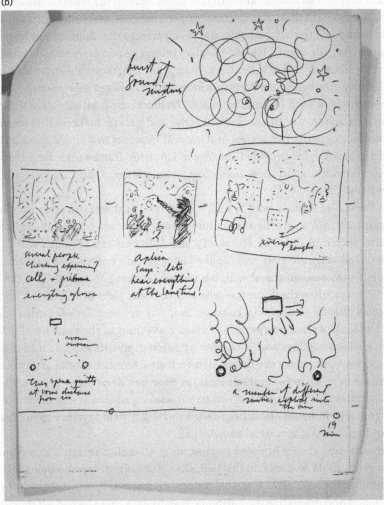

Figures 5.15a and 5.15b On these pages, Aplisa approaches glowing cell growth and asks everyone in the lab to turn on all audio technology at once, creating a "theme" that involves a "burst of sound mixtures" and sends myriad musics into the air," (or x-space) according to the storyboard's "sound" panel. In the perceptual geographic terms germane to her *Additional Tones Workbook, Intelligent Life* takes place across x-space as well as y- and z-space, as evidenced in Fig. 5.14. Courtesy of the Maryanne Amacher Foundation.

musical that stoked fascination with fast-paced work in the entertainment industry in stories that followed musicians, singers, dancers, and other entertainment workers into auditions, rehearsals, and performances that doubled as spectacular on-screen diegetic events. Her media opera intervened on more straightforwardly didactic genres, as well. 1950s science education programming embedded novel explanatory strategies into narrative forms that conveyed new scientific knowledge as, itself, a kind of entertainment. Technical explanations were delivered in bite-sized chunks with novel visual styles and generic markers that convened animation, puppetry, live action, and musical numbers in a single episode. Both mediatic genealogies provided *Intelligent Life* with frameworks for sense and experience within which new technological knowledge could take relatable narrative form.[197]

At the end of episode one, Ty and Aplisa arrive at their laboratory. In silence, the pair walk into a cavernous structure, its walls covered in petri dishes, as the sketches shown in Fig. 5.15 reveals. Ty and Aplisa enter a lab filled with "fresh slides of cell magnification" but, unlike *Living Sound*'s unattended *mise-en-scène*, viewers would see, on the screen, lab staffers working at monitors in the cell-covered room; they check on the cells and the cells glow in response.[198] Sound is applied directly to microbial cultures, as it was in *Living Sound*'s fictive laboratory. Suddenly, Aplisa interjects: "Let's hear everything at the same time!" With a laugh, everyone obliges and "a number of different musics explode into the air." This moment prioritizes the fictive high-tech environment's social and experiential forms over narrative emplotments, as *Saga* had done a few years earlier. It demonstrates that, at Supreme Connection, making science is making music and both converge in moments of heightened sociability held together by an exuberant joy in producing acoustical knowledge.

Amacher was clearly invested in presenting acoustical research as a dramatic music genre all its own and, to this end, she never quite stopped moving interaural sound across new, often unstable conceptual ground. Ty and Aplisa, for example, inhabit and dramatize the epistemic standpoints that she had established in the *Additional Tones Workbook*: one generates eartone that the other figures out how to enhance; together, they debate unfinished projects; they align historical precedents and genealogies with speculative approaches to public media interactivity; they enfold attention to one another's auditory thresholds into romantic love; they inhabit a speculative world in which the music that Amacher wanted "to become popular," actually did become "popular" within a new kind of media industrial complex. Like *Living Sound*, this version of *Intelligent Life* extended

[197] For more, in particular, on the intersections between the science programming and Hollywood musical, please see Amy Cimini, "In Your Head: Notes on Maryanne Amacher's Intelligent Life," *The Opera Quarterly* 33, nos. 3–4 (Summer–Autumn 2017): 269–302. See also Marcel Chotkowski LaFollette, *Science on American Television: A History* (Chicago: University of Chicago Press, 2013).

[198] Amacher, *Intelligent Life*, "Sound Treatment."

Amacher's research practice into a speculative drama that introduced viewers to the scope, aspect, and modes of access that constituted perceptual geographic knowledge, using clues and plot points that implicated its fictive and historical coordinates in the everyday lives of visitors, viewers, listeners, and characters alike. When the audience "enters the world of the story," their eartones will come through diegetic contexts that also explain the very terms in which those tones can be made meaningful and valuable.

With abandon, this chapter has embraced the fictive worlds that Amacher created in *Living Sound* and *Intelligent Life*. It has suspended disbelief in microbes that metabolize sound and that entangle human and biospheric life in enhanced perceptual geographies. One could, of course, have simply summarized: "Amacher believed that hearing had to be changed at the cellular level."[199] However, such a summary would itself arrive already packed with figurations that structured episodes in the governance of life in Amacher's historical moment, not least *Diamond*'s complex and ambivalent "aftersound." Eartones desire this exposure to other forms of life, but the standpoints that they cohere within the bodies of listeners also call for an ethics of care that traverses mediatic form, narrative strategy, musical canons, research practices, and complex biologies. Such figurations remain also implicated in webs of power and metaphors they could never have controlled; indeed, this had been the impetus for some of this book's wilder juxtapositions. In research, practice, and fiction, Amacher created places for herself and for eartone music where none seemed to exist. Recall the text that, with Haraway, Amacher had begun to write: "I want a music . . ." Continuing with Haraway would have tasked Amacher to write what that music could do: how it "metaphorically emphasizes listening . . ."; from what or who it "reclaims the sense . . ."; how it enables us to "find our way out of visualizing tricks" (and auditory ones, too). The structure-borne dramas ask listeners to undertake these ironic interventions for themselves. To embrace not "hearing of hearing," but exposures and interimplications that transport vital energy within and between bodies. To move something "just in my head" into history and discourse in dialogue with Amacher's own clues. To experience the "listener's music" as a transport into worlds that prompt one to ask anew "where we are and where we are not." To cultivate auditory attachments to a "space we barely know how to name." For all of the principled guesswork that had carried this chapter, it will not include an attempt to fill in the text that Amacher may or may not have written, beginning with "I want a music . . ." Such a demand touches upon a hypothetical situation. If it demands anything in particular, it is to remain in the subjunctive.

[199] Helga de la Motte-Haber, "Perceptual Geographies," https://ima.or.at/en/imafiction/video-portr ait-06-maryanne-amacher/, accessed August 19, 2020. "Amacher was fascinated by biochemical and neurophysiological research," writes Motte-Haber, "New neuronal processes needed to be stimulated."

Afterword: Notes with Ears

> *It's 1937.* Visualize the time. John Cage was twenty-five years old
> when he delivered the lecture "The Future of Music: Credo" in
> Seattle. And consider his birth year, 1912. Women were still wear-
> ing long skirts, and musical activity was dominated (perhaps more
> than today) by unquestioned and habitual patterns. Simulate the
> time, and imagine his presence in it. In the halls of conservatories,
> musicians are practicing eight to ten hours a day, filling the build-
> ing with every kind of possible melodic pattern; composers scrib-
> bling "notes without ears."
>
> In "The Future of Music: Credo," Cage described percussion
> music as a contemporary transition from keyboard-influenced
> music to the "all-sound music of the future." A similar transition is
> occurring now, as we move from concert, CD, and DVD temporally
> based music to media with infinitely greater memory. Instead of
> the availability of all sounds, it is the availability of vast memory
> that will make possible an unprecedented expansion of musical
> time and influence a new course of composition: the "all-time"
> music of the future.
>
> ——Maryanne Amacher on "Cage's Influence"

Although Amacher was talking about Cage in this 2001 panel discussion, this path
toward an "all-time music" could also have been her own. An "all-sound" music
had already come to pass, she argued. But, "all sounds" had always also meant "all
sounds *ongoing all the time*," which remained yet to come. While Amacher trained
her remarks on media formats—like CDs or DVDs or something else with "infi-
nitely greater memory"—an "all-time" music had shimmered across her corpus at
a very early stage. Already in 1966 and 1967, Amacher had moved percussionistic
experiments into critical media practices that prioritized long durations and a
here-ish and there-ish kind of presence, to register the time of ongoing life in the
subjunctive. Her long-term harbor feed had afforded the installation-study *Tone
and Place (Work One)* and elaborated a long distance music that could, between
the subjunctive and the durative present, also remain all the time ongoing. In

Wild Sound. Amy Cimini, Oxford University Press. © Oxford University Press 2022.
DOI: 10.1093/oso/9780190060893.003.0006

her 2001 talk, Amacher conjured Cage's story as much as she told it: *"visualize the time"* and *"simulate the time,"* she exhorted, using terminology germane to her own working methods. These enjoinders recall the walk-in formats, where structure-borne drama generated diegetic simulations that could be experienced, as though one was in another time and place. Imagine, for example, the biographical episodes that she sketched from Cage's life, in 1937 and 1912, staged in *Music for Sound-Joined Rooms* or *Mini Sound Series*: the props, the projections, the sound characters, the interventions across "where sound comes from" that would arrange fictive and factical auditory thresholds in relation to the project's central question: what perceptual geographies will cohere within an "all-time music" of the future in which no one writes "notes without ears"?

Amacher used this phrase often, and frequently to it attached the acid elaboration "pushing around other men's notes." Such a music, in other words, would never allow the more radical implications of the question "where does sound come from" to be constitutive, in its design: no distributed interplay between threshold levels at which auditory structures respond differently to specific frequency structures in time; no extraterrestrial audition; no microbial violins whose orchestras metabolize mid-range frequencies. To compose notes *"with* ears" would not mean taking interaural responses into account in some additive way. Instead, such an effort might accept partial knowledge in the strongest sense; naming "where we are not" touches on biases that structure whatever one might believe a legitimate listener or composer to be, in the first place. In her talk, she staged this provocation within a scene that also wove reproductive musical work on traditional instruments into sardonic remarks on gender, sex, and discipline. Who might be, still, lost among composers scribbling down music so unconcerned with ears that would hear it that it might as well be heard by none at all? Amacher's early twentieth-century conjurations contrast sharply with the speculative world that she had already constructed in *Intelligent Life*: that is, a full-fledged music research program devoted to situated perceptual geographic projects and backed by popular culture, social knowledge, political economy, and mediatic forms. Aplisa is an ebullient researcher, but she is also more than a "jolly good fellow," in *Intelligent Life*'s fictive world. In it, compositional strategies that wove perceptual geographies into ways of listening in continuous time could also intervene on historical divisions of creative and reproductive work along many lines and across music historiography, mediatic environments, compositional practice, and collaborative method. *It's 2021. Visualize the time.*

When I opened Bonnie Spanier's book *Im / Partial Science: Gender Ideology in Molecular Biology* in order to read about Rita Levi-Montalcini, I also found Amacher.[1] In the Acknowledgments, Spanier had thanked her, among the "friends and teachers" at the Bunting Institute who, as she wrote, "enlightened me in ways

[1] Spanier, *Im / Partial*, 54–56.

that still affect me today."[2] About first meeting Amacher in fall 1978, she had this
to say:

> We introduced ourselves and our projects. (I was a scientist who wanted
> to interview women scientists as a way of sharing their science. I was
> very naive and ignorant about feminism and women in science at first.)
> Maryanne came up to me after. Medium-tall, thin-to-scrawny; strag-
> gly blonde hair. In her dry low voice, she said: "you are a biochemist!
> I wanted to be a biochemist!" I was stunned that this musical genius/
> composer loved science. We became friends.[3]

The pair surprised one another. Amacher, eager to meet the biochemist, the
biochemist puzzled by the composer's love for science. For both Amacher and
Spanier, this fellowship was an auspicious interval. The ground was indeed still
settling under Amacher's *Additional Tones* research program and she would
soon give her talk "Psychoacoustic Phenomena" in the Institute's colloquium
series. After completing her doctorate, Spanier started a position in a college
biology department in 1975. Though she had received coveted research grants
at American Lung Institute and National Institutes of Health, she declined
both—and left her tenure-track position—to instead undertake two years of
post-doctoral research at the Bunting Institute.[4] Effectively abdicating labora-
tory work, she embarked on a project that began as a plan to interview women
scientists and grew into an interdisciplinary research program across classical
biology, biochemistry, molecular biology, history, and the social study of science
that deconstructed gender ideology in cell and microbiology. Spanier helped
Amacher move back to New York City at the end of her fellowship in 1979, and
the two remained friends.

"I only glimpsed her take on science," Spanier explained. "Her way of talk-
ing about biology and DNA made me step out of my deep training in 'scientific
objectivity'. Like having a live beetle as a pin. Or thinking about DNA from a cos-
mic viewpoint. Felt liberating, like opening up creativity, to me."[5] Her responses
diverge sharply from the disciplinary intransigence that Amacher highlighted,
so often in a so-called psychoacoustics, that would not "step out" of itself, as
Spanier had done. One might be tempted to attach Spanier's provocations to
Living Sound or *Intelligent Life*. Who might take their fictive scenarios seriously
enough to question concepts of objectivity that barred other knowledges from
scientific inquiry? Though the sets were "make-believe," Amacher said, in 1989,
one might follow Spanier to imagine that, ongoing amid structure-borne project's

[2] Ibid., xi.
[3] Email to the author, September 2020.
[4] Spanier, *Im / Partial Science*, xiii.
[5] Email to the author, September 2020.

undeniable and well-chronicled visceral impacts, was an epistemic drama that troubled how sound and listening could be known and what could be known in and through them, in the first place. How might exhibition and performance practice take this interimplication between structure-borne drama and epistemic drama seriously in order to navigate Amacher's work and practice across other registers of analysis? What the outcomes of such a hybrid approach would be, I do not know.

After a talk in January 2018 that worked through research and interpretations that became Chapter 5 in this book, someone from the audience who knew Amacher well pulled me aside. She told me: "people need to know that she was poor." This I knew, having read and spoken with people who had given accounts of knowing her in existential terms. In this particular context, the caveat gathered up quite a lot. Unpacking *Living Sound* in relation to high-capital technoscience, as I had done in the talk, made it seem as though Amacher had benefitted in material ways from the project's conceptual proximity to those figurations. The complex knowledges cited in her clues had seemed too readily attributable to elite economic positions—not critical sound work—that did not include Amacher. Certainly, the moment of *Living Sound* had biographical significance. Amacher's fellowship at Radcliffe had ended the previous year, and, although Amacher was about to begin an extremely productive period that developed *MSJR* and *MSS*, she would not have another stretch of institutional support comparable to the 1960s and 1970s interval that included fellowships at CAs, CAVS, and Bunting. There are also additional versions. To this end, Spanier added, "she spoke of a lifetime of being ignored and not taken seriously in her work. Of men using her ideas and taking credit. Of men getting prestigious jobs she would not be considered for, despite her giving successful and exciting workshops/classes in those men's courses/circles." Working in the interstices of dominant institutions, knowledge projects, and technoscientific figurations with high-capital needs, as well as at the epistemic edges of barely qualified knowledges, as Amacher had done, can nourish creative work, but also deplete it. This is the contradiction that Tiziana Terranova identifies in a seemingly "free" quality of creative work, that capital does not so much appropriate as both sustain and exhaust. Swept into this contradiction was Amacher, that "jolly good fellow."

This book has not tried to prognosticate what an Amacher studies might become, much less so to inaugurate such a thing. Amacher and her figurations suggest open-ended approaches, and this book has accented how that openness has been emplotted into material traces and other documents, as much by Amacher herself as by others. "She had secrets," wrote Micah Silver in his 2009 "Remembrance." This book did not set out to tell them, or even to seek them out and then decline to share. Instead, it has gathered up a few episodes in her work, and, with the capacious keywords "tense," "life," and "body," crafted interpretive gestures that inhabit them in three registers of analysis: (1) with respect to how Amacher imagined, planned, or carried out some realized and unrealized

projects; (2) with respect to how those projects convoked figurations of life and technoscience that could be partially and ironically accessed or conceptualized via complex perceptual geographies; and (3) with respect to how those modes of access touch upon questions about life in a sound forged in contemporary and historical spaces of biopolitics. This triplication is indeed constructed to move across partial and uneven vantages; that is, to follow Amacher's ethics of narration and juxtaposition, but also to go just a little too far, and end up in another wild figuration. Of this unruly approach, one could say, as Amacher did in 2005, "I just like learning more, because I don't understand this . . ." It seems right to end with another unfinished ventriloquy.

BIBLIOGRAPHY

1. Published Books, Articles, and Interviews

Allen, Jack. "University, Radio Station Beacon of Light Amid Strife." *Beacon Courier Express*, April 19, 1970.

Amacher, Maryanne. "Untitled Program Essay." WBFO Program Guide. Buffalo, NY, 1967. John Cage Collection, Northwestern University Library.

Amacher, Maryanne . "Hearing the Space, Day by Day 'Live.'" *Interventions in Landscape* at the Hayden Gallery, 1973. Walker Art Center Archives.

Amacher, Maryanne. Interview with Norman Pelligrini. In *Maryanne Amacher: Selected Writings*, edited by Amy Cimini and Bill Dietz, 137–46. New York: Blank Forms, 2020.

Amacher, Maryanne. "Hearing the Space, Day by Day, 'Live'" at the Museum of Contemporary Art Chicago, 1974. MCA Archives.

Amacher, Maryanne. "Hearing the Space, Day by Day, 'Live,'" a sound environment prepared for the space of Walker Art Center Auditorium. Walker Art Center, 1974.

Amacher, Maryanne. "Research and Development." The Kitchen, December 1, 1979. Maryanne Amacher Foundation.

Amacher, Maryanne. "Sound Characters for 'Third Ear Music.'" *Sound Characters: Making the Third Ear* (Tzadik 1999).

Amacher, Maryanne. "Thinking of Karlheinz Stockhausen." Artforum 2008, Vol. 46, No. 7. In *Supreme Connections Reader*, edited by Bill Dietz, 219–22. Unpublished. Kingston/Berlin, 2012.

Amacher, Maryanne. "As Told To and Edited by Simone Forti." In *Supreme Connections Reader*, 174–86. Unpublished. Kingston/Berlin, 2012.

Amacher, Maryanne. Interview with Frank Oteri. "Extremities: Maryanne Amacher." *New Music Box*. May 1, 2004. https://nmbx.newmusicusa.org/extremities-maryanne-amacher-in-conversation-with-frank-j-oteri/. Accessed September 7, 2019.

Amacher, Maryanne. Interview with Eliot Handelman. In *Maryanne Amacher: Selected Writings*, edited by Amy Cimini and Bill Dietz, 279–88. New York: Blank Forms, 2020.

Amacher, Maryanne. "Untitled Lecture." In *Eight Lectures on Experimental Music*, edited by Alvin Lucier, 45–58. Middletown, CT: Wesleyan University Press, 2017.

Amacher, Maryanne. "Psychoacoustic Phenomena in Musical Composition: Some Features of a Perceptual Geography." In *Arcana III: Musicians on Music*, edited by John Zorn, 9–24. New York: Hips Road/Tzadik, 2008.

Amacher, Maryanne. Interview with Jeffery Bartone and Gordon Monahan. *Musicworks* 41 (Summer 1988): 4–5.

Amacher, Maryanne. "2011 The Life People: A Four Part Mini-Sound Series for Ars Electronica, Linz." In *Kunstforum Internation* 103 (September–October 1989): 248–54.

Amacher, Maryanne, and La Monte Young. "How Time Passes." *Artforum* 46, no. 2 (March 1, 2008): 312–17.

Appadurai, Arjun. *Archive Public: Performing Archives in Public Art.* Athens: Cube Art Editions, 2012.

Armstrong, Justin. "Archaeologies of the Future: Review." *Politics and Culture* 2 (2006). https://politicsandculture.org/2009/10/02/justin-armstrong-archaeologies-of-the-future/. Accessed April 14, 2020.

Asad, Talal. "Free Speech, Blasphemy, and Secular Criticism." In *Is Critique Secular?: Blasphemy, Injury, and Free Speech,* edited by Talal Asad, Wendy Brown, Judith Butler, and Saba Mahmood, 14–57. New York: Fordham University, 2013.

Atanasoski, Neda, and Kalindi Vora. "Surrogate Humanity: Posthuman Networks and the (Racialized) Obsolescence of Labor." *Catalyst: Feminism, Theory, Technoscience* 1, no. 1 (2016): 1–40.

Atanasoski, Neda, and Kalindi Vora. *Surrogate Humanity: Race, Robots and the Politics of Technological Futures.* Durham, NC: Duke University Press, 2019.

Auner, Joseph. *Music of the Twentieth Century.* Cambridge: Cambridge University Press, 2011.

Bachelard, Gaston. *The Psychoanalysis of Fire.* Translated by Alan C. Ross. Boston: Beacon Press, 1964.

Bailey, William, Thomas Bey, and Barbara Ellison. *Sonic Phantoms: Composition with Auditory Phantasmatic Presence.* London: Bloomsbury, 2020.

Baldinger, W. R., and G. T. Clark. "Physical Design." *The Bell System Technical Journal* 49, no. 10 (December 1970): 2685–709.

Ballard, J. G. "The Sound Sweep." In *The Complete Stories of J. G. Ballard,* 106–36. New York: W.W. Norton, 2009.

Balsamo, Ann. "Digital Humanities Catalyzes Technological Innovation: You'll never Believe What Happened Next." Paper delivered at Creativity, Cognition and Critique: Bridging the Arts and Humanities, a 50th Anniversary Symposium at University of California Irvine, May 21, 2016.

Bastian, Michelle. "Haraway's Lost Cyborg and the Possibilities of Transversalism." *Signs* 31, no. 4 (Summer 2006): 1027–49.

Bayley, SA, DW Morris, and P. Broda. "The Relationship of Degradative and Resistance Plasmids of Pseudomonas Belonging to the Same Incompatibility Group." *Nature* 280, no. 5720 (1979): 338–39.

Beal, Amy C. "'Music is a Universal Right': Musica Elettronica Viva." In *Sound Commitments: Avant Garde Music and the Sixties,* edited by Robert Adlington, 99–120. Oxford: Oxford University Press, 2009.

Berlant, Lauren. *Cruel Optimism.* Durham, NC: Duke University Press, 2014.

Bewley, John. "The Center of the Creative and Performing Arts: Commemorating the Fiftieth Anniversary of Its Founding." University at Buffalo Music Library Exhibit, January–May 2015. https://library.buffalo.edu/exhibitions/pdf/ubmu_pdf_center2015.pdf. Accessed February 10, 2020.

Bishop, Claire. *Radical Museology: Or, What's "Contemporary" in Museums of Contemporary Art.* London: Koenig Books, 2013.

Blakinger, John R. *György Kepes: Undreaming the Bauhaus.* Cambridge: The MIT Press, 2019.

Blodgett, Cameron. "No More Miles." *The Minnesota Daily,* September 1974.

Blom, Ina. "The Touch through Time: Raoul Hausmann, Nam June Paik and the Transmission Technologies of the Avant-Garde." *Leonardo* 34, no. 3 (2001): 209–15.

Boltanski, Luc, and Eve Chiapello. "The New Spirit of Capitalism." *International Journal of Politics, Culture and Society* 8, nos. 3–4 (Spring–Summer 2005): 161–88.

Born, Georgina. "Music Research and Psychoacoustics." In *The Sound Studies Reader,* edited by Jonathan Sterne, 419–26. New York: Routledge, 2012.

Boronin, AM. "Diversity of Pseudomonas Plasmids." *FEMS Microbiology Letters* 100, nos. 1–3 (December 1992): 461–67.

Bower, Anthony. "Friendly 'Third Ear.'" *New York Times,* August 18, 1948, Section BR, 6.

The Boston Harbor Associates, *The Boston Harbor: An Uncertain Future*, edited by Howard Ris. Boston, MA: Boston Harbor Associates, December 1978.

Braidotti, Rosi. "The Politics of 'Life Itself' and New Ways of Dying." In *New Materialism*, edited by Diana Coole and Samantha Frost, 201–20. Durham, NC: Duke, 2012.

Brault, Pascale-Anne, and Michael Naas. "Introduction: To Reckon with the Dead: Jacques Derrida's Politics of Mourning." In *The Work of Mourning*, edited by Jacques Derrida, trans. Brault and Nass, 1–30. Chicago: University of Chicago Press, 2001.

Braxton, Anthony *Composition Notes. Vol. A*. Lebanon, NH: Frog Peak Music, 2009.

Brooks, John. *Telephone: The First Hundred Years*. New York: Harper & Row, 1975.

Bream, Jon. "New Music in the Key of Fun." *Minnesota Star*, June 16, 1980.

Brennan, Teresa. *The Transmission of Affect*. Ithaca, NY: Cornell University Press, 2004.

Brew, Kathy. "Through the Looking Glass." In *Women, Art and Technology*, edited by Judith Malloy, 87–101. Cambridge: MIT Press, 2003.

Browne, Malcolm W. "World's Biggest Accelerator Surges to Life." *The New York Times*, August 8, 1989.

Bruhn, Siglind. *Messaien's Explorations of Love and Death: Musico-Poetic Signification in the "Tristan Trilogy" and Three Related Song Cycles*. Hillsdale, NY: Pendragon, 2008.

Burgos, Glenn E., and Daniel J. Kevles. "Plants as Intellectual Property: American Practice, Law, and Policy in World Context." *Osiris* 7 (1992): 74–104.

Butler, Judith. *Bodies That Matter: On the Discursive Limits of Sex*. New York: Routledge, 1993.

Butrica, Andrew J. *To See the Unseen: A History of Planetary Radar Astronomy*. Washington DC: The NASA History Series, 1996. https://historynasa.gov/SP-4218/ch4.htm. Accessed August 31, 2020.

California College of the Arts Libraries, "Fifty Years Ago, Fifty Years Forward." April 14, 2006. https://libraries.cca.edu/news/fifty-years-ago-fifty-years-forward/. Accessed August 30, 2020.

Carl, Robert. "Review: Music For Merce 1952–2009" in *Fanfare*, July/August 11 (2010): 518–20.

Carr, Bruce. "Report From Buffalo: The Third International Webern Festival." *Current Musicology* no. 5 (January 1, 1967): 117–19.

Casadei, Delia. "I fatti di Milano, 1969: Recording a Milanese Riot." Paper present at the American Musicological Society National Meeting, Louisville, KY, 2015.

Casillo, Robert. "Olaf Stapledon and John Ruskin." *Science Fiction Studies* 9, no. 3 (November 1982): 306–21.

Chanter, Tina, and Pleshette DeArmitt, eds. *Sarah Kofman's Corpus*. Albany: SUNY Press, 2008.

Chechile, Alex. "The Ear Tone Toolbox for Auditory Distortion Products." *Proceedings of the International Computer Music Association* (2016): 519–23.

Chernosky, Louise Elizabeth. "Voices of New Music on National Public Radio: *Radio Net, RadioVisions* and *Maritime Rites*." Ph.D. diss., Columbia University, 2012.

Chon, Margaret. "'Postmodern 'Progress': Reconsidering the Copyright and Patent Power." *DePaul Law Review* 43 (1993): 97–146.

Christensen, Thomas. *Rameau and Musical Thought in the Enlightenment*. Cambridge: Cambridge University Press, 1993.

Chua, Daniel. *Absolute Music and the Construction of Meaning*. Cambridge: Cambridge University Press, 1999.

Cimini, Amy. *Long Distance Music Reader*. Unpublished. San Diego, 2016.

Cimini, Amy. "Some Sound and Shapes: Maryanne Amacher's *Adjacencies*." In *Blank Forms Journal, Vol. 2: Music From the World Tomorrow*, 247–68. New York: Blank Forms, 2017.

Cimini, Amy. "In Your Head: Notes on Maryanne Amacher's *Intelligent Life*." *The Opera Quarterly* 33, nos. 3–4 (Summer–Autumn 2017): 269–302.

Cimini, Amy, and Bill Dietz, eds. *Stolen Souls Reader*. Unpublished. Berlin/San Diego, 2016.

Cimini, Amy, and Bill Dietz, eds. *Labyrinth Gives Way to Skin Reader*. Unpublished. Berlin/San Diego, 2016.

Cimini, Amy, and Bill Dietz, eds. *Anywhere City Reader*. Unpublished. Berlin /San Diego, 2017.

Cimini, Amy, and Bill Dietz, eds. *Seminar on Maryanne Amacher: A Reader*. Unpublished. Berlin/San Diego, 2018.

Cimini, Amy, and Bill Dietz. "Introduction: 'Premature Attempts to Think about Ways of Indicating [. . .] Range of (B) with Given A Intervals. Part of the 'Understanding Ritual,' Before Finding Approach." In *Maryanne Amacher: Selected Writings*, edited by Amy Cimini and Bill Dietz, 1–18. New York: Blank Forms, 2020.

Cimini, Amy, and Jairo Moreno. "On Diversity." *Gamut: Online Journal of the Music Theory Society of the Mid-Atlantic* 2, no. 1 (July 2009): 1–86.

Cimini, Amy, and Jairo Moreno. "Inexhaustible Sound and Fiduciary Aurality." *Boundary 2: An International Journal of Literature and Culture* 43 no. 1 (February 2016): 5–41.

Clarke, Arthur C. *The City and the Stars*. New York: Rosetta Books, 2012.

Close, Roy. "Progressive Programming: Minnesota Since the 40s." In *New Music America Program Book*, 12–17. Minneapolis: Walker Art Center, 1980.

Coles, Robert Traynham. "Community Facilities in a Redevelopment Area: A Study and Proposal for the Ellicott District in Buffalo New York." MA thesis, Massachusetts Institute of Technology, 1955.

Collins, Patricia Hill. *Black Feminist Thought*. Boston, MA: Unwin Hyman, 1990.

Collins, Nicholas. "Introduction: Thoughtful Pleasures." *Leonardo Music Journal* 12 (2002): 1–2.

Communication Workers of America. *Managerial Initiatives*. 1980. CWA Collection at the Tamiment Labor Archive at the New York University Library.

Communication Workers of America. Case Description: Columbus, Ohio Operator Service. 1980. CWA Collection at the Tamiment Labor Archive at the New York University Library.

Connor, Steven. *The Matter of Air*. London: Reaktion Books, 2010.

Connor, Steven. "Acousmania." Lecture given at Sound Studies: Art, Experience, Politics, CRASSH, Cambridge, July 10, 2015.

Connolly, Brian. "Playing the Ear: Non-Linearities of the Inner Ear and their Creative Potential." Ph.D. diss., Maynooth University, 2016.

Cooper, Melinda. *Life as Surplus: Biotechnology & Capitalism in the Neoliberal Era*. Seattle: University of Washington Press, 2008.

Coppola, Lee. "250 Delaware Park Audience Improvises with 104 Spray Cans." *Buffalo Evening News*, October 21, 1967.

da Costa, Beatriz da. "Reaching the Limit: When Art Becomes Science." In *Tactical Biopolitics: Art, Activism, and Technoscience*, edited by Beatriz da Costa and Kavita Philip, 365–87. Cambridge, MA: MIT Press, 2008.

Cowie, Jefferson, and Joseph Heathcott, eds. "Introduction." In *Beyond the Ruins: The Meanings of Deindustrialization*, 1–16. Ithaca, NY: Cornell University Press, 2003.

Cox, Christoph. "Beyond Representation and Signification: Toward a Sonic Materialism." *Journal of Visual Culture* 10, no. 2 (2011): 145–61.

Cox, Christoph. "The Alien Voice: Alvin Lucier's North American Time Capsule, 1967." In *Mainframe Experimentalism: Early Computing and the Foundation of the Digital Arts*, edited by Hannah B. Higgins and Douglas Kahn, 170–86. Berkeley: University of California Press, 2012.

Cox, Christoph, and Daniel Warner, eds. *Audio Culture: Readings in Modern Music*. New York: Continuum, 2006.

Crary, Jonathan. *Techniques of the Observer: On Vision and Modernity in the 19th Century*. Cambridge, MA: MIT Press, 1990.

Creshevsky, Noah. "Imaginary Landscapes." *Newsletter—Institute for Studies in American Music* 19, no. 2 (Spring 1990): 6.

Curran, Alvin. "The Score: In Memory of Maryanne Amacher." *New York Times*, December 27, 2009.

Cusick, Suzanne. "Feminist Theory, Music Theory and the Mind/Body Problem." *Perspectives of New Music* 32, no. 1 (Winter 1994): 8–27.

Demers, Joanna. *Listening Through the Noise: The Aesthetics of Experimental Electronic Music*. Oxford: Oxford University Press, 2010.

Derrida, Jacques. "Telepathy." Translated by Nicholas Royle. *Oxford Literary Review* 10, no. 1/2 (1988): 3–41.

Derrida, Jacques. *The Ear of the Other: Texts and Discussions*. Translated by Avital Ronell. Edited by Christie McDonald. Lincoln: University of Nebraska Press, 1988.

"Designs on the Waterfront' is Subject of Conference." *Buffalo Courier*, November 15, 1966.

Dewar, Andrew. "Reframing Sounds: Recontextualization as Compositional Process in the Work of Alvin Lucier." Online Supplement: Lucier Celebration. *Leonardo Music Journal* 22, no. 1 (November 2012): unpaginated.

Diamond v. Chakrabarty, 447 U.S. 303 (US Supreme Court 1980).

Dietz, Bill. Pre-Concert Remarks on Amacher's *Glia* (2006). Institute for Contemporary Art, London, May 31, 2019.

Dietz, Bill. "Rare Decays." In *Tube Dust Drone—Brückenmusik 1995–2015*, edited by hans w. koch and the Therapeutische Hörgruppe Köln, 79–86. Cologne: BRÜCKENMUSIK, 2016.

Dietz, Bill, ed. *Supreme Connections Reader*. Unpublished. Kingston/Berlin, 2012.

Dillaway, Diana. *Power Failure: Politics, Patronage and the Economic Future of Buffalo, New York*. New York: Prometheus Books, 2006.

Dohoney, Ryan. "A Flexible Musical Identity: Julius Eastman in New York City." In *Gay Guerrilla: The Life and Music of Julius Eastman*, edited by Renee Levine-Packer and Mary Jane Leach, 116–30. Rochester, NY: University of Rochester Press, 2016.

Dolan, Emily I. *The Orchestral Revolution: Haydn and the Technologies of Timbre*. Cambridge: Cambridge University Press, 2013.

Dolan, Emily I., and John Tresch. "Toward a New Organology: Instruments of Music and Science," *Osiris* 28, no. 1 (January 2013): 278–98.

Dornan, Terry. "A Psychedelic Week-end of Color, Sound." *Buffalo News*, October 20, 1967.

Dornan, Terry. "The Avant Garde Sound: Music to Turn Buffalo On: Widely Known Solo Percussionist Composed 'Drive-in Music No. 1' for New Art Project." *Buffalo News*, October 1967.

Dumit, Joseph. "Writing the Implosion: Teaching the World One Thing at a Time." *Cultural Anthropology* 29, no. 2 (2014): 344–62.

Dunning, Jennifer. "Dance: Torse by Merce Cunningham." *New York Times*, March 1, 1980.

Durner, Leah. "Maryanne Amacher: Architect of Aural Design." *EAR: Magazine of New Music* 13, no. 10 (February 1989): 28–34.

Dwyer, John. "Nation Comes to Know Buffalo as a City of Musical Foment." *Buffalo Evening News*, January 26, 1966.

Dwyer, John. "Far-out Crowd is Back In, With (Yes) Lovely Effect." *Buffalo Evening News*, November 7, 1966.

Dwyer, John. "'In-City' Concert Honors Grand Old Architecture." *Buffalo Evening News*, October 21, 1967.

Dwyer, John. "Gifted Far-Outers Offer Space Tunes, Forceful Duo." *Buffalo Evening News*, October 22, 1967.

Eckenroth, Lindsey. Review of *Towards a Twentieth Feminist Politics of Music* by Sally McArthur. *Women and Music: A Journal of Gender and Culture* 17 (2013): 92–101.

Eidsheim, Nina Sun. *Sensing Sound: Singing and Listening as Vibrational Practice*. Durham, NC: Duke University Press, 2015.

Ellner, Steve, and David J. Meyers. "Caracas: Incomplete Empowerment Amid Geopolitical Feudalism." In *Capital City Politics in Latin America*, edited by David J. Meyers and Henry A. Dietz, 95–132. London: Lynne Reyner, 2002.

Eng, David L., and David Kazanjian, eds. "Mourning Remains." In *Loss: The Politics of Mourning*, 1–28. Berkeley: University of California Press, 2003.

Farina, Jonathan. "Dickens's 'As If': Analogy and Victorian Virtual Reality." *Victorian Studies* 53, no. 3 (Spring 2011): 427–36.

Farquhar, Judith, and Margaret Lock. "Introduction." In *Beyond the Body Proper: Reading the Anthropology of Material Life*, edited by Margaret Lock and Judith Farquhar, 1–18. Durham, NC: Duke University Press, 2007.

Felman, Shoshana. *The Scandal of the Speaking Body: Don Juan with J. L. Austin or Seduction in Two Languages*. Stanford, CA: Stanford University Press, 1980.

Fennelly, Jaime, and Haley Fohr. "Mind Over Mirrors: On Electronic Music Pioneers." *Impose Magazine*, October 2015.

Fisher, Scott. "Interview." With Mimi Ito and Joi Ito. November 11, 2003. Personal copy shared with the author.

Flood, Lauren. "Building and Becoming: DIY Music Technology in New York and Berlin." Ph.D. diss., Columbia University, 2016.

Forel, August. *Ants and Some Other Insects: An Inquiry into the Psychic Powers of these Animals*. Translated by William Mortone Wheeler. Chicago: Open Court Publishing, 1904.

Fortun, Mike. "Genomic Scandals and Other Volatilities of Promising." In *Lively Capital: Biotechnologies, Ethics and Governance in Global Markets*, edited by Kaushik Sunder Rajan, 329–53. Durham, NC: Duke University Press, 2012.

Foucault, Michel. *The Birth of the Clinic: An Archaeology of Medical Perception*. Translated by A. M. Sheridan Smith. New York: Random House, 1994.

Foucault, Michel. "Nietzsche, Genealogy History." Translated by Donald F. Bouchard and Sherry Simon. In *Language, Counter-Memory and Practice: Selected Essays and Interviews*, edited by Donald Bouchard, 139–64. Ithaca, NY: Cornell University Press, 1977.

Foucault, Michel. *Society Must be Defended: Lectures at the Collége de France, 1975–1976*. Translated by David Macey. New York: Picador, 2007.

Foucault, Michel. *Security, Territory, Population: Lectures at the Collége de France, 1977–1978*. Translated by Graham Burchell. Edited by Michel Senellart. New York: Picador, 2007.

Foucault, Michel. *The Birth of Biopolitics: Lectures at the Collége de France, 1978–1979*. Translated by Graham Burchell. New York: Picador, 2008.

Fowler, Cary. "The Plant Patent Act of 1930: A Sociological History of its Creation." *Journal of the Patent and Trademark Office Society* 82, no. 9 (September 2000): 620–44.

Freud, Sigmund. "Psychoanalysis and Telepathy." In *Psychoanalysis and the Occult*, edited by George Devereux, 56–68. New York: International Universities Press, 1953 [1921].

Freud, Sigmund. "Dreams and Telepathy." In *Psychoanalysis and the Occult*, edited by George Devereux, 69–86. New York: International Universities Press, 1953 [1922].

Freud, Sigmund. "Dreams and Occultism." In *Psychoanalysis and the Occult*, edited by George. Devereux, 91–109. New York: International Universities Press, 1953 [1933].

Gallope, Michael. "On Close Reading and Sound Recording." *Humanities Futures*. John Hope Franklin Humanities Institute at Duke University, 2017. https://humanitiesfutures.org/papers/close-reading-sound-recording/. Accessed September 5, 2018.

Gann, Kyle. "Shaking the Kitchen." *Village Voice*, March 22, 1988, 96.

Gann, Kyle. "Maryanne Amacher: Sound Characters (1999)." *Village Voice*, August 17, 1999.

Gann, Kyle. "Improper Ladies: Women Composers Shatter the Glass (Ceiling)." *Village Voice*, December 12, 1995.

Gann, Kyle. "It's Sound, It's Art, Some Call it Music." *The New York Times*, January 9, 2000, Section 2, p. 41.

Gluck, Robert J. "Silver Apples, Electric Circus, Electronic Arts and Commerce, in Late 1960s New York." In *Proceedings of the International Computer Music Conference* (2009): 149–52.

GoGwilt, Keir. *The Liberal Art of the Violin: A History of Performance as Experimental Research (1740–Present)*. Ph.D. diss. in progress, University of California San Diego, 2021.

von Goethe, Johann Wolfgang. *Theory of Colors*. London: Dover Fine Art, 2006.

Gold, Thomas. "Hearing. II. The Physical Basis of the Action of the Cochlea." *Proceedings of the Royal Society* 135, no. 881 (December 1948): 492–98.

Gold, Thomas. "The Inertia of Scientific Thought." *Speculations in Science and Technology* 12, no. 4 (1990): 245–53.

Goldman, Mark. *City on the Edge: Buffalo New York, 1900–Present*. New York: Prometheus Books, 2007.

Goodyear, Anne Collins. "Gyorgy Kepes, Billy Kluver, and American Art of the 1960s: Defining Attitudes Toward Science and Technology." *Science in Context* 17, no. 4 (2004): 611–35.

Greene, Bob. "Maryanne Amacher and the Music Around Us." *Chicago Guide*, May 1974.

Green, Venus. *Race on the Line: Gender, Labor, & Technology in the Bell System, 1880–1980*. Durham, NC: Duke University Press, 2001.

Grimshaw, Jeremy. *Draw a Straight Line and Follow It: The Music and Mysticism of La Monte Young*. Oxford: Oxford University Press, 2011.

Guerrieri, Matthew. "When We Listen to Aretha Franklin, Why Do Words Fail?" *The Boston Globe*, April 8, 2016.

Halpern, Orit. *Beautiful Data: A History of Vision and Reason since 1945*. Durham, NC: Duke University Press, 2014.

Hamilton, Sally M. "CAVS' Amacher to Create Work for Buffalo Center." *MIT Newspaper*, January 1975.

Haraway, Donna Jeanne. "Situated Knowledges: The Science Question in Feminism and the Privilege of Partial Perspective." In *Simians, Cyborgs and Women: The Reinvention of Nature*, 183–202. London: Free Association, 1991.

Haraway, Donna Jeanne. "The Biopolitics of Postmodern Bodies." In *Simians, Cyborgs and Women: The Reinvention of Nature*, 202–30. London: Free Association, 1991.

Haraway, Donna Jeanne. *Modest_Witness@Second_Millennium.Femaleman_Meets_Oncomouse: Feminism and Technoscience*. New York: Routledge, 1997.

Harding, Sandra. "Rethinking Standpoint Epistemology: What is Strong Objectivity?" In *Feminist Epistemologies*, edited by Linda Alcoff and Elizabeth Potter, 49–82. London: Routledge, 1993.

Hartmann, William M. *Signals, Sound and Sensation*. New York: Springer, 1998.

Hartsock, Nancy. *Money Sex and Power*. New York & Boston: Northeastern University Press, 1983.

Hartsock, Nancy. "The Feminist Standpoint: Developing the Ground for a Specifically Feminist Historical Materialism." In *Feminism and Methodology: Social Science Issues*, edited by Sandra Harding, 157–80. Bloomington: Indiana University Press, 1987.

Haworth, Chris. "Composing with Absent Sound." *Proceedings of the International Computer Music Association* (2011): 342–45.

Hayles, N. Katherine. *How We Became Posthuman: Virtual Bodies in Cybernetics and Informatics*. Chicago: University of Chicago Press, 1999.

Hecker, Florian. "Best of 2010." *Artforum*. 49, no. 4 (December 2010). https://www.artforum.com/print/201010/their-favorite-exhibitions-of-the-year-26861. Accessed, March 5, 2021.

Heller, Michael C. *Loft Jazz: Improvising New York in the 1970s*. Oakland: University of California Press, 2013.

Heller, K. A, D. A. Schmitt, and R. M. Taylor. "System Testing." *The Bell System Technical Journal* 49, no 10 (August 1970): 2711–728.

Helmreich, Stefan. "Trees and Seas of Information: Alien Kinship and the Biopolitics of Gene Transfer in Marine Biology and Biotechnology." *American Ethnologist* 30, no. 3 (August 2003): 340–58.

Helmreich, Stefan. "What Was Life? Answers from Three Limit Biologies." *Critical Inquiry* 37, no. 4 (Summer 2011): 671–96.

Helmreich, Stefan, and Sofia Roosth. "Life Forms: A Keyword Entry." *Representations* 112 (Fall 2010): 27–53.

Herrera, Eduardo, Alejandro Madrid, and Ana Alonso Minutti. "The Practices of Experimentalism in Latin@ and Latin American Music: An Introduction." In *Experimentalisms in Practice: Music Perspectives from Latin America*, 1–18. Oxford: Oxford University Press, 2018.

Hiatt, Blanchard. "The Great Astronomical Ear." *Mosaic: The National Science Foundation* 11, no 1 (January/February 1980): 30–37.

High, Steve, and David W. Lewis. *Corporate Wasteland: The Landscape and Memory of Deindustrialization*. Ithaca, NY: Cornell University Press, 2007.

Hight, Tom. "The Arts." *Omni* 4, no. 2 (November 1981): 32, 142, 146.

Hill, Clive E. "The Evolution of the Masculine Middlebrow: Gissing, Bennett and Priestly." In *The Masculine Middlebrow, 1880–1950: What Mr. Miniver Read*, edited by Kate MacDonald, 38–55. London: Palgrave MacMillan, 2011.

Hosford, John E. "Optimal Allocations of Leased Lines." *Management Science* 9, no. 4 (July 1963): 613–22.

Hubbard, Ruth. "Science and Science Criticism." In *The Gender and Science Reader*, edited by Muriel Lederman and Ingrid Bartsch, 49–51. London: Routledge, 2001.

Hubbard, Ruth. "Science, Power, Gender: How DNA Became the Book of Life." *Signs* 28, no. 3 (Spring 2003) 791–99.

Huntington, John. "Remembrance of Things to Come: Narrative Technique in *Last and First Men*." *Science Fiction Studies* 9, no. 3 (November 1982): 257–64.

Hyde, Megan, Patrick O'Rourke, and Shannon Thompson. *Elevator Music 16, Maryanne Amacher: Head Rhythm 1 and Plaything 2, 1999*. Tang Teaching Museum, 2010.

Jackson, Yvette. "Destination Freedom: Strategies for Immersion in Narrative Soundscape Composition." Ph.D. diss., University of California San Diego, 2017.

Jackson, Sandra, and Julie E. Moody-Freeman, eds. *The Black Imagination: Science Fiction, Futurism and the Speculative*. New York: Peter Lang, 2010.

Jaeger, Jr. R. J., and A. E. Joel, Jr. "System Organization and Objectives," *The Bell System Technical Journal* 49, no. 10 (December 1970): 2417–443.

James, Robin. *The Sonic Episteme: Acoustic Resonance, Neoliberalism and Biopolitics*. Durham, NC: Duke University Press, 2019.

Jameson, Fredric. *Archaeologies of the Future: The Desire Called Utopia and Other Science Fiction*. London: Verso, 2005.

Jameson, Fredric. "*History and Class Consciousness* as an 'Unfinished Project.'" *Rethinking MARXISM* 1, no. 1 (Spring 1988): 49–72.

Jameson, Fredric. *Postmodernism, or the Cultural Logic of Late Capitalism*. Durham, NC: Duke University Press, 1991.

Jasanoff, Sheila. "Taking Life: Private Rights in Public Nature." In *Lively Capital: Biotechnologies, Ethics and Governance in Global Markets*, edited by Kaushik Sunder Rajan, 155–83. Durham, NC: Duke University Press, 2012.

Jasen, Paul C. *Low End Theory: Bass Bodies and the Materiality of Sonic Experience*. London: Bloomsbury, 2016.

Jean-François, Isaac Alexandre. "Julius Eastman: The Sonority of Blackness Otherwise." *Current Musicology* 106 (Spring 2020): 9–35.

Johnson, Barbara. "Apostrophe, Animation, and Abortion." *Diacritics* 16, no. 1 (Spring 1986): 28–47.

Johnson, Tom. "Maryanne Amacher: Acoustics Joins Electronics." *Village Voice*, December 15, 1975.

Johnson, Tom. "Someone's in The Kitchen—With Music." *New York Sunday Times*, October 8, 1972.

Johnson, Tom. "The Empty House." *The Voice of New Music, New York City 1971–1988: A Collection of Articles Published in Village Voice* (Digital Edition), edited by Tom Johnson and Paul Panhuysen (unpaginated). New York: Editions 75, 2014.

Joseph, Brandon. *Beyond the Dream Syndicate: Tony Conrad and the Arts After Cage*. New York: Zone, 2011.

Kahn, Douglas. *Noise, Water, Meat: A History of Sound in the Arts*. Cambridge, MA: MIT Press, 2001.

Kahn, Douglas, and William R. Macauley. "On the Aelectrosonic and Transperception." *The Journal of Sonic Studies* 8 (December 2014): unpaginated. https://www.researchcatalogue.net/view/108900/108901. Accessed August 1, 2020.

Kahn, Douglas. "Active Hearing: Jacob Kierkegaard's *Labyrinthitis*." (2008) http://fonik.dk/works/labyrinthitis-kahn.html. Accessed March 30, 2020.

Kahn, Douglas, and Gregory Whitehead, eds. *The Wireless Imagination: Sound, Radio and the Avant Garde*. Cambridge, MA: MIT Press, 1992.

Kane, Brian. "Sound Studies without Auditory Culture: A Critique of the Ontological Turn." *Sound Studies* 1, no. 1 (2015): 2–21.

Kane, Brian. *Sound Unseen: Acousmatic Sound in Theory and Practice*. Oxford: Oxford University Press, 2014.

Kane, Brian. "Xenakis: The First Composer of Biopolitics?" In *Exploring Xenakis*, edited by Sharon Kanach, 91–100. Hillsdale, NY: Pendragon Press, 2012.

Kane, Brian. "Musicophobia: Sound Art and the Demands of Art Theory." http://nonsite.org/arti cle/musicophobia-or-sound-art-and-the-demands-of-art-theory. Accessed July 17, 2016.

Keller, Evelyn Fox. *Making Sense of Life: Explaining Biological Development with Models, Metaphors, and Machines*. Cambridge: Harvard University Press, 2002.

Kemp, David T. *Understanding and Using Otoacoustic Emissions*. London: Otodynamics, 1997.

Kendall, Gary S., Christopher Haworth, and Rodrigo F. Cádiz. "Sound Synthesis with Auditory Distortion Products." *Computer Music Journal* 38, no. 4 (Winter 2014): 5–23.

Kerner, Leighton. "Contemporary Series." *Village Voice*, November 17, 1966.

Kettley, A. W. E. J. Pasternak, and M. F. Sikorsky, "Operational Programs." *The Bell System Technical Journal*. December 1970: 2625–683.

Kevles, Daniel J. "Ananda Chakrabarty Wins a Patent: Biotechnology, Law, and Society." *Historical Studies in the Physical and Biological Sciences* 25, Part 1 (1994): 111–35.

Kevles, Daniel J. "Patents, Protections, and Privileges: The Establishment of Intellectual Property in Animals and Plants." *Isis* 98, no. 2 (June 2007): 323–31.

Kheshti, Roshanak. "Towards a Rupture in the Sensus Communis: On Sound Studies and the Politics of Knowledge Production." *Current Musicology* 99 (2017): 7–20.

Kheshti, Roshanak. *Wendy Carlos' Switched-On Bach*. London: Routledge, 2019.

Kheshti, Roshanak. *Modernity's Ear: Listening to Race and Gender in World Music*. New York: New York University Press, 2015.

Kim-Cohen, Seth. *Against Ambience and Other Essays*. London: Bloomsbury, 2016.

Kim-Cohen, Seth. *In the Blink of an Ear: Towards a Non-Cochlear Sound Art*. London: Bloomsbury, 2013.

Kino, Carol. "Renaissance in an Industrial Shadow." *New York Times*, May 2, 2012.

Kirk, Jonathon. "Otoacoustic Emissions as a Compositional Tool." *Proceedings of the International Computer Music Association* (2011): 316–18.

Kisselgoff, Anna. "Dance: A Classic by Merce Cunningham." *New York Times*, January 21, 1977.

Kisselgoff, Anna. "Merce Cunningham, The Maverick of Modern Dance." *New York Times*, March 21, 1982, section 6, p. 23.

Kofman, Sarah. *Nietzsche and Metaphor*. Translated by Duncan Large. Stanford, CA: Stanford University Press, 1994.

Kofman, Sarah, and Francoise Lionnet-McCumber. "Nietzsche and the Obscurity of Heraclitus." *Diacritics* 17, no. 3 (Autumn 1987): 39–55.

Kostelanetz, Richard. *Conversing with Cage*. New York: Routledge, 2003.

Kozinn, Allan. "Maryanne Amacher, 71, Visceral Composer, Dies." *New York Times*, October 28, 2009.

Kraus, Neil. *Race, Neighborhoods, and Community Power: Buffalo Politics, 1934–1997*. Albany: SUNY University Press, 2000.

Kubisch, Cristina. "Time into Space/Space into Time: New Sound Installations in New York," *Flash Art Italy* no. 88–89 (March–April 1979): 16–20.

Kubisch, Cristina. "Music: Best of 2006." *Artforum International* 45, no. 4 (Dec 2006). https://www.artforum.com/print/200610/christina-kubisch-42549. Accessed March 3, 2021.

LaBelle, Brandon. *Background Noise: Perspectives on Sound Art*. New York: Continuum, 2006.

LaBelle, Brandon. "Short Circuit: Sound Art and the Museum." *Contemporary*, no. 53–54 (2003): 66–71.

Lacoue-Labarthe, Philippe. *Typography: Mimesis, Philosophy, Politics*, edited by Christopher Fynsk. Cambridge, MA: Harvard University Press, 1989.

LaFollette, Marcel Chotkowski. *Science on American Television: A History*. Chicago: University of Chicago Press, 2013.

Large, Duncan. "Introduction." In *Nietzsche and Metaphor*, edited by Sarah Kofman, translated by Duncan Large, vii–xv. Stanford, CA: Stanford University Press, 1994.

LeGuin, Elisabeth. *Boccherini's Body: An Essay in Carnal Musicology*. Berkeley: University of California Press, 2006.

Leone, Dominque. "OHM+: The Early Gurus of Electronic Music: 1948–1980." *Pitchfork*, January 5, 2006. http://pitchfork.com/reviews/albums/2106-ohm-the-early-gurus-of-electronic-music-1948–1980/. Accessed December 5, 2015.

Levine Packer, Renée. *This Life in Sounds: Evenings for New Music in Buffalo*. Berkeley: University of California Press, 2010.

Levy, Sophie. "Man/Ray: The Camera as (Bachelor) Machine in Surrealist Photography." Abstract for Paper Given at 10th Annual French Graduate Student Conference Maison française, Columbia University, March 24, 2001.

Licht, Alan. "Maryanne Amacher: Expressway to Your Skull." *The Wire* 181 (March 1999). http://www.thewire.co.uk/in-writing/interviews/p=14992.

Licht, Alan. *Sound Art: Beyond Music, Beyond Categories*. New York: Rizzoli, 2007.

Lippard, Lucy. *Overlay: Contemporary Art and the Art of Prehistory*. New York: The New Press, 1995.

Lippard, Lucy. *Undermining: A Wild Ride through Art, Land Use and Politics in the Changing West*. New York: The New Press, 2014.

Lippit, Akira. *Electric Animal: Toward a Rhetoric of Wildlife*. Minneapolis: Minnesota University Press, 2008.

Lothian, Alexis. *Old Futures: Speculative Fiction and Queer Possibility*. New York: New York University Press, 2018.

Lotringer, Sylvère, Chris Kraus, and Hedi El Kholti, eds. *Nietzsche's Return*. Semiotext(e), Vol. 3 no. 1, New York: Polymorph Press, 1977.

Lsnikowski, Amanda. "Butler Square, Minnesota." Society of Architectural Historians: SAH Archipedia, edited by Gabrielle Esperdy and Karen Kingsley (2012). http://sah-archipedia.org/buildings/MN-01-053-0044. Accessed August 18, 2020. Lugo, Tobler. "Spaces and Fests." *Performing Arts Journal, LIVE performance art magazine* 6 no. 7 (1982): 120.

Lumelsky, Anna. "Diamond v Chakrabarty: Gauging Congress's Response to Dynamic Statutory Interpretation by the Supreme Court." *University of San Francisco Law Review* 39, no. 3 (2004): 641–92.

Maconie, Robin. "Stockhausen's *Mikrophonie I*: Perception in Action." *Perspectives of New Music* (Spring–Summer, 1972): 92–101.

Maconie, Robin. "Revisiting 'Mikrophonie I.'" *The Musical Times* 152, no. 1914 (Spring 2011): 95–102.

Maier, Tobi, Micah Silver, Robert The, and Axel Wieder. "Maryanne Amacher: City-Links." Exhibition booklet, Ludlow 38, 2010.

Makari, George. *Revolution in Mind: The Creation of Psychoanalysis*. New York: Harper Perennial, 2009.

Malin, Brenton J. *Feeling Mediated: A History of Technology and Emotion in America*. New York: New York University Press, 2014.

Margulis, Lynn, and Dorion Sagan. *What is Life?* Berkeley: University of California Press, 1995.

Masaoka, Miya. "The Vagina Is the Third Ear." *The Drama Review* 64, no. 1 (Spring 2020): 2–7.

Massumi, Brian. *Parables for the Virtual*. Durham, NC: Duke University Press, 2002.

McCullough, Malcolm. Ambient *Commons: Attention in the Age of Embodied Information*. Cambridge, MA: MIT Press, 2013.

McFadden, Robert. "Phone Strikes Slow Customer Service in 3 Regions." *New York Times*, August 8, 1989.

Melzer, Patricia. *Alien Constructions: Science Fiction and Feminist Thought*. Austin: University of Texas Press, 2006.

Mills, Mara. "Cochlear Implants After Fifty Years: A History and an interview with Charles Graser." In *Oxford Handbook of Mobile Music Studies*, edited by Sumanth Gopinath and Jason Stanyek, I:261–97. Oxford: Oxford University Press, 2014.

Mills, Mara. "Hearing Aids and the History of Electronics Miniaturization." *IEEE Annals of the History of Computing* 33 (2011): 24–45.

Minow, Martha. *All the Difference: Inclusion, Exclusion, and American Law*. Ithaca, NY: Cornell University Press, 1991.

Minsky, Marvin. "Maryanne Amacher." *Kunstforum International* 103 (September–October 1989): 255.

Minsky, Marvin. "Music, Mind, and Meaning." *Computer Music Journal* 5, no. 3 (Fall 1981): 28–44.

Mockus, Martha. *Sounding Out: Pauline Oliveros and Lesbian Musicality*. New York: Routledge, 2008.

Mody, Cyrus. "The Sounds of Science: Listening to Laboratory Practice." *Science, Technology & Human Values* 30, no. 2 (Spring 2015): 175–98.

Monelle, Raymond. Review of *Music/Ideology: Resisting the Aesthetic* by Adam Krims. *Music Analysis* 20, no. 3 (October 2001): 407–13.

Monsen, Karen. "Maryanne Amacher Makes Music from the Sound of Chicago." *Chicago Today*, May 10, 1974.

Moreno, Jairo. *Musical Representation, Subjects and Objects in the Construction of Musical Thought in Zarlino, Descartes, Rameau and Weber*. Bloomington: Indiana University Press, 2004.

de la Motte-Haber, Helga. "Perceptual Geographies." https://ima.or.at/en/imafiction/video-portrait-06-maryanne-amacher/. Accessed August 19, 2020.

Mueller, H. Gustav. "Probe Microphone Measurements: 20 Years of Progress." *Trends in Amplification* 5, no. 2 (June 2001): 35–68.

Murphy, Michelle. "'What Can't a Body Do?' *Catalyst: Feminism, Theory*." *Technoscience* 3, no. 1 (2017): 1–15.

Nakai, You. "Hear After: Matter of Life and Death in David Tudor's Electronic Music." *communication +1* 3, no. 1 (September 2014): 10–32.

Nakamura, Lisa. "Indigenous Circuits: Navajo Women and the Racialization of Early Electronics Manufacture." *American Quarterly* 66, no. 4 (December 2014): 919–41.

Name, Leo. "Caracas and Mérida, Venezuela: Coloniality, Space and Gender in the film *Azul u no tan rosa*." In *Urban Latin America: Images, Words, Flows and the Built Environment*, edited by Bianca Freire-Medieros and Julia O'Donnell. New York: Routledge, 2018.

Nancy, Jean-Luc. *The Inoperative Community*. Translated by Peter Connor, Lisa Garbus, Michael Holland, and Simona Sawhney. Minneapolis: University of Minnesota Press, 1991.

Ngai, Sianne. *Ugly Feelings*. Cambridge, MA: Harvard University Press, 2005.

Nietzsche, Friedrich. "Beyond Good and Evil." In *Basic Writings of Nietzsche*, edited and translated by Walter Kaufmann. New York: Random House, 2000.

Noguera, Felipe. "Beyond Structural Adjustment: Implications of the Privatization of Telecommunications in the Political Economy of the Caribbean." Presented to the Caribbean Studies Association Conference, Kingston, Jamaica. May 1993.

O'Brien, Paul. "*Ars Electronica*." *Circa*, no. 114 (December 2005): 83–85.

O'Brien, Paul. "News." *Computer Music Journal* 29, no. 4 (Winter 2005): 7–10.

Ochoa Gautier, Ana Maria. *Aurality: Listening and Knowledge in Nineteenth Century Colombia*. Durham, NC: Duke University Press, 2013.

Omi, Michael, and Howard Winant. *Racial Formation in the United States from the 1960s to the 1990s*. New York: Routledge, 1994.

O'Reilly, Meara. "Resonance and Illusion Games: Resonant Frequencies of Spaces, Objects, and Humans, and Illusions That Arise out of Play." *SFMOMA Open Space Blog*, May 11, 2009.

Osborne, Albert E. *The Stereograph and the Stereoscope: With Special Maps and Books Forming a TRAVEL SYSTEM*. New York: Underwood & Underwood, 1909.

Osborne, Peter. *Anywhere or Not At All: Philosophy of Contemporary Art*. London: Verso, 2013.

Ouzonian, Gascia. "Embodied Sound: Aural Architectures and the Body." *Contemporary Music Review* 25 no. 2 (August 2006): 69–79.

Patrizi, Enrica, Mario Romano, and Gilled Wright. "Marianne Amacher: Opening Concerts/ Concerti d'Apertura." Concert Program, Rome, Italy, 1980.

Penny, Simon. "The Desire for Virtual Space: The Technological Imaginary in 1990s Media Art." Unpublished Manuscript, 2009.

Peters, John Durham. *Speaking Into the Air: A History of the Idea of Communication*. Chicago: University of Chicago Press, 1999.

Piekut, Benjamin. *Experimentalism Otherwise: The New York Avant Garde and Its Limits*. Oakland: University of California Press, 2011.

Piene, Otto. "Weather: A Campus Exhibition at the Massachusetts Institute of Technology." Exhibition Catalogue. Designed by Suzanne Weinberg, Mitchell Benoff, Lobby 7 Committee. November 14–21, 1973.

Pollock, Ann. "Heart Feminism." *Catalyst: Feminism, Theory, Technoscience* 1, no. 1 (2015): 1–30.

Povinelli, Elizabeth A. *Economies of Abandonment: Social Belonging and Endurance in Late Capitalism*. Durham, NC: Duke University Press, 2011.

Povinelli, Elizabeth A. *Geontologies: A Requiem to Late Liberalism*. Durham, NC: Duke University Press, 2016.

Powell, Kirsten Hoving. "Le Violon d'Ingres: Man Ray's Variations on Ingres, Deformation, Desire and de Sade." *Art History* (December 2003): 722–99.

Puar, Jasbir. "I Would Rather be a Cyborg than a Goddess: Becoming-Intersectional in Assemblage Theory." *philoSOPHIA* 2, no. 1 (2012): 49–66.

Rajan, Kaushik Sunder. *Biocapital: The Constitution of Postgenomic Life*. Durham, NC: Duke University Press, 2006.

Rajan, Kaushik Sunder, ed. "Introduction: The Capitalization of Life and the Liveliness of Capital." In *Lively Capital: Biotechnologies, Ethics and Governance in Global Markets*, 1–44. Durham, NC: Duke University Press, 2012.

Rancière, Jacques. *The Politics of Aesthetics*. Translated by Gabriel Rockhill. New York: Continuum, 2004.

Reik, Theodor. *The Haunting Melody: Psychoanalytic Experiences in Life and Music*. New York: Da Capo Press, 1953.

Reik, Theodor. *Listening with the Third Ear*. New York: Farrar, Straus and Giroux, 1975.

Reinbolt, Brian. "The 18th Annual Electronic Music Plus Festival." *Computer Music Journal* 15, no. 4 (Winter 1991): 89–94.

Roberts, Eleanor. "Charlotte Moorman and Avant Garde Music: A Feminist History of Performance Experimentation." In Performance, *Subjectivity and Experimentation*, edited by Catherine Laws, 159–63. Leuven: Leuven University Press, 2020.

Roberston, Allen. "Chamber Orchestra Won't be the Same; Davies Started a Music Adventure." *Minnesota Star*, May 3, 1980.

Rockwell, John. "Music: Miss Amacher." *New York Times*, December 3, 1979.

Roederer, Juan G. *Introduction to the Physics and Psychophysics of Music*. New York: Springer, 1975.

Rodgers, Tara. "Approaching Sound." In *The Routledge Companion to Media Studies and Digital Humanities*, edited by Jentry Sayers, 233–42. New York: Routledge: 2007.

Rodgers, Tara. *Pink Noises: Women on Electronic Music and Sound*. Durham, NC: Duke University Press, 2010.

Rodgers, Tara. "'What for Me Constitutes Life in a Sound?': Electronic Sounds as Lively and Differentiated Individuals." *American Quarterly* 63, no. 3 (2011): 509–30.

Ross, Christine. *The Past Is the Present; It's the Future Too: The Temporal Turn in Contemporary Art*. London: Continuum, 2013.

Sandoval, Chela. "New Sciences: Cyborg Feminism and the Methodologies of the Oppressed." In *Cybersexualities: A Reader in Feminist Theory, Cyborgs and Cyberspace*, edited by Jenny Wolmark (Edinburgh: Edinburgh University Press, 1999), 247–63.

Savage, Kirk. "Monuments of a Lost Cause: The Postindustrial Campaign to Commemorate Steel." In *Beyond the Ruins: The Meanings of Deindustrialization*, edited by Jefferson Cowie and Joseph Heathcott, 237–58. Ithaca: Cornell University, 2003.

Sawyer, Andy. "Olaf Stapledon: Professor of Philosophy, University of Liverpool, 1925–1950." https://www.liverpool.ac.uk/philosophy/olaf-stapledon/. Accessed November 18, 2020.

Schick, Steven. *The Percussionist's Art: Same Bed, Different Dreams*. Rochester, NY: University of Rochester Press, 2006.

Schlaerth, J. Don. "27 Hours of Sounds—A Unique Experience." *Buffalo Courier Express*. 28 May, 1967.

Schoener, Allon. "2066 And All That." *Art in America* 54, no. 2: (March–April 1966): 40–43.

Schultz, Nora. "Top Ten." *Artforum* (April 2008). https://www.artforum.com/print/200804/nora-schultz-19724.

Seward, Scott. "Metal Machine Music." *Village Voice*, May 23, 2000.

Shoard, Marion. "Edgelands of Promise." *Landscapes* 1, no. 2 (2000): 74–93.

Shintani, Joyce. "Review: Ars Electronica 2005: Festival for Art, Technology and Society, Linz, Austria, 1–6 September 2005." *Computer Music Journal* 30, no. 2 (Summer 2006): 84–87.

Siedel, Miriam. "Performance Piece Debuts at Fleischer." *Philadelphia Inquirer*, September 21, 1990.

Silver, Micah. "Remembrance." http://www.arts-electric.org/stories/091028_Amacher.html. Accessed July 17, 2015.

"Six Artists Will Project at the Walker Center." *St. Paul Sunday Pioneer Press*, September 8, 1974.

Smith, Douglas. "Mr. Pseudomonas." *Medium*, October 23, 2015. https://medium.com/lsf-magazine/mr-pseudomonas-198a5eddc47, accessed October 10, 2019.

Smith, Neil. *The New Urban Frontier: Gentrification and the Revanchist City*. New York: Routledge, 1996.

Solie, Ruth, ed. *Musicology and Difference: Gender and Sexuality in Music Scholarship*. Berkeley: University of California Press, 1993.

Spanier, Bonnie. *Im/Partial Science: Gender Ideology in Molecular Biology*. Albany, NY: SUNY Press, 1996.

Spillers, Hortense J. "Mama's Baby, Papa's Maybe: An American Grammar Book." *Diacritics* 17, no. 2 (Summer 1987): 64–80.

Staebler, James. "The Stereograph: The Rise and Decline of Victorian Virtual Reality." MS thesis, Ohio University, 2000.

Stapledon, Olaf. *Last and First Men: A Story of the Near and Far Future*. Mineola, NY: Dover Literature, 2008.

STAR FEM COL*AB. *The Science We Are For: A Feminist Pocket Guide*. Manuscript in Progress, 2021.

Sterne, Jonathan. *The Audible Past: Cultural Origins of Sound Reproduction*. Durham, NC: Duke University Press, 2003.

Sterne, Jonathan. "The Cat Telephone." *The Velvet Light Trap* 64 (Fall 2009): 83–84.

Sterne, Jonathan. *MP3: The Meaning of a Format*. Durham, NC: Duke University Press, 2012.

Stockhausen, Karlheinz. *Kontakte: elektronische Musik, Nr. 12*. London: Universal Edition, 1976.

Stockhausen, Karlheinz. *Stockhausen on Music: Lectures and Interviews*. Edited by Robin Maconie. New York: M. Boyars, 1989.

Stoler, Ann Laura. "Colonial Archives and the Arts of Governance: On the Content in the Form." In *Refiguring the Archive*, edited by Carolyn Hamilton, Verne Harris, Jane Taylor, Michele Pickover, Graeme Reid, and Raiza Saleh, 83–102. Dordrecht: Kulwer Academic Publishers, 2002.

Straebel, Volker. "The Day the Music Died: From Work to Practice." Paper Delivered at Maryanne Amacher: Concert and Presentation: Supreme Connections Laboratory" Berlin, July 28, 2012.

Strathern, Marilyn. *Reproducing the Future: Essays on Anthropology, Kinship and the New Reproductive Technologies*. New York: Routledge, 1992.

Taylor, Diana. *The Archive and the Repertoire: Performing Cultural Memory in the Americas*. Durham, NC: Duke University Press, 2003.

Terranova, Tiziana. "Another Life: The Nature of Political Economy in Foucault's Genealogy of Biopolitics." *Theory, Culture and Society* 26, no. 6 (2009): 234–62.

Thomka-Gazdik, Julien G. "International Cooperatives—Users of Private Leased Lines." *Jurimetrics* Vol. 25, no. 1 (Fall 1984): 94–104.

Thurschwell, Pamela. *Literature, Technology and Magical Thinking, 1900–1920*. Cambridge: Cambridge University Press, 2004.

Thurschwell, Pamela. *Literature, Technology and Magical Thinking, 1900–1920*. Cambridge: Cambridge University Press, 2004.

Truax, Barry. "Soundscape Composition." https://www.sfu.ca/~truax/scomp.html. Accessed July 3, 2020.

Tsing, Anna. *The Mushroom at the End of the World: The Possibility of Life in Capitalist Ruins*. Princeton, NJ: Princeton University Press, 2015.

Tyranny. "'Blue'" Gene. "'Out to the Stars, Into the Heart: Spatial Movement in Recent and Earlier Music.'" *New Music Box*, January 1, 2003.

University of Pennsylvania Course Catalogue. "Music" (1954): 40–45. University of Pennsylvania Records.

Vágnerová, Lucie. "'Nimble Fingers' in Electronic Music: Rethinking Sound Through Neo-Colonial Labour." *Organised Sound* 22, no. 2 (2017): 250–58.

Vora, Kalindi. *Life Support: Biocapital and the New History of Outsourced Labor.* Minneapolis: Minnesota University Press, 2015.

Wald, Priscilla. "Cells, Genes and Stories: HeLa's Journey from Labs to Literature." In *Genetics and the Unsettled Past: The Collision of DNA, Race and History*, edited by Keith Wailoo, Alondra Nelson, and Catherine Lee, 247–65. New Brunswick, NJ: Rutgers University Press, 2012.

Wald, Priscilla. "Replicant Being: Law and Strange Life in the Age of Biotechnology." In *New Directions in Law and Literature*, edited by Elizabeth S. Anker and Bernadette Meyler, section 2, page 3. Oxford: Oxford University Press, 2017.

Waltham-Smith, Naomi. *Shattering Biopolitics: Militant Listening and the Sound of Life.* New York: Fordham University Press, 2021.

Waltham-Smith, Naomi. "The Sound of Biopolitics." Colloquium talk at University of California San Diego Music Department, September 20, 2016.

Wark, McKenzie. "Blog-Post for Cyborgs" *Public Seminar* (September 2015). https://publicsemi nar.org/2015/09/blog-post-for-cyborgs/. Accessed October 4, 2015.

Watkins, Holly, and Melina Esse. "Down with Disembodiment; or Musicology and the Material Turn." *Women and Music: A Journal of Gender and Culture* 19 (2015): 160–68.

Watrous, Peter. "Music Review: Maryanne Amacher." *New York Times*, February 28, 1988.

Webster, Daniel. "Cunningham Group Danced with Joy." *Philadelphia Inquirer*, January 17, 1976.

Weheliye, Alexander G. *Habeus Viscus: Racializing Assemblages, Biopolitics and Black Feminist Theories of the Human.* Durham, NC: Duke University Press, 2014.

Weindling, Paul. *Health, Race, and German Politics between National Unification and Nazism, 1870–1945.* Cambridge: Cambridge University Press, 1989.

"What Does WBFO Have in Common with NBC and CBS?," New York: Parents Press, Inc, 1967.

Whitelaw, Mitchell. "Sound Particles and Microsonic Materialism." *Contemporary Music Review* 22, no. 4 (2003): 93–101.

Wiegman, Robyn. *Object Lessons.* Durham, NC: Duke University Press, 2012.

Wilderson, Frank B., III. *Red, White & Black: Cinema and the Structure of U.S. Antagonisms.* Durham, NC: Duke University Press, 2010.

Willis, Thomas. "A Sound Ambience from Inner Space." *Tribune*, May 10, 1974, weekend edition, section 2–3.

Wilson, Elizabeth. *Gut Feminism.* Durham, NC: Duke University Press, 2014.

Wilson, Gregory S. "Deindustrialization, Poverty and Federal Area Redevelopment in the United States, 1945–1965." In *Beyond the Ruins: The Meanings of Deindustrialization*, edited by Jefferson Cowie and Joseph Heathcott, 181–200. Ithaca, NY: Cornell University, 2003.

Wlodarski, Amy Lynn. *George Rochberg, American Composer: Personal Trauma and Artistic Creativity.* Rochester: University of Rochester Press, 2019.

Wood, John. "Up a Laser River with MIT." *The Boston Globe*, October 7, 1971, 16.

Wooley, Nate. "Guide to American Weirdos." *The Wire* (July 2016). https://www.thewire.co.uk/in-writing/the-portal/nate-wooleys-guide-to-american-weirdos. Accessed May 10, 2020.

Wright, Susan. "Recombinant DNA Technology and Its Social Transformation, 1972–1982." *Osiris* 2 (1986): 303–60.

Yetisen, Ali K., Joe Davis, Ahmet F. Coskun, George M. Church, and Seok Hyun Yun. "Bioart: Trends in Biotechnology." *Trends in Biotechnology* 33, no. 2 (2015): 724–34.

Yúdice, George. *The Expediency of Culture: Uses of Culture in the Global Era.* Durham, NC: Duke University Press, 2004.

Yusoff, Katherine. *A Billion Black Anthropocenes or None.* Minneapolis: University of Minnesota Press, 2016.

Z, Pamela. "A Tool Is a Tool." In *Women, Art and Technology*, edited by Judith Malloy, 348–61. Cambridge: MIT Press, 2003.

Zaimont, Judith Lang, and Catherine Overhauser, eds. *The Musical Woman: An International Perspective, Volume II, 1984–1985*. Westport, CT: Greenwood Press, 1984.

Zeldner, Charles. "WBFO Receives National Award." *The Spectrum*, February 16, 1968.

2. Unpublished Writings, Notes, and Correspondence

Amacher, Maryanne. College Transcript, 1960. University of Pennsylvania Records.

Amacher, Maryanne. Letter to Parents. Undated, mid-1960s. Maryanne Amacher Archive.

Amacher, Maryanne. *Adjacencies*. Score and Performance Instructions, 1965/66. Maryanne Amacher Archive.

Amacher, Maryanne. *Adjacencies*. Working Notes and Papers. Undated, mid-1960s. Maryanne Amacher Archive.

Amacher, Maryanne. *Space Notebook*. Undated, mid-1960s. Maryanne Amacher Archive.

Amacher, Maryanne. Program Notes. "Adjacencies from Audjoins Suite." 1965. Maryanne Amacher Archive.

Amacher, Maryanne. "In City, Buffalo 1967." Maryanne Amacher Archive.

Amacher, Maryanne. "In-City, Diagram Schedule." 1967. Maryanne Amacher Archive.

Amacher, Maryanne. Works List. Undated, early 1970s. Maryanne Amacher Archive.

Amacher, Maryanne. *Long Distance Music*. 1970. Maryanne Amacher Archive.

Amacher, Maryanne. "Garden of Stillness for the Charles River." 1973. CAVS Special Collection.

Amacher, Maryanne. "Garden of Energy for the Charles River." 1973. CAVS Special Collection.

Amacher, Maryanne. Work Summary. Spring 1973. Maryanne Amacher Archive.

Amacher, Maryanne. Collaborative Projects. 1973. Maryanne Amacher Archive.

Amacher, Maryanne. Resume. 1973. Maryanne Amacher Archive.

Amacher, Maryanne. Letter to Nancy Tebeau. October 26, 1973. Maryanne Amacher Archive.

Amacher, Maryanne. "Sound and the Environment" and "Anywhere City." Proposal with Luis Frangella and Juan Navarro Baldeweg submitted to the National Endowment for the Arts, Maryanne Amacher Archive.

Amacher, Maryanne. "Everything-in-Air, Cunningham Studio in Westbeth." March 30 and 31, 1974. Maryanne Amacher Archive.

Amacher, Maryanne. Letter to Ailene Valkanas. Undated, spring 1974. MCA Chicago Archive.

Amacher, Maryanne. Letter to Sue Weil. July 14, 1974. Walker Art Center Archives.

Amacher, Maryanne. Working Notes, Walker Art Center Projects. August–September 1974. Maryanne Amacher Archive.

Amacher, Maryanne. Letter to Tom Crosby. September 6, 1974. Walker Art Center Archives.

Amacher, Maryanne. "Specific History of the Order to Northwestern Bell for 15 kcl Lines Terminating at Walker Art Center." Walker Art Center Archives.

Amacher, Maryanne. "Recent Individual Projects, 1974." Maryanne Amacher Archive.

Amacher, Maryanne. Equipment List and Installation Notes. September 1974. Walker Art Center Archives.

Amacher, Maryanne. "Notes on Photo Documentation: NO MORE MILES, An installation of Sound and Image." October–November, 1974. Walker Art Center Archives.

Amacher, Maryanne. Letter to Sue Weil. Undated September 1974. Walker Art Center Archives.

Amacher, Maryanne. Letter to John Cage. September 10, 1976. John Cage Collection at Northwestern University.

Amacher, Maryanne. *Additional Tones Workbook IV*. 1976/rev. 1987. Maryanne Amacher Archive.

Amacher, Maryanne. Letter to Libby Larsen. February 4, 1980. Walker Art Center Archives.

Amacher, Maryanne. *Intelligent Life*. 1980, Maryanne Amacher Archive.

Amacher, Maryanne. "Living Sound (Patent Pending)." 1980. Maryanne Amacher Archive.

Amacher, Maryanne. "Project Notes: Music for Sound Joined Rooms." Undated, possibly 1981. Maryanne Amacher Archive.

Amacher, Maryanne. Interview with Barbara Golden, 1985. Maryanne Amacher Archive.

Amacher, Maryanne. "Dynamic Range/The Head Stretch." Possibly 1982. Maryanne Amacher Archive.

Amacher, Maryanne. *Intelligent Life Project Description*. 1979. Maryanne Amacher Archive.

Amacher, Maryanne. "Direction of Work about the Big Waves of Structure Borne Sound." 1983. Maryanne Amacher Archive.

Amacher, Maryanne. "Haraway Transcriptions." Undated, early 1980s. Maryanne Amacher Archive.

Amacher, Maryanne. Working notes for *The Biaurals: A Four-Part Mini-Sound Series*. Undated, late 1980s. Maryanne Amacher Archive.

Amacher, Maryanne. Works List. 1985. Maryanne Amacher Archive.

Amacher, Maryanne. *Empty Words/Close-Up*. Proposal to the NEA. John Cage Collection at Northwestern University.

Amacher, Maryanne. Letter to Gottfriend Herder. Undated, September 1989. Maryanne Amacher Archive.

Amacher, Maryanne. Working Notes, Linz. 1989. Maryanne Amacher Archive.

Amacher, Maryanne. Working Notes, SAGA. Maryanne Amacher Archive.

Amacher, Maryanne. Working Notes, Pier A. Maryanne Amacher Archive.

Amacher, Maryanne. "Concept Summary" for "THE LEVI MONTALCINI VARIATIONS" for the Kronos String Quartet. July 1992. Maryanne Amacher Archive.

Baldeweg, Juan Navarro. "Report." September 1972. CAVS Special Collection.

Bochenek, Nancy. "Floating Modules on the Charles River." Sketch. 1972. CAVS Special Collection.

Burgess, Lowry. "The Reforestation of the Charles Rives: A Concept for a New Park." CAVS Special Collection.

Burgess, Lowry. "Star-Pits Waiting for Light Planes." CAVS Special Collection.

Cage, John. "Handwritten Phone Number List." 1976. John Cage Collection at Northwestern University Library.

Center for Advanced Visual Studies Course Descriptions, 1975–1976.

Curtis, Joseph. Letter to Kepes, October 19, 1971. CAVS Special Collection.

Fisher, Scott. "Eye in Time - 3," *Boston Celebrations I*, 1975. CAVS Special Collection.

Kepes, György. Untitled Plant Description. CAVS Special Collection.

Kepes, György. Charles River Project Members. CAVS Special Collection.

Kepes, György. Letter to Frank Press, Naval Architecture, Hydrodynamics Laboratory, Commissioner John Sears. May 4, 1971. CAVS Special Collection.

Kepes, György. "Charles River Memo." June 28, 1971. CAVS Special Collection.

Kepes, György. Letter to Commissioner Joseph E. Curtis. October 19, 1971. CAVS Special Collection.

Kepes, György. "Additional Information Related to the Application of the Center for Advanced Visual Studies for Funds from the Massachusetts Council for the Arts and Humanities." October 22, 1971. CAVS Special Collection.

Kepes, György. Letter to Bertram Kessel. January 12, 1972. CAVS Special Collection.

Kepes, György. Letter to Mr. Brian O'Doherty, Director, Visual Arts Program and that National Foundation for the Arts and Humanities. September 6, 1972. CAVS Special Collection.

Kepes, György. Charles River Project Meeting. February 22, 1973. CAVS Special Collection.

Kepes, György. Letter to William Lacy. January 14, 1974. CAVS Special Collection.

Kessel, J. Bertram. Meeting Announcement: The Charles River Recreational Council. January 6, 1972. CAVS Special Collection.

Mariano, Bob. Letter to NEA Director of Public Media. September 17, 1976. John Cage Collection at Northwestern University Library.

McNulty, Tom. "Charles River Project." CAVS Special Collection.

Larsen, Libby. Letter to Maryanne Amacher. January 4, 1980. Walker Art Center Archives.

Larsen, Libby. Letter to Maryanne Amacher. January 29, 1980. Walker Art Center Archives.

Piene, Otto. Letter to Maryanne Amacher. October 1974. CAVS Special Collection.

Piene, Otto. Letter to Maryanne Amacher. April 8, 1975. CAVS Special Collection.

Piene, Otto. Letter to Maryanne Amacher. February 18, 1975. CAVS Special Collection.

Piene, Otto. Letter to Maryanne Amacher. March 24, 1976. CAVS Archives.

Prince, Keiko. *The Shelter—Sun Water Dial*. Project notes. CAVS Special Collection.

Prince, Keiko. Wind Belt and Fountain Maze. CAVS Special Collection.

Prince, Keiko. Letter to John Sears, April 11, 1972. CAVS Special Collection.

Redden, Nigel. Letter to Maryanne Amacher. February 12, 1980. Walker Art Center Archives.

Redden, Nigel. Letter to Richard Roch. April 12, 1980. Walker Art Center Archives.

"Repertory Sheet—TORSE." January 7, 1976. The Merce Cunningham Archive.

Seimering, William H. Letter to John Cage. May 31, 1967. John Cage Collection at Northwestern University.

Seimering, William H. "National Public Radio Purposes." Personal copy shared with the author.

Seimering, William H. Untitled Report. Spring 1967. John Cage Collection at Northwestern University.

Weil, Suzanne. Letter to Maryanne Amacher. July 12, 1974. Walker Art Center Archives.

Weil, Suzanne. Letter to Dick Paske. Undated, summer 1974. Walker Art Center Archives.

3. Discography and Videography

Amacher, Maryanne. "Sound Characters (Synaptic Island & A Step Into It, Imagining 1001 Years)." On *Swarm of Drones*. Asphodel CD, 1995.

Amacher, Maryanne. "KARYON Sound Character." On *A Storm of Drones*. Asphodel CD, 1995.

Amacher, Maryanne. "Sound Characters." On *The Throne of Drones*. Asphodel CD, 1995.

Amacher, Maryanne. "Excerpt from Stain - The Music Rooms." On *Imaginary Landscapes: New Electronic Music*. Elektra Nonesuch CD, 1989.

Amacher, Maryanne. *Sound Characters (making the third ear)*. Tzadik CD, 1999.

Amacher, Maryanne. "Living Sound." On *Ohm: The Early Gurus of Electronic Music: 1948–1980*. Ellipsis Arts CD, 2000.

Amacher, Maryanne. "Remainder." On *Music for Merce, 1952–2000, Vol. 4*. New World Records CD, 2000.

Amacher, Maryanne. *Teo! Sound Characters 2 (Making Sonic Spaces)*. Tzadik CD, 2008.

Amacher, Maryanne. "Sound Characters." On *The Throne of Drones*. Asphodel CD, 1995.

Amacher, Maryanne. "The Jet Sono" at Capp Street Project, 1985.

Amacher, Maryanne. Lecture at Ars Electronica. 1989.

Amacher, Maryanne. With Marianne Schroeder. *Petra*. Performance recording, 1991.

Amacher, Maryanne. *Glia*. Performance recording, 2006.

Amacher, Maryanne. Lecture at Ars Electronic. 2005.

Amacher, Maryanne. *Sea Legs* with Mike Guran, Music Image Workshop: WGBH TV Cambridge, MA, 1973.

Atlas, Charles, dir. Torse. 1975. Choreography by Merce Cunningham. [Place of Publication not Identified]: Merce Cunningham Foundation, 1978. Videocassette.

Dhomme, Sylvain, dir. *Mikrophonie I*. 1966. Groupe de Recherches Musicales de L.O.R.T.F. Kürten, Germany: Stockhausen-Verlag, 1975. Videocassette.

Karel, Ernst. *Heard Laboratories*. OAR. CD, 2013.

Kierkegaard, Jacob. *Labyrinthitis*. Touch. Digital release, 2008.

Schick, Steven, and Red Fish Blue Fish. *Stockhausen: Complete Early Percussion Works*: (2014) Mode CD.

4. Archival Tapes

With the exception of *Here*, the tapes listed in this section have been digitized and partly inventoried in the Maryanne Amacher Archive prior to its placement at the New York Public Library. I have listed the tapes based on how they were inventoried in 2016. This includes the numbering systems and content descriptions which mostly come from Amacher's labels. Tapes were digitized by Bob Bielecki, Robert The, and Lawrence Kumpf with the support of Blank Forms.

Here c. 1966. Sousa Archives at the University of Illinois. Experimental Music Studio Records. Series 3, Subseries 1, Box 13.

MA2 Buffalo.

MA3 Buffalo.

M4—Living Sound spiral circulation, Ring Mod Alone with Here, Bauls, Master Mix Reel prepared for MELT, Boston Harbor Spirals.

M7—Bells from Droppings, Droppings, Tensegrity, Droppings Low Tone Columbia, Master Figure 6'16" Structure.

M10—R-D Film, Difference Tone Structure with Droppings Harbor Mix, Buffalo instruments segments.

M22—City Links WBFO Buffalo—Last Half Hour.

M23—City Links WBFO Buffalo, 8–9 p.m.

M24—City Links WBFO Buffalo, 9–10 p.m.

M25—City Links WBFO Buffalo, 10:15 p.m.–11:15 p.m.

M38 (Travel 9)—wave 15, full song chorus, full harmony, point is made, long drawn rise, Gary's wave, Energy A, Another region.

M45—Intercept Mix structures.

M59—Midnight to EA Sequence versions used for Kitchen.

M103—Pocket Melody (Low Neural M), Et Episode Structure.

M104—Pocket Melody Part 2.

Pier A NYC #14—Night of Ships Horns, Thanksgiving, November 22.

Pier A, NYC #16, November 22—Night of Boat Horns, 3 of 6.

Audio & Video Tape + more Sony Umatic KC 30—Copy of Navy Pier Tape NO SOUND—color, Spring 1974, for Show at Museum of Contemporary Art with Amacher, by students of University of Illinois at Chicago Circle, Ed Rankus, principal worker, processes on Dan Sandin.

Minneapolis on-site research.

Minneapolis LaSalle Arcade Research—No More Miles—on site recordings, locations, late site for "live" installation.

More Minneapolis: Kenwood tower, Canal front, Walker a little outdoor, Beginnings of Milll, Dayton Radtson [Radisson].

5. Personal Communications with the Author

Braxton, Anthony. Conversation with the author. October 17, 2013.

Brew, Kathy. Conversation with the author. October 11, 2016.

Brew, Kathy. Conversation with the author. March 29, 2018.

Curran, Alvin. Conversation with the author. March 16, 2015.

Dietz, Bill. Conversation with the author. August 7, 2012.

Dietz, Bill. Conversation with the author. October 21 and 22, 2016.

Dietz, Bill. Conversation with the author. December 11, 2016.

Dietz, Bill. Conversation with the author. July 17, 2017.

Dietz, Bill. Conversation with the author. January 14, 2018.

Dietz, Bill. Conversation with the author. March 29, 2018.

Dietz, Bill. Conversation with the author. November 7 and 8, 2018.

Dietz, Bill. Conversation with the author. June 1, 2019.

Fisher, Scott. Telephone conversation with the author. September 13, 2017.

Levine Packer, Renée. Conversation with the author. September 29, 2013.

Levine Packer, Renée. Conversation with the author. January 18, 2018.

Phillips, Liz, and Earl Howard. Conversation with the author. December 3, 2016.

Prince, Keiko. Conversation with the author. February 20, 2017.

Prince, Keiko. Conversation with the author. September 18, 2017.

Prince, Keiko. Conversation with the author. April 13, 2019.

Prince, Keiko. Video conference conversation with Bill Dietz, Kabir Carter, and the author. May 23, 2020.

Seimering, William. Telephone conversation with the author. August 22, 2019.

Spanier, Bonnie. E-mail correspondence with the author. September 4–15, 2020.

Sullender, Woody. Conversation with the author. August 3, 2013.

Tcherepnin, Sergei. Conversation with the author. October 21, 2016.

Tcherepnin, Stefan. Conversation with the author. February 20, 2017.

The, Robert. Conversation with the author. August 7, 2012.

The, Robert. Conversation with the author. October 23, 2016.

The, Robert. Conversation with the author. December 11, 2016.

Williams, Jan. Telephone conversation with the author. August 17, 2017.

INDEX

For the benefit of digital users, indexed terms that span two pages (e.g., 52–53) may, on occasion, appear on only one of those pages.

Tables and figures are indicated by t and f following the page number